Engaging Smithsonian Objects through Science, History, and the Arts

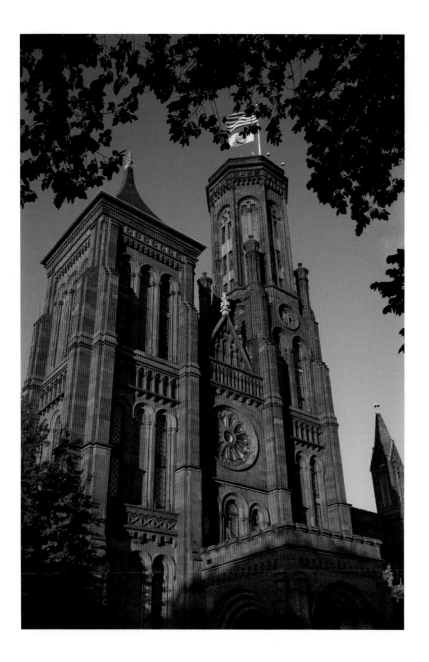

FRONTISPIECE.

The Smithsonian Institution's first building, the Castle, was designed by architect James Renwick and completed in 1855. Until 1881, it housed research and administration offices, lecture and exhibit halls, a library, laboratories, collections storage, and living quarters for the Secretary. Today, the Castle houses administrative offices and the Smithsonian Information Center. It remains an iconic symbol of the Institution. Photo by Eric Long.

Engaging Smithsonian Objects through Science, History, and the Arts

Edited by **Mary Jo Arnoldi**

A Smithsonian Contribution to Knowledge

Smithsonian Institution
Scholarly Press

Washington, D.C.
2016

Published by
SMITHSONIAN INSTITUTION SCHOLARLY PRESS
P.O. Box 37012, MRC 957
Washington, D.C. 20013-7012
www.scholarlypress.si.edu

Front cover images (left to right, top to bottom): Damaged American flag recovered from World Trade Center debris (see Gardner, Figure 2); Still image of *Study in Depth, Opus 152* (see Plate 2); Portrait of James Smithson (see Hunt, Figure 15, top right); Bell Aircraft–designed U.S. Army helicopter (see Connor, Figure 2); The Ole Bull violin (see Plate 4); Kīlauea volcano (see Plate 3); Daguerreotype of Frederick Douglass (see Goodyear, Figure 1); Central African throwing knife (see Plate 6); Miniature interactive iron lung (see Ott, Figure 4); The Smithsonian Castle (see Frontispiece).

Back cover images (left to right, top to bottom): James Smithson's skull (see Hunt, Figure 6); Color wheel used in *Study in Depth, Opus 152* (see Finn, Figure 3); Partially burned ID badge of Commander Patrick Dunn (see Plate 10); Ancient lava flow specimen, Kīlauea volcano (see Fiske, Figure 1); Color graph of the Hellier violin (see Frohlich and Sturm, Figure 5); Huey 65-10126 helicopter (see Plate 5); Comment card from the exhibition *Whatever Happened to Polio?* (see White, Figure 3); X-ray of Central African throwing knife (see Childs, Figure 5); Daguerreotype portrait of John Brown (see Plate 8); Sojourner Truth (see Goodyear, Figure 4); *Ipu heke* gourd idiophone (see Kaeppler, Figure 1).

Library of Congress Cataloging-in-Publication Data:
Engaging Smithsonian objects through science, history, and the arts / edited by Mary Jo Arnoldi.
 pages cm
 "A Smithsonian contribution to knowledge."
 Includes bibliographical references.
 ISBN 978-1-935623-16-8 (hardcover : alk. paper) -- ISBN 978-1-935623-73-1 (ebook) 1. Material culture. 2. Museum exhibits--Social aspects. 3. Smithsonian Institution--Exhibitions. 4. Smithsonian Material Culture Forum. I. Arnoldi, Mary Jo.
 GN406.E655 2016
 069--dc23
 2015018885

ISBN: 978-1-935623-16-8 (cloth)
ISBN: 978-1-935623-73-1 (ebook)

Printed in the United States of America

♾ The paper used in this publication meets the minimum requirements of the American National Standard for Permanence of Paper for Printed Library Materials Z39.48–1992.

Contents

Material Matters: Ways of Knowing Museum Objects

Mary Jo Arnoldi

The Smithsonian is the steward of the national collections numbering well over 137 million objects. These collections include many millions of natural history specimens, as well as several million art works and cultural artifacts, both hand-crafted and machine made.[1] Since its founding the in mid-nineteenth century, generations of Smithsonian curators and scholars have cataloged, studied, and interpreted these collections for museum visitors. Today, these national collections are distributed among 19 museums and galleries, 16 archives, the libraries, and the cultural and scientific research centers. The largest number of objects includes natural history specimens (about 125 million), which were collected for the most part on scientific expeditions. Hundreds of cultural objects were also acquired on research expeditions. Some of the objects and collections were pur-chased, although many more were obtained through the generous donations of individuals and institutions. Although the essays in this volume feature only a

handful of the millions of objects or collections, the 13 discussed were chosen to represent both the diversity and breadth of the Smithsonian holdings and to highlight the many different approaches and methods that constitute the ways that curators come to know museum objects.

The idea for this volume was inspired by the Smithsonian Material Culture Forum, which was founded in 1988 and is now in its 28th year. The forum brings together Smithsonian staff and fellows from across the institution and from within the disciplines of art history, anthropology, archaeology, folklore, geography, history, and the material and natural sciences in a lively exchange centered on topics related to museum objects and their display.[2] These ongoing dialogues have worked to bridge the gap between disciplines like art history, archaeology, and the material and natural sciences, which have a longstanding tradition of studying the material properties of objects or specimens, and disciplines like anthropology, folklore, geography, and history, which, when they engage material culture, generally give priority to the analysis of the cultural and social contexts in which these objects are embedded. In addition to a discussion of objects, the forum also examines exhibition practices within the institution with an eye to how museum objects have been selected and displayed at the Smithsonian over its more than 150 year history and how, through exhibits, new and different meanings accrue to objects and collections.

During the same period when the Material Culture Forum was taking shape, the Smithsonian sponsored national and international seminars, symposia, and conferences around the study of objects and museums. These conversations included both museum curators and academics. Notable among them were the annual seminars on material culture (1988–1997) organized by the Smithsonian and Yale University's Center for American Studies; several conferences organized by the National Museum of American History on the study of material culture and the history of technology; and, from the Department of Anthropology at the National Museum of Natural History, two international conferences on exhibiting and on museums and the politics of public culture.[3] These conferences and seminars were part of an exciting revitalization in material culture and museum studies that was then taking place worldwide, and indeed, over the past several decades, the body of material culture literature has grown steadily.[4]

Like the focus of the Material Culture Forum, each part in this volume begins with an object or a collection. For curators who are charged with studying, analyzing, and interpreting objects, their first encounter and engagement with

their collections is with their physical and tactile properties. Sandra Dudley defines these qualities as "the very thingness of the objects themselves."[5] To this end each of the 10 parts begins with a photograph of the featured object and a catalog record that notes its physical properties, including the object's material composition and size. The records also include information on when and under what circumstances the objects came to the collections. In each part, two paired essays expand upon these catalog entries and move out across a landscape of discovery not only to further elucidate the objects' material properties but to engage their cultural and social biographies. Essays by Bowers, Connor, Childs, Finn, Frohlich and Sturm, Ott, and Stamm focus attention on the formal style and material properties of the object they study and on the technologies and the contexts of these objects' production. Those by Fiske, Frohlich and Sturm, Hunt, and Childs feature the various technologies and techniques used to study objects or collections and explore how these different vantage points—the microscopic, the telescopic, or the kaleidoscopic—contribute to new knowledge. Zilczer, Shumard, and Sturm and Frohlich provide us with important insights about the biographies of the artists who created objects, and Arnoldi, Goodyear, Kaeppler, and Jakab tease out the nuances of the historical and social networks within which the particular objects were produced, performed, and consumed. Directing our attention to how meanings accrue to objects over time and space and how these meanings change, Arnoldi, Hughes, Ott, and White analyze the ways that exhibits of these objects shaped their interpretation, and Gardner and Fiske lay out their methodologies for collecting. Finally, Fiske and London demonstrate the roles that research collections regularly play in training students and in future scientific inquiry.

The objects that are featured in this volume include a seventeenth-century violin and several nineteenth-century objects, including a marble monument, daguerreotypes, and a hand-forged iron knife. More recent objects dating from the twentieth and twenty-first centuries include a light sculpture, a medical device, anatomical collections, a helicopter, and a movie prop, among others. Some objects enjoy an iconic status at the Smithsonian, such as the Ruby Slippers from the 1939 movie *The Wizard of Oz,* which have been on exhibit almost continuously since they were donated in 1979.[6] Others, such as the Central African throwing knife and the Thomas Wilfred light sculpture, are lesser known and more enigmatic. Neither the knife nor the light sculpture is currently on display, although both were previously featured in Smithsonian exhibits. Six of the objects in the

book came into the Smithsonian from the mid-nineteenth century up to 1970 and are part of historical collections that the generation of curators writing for this volume inherited. Seven objects or collections arrived during the tenure of these curators, and a number of the objects were actively collected by them.

The objects featured in the first three parts were specifically chosen to complicate our understanding of what constitutes a museum object. The first part features James Smithson's crypt, which is located in the Smithsonian Institution Building, commonly referred to as the Castle. The paired essays by Richard Stamm and David R. Hunt raise the question of what constitutes the museum object in this instance. Is the object Smithson's marble sarcophagus? Is it Smithson's physical remains that are entombed below the sarcophagus? Taken together the two essays provide us with a richer story and bring together insights from the arts and the sciences as complementary ways of engaging Smithson's crypt.

The paired essays in the second part also raise the question of what constitutes the museum object, albeit with somewhat different issues at stake. The intangible and tangible and light and matter are inextricably linked within *Opus 152*, a sculpture by Thomas Wilfred. Originally collected in 1996 by the Division of Technology at the National Museum of American History, the work was transferred a few years later to the Hirshhorn Museum and Sculpture Garden, where the mechanism was restored and the light sculpture was featured in a 2005 exhibit. Is the object then the projected light or the mechanism that produces it or both? Perspectives from the history of art and from the history of technology play an equally important role in our knowing this object. Bernard Finn discusses *Opus 152* from the perspective of technology, describing and analyzing the mechanical apparatus that creates the projections in light and color, whereas Judith Zilczer discusses Wilfred's artistic career and describes his experiments with light sculptures and his influence on the generation of artists that would follow.

In the third part Richard Fiske and Adrienne Kaeppler expand our imagination further and in two distinctly different ways as they pose the question, "How do we know a Hawaiian volcano?" Fiske demonstrates how, in making the volcanic rock collection from the Kīlauea volcano site, the locations of the individual rock samples in the landscape constitute critical scientific data. Moreover, through the use of judicious destructive sampling carried out on this collection, our understanding of the volcano's dynamic geological history advances. The interests of science (destructive sampling to further chemical analysis) and the primary interest of museum management (the preservation of collections) are held

in a tight tension. From a quite different perspective, Kaeppler introduces us to another way of knowing the Kīlauea volcano through the ritual performances associated with Pele, the Hawaiian goddess of volcanoes. Pele, as the divine artist, periodically reshapes the island landscape by means of volcanic eruptions. In a manner similar to Finn's and Zilczer's discussion of what constitutes the object in the case of the Wilfred light sculpture, Kaeppler begins with a gourd drum, mute in the anthropology collections, and extends our understanding of this museum object through an analysis of the performed landscape created through the dance, poetry, and drumming of the hula dedicated to Pele.

Connoisseurship and computer tomography (CT scanning), the art and the science of knowing an object, come together in the fourth part in two coauthored essays on the Stradivarius violins and cellos in the National Museum of American History collections. In the first essay Gary Sturm and Bruno Frohlich provide a history of the Antonio Stradivari workshop and its known production. Sturm shares his insights about how to identify a Stradivarius instrument on the basis of his long curatorial career in carefully examining and handling the Stradivarius stringed instruments in the Smithsonian collection and in other museum and private collections and by comparing Stradivarius instruments with other violin makers' instruments from the same and later periods. Sight, touch, sound, and time all play a critical role in building curatorial knowledge and connoisseurship. In the second essay Bruno Frohlich presents the findings of a pilot study of Stradivarius violins that used nondestructive CT scanning to see inside the instruments and to accurately measure the weight, curvature, and density of the different woods used in the different sections of the violin. The preliminary results of the study are suggestive and point to how different master violin makers, including Stradivari, manipulated and altered material relationships to produce their unique instruments.

In the fifth part the National Air and Space Museum's Huey helicopter (Huey 65-10126) takes center stage, and the two essays weave together the object's technological history and its social biography. Roger Connor discusses the development of the Huey helicopter, its technical innovations in terms of vertical flight, and the key features that made it the Army's work horse. Peter L. Jakab recounts his own curatorial journey of discovery about the helicopter. Each Huey helicopter is uniquely identified with a number as it leaves the factory, and in the process of developing an exhibition on Vietnam, Jakab located and reached out to the crew that had flown this Huey 65-10126 during the war. Through extensive

interviews with the crew, Jakab was able to document this helicopter's compelling and unique biography.

Material science and social history are the orientations of the two essays in the sixth part featuring a Central African throwing knife in the National Museum of Natural History. S. Terry Childs locates this throwing knife within the long history of metallurgy in Central Africa. Through binocular microscopy and X-rays she gives us a close view of the knife and reveals critical features that relate to its material attributes and the technology of its manufacture. I take up the story of the knife's life history at the point when it enters the ethnographic collection of Herbert Ward, an Englishman who worked in the Congo from 1884 through 1889. My essay focuses on the relationship of this knife to the other 1,700 Central African weapons in the Ward collection and interrogates Ward's collecting philosophy and his methodology. My essay then follows the knife through its exhibition history from its original display in Ward's private Paris museum to two different permanent exhibitions of African cultures at the Smithsonian.

In the seventh part the iron lung, a tank respirator, is the central object in two essays that examine the history of this medical device, its role in the treatment of victims of poliomyelitis during the first half of the twentieth century, and the memories that the iron lung evoked when it was put on exhibit in 2005 at the National Museum of American History. Katherine Ott engages the material and social history of this object through a careful examination of both the device's material properties and the role that the iron lung played in the treatment of polio. Matthew A. White analyzes the associative power of the iron lung. He interrogates the powerful memories and compelling stories that this device engendered in visitors to the polio exhibit. Using visitor comment cards, White surveys the drawn and written memories of polio survivors and their families and families whose members died from the disease. He also highlights the many visitors' memories about the fear that swept through communities during polio outbreaks, the role of the March of Dimes and people's hope for a cure, and the mass campaigns that followed the development of the Salk and Sabin vaccines.

The eighth part features a portrait of the abolitionist John Brown in the collections of the National Portrait Gallery taken by Augustus Washington, an African American photographer. Ann M. Shumard explores the artist's biography and places this portrait of John Brown within Washington's larger artistic oeuvre

beginning with his first work in Hanover, New Hampshire, through his final daguerreotype portraits produced in Monrovia, Liberia. Frank H. Goodyear III locates John Brown's portrait within the larger body of photographs that were circulated in the nineteenth-century American abolitionist movement.

The Smithsonian's Ruby Slippers are featured in the ninth part. They are one of five known extant pairs of shoes created for the 1939 MGM film *The Wizard of Oz* and were donated to the museum in 1979. Dwight Blocker Bowers examines the material properties and construction of the shoes and their evolution both in color and style from the original Frank Baum story—in which they were silver slippers—through several iterations of the movie script. Ellen Roney Hughes surveys the many interpretations of the Ruby Slippers over the years, some fanciful and others tortuous.

The terrorist attack on the United States on September 11, 2001, was a traumatic day for America, and in the last part, in the final essay pair in this collection, the authors step back from the focus on a single museum object to take a broader look at the role that two quite different collections played in the aftermath of this national tragedy. James B. Gardner sheds light on the museum's internal discussions about how and what to collect to document the 9/11 tragedy, and he discusses the best curatorial practices that guided the making of the collection. Marilyn R. London, a member of the national Disaster Mortuary Operational Response Team that was sent to the Flight 93 crash site in Pennsylvania, discusses the important role that the National Museum of Natural History's anatomical skeletal collections have played in training a generation of forensic anthropologists. She discusses how the careful study of these and other documented skeletal collections in museums have contributed to the establishment of standards for analysis and have provided new knowledge, techniques, and tools to aid in the identification of human remains.

Engaging Smithsonian Objects highlights the multiple ways of knowing single objects or collections, and although many themes are shared and link these 20 essays to one another, differences in curators' orientation and in the scope and method of their studies demonstrate the generative power of interdisciplinary inquiry. As this volume makes clear, no single academic discipline or theoretical perspective can lay sole claim to material culture studies. Furthermore, although these 20 authors represent different disciplines and approaches to museum objects, what they all share is passion for the objects and a commitment to this ongoing journey of discovery.

1. According to collection statistics published in 2015 the Smithsonian Collections number 138 million artifacts, works of art, and specimens. Of these, 127 million are held by the National Museum of Natural History. There are also 9 million digital records, 2 million library volumes, and over 136,194 cubic feet of archival material. See "Smithsonian Collections," Smithsonian Institution, accessed June 10, 2015, http://www.si.edu/Collections.

2. The Material Culture Forum was the inspiration of Dr. Cynthia Adams Hoover, emeritus curator of music in the National Museum of American History. Although it has always been a grassroots organization, it has received generous annual funding from the Smithsonian administration in support of its activities. Since the first forum in 1988, the Material Culture Forum has met quarterly, and many of the authors in this volume presented preliminary versions of their essays at these meetings. Several authors, including me, have served as Forum chairs; others served as members of the Steering Committee, and many of them have organized Forum sessions. The Forum published a quarterly newsletter, the *Grapevine*, from 1991 to 2001 that was superseded by an online publication, *Material Matters*, from 2001 to 2010. Forum records and newsletters are housed in the Smithsonian Institution Archives (Accession 12-520).

3. Reports from 4 of the 10 Yale-Smithsonian Seminars have been published: Kathleen O'Connor, ed., *Nineteenth Century American Silver: Report of the Yale-Smithsonian Seminar Held at Yale University, 7–8 April, 1988* (New Haven, CT: Yale University, 1989); Kirk R. Johnson, Leo Hickey, and Cynthia Hoover, eds., *Crossroads of Continents: The Material Culture of Siberia and Alaska* (Washington, D.C.: Yale-Smithsonian Seminar on Material Culture, 1991); Joshua W. Lane, ed., *The Impact of New Netherlands upon the Colonial Long Island Basin: Report of a Yale-Smithsonian Seminar Held at the Yale University, New Haven, CT, May 3–5, 1990* (New Haven, CT: Yale-Smithsonian Seminar on Material Culture, 1993); Patricia Thatcher, Paul Taylor, and Cynthia Hoover, eds., *The Gift as Material Culture: Report of a Yale-Smithsonian Seminar Held at the Smithsonian Institution, Washington, D.C., April 28–30, 1991* (New Haven, CT: Yale-Smithsonian Seminar on Material Culture, 1995). Two edited volumes from the National Museum of American History conferences were also published on material culture and the history of technology during this same time period: Steven Lubar and W. David Kingery, eds., *History from Things: Essays on Material Culture* (Washington, D.C.: Smithsonian Institution Press, 1993); W. David Kingery, ed., *Learning from Things: Method and Theory of Material Culture Studies* (Washington, D.C.: Smithsonian Institution Press, 1998). In addition to these works, edited volumes were published from the 1987 international conference on exhibiting and the 1988 international conference on museums and politics of public culture: Ivan Karp and Steven D. Lavine, eds., *Exhibiting Cultures: The Poetics and Politics of Museum Display* (Washington, D.C.: Smithsonian Institution Press, 1991); Ivan Karp, Christine Mullen Kreamer, and Steven D. Lavine, eds., *Museums and Communities: The Politics of Public Culture* (Washington, D.C.: Smithsonian Institution Press, 1992). These publications continue to be influential in current museum studies. In 1997, influenced by the issues of representations and the politics of public culture raised in these earlier conferences, Henderson and Kaeppler edited a volume of contributions by Smithsonian curators that focused on curatorial dilemmas that they encountered in exhibiting at the institution. Smithsonian curators in the National Museum of American History were also the founding members of Artefacts, a consortium of scholars

of technology and science in museums and universities who are dedicated to using objects in historical studies of science and technology. Founded in 1996, the consortium has produced nine edited volumes from their annual conferences. For a listing of these publications see the Artefacts website, accessed June 10, 2015, http://www.artefactsconsortium.org/Publications/MainPublicationsF.html.

4. The literature on material culture is now so rich and vast that it is possible to include only a very small sampling of influential works that cut across a number of academic disciplines. For example, two recent handbooks cover a wide range of current topics in material culture studies in their respective fields and include extensive bibliographies; see Dan Hicks and Mary C. Beaudry, eds., *The Oxford Handbook of Material Culture Studies* (London: Oxford University Press, 2010) for archaeology and Chris Tilley, Webb Keane, Susan Küchler, Mike Rowlands, and Patricia Spyer, eds., *Handbook of Material Culture* (London: Sage, 2006) for anthropology. Sophie Woodward's online bibliography highlights primarily current British publications in the study of material culture in anthropology; see Sophie Woodward, "Material Culture," in *Oxford Bibliographies in Anthropology*, ed. John L. Jackson Jr. (New York: Oxford University Press, 2013), accessed June 10, 2015, http://www.oxfordbibliographies.com/view/document/obo-9780199766567/obo-9780199766567-0085.xml. Although I include a few monographs here from various fields (see James Deetz, *In Small Things Forgotten* [Garden City, NY: Doubleday Natural History Press, 1977] and Ian Hodder, *Entangled: An Archaeology of the Relationships between Humans and Things* [Malden, MA: Wiley-Blackwell, 2012] for archaeology; Alfred Gell, *Art and Agency: An Anthropological Theory* [Oxford: Oxford University Press, 1998]; Webb Keane, *Signs of Recognition: Power and Hazards of Representations in an Indonesian Society* [Berkeley: University of California Press, 1997]; and

Nicolas Thomas, *Entangled Objects: Exchange, Material Culture and Colonialism in the Pacific* [Cambridge, MA: Harvard University Press, 1991] for anthropology; Henry Glassie, *Material Culture* [Bloomington: Indiana University Press, 1999] for folklore; Jules Prown, *Art as Evidence: Writing on Art and Material Culture* [New Haven, CT: Yale University Press, 2001] and W. J. T. Mitchell, *Picture Theory: Essays on Verbal and Visual Representation*, 2nd ed. [Chicago: University of Chicago Press, 1995] for art history; and Steven Conn, *Do Museums Still Need Objects?* [Philadelphia: University of Pennsylvania Press, 2009] for history), many influential edited volumes bring together studies that address key themes in current material culture and museum studies (see Arjun Appaduri, ed., *The Social Life of Things: Commodities in Cultural Perspective* [Cambridge: Cambridge University Press, 1986] on consumption; Sandra H. Dudley, *Materiality Matters: Experiencing the Displayed Object*, University of Michigan Working Papers in Museum Studies, No. 8 [Ann Arbor: University of Michigan, 2012] and Sandra H. Dudley, ed. *Museum Objects: Experiencing the Properties of Things* [London: Routledge, 2012] on experiencing museum objects; Ian Hodder, ed., *The Meaning of Things: Material Culture and Symbolic Expression* [London: Unwin Hyman, 1989] on symbolism; Ivan Karp, Corrine A. Kratz, Lynn Szwaja, Tomás Ybarra-Frausto, and Barbara Kirshenblatt-Gimblett, eds., *Museum Frictions: Public Cultures/Global Transformations* [Durham, NC: Duke University Press, 2006] on globalization; Simon Knell, ed., *Museums in the Material World* [London: Routledge, 2007] on museums; Daniel Miller, ed., *Material Culture: Why Some Things Matter* [Chicago: University of Chicago Press, 1998] and Daniel Miller, ed., *Materiality* [Durham, NC: Duke University Press, 2005] on materiality; Susan M. Pearce, "Museum Objects," in *Interpreting Objects and Collections*, ed. Susan M. Pearce [London: Routledge, 1994], 9–11 on

museum objects; and Helen Sheumaker and Shirley Teresa Wajda, eds., *Material Culture in America: Understanding Everyday Life* [Santa Barbara, CA: ABC-CLIO, 2008] on material culture in American Studies).

5. Dudley, *Materiality Matters*, 1.
6. The Ruby Slippers are a featured object in Richard Kurin's book *The Smithsonian's History of America in 101 Objects* (New York: Penguin Press, 2013), 420–425.

BIBLIOGRAPHY

Appaduri, Arjun, ed. *The Social Life of Things: Commodities in Cultural Perspective.* Cambridge: Cambridge University Press, 1986.

Artefacts website. Accessed June 10, 2015. http://www.artefactsconsortium.org/Publications/MainPublicationsF.html.

Buchli, Victor, ed. *The Material Culture Reader.* Oxford: Berg, 2002.

Conn, Steven. *Do Museums Still Need Objects?* Philadelphia: University of Pennsylvania Press, 2009.

Deetz, James. *In Small Things Forgotten.* Garden City, NY: Doubleday Natural History Press, 1977.

Dudley, Sandra H. *Materiality Matters: Experiencing the Displayed Object.* University of Michigan Working Papers in Museum Studies, No. 8. Museum Studies Program, Charles H. Sawyer Center for Museum Studies, University of Michigan Museum of Art. Ann Arbor: University of Michigan, 2012.

———, ed. *Museum Objects: Experiencing the Properties of Things.* London: Routledge, 2012.

Gell, Alfred. *Art and Agency: An Anthropological Theory.* Oxford: Oxford University Press, 1998.

Glassie, Henry. *Material Culture.* Bloomington: Indiana University Press, 1999.

Hicks, Dan, and Mary C. Beaudry, eds. *The Oxford Handbook of Material Culture Studies.* London: Oxford University Press, 2010.

Hodder, Ian. *Entangled: An Archaeology of the Relationships between Humans and Things.* Malden, MA: Wiley-Blackwell, 2012.

———, ed. *The Meaning of Things: Material Culture and Symbolic Expression.* London: Unwin Hyman, 1989.

Johnson, Kirk R., Leo Hickey, and Cynthia Hoover, eds. *Crossroads of Continents: The Material Culture of Siberia and Alaska.* Washington, D.C.: Yale-Smithsonian Seminar on Material Culture, 1991.

Karp, Ivan, Corrine A. Kratz, Lynn Szwaja, Tomás Ybarra-Frausto, and Barbara Kirshenblatt-Gimblett, eds. *Museum Frictions: Public Cultures/Global Transformations.* Durham, NC: Duke University Press, 2006.

Karp, Ivan, Christine Mullen Kreamer, and Steven D. Lavine, eds. *Museums and Communities: The Politics of Public Culture.* Washington, D.C.: Smithsonian Institution Press, 1992.

Karp, Ivan, and Steven D. Lavine, eds. *Exhibiting Cultures: The Poetics and Politics of Museum Display.* Washington, D.C.: Smithsonian Institution Press, 1991.

Keane, Webb. *Signs of Recognition: Power and Hazards of Representations in an Indonesian Society.* Berkeley: University of California Press, 1997.

Kingery, W. David, ed. *Learning from Things: Method and Theory of Material Culture Studies.* Washington, D.C.: Smithsonian Institution Press, 1998.

Knell, Simon, ed. *Museums in the Material World.* London: Routledge, 2007.

Kurin, Richard. *The Smithsonian's History of America in 101 Objects.* New York: The Penguin Press, 2013.

Lane, Joshua W., ed. *The Impact of New Netherlands upon the Colonial Long Island Basin: Report of a Yale-Smithsonian Seminar Held at the Yale University, New Haven, CT, May 3–5, 1990.* New Haven, CT: Yale-Smithsonian Seminar on Material Culture, 1993.

Arnoldi

Lubar, Steven, and W. David Kingery, eds. *History from Things: Essays on Material Culture*. Washington, D.C.: Smithsonian Institution Press, 1993.

Miller, Daniel, ed. *Material Culture: Why Some Things Matter*. Chicago: University of Chicago Press, 1998.

———, ed. *Materiality*. Durham, NC: Duke University Press, 2005.

Mitchell, W. J. T. *Picture Theory: Essays on Verbal and Visual Representation*. 2nd ed. Chicago: University of Chicago Press, 1995.

O'Connor, Kathleen, ed. *Nineteenth Century American Silver: Report of the Yale-Smithsonian Seminar Held at Yale University, 7–8 April, 1988*. New Haven, CT: Yale University, 1989.

Pearce, Susan, ed. *Interpreting Objects and Collections*. London: Routledge, 1994.

———. "Museum Objects." In *Interpreting Objects and Collections*, ed. Susan M. Pearce, pp. 9–12. London: Routledge, 1994.

Prown, Jules. *Art as Evidence: Writing on Art and Material Culture*. New Haven, CT: Yale University Press, 2001.

Prown, Jules David, and Kenneth Haltman. *American Artifacts: Essays in Material Culture*. East Lansing: Michigan State University Press, 2000.

Sheumaker, Helen, and Shirley Teresa Wajda, eds. *Material Culture in America: Understanding Everyday Life*. Santa Barbara, CA: ABC-CLIO, 2008.

Smithsonian Institution. "Smithsonian Collections." Accessed June 10, 2015. http://www.si.edu/ Collections.

Smithsonian Material Culture Forum. Material Matters Bulletin. Accession 12-520. Smithsonian Institution Archives.

Thatcher, Patricia, Paul Taylor, and Cynthia Hoover, eds. *The Gift as Material Culture: Report of a Yale-Smithsonian Seminar Held at the Smithsonian Institution, Washington, D.C., April 28–30, 1991*. New Haven, CT: Yale-Smithsonian Seminar on Material Culture, 1995.

Tilley, Chris, Webb Keane, Susan Küchler, Mike Rowlands, and Patricia Spyer, eds. *Handbook of Material Culture*. London: Sage, 2006.

Thomas, Nicolas. *Entangled Objects: Exchange, Material Culture and Colonialism in the Pacific*. Cambridge, MA: Harvard University Press, 1991.

Woodward, Sophie. "Material Culture." In *Oxford Bibliographies in Anthropology*, ed. John L. Jackson, Jr. New York: Oxford University Press, 2013. Accessed June 10, 2015. http://www.oxfordbibliographies.com/view/document/obo-9780199766567/obo-9780199766567-0085.xml.

James Smithson's Crypt

Plate 1
James Smithson monument

Date: 1829
Materials:
Monument: Italian marble
Base: Red Tennessee marble
Measurements:
Monument: 239.39 cm (94.3 in) height × 166.37 cm (65.5 in) width × 90.17 cm
(35.5 in) depth
Base: 47.62 cm (18.8 in) height × 200.81 cm (79.1 in) width × 124.77 cm
(49.1 in) depth
Catalog number: SI.2012.009
Smithsonian Institution Castle Collection
Originally erected at James Smithson's gravesite in Genoa, Italy; acquired December 1904.
James Smithson (ca. 1765–1829) was buried in 1829 in an English cemetery in Genoa, Italy,
disinterred in 1906, and then reinterred in Washington, D.C., in this crypt in the original
Smithsonian Institution Building (the Castle).

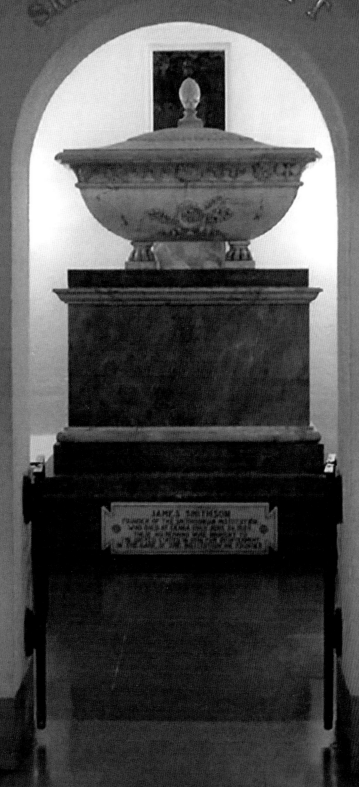

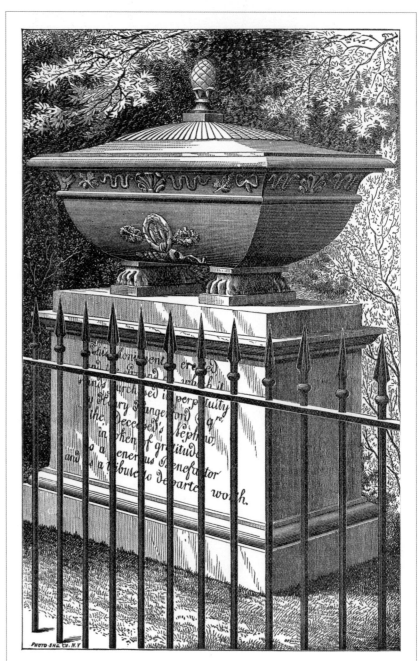

TOMB OF JAMES SMITHSON.

At Genoa, Italy.

FIGURE 1.
Engraving of Smithson's grave in Genoa, Italy. From a photograph acquired in 1857. Printed in *James Smithson and His Bequest* by William Jones Rhees (Washington, D.C.: Smithsonian Institution, 1880).

Smithson's Crypt and the Search for a Proper Memorial

Richard Stamm

A curious sight greets visitors to the Smithsonian Institution Building (the Castle) as they enter through the building's main entrance. A small room to the left of the vestibule housing a marble monument and a memorial plaque is simply labeled "Smithson Crypt" (Plate 1).[1] The classically designed monument and plaque are among the most unusual and compelling objects cataloged in the eclectic Castle Collection.

James Smithson (1765–1829), the English scientist whose bequest led to the formation of the Smithsonian Institution, was buried in the English Protestant cemetery on the heights of San Benigno near Genoa, Italy. Early proposals to erect a monument to Smithson by the fledgling institution began to develop in 1852 even before the Smithsonian Institution Building was completed. Although there was great interest in the Institution's benefactor among the Smithsonian's regents, the business of completing the building and directing the course of the Institution took precedence. No one at that time could have known that 52 years later the regents would again entertain designs for a Smithson memorial or that the Smithsonian would have collected not only facts and objects relating to James Smithson but, incredibly, the remains of Smithson himself!

THE ITALIAN GRAVESITE AND THE MEMORIAL MONUMENT

From a daguerreotype obtained early in 1857, Smithsonian officials got their first glimpse of Smithson's Italian gravesite erected by his nephew, Henry James Hungerford.[2] What they saw was a handsome grave marker in the shape of a sarcophagus resting atop a high marble base surrounded by an iron spearheaded fence. Although the monument was designed in the shape of a sarcophagus, an ancient funerary form constructed to hold the earthly remains of the deceased, it was not Smithson's repository, but rather a grand marker for the grave below (Figure 1).

The regents would also have noted that the sarcophagus-shaped urn was carved with images heavy with funerary symbolism. The massive urn is supported on platforms carved in the shape of lions' feet. The lion represents strength, and its paws have been used as decorative devices on chairs and thrones in both ancient Egypt and Greece.[3] Large central medallions, composed of a moth or butterfly inside a laurel wreath, decorated with laurel branches, and festooned with ribbon, are carved into the front and back of the marker. Moths, having "died" as caterpillars, represent new life after death. In classical times, the long-lasting laurel leaf fashioned into a wreath signified achievement, victory, immortality, and eternity.[4] A coved frieze is carved with a bird, two laurel branches, two serpents, a scallop shell, and a moth. The bird represents flight, particularly that of a soul ascending to heaven. To the ancients, the serpent was an object of veneration, as a repository of great wisdom and power. The scallop shell was a favorite decorative device of the Greeks and Romans, who associated it with the sea and thus with eternity and rebirth.[5] The marker is capped with a pine cone finial, which symbolizes regeneration.[6]

What the gravesite lacked was any mention that Smithson was the Institution's namesake and benefactor. Samuel Pierpont Langley (1834–1906), third secretary of the Smithsonian Institution, took note, suggesting that a suitable memorial plaque be placed nearby.[7] To that end, George Brown Goode (1851–1896), assistant secretary in charge of the U.S. National Museum, recommended a young French-born American sculptor named William Ordway Partridge (1861–1930).[8] Partridge was an emerging artist who had recently gained much notoriety at the 1893 Chicago World's Fair. Partridge's approved design was based in part on a small bronze portrait medallion found among Smithson's personal effects.[9] Langley ordered three plaques, one for the gravesite, one for the

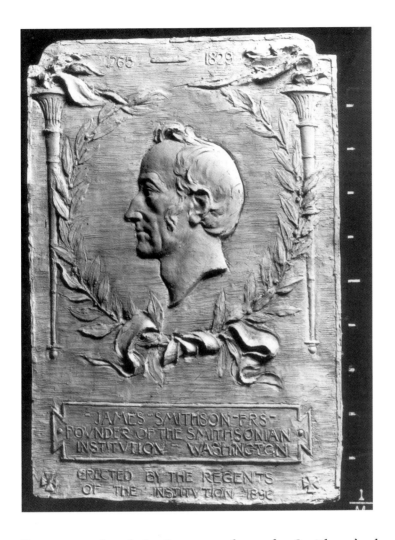

FIGURE 2.

Plaster model of the Smithson plaque by William Ordway Partridge, 1896. Smithsonian Institution Archives. Image 11812.

Protestant church in Genoa, and one for Smithson's alma mater, Pembroke College, Oxford.[10] Upon seeing the finished bronze plaque intended for the gravesite, Langley halted production, complaining of its "rough sketch-like appearance";[11] however, all three were cast as originally modeled in spite of Langley's objections (Figure 2).[12]

The Pembroke plaque is today still mounted in the college's courtyard, but the two Italian plaques proved ill-fated, and neither survives as originally executed.[13] Within four years, the plaque at Smithson's gravesite had been stolen. It was immediately replaced (minus Langley's perceived "defects") with a copy of the chapel's plaque but in Carrara marble rather than bronze.[14] The chapel plaque was pilfered after the chapel was gutted by fire following Allied bombing during World War II. Years later in 1960, after the chapel had been restored, the

FIGURE 3.
James Smithson's flag-draped coffin on the horse-drawn caisson leaving the Washington Navy Yard, January 25, 1904. Smithsonian Institution Archives. Image 82-3232.

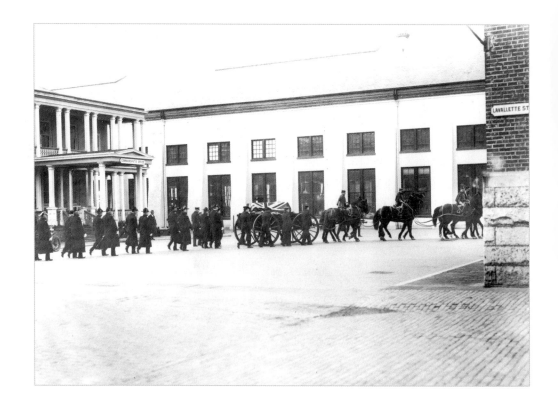

FIGURE 4.
James Smithson's flag-draped coffin lying in state in the Regents' Room of the Castle, 1904. Smithsonian Institution Archives. Image MAH-15883.

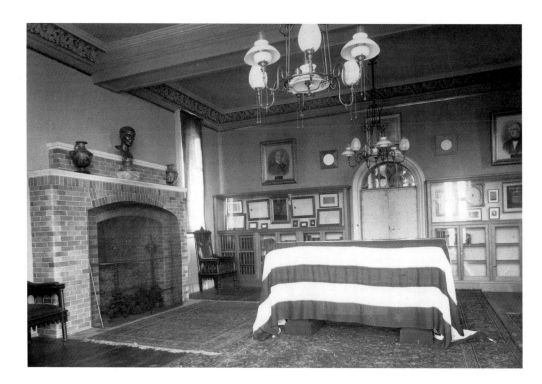

Board of Regents appropriated funds for a replacement.[15] Ironically, this replica was copied from the marble gravesite plaque, itself a copy of the chapel's original bronze plaque. The new plaque was dedicated in 1963.[16]

REMOVAL OF SMITHSON'S REMAINS TO AMERICA

Although purchased "in perpetuity" by his nephew, Smithson's burial site in Genoa proved as doomed as the two bronze plaques. In 1901, Smithsonian regents were notified that by 1905 all graves in the Protestant cemetery would be relocated because of expansion of the stone quarry located at the foot of the hill upon which the cemetery rested.[17] Regent Alexander Graham Bell (1847–1922) urged his fellow board members to authorize removal of Smithson's remains to this country, a trip he had never made during his lifetime.[18]

Immediately after board approval, Bell and his wife, Mabel, embarked for Italy, arriving in Genoa on Christmas Day, 1903. Smithson's remains were exhumed under Bell's direct supervision during a pelting winter rain storm a week later. Present throughout and reportedly undeterred by the inclement weather, Mrs. Bell "pluckily took a great variety of photographs of the place and ceremonies."[19] The Bells then left Genoa for New York on January 7, 1904, with their precious cargo stowed aboard the German steamship *Princess Irene*.[20]

The coffin was transferred to the USS *Dolphin* for the final leg of its journey to the Washington Navy Yard.[21] After brief ceremonies on the dock, carriages carrying Bell, Langley, and other dignitaries and the caisson bearing the coffin were escorted through the streets of southwest Washington by a squadron of the U.S. Cavalry (Figure 3). Upon his arrival at the Smithsonian Institution Building, Bell symbolically handed over Smithson's remains to the Institution, saying "And now … my mission is ended and I deliver into your hands … the remains of this great benefactor of the United States."[22]

The coffin, draped in both the U.S. and British flags, was placed in the center of the Great Hall for another brief ceremony. After which, it was taken upstairs to lie in state temporarily in the Regents' Room. In a purely symbolic gesture, the British flag was removed so that the coffin was then draped in just the American flag (Figure 4). With Smithson's voyage at an end, Smithsonian officials embarked on a journey of their own: to erect a permanent memorial in honor of the Institution's patron.[23]

PLANS FOR THE MONUMENT

The yearlong endeavor to find a fitting final resting place for James Smithson began on a small scale early in 1904, but the scope soon broadened with expectations that Congress would fully fund the project. Secretary Langley was directed by the Board of Regents to contact renowned artists to prepare designs for a monument. However, a few board members had also begun soliciting designs from artists and architects independently. Proposals were received, reviewed, and rejected one by one throughout the year.

The regents resolved at the March 4, 1904, board meeting that "a fitting tomb should be erected in the grounds of the Institution and … Congress be requested to make an adequate appropriation for it."[24] Regent John B. Henderson (1826–1913), chairman of the Smithsonian's Executive Committee, presented two sketches prepared at his request by the local architectural firm, Totten & Rogers, both of which depicted mausoleums that, if built, would rival or exceed in both size and scale the present-day Lincoln Memorial (Figure 5).

When hope for federal funding began to evaporate, Congressman Robert R. Hitt (1834–1906) suggested that the Smithsonian might replicate the ancient Choragic Monument of Lysicrates.[25] Henderson balked, saying that "if Athens

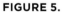

Stamm

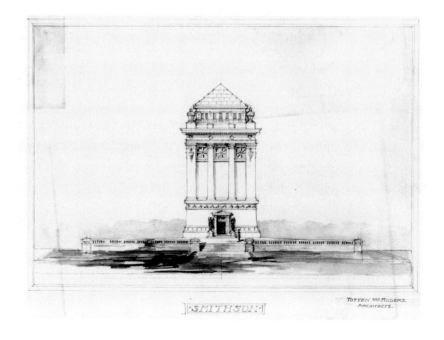

FIGURE 5.
Proposal for a Smithson Memorial by Totten & Rogers, 1904. The design seems to have been influenced by both the ancient Greek Mausoleum at Halicarnassus and Grant's Tomb in New York, built in 1897. Smithsonian Institution Archives. Image 89-8544.

FIGURE 6.
Henry Bacon's first design for a Smithson Memorial consisted of a bust of Smithson mounted on a pedestal protected by a vine-covered pergola. Smithsonian Institution Archives. Image 90-16191.

could give this to the leader of a theatrical chorus or bandmaster; I think we might double the size at least for Smithson."[26] The search for a memorial the Smithsonian could afford then began in earnest.

THE SAINT-GAUDENS/BACON PROPOSALS

Mindful of reduced funding, Secretary Langley pursued his directive of contacting renowned artists. Langley's first choice was Augustus Saint-Gaudens (1848–1907), the most prominent American sculptor of the time. Saint-Gaudens's response was that the Smithsonian could not afford his services.[27] He suggested that his brother Louis, also a sculptor, might be more affordable and that the New York architect Henry Bacon might provide the architectural design.

Henry Bacon (1866–1924) described his design as "a bust of Smithson surmounting a piece of architecture on which would be carved an allegorical figure in low relief."[28] Enclosed inside a pergola, it consisted of a platform, pedestal, columns, and lintels over the columns, all constructed of Pentelic marble, the white marble favored in ancient Greece. It was topped with gilded bronze rafters spanning the lintels (Figure 6).

Although the plan was relatively expensive, Bacon thought it was "so unique that it would be a pity to have any alternative."[29] Langley disagreed, and Bacon was obliged to send a second less costly design that took the form of an exedra, a semicircular stone bench of classical derivation. The white marble monument featured a profile bust of Smithson surrounded by laurel branches carved in low relief. It was to sit atop an underground vault for Smithson's remains that would be covered with a suitably inscribed stone slab.[30]

THE FINAL DESIGN: REPURPOSING THE ORIGINAL ITALIAN GRAVESITE MONUMENT

Meanwhile, Langley began exploring two even less costly alternatives. One was to repurpose a marble sarcophagus that had long been located in front of the National Museum (now the Arts and Industries Building of the Smithsonian). The sarcophagus was brought to this country from Beirut in 1839 by Jesse Duncan Elliott (1782–1845), commodore-in-chief of the U.S. Navy in the Mediterranean. Elliott, a staunch "Jacksonian," presented the so-called Syrian Sarcophagus to the National Museum as a final resting place for the former president, who, still very much alive at the time, declined the intended honor.[31]

Langley's second option was to retrieve the pieces of Smithson's gravesite from Italy. Bell had abandoned the monument, iron fence, and memorial tablet in 1903 believing that they were not Smithsonian property.[32] The British Consulate General in Genoa assured Langley of the legality of transferring the tomb to the United States.[33] However, still fearing a possible legal challenge by the family of Smithson heir Henry Hungerford, the regents discussed the issue throughout the summer, finally resolving it in November. The monument, tablet, and fencing, packed in 16 crates, arrived in New York on December 28, 1904.[34]

While this discussion was transpiring, Bell requested two designs from Gutzon Borglum (1867–1941), an emerging New York artist who later sculpted the Mount Rushmore monument. Borglum's first plan united the Italian grave marker with his own tomb design to occupy a room in the South Tower. He described the room as vaulted, supported by four pillars surrounding the Italian grave marker in the center, with a leaded glass window in the south wall above it. The floor would be mosaic tile, whereas the walls were to be sheathed in marble while the plaque from Genoa would be mounted behind the monument to one side, with a second similar tablet on the other.

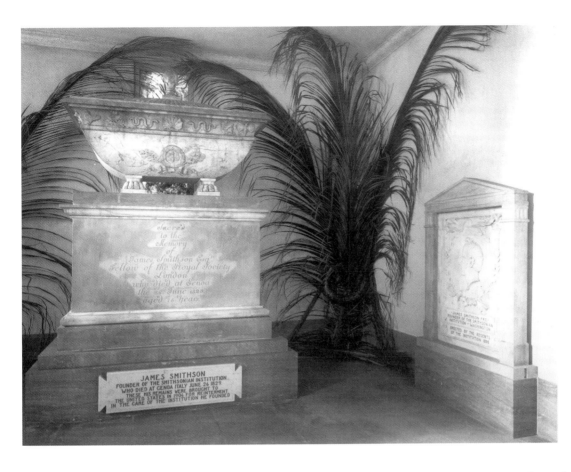

FIGURE 7.
James
Smithson's
Mortuary
Chapel, 1905.
Smithsonian
Institution
Archives.
Image 16957.

Borglum's second, preferred plan was that of a bronze statue of Smithson seated in a "thoughtful attitude" examining a mineral.[35] He suggested mounting the statue atop a 5 foot high white marble base to achieve "heroic" stature and placing it in front of the building with the walkway widened to allow passage on either side.[36] When finally notified that the Institution would get no funding from Congress for the memorial,[37] the regents passed a resolution directing the creation of a memorial using the Italian grave marker, placed on the grounds of the Institution to be paid for entirely with Smithsonian funds.[38]

Rather than erect the monument on the grounds, Langley instead decided to create a "mortuary chapel" in a vacant room to the left of the building's north entrance. The Washington architectural firm Hornblower & Marshall, employed at the time by the Smithsonian in planning the Natural History Building, was directed to provide designs.[39] Stating that it was probably the most "decorous and fitting room in the building to contain the existing monument to Smithson and his remains," Joseph Hornblower designed a simple, dignified chamber.[40]

Hornblower's plan placed the marble monument centered along the eastern wall with the plaque from the grave site located to its right. The room featured three nonecclesiastical stained-glass windows, a plaster drop ceiling with a deep cove molding, and a floor made of dark red Tennessee marble. The entrance to the room was sealed off with a heavy iron gate fashioned from pieces of the fence that had surrounded the Italian grave site. The resulting effect, somber and contemplative, was further enhanced for the dedication ceremony by two huge palm and laurel wreath arrangements flanking the tomb. The significance of the palm as a symbol of eternal peace and the laurel wreath as a symbol of glory made these appropriate adornments for the tomb (Figure 7).[41]

Entombment took place on March 6, 1905, in a modest ceremony following the regents' meeting. Smithson's casket was carried from the old Regents' Room down the grand staircase and placed in a specially built chamber constructed at the base of the monument.

The austere and chaste Mortuary Chapel was meant to be but a temporary resting place for Smithson's remains until Congress provided an adequate appropriation for a "proper memorial."[42] In the decades since Smithson's remains were interred within the walls of the Smithsonian Building, the institution bearing his name has literally grown up around him, far exceeding anything he could ever have envisioned. The Smithsonian Institution itself then has become the most splendid and fitting memorial to its benefactor.

Stamm

NOTES

1. The denotation "crypt" is somewhat of a misnomer. Technically, a crypt is a subterranean stone chamber or a vault located beneath the floor.

2. Smithsonian Institution Archives, Smithsonian Fiscal Records, RU 110, box 1, folder 1, vol. 2, June 1856–December 1859, p. 108, no. 138, March 24, 1857.

3. Franz S. Meyer, *Meyer's Handbook of Ornament* (London: Omega Books, 1987), 63.

4. Jean Chevalier and Alain Gheerbrant, *The Penguin Dictionary of Symbols* (London: Penguin Books, 1996), 592–593 (laurel), 676 (moth).

5. Chevalier and Gheerbrant, *The Penguin Dictionary of Symbols*, 86–87 (bird), 850–851 (serpent), 871 (shells).

6. Chevalier and Gheerbrant, *The Penguin Dictionary of Symbols*, 755.

7. Samuel P. Langley to George Brown Goode, August 6, 1891, Smithsonian Institution Archives, Office of the Secretary, 1891–1906, RU 31, box 4, folder 6. Langley deposited 30 pounds sterling with Granet Brown & Co., the treasurers of the British burial ground fund, "for the care, in perpetuity of the tomb of James Smithson."

8. Langley to Goode, August 7, 1895, Smithsonian Institution Archives, Office of the Secretary, 1891–1906, RU 31, box 41, folder 6.

9. Smithsonian Institution, *Annual Report of the Board of Regents of the Smithsonian Institution*

Showing the Operations, Expenditures, and Condition of the Institution to July, 1896 (Washington, D.C., 1898), 16. Smithsonian annual reports are hereafter cited as *Smithsonian Institution Annual Report for [year]*.

10. Langley to William Ordway Partridge, March 23, 1896, Smithsonian Institution Archives, Office of the Secretary, 1891–1906, incoming correspondence, RU 31, box 51, folder 12. For reference to the plaque for Pembroke College, see *Smithsonian Institution Annual Report for 1898*, 19.

11. Langley to Partridge, April 11, 1896, Smithsonian Institution Archives, Office of the Secretary, 1891–1906, RU 31, box 51, folder 12.

12. One obvious "defect" in Partridge's design is that the inscription "James Smithson FRS…" is off-center.

13. Smithsonian Institution Archives, Office of Architectural History and Historic Preservation, Building Files, accession 09-007, box 24. For reference to location today, see memorandum from Wilton Dillon to James Goode, August 15, 1980.

14. *Smithsonian Annual Report for 1900*, 26.

15. Smithsonian Institution Archives, Smithsonian Institution Board of Regents, Minutes, 1846–1986, accession 98-019, box 1, p. 1513. The meeting was held May 4, 1960.

16. *Smithsonian Annual Report for 1963*, 24–25, pl. 1. The report identified the sculptor as Raffaello Romanelli of Florence; however, Raffaello died in 1928. The family business Galleria Romanelli was continued by his son Romano (1882–1968) and later by his grandson Folco.

17. *Smithsonian Annual Report for 1901*, XIX.

18. *Smithsonian Annual Report for 1902*, XIV.

19. Letter from Alexander Graham Bell to Langley with attached notes by William Henry Bishop, U.S. Consul at Genoa, Italy, describing the exhumation of Smithson's remains in Italy, March 15, 1904, Smithsonian Institution Archives, Office of the Secretary, 1891–1906, RU 31, box 4, folder 10. The glass negatives taken by Mrs. Bell are in the Prints and Photographs Division of the Library of Congress.

20. *Smithsonian Annual Report for 1904*, XX–XXIII.

21. *Smithsonian Annual Report for 1904*, XXIX–XXXIII. Upon entering U.S. coastal waters on January 20, 1904, the *Princess Irene* was escorted to the port at Hoboken, New Jersey, by the USS *Dolphin* at the direction of President Roosevelt. Smithson's coffin was then transferred to the *Dolphin* for the final leg of its journey to the Washington Navy Yard, arriving January 25.

22. *Smithsonian Annual Report for 1904*, XXIV.

23. *Smithsonian Annual Report for 1904*, 10.

24. *Smithsonian Annual Report for 1904*, 5.

25. John B. Henderson to Langley, March 12 and 16, 1904, Smithsonian Institution Archives, Office of the Secretary, 1891–1906, RU 31, box 4, folder 10.

26. Henderson to Langley, March 16, 1904, Smithsonian Institution Archives, Office of the Secretary, 1891–1906, RU 31, box 4, folder 10.

27. Augustus Saint-Gaudens to Langley, March 18, 1904, Smithsonian Institution Archives, Office of the Secretary, 1891–1906, RU 31, box 4, folder 10.

28. Henry Bacon to Langley, March 29, 1904, Smithsonian Institution Archives, Office of the Secretary, 1891–1906, RU 31, box 4, folder 10.

29. Henry Bacon to Langley, April 29, 1904, Smithsonian Institution Archives, Office of the Secretary, 1891–1906, RU 31, box 4, folder 10.

30. Henry Bacon to Langley, May 4, 1904, Smithsonian Institution Archives, Office of the Secretary, 1891–1906, RU 31, box 4, folder 10.

31. William J. Rhees, *An Account of the Smithsonian Institution, Its Founder, Building, Operations, etc., Prepared from the Reports of Prof. Henry to the Regents, and Other Authentic Sources* (Washington, D.C., 1859), 84.

32. Alexander Graham Bell to John B. Henderson, July 27, 1904, Smithsonian Institution Archives, Office of the Secretary, 1891–1906, RU 31, box 4, folder 12. The inscription on

the back of the base reads, "This monument is erected and the ground on which it stands is purchased in perpetuity by Henry Hungerford. Esq., the deceased's nephew, in token of gratitude to a generous benefactor and as a tribute to departed worth." Henry James Dickenson, Smithson's nephew, adopted the family name "Hungerford" at his uncle's request.

33. Noel Lees to Langley, June 6, 1904, Smithsonian Institution Archives, Office of the Secretary, 1891–1906, RU 31, box 4, folder 10.

34. For date of shipping, see Smithsonian Institution Archives, Office of the Secretary, 1891–1906, RU 31, box 5, folder 1. In a letter dated December 9, 1904, Langley was notified by William Henry Bishop (American Consul at Genoa, Italy) that the "James Smithson monument has been duly shipped." For the date of arrival in the United States, see Smithsonian Institution Archives, Office of the Secretary, 1891–1906, RU 31, box 5, folder 1.

35. Gutzon Borglum to Alexander Graham Bell, October 8, 1904, Library of Congress, Alexander Graham Bell Papers from the Gilbert H.

Grosvenor Collection, subject file: Smithson, J., container 272.

36. Gutzon Borglum to Alexander Graham Bell, October 8, 1904, Library of Congress, Alexander Graham Bell Papers from the Gilbert H. Grosvenor Collection, container 272.

37. "Minutes of the Board of Regents Annual Meetings," December 6, 1904, Smithsonian Institution Archives, RU 1, vol. 2, 1891–1905.

38. *Smithsonian Annual Report for 1905*, XII.

39. The partnership consisted of Joseph C. Hornblower (1848–1908) and James R. Marshall (1851–1927) and was active from 1883 until Hornblower's untimely death in 1908.

40. Hornblower to Langley, January 24, 1905, Smithsonian Institution Archives, Office of the Secretary, 1891–1906, RU 31, box 5, folder 2. On Hornblower's acceptance of the job, see Hornblower to Langley, January 26, 1905, Smithsonian Institution Archives, Office of the Secretary, 1891–1906, RU 31, box 5, folder 2.

41. Meyer, *Meyer's Handbook of Ornament*, 43 (laurel), 48 (palm).

42. Smithsonian Institution Archives, Office of the Secretary, 1891–1906, RU 31, boxes 6–7.

BIBLIOGRAPHY

Archival Sources

Bell, Alexander Graham. Papers. Gilbert H. Grosvenor Collection. Library of Congress.

Smithsonian Institution Board of Regents. Minutes. Record Unit 1. Smithsonian Institution Archives.

Smithsonian Institution Board of Regents. Minutes, 1846–1986. Accession 98-019. Smithsonian Institution Archives.

Smithsonian Institution Office of Architectural History and Historic Preservation. Building Files, c. 1960–2000. Accession 09-007. Smithsonian Institution Archives.

Smithsonian Institution Office of the Secretary. Correspondence, 1866–1906. Record Unit 31. Smithsonian Institution Archives.

United States National Museum Office of the Registrar. Accession Records, 1859–1921 [Smithsonian Fiscal Records]. Record Unit 110. Smithsonian Institution Archives.

Chevalier, Jean, and Alain Gheerbrant. *The Penguin Dictionary of Symbols*. London: Penguin Books, 1996.

Meyer, Franz S. *Meyer's Handbook of Ornament*. London: Omega Books, 1987.

Rhees, William J. *An Account of the Smithsonian Institution, Its Founder, Building, Operations, etc., Prepared from the Reports of Prof. Henry to the Regents, and Other Authentic Sources*. Washington, D.C.: 1859.

———. *James Smithson and His Bequest*. Washington, D.C.: Smithsonian Institution, 1889.

Smithsonian Institution. *Annual Report of the Board of Regents of the Smithsonian Institution…* for the years 1896, 1898, 1900, 1901, 1902, 1904, 1963. Washington, D.C.

Smithson's Crypt and the Search for a Proper Memorial

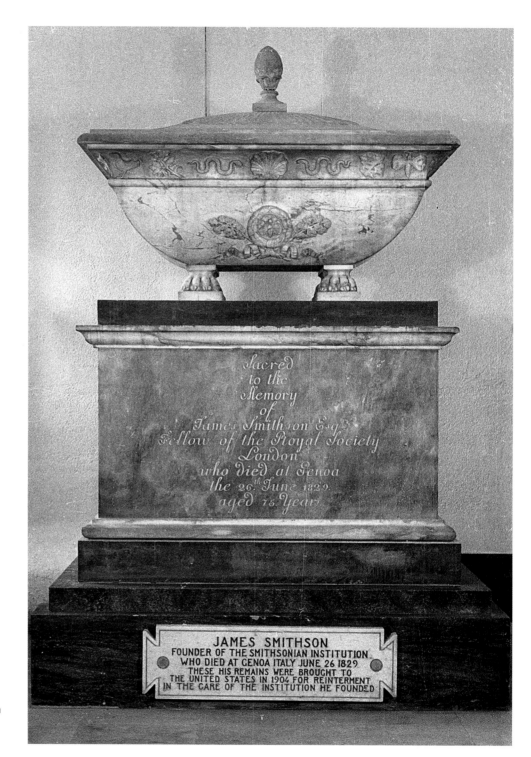

FIGURE 1.

James Smithson's crypt in the Smithsonian Castle foyer. Smithsonian Institution Archives. Image 73-10115-24.

James Smithson's Remains: A Biological Perspective

David R. Hunt

In 1904 the grave of James Smithson, benefactor and founder of the Smithsonian Institution, was eroding out of the ground in the Genoa, Italy, cemetery where he was buried. Not wanting his remains to be lost to history, Alexander Graham Bell and his wife made the long journey in December of that year to supervise the exhumation of the coffin.[1] During the exhumation they found that the coffin was badly disintegrated and that Smithson's remains were intermingled with the coffin and in a state of extreme disarray. William Bishop, the American Consul in Genoa, who had arranged for the exhumation, stated his belief that the gravesite and the remains were that of James Smithson and despite the poor condition of the remains he also speculated that Smithson looked to have been 5 feet 10 inches tall. When the remains arrived in Washington in February 1905, they were placed in a new copper-lined casket and put into a marble crypt located in the Smithsonian Institution Building (the Castle), where they remained undisturbed for 68 years (Figure 1).

In 1973 renovations were planned for the foyer of the Castle, and the plans included the crypt. In order for the work to be carried out, Smithson's remains needed to be moved, but attempts to secure the remains were confounded by a problem: no one knew for sure where the remains had been placed in the crypt. Were they "buried" in the floor in front of the crypt, in the crypt base, or in the top of the tomb? In September of 1973, the floor was tested, and its depth was 10 to 21 inches, not sufficiently deep to house the coffin. On October 1, 1973, the lid of the marble tomb was lifted, but the chamber proved to be empty. The next day, a hole was drilled into the granite plate at the north side of the crypt base, and that was where workmen found the coffin.

The Smithsonian Institution Archives had only scant records about Smithson's remains. When they arrived in Washington in February 1905, only one very brief study of the remains was carried out prior to Smithson's interment in the mortuary chapel in the Smithsonian Castle. Dr. Z. T. Sowers was given only one day to carry out his examination, and not surprisingly his investigation yielded only a scant descriptive report. Sowers noted that the remains were loosely packed in the box that had carried them from Italy along with dark brown, fibrous roots, fragments of rotted wood, and brass nails intermixed. The bones were dark in color and light in weight, the muscle markings and the shape of the bones suggesting "a man of sedentary habits and somewhat advanced age." His measurements of the long bone produced an estimated height of about 5 feet 4 inches tall, clearly different from Consul Bishop's estimate of Smithson's height as 5 feet 10 inches.

Smithsonian staff also speculated that there might be papers and/or other artifacts buried with Smithson, a sort of time capsule in his crypt. Thus, it was decided that while the casket was removed from the crypt, it would be opened to see if anything other than his skeleton had been placed in the coffin. J. Lawrence Angel, a forensic anthropologist in the National Museum of Natural History, saw the exhumation as an excellent opportunity to restudy the remains and indeed to confirm that the remains in the coffin were those of James Smithson. He successfully argued that a complete examination of the skeletal remains would shed light on Smithson's biological life, health, and physical features. His request to study the skeleton was permitted as long as it could be completed as quickly as possible.

In 2007 Heather Ewing published a biography of James Smithson based on extensive archival research,[2] and I remembered Angel and other staff members talking about the 1973 study. As a forensic anthropologist, my interest was

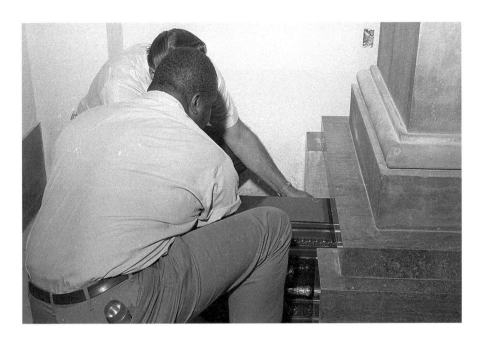

FIGURE 2.
Workers removing the coffin from the crypt base. Smithsonian Institution Archives. Image 73-10116-8.

piqued, and I set out to reexamine Angel's data using new forensic technologies and methods to evaluate and possibly refine the results of his study.

THE 1973 EXHUMATION AND ANGEL'S STUDY

Archival records note that at 10:00 AM, Wednesday, October 3, 1973, the coffin was removed from the crypt base, with a contingent of the Smithsonian upper administration to oversee the coffin removal and opening (Figure 2). Once removed from the crypt base, the wooden coffin was opened and a copper box was found tightly fitted inside. This metal casket was sealed with solder, so a blow torch was used to melt the solder in order to open the lid. In the process of melting the solder, the torch also ignited the deteriorated silk lining on the inside of the metal casket.

The nearby fire extinguisher could not be used to extinguish the fire because of the possibility that the chemicals and pressure might damage the artifacts within the casket. Instead, the laborers ran to the water fountain and filled their mouths with water and discharged the water from their mouths onto the fire. Once the smoke cleared, the lid was removed. A skull was found positioned at one end of the coffin, resting on its base, and the rest of the bones were scattered in the box, with soil, wood, metal, and cloth remnants from the original 1829 coffin on the bottom of the new casket (Figure 3).

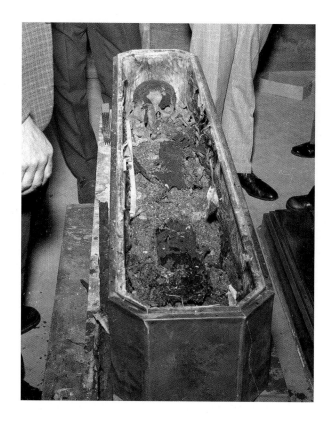

FIGURE 3.
The opened copper coffin liner, holding the remains of James Smithson. Smithsonian Institution Archives. Image 73-10116-27.

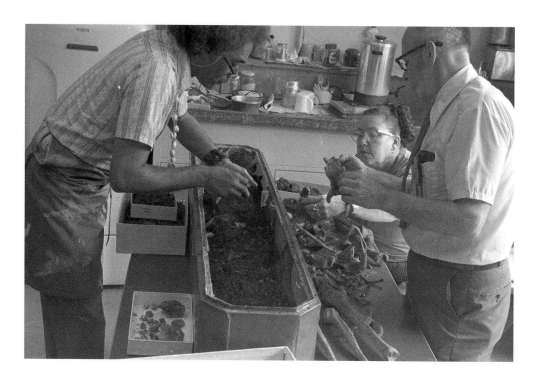

FIGURE 4.
Robert Jenkins, Lucile St. Hoyme, and J. Lawrence Angel removing and inventorying the remains. Smithsonian Institution Archives. Image 73-10115-10A.

No manuscripts, documents, or time capsule artifacts were present in the copper box. The lid was placed back on the box; the coffin was transported across the Mall to Angel's laboratory in the Museum of Natural History. During the afternoon of October 3 and all through the day of October 4, Angel and other Department of Anthropology staff members (Lucile St. Hoyme, T. Dale Stewart, Donald Ortner, Douglas Ubelaker, and Robert Jenkins) worked feverishly to clean, measure, radiograph, and analyze the skeleton of James Smithson. The purpose of this activity was to confirm the identity of the remains (i.e., that the skeleton was likely to be that of James Smithson) and to expand our knowledge of Smithson the person, purely biological information that would be unknown through material artifacts and archival records alone (Figure 4).

An inventory of the bones was made, and almost all of the bones of the skeleton were present, with only a few of the smaller bones of the hands and feet missing. Angel noted that there was some evidence of postmortem damage (breakage) of some of the ribs and portions of the spine that likely occurred during the original exhumation. The dark brown staining of the bones was from the decay of the wood of the original casket. Forensic anthropological investigation is normally interdisciplinary in its approach, and Angel's team was careful to include the perspectives of other experts available throughout the Smithsonian wherever possible. For example, fragments of the wood from the coffin were given to the Department of Botany to study; the original casket was made from pine wood.

In any biological anthropological investigation, morphological features of the skeleton are assessed by both nonmetric and metric methods to gain insight about the individual represented by the remains. In a forensic setting, the biological evidence is evaluated to confirm consistency with the information known about the presumed individual.

The information provided below serves to reassess Angel's study by using his metric data records, photographs, and radiographs from 1973 and then re-evaluating the data and the analysis using present-day methodology and new technology. With this new technology, we can augment the earlier information and detail a more precise portrait of James Smithson.

SEX

Male and female skeletons are different, primarily reflected in females' structural anatomy for childbirth as well as hormonal differences and differences in size.

The pelvis from the crypt has typical male morphology (Figure 5).[3] The skull is also diagnostically male, with a large brow ridge, marked muscle attachments in the neck, and a squared chin.[4] However, the skull features are not strongly male in their size and shape (Figure 6). The rest of the skeletal elements are also not strongly indicative of a male, with the femoral (upper leg) head diameter being intermediate in size (46 mm). The individual in the crypt was of intermediate build, not a large male.[5]

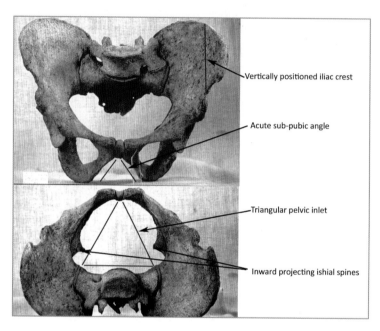

FIGURE 5.
Pelvis of Smithson. Vertically positioned iliac plates, acute subpubic angle, triangular pelvic inlet, and ischial spines protruding into inlet are all male features of the pelvis. John Lawrence Angel Papers, National Anthropological Archives, Smithsonian Institution.

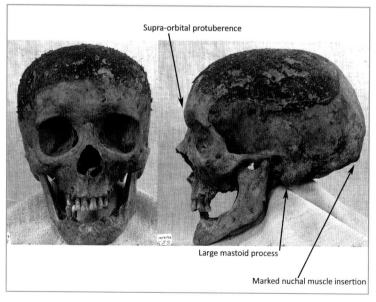

FIGURE 6.
Skull of Smithson, showing the large mastoid process, marked nuchal muscle insertion, and supraorbital protuberance, all features common in a male skull. These features are not extreme in this skull, indicating that Smithson was not a large male. John Lawrence Angel Papers, National Anthropological Archives, Smithsonian Institution.

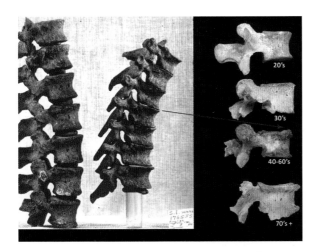

FIGURE 7.
Left: Thoracic and lumbar vertebrae of Smithson showing arthritic lipping. John Lawrence Angel Papers, National Anthropological Archives, Smithsonian Institution. **Right:** Four anatomical lumbar vertebrae (by age) showing arthritic changes to the rims of the vertebral bodies. The lipping and arthritic changes in Smithson are most consistent with those of individuals aged 40 through 60 years. Photo by the author.

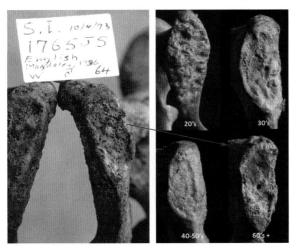

FIGURE 8.
Left: Morphological features of the pubic symphysis (where the two hip bones meet in the front) of Smithson. John Lawrence Angel Papers, National Anthropological Archives, Smithsonian Institution. **Right:** Four comparative known-age anatomical symphyses showing age changes. Smithson's symphyseal face morphology is similar to the 60+ age range. Photo by the author.

AGE

The arthritic changes of the spine and the long bone joint articulations are consistent with features found in individuals who are older than 45 years of age but are not in the range of advanced age older than 70 years (Figure 7).[6] Age indicators in the skeleton, such as in the pubic symphysis, are consistent with male individuals over 50 years of age but not older than their mid-70s (Figure 8).[7] Radiographic study of Smithson's long bones shows thinning of the outer cortical bone and loss of the inside structural trabecular bone. This bony loss is consistent with the levels of cortical and trabecular bone loss seen in older individuals.[8]

The biological evidence of Smithson's remains indicates someone of slightly younger age than his 64 years at death. Angel speculated that the amount of wine

and other alcohol that Smithson probably consumed, a normal practice in the late eighteenth century, may have slowed down the normal bone remodeling speed, making the bone-related age a bit younger than his chronological age.

ANCESTRY

All of the visual morphological features of the cranium are consistent with population groups of European ancestry. The facial skeleton has features that are normal in an individual of European ancestry: a narrow nasal aperture with a sharp inferior margin, centrally pinched nasal bones, and close-set eye orbits.[9] Using FORDISC 2.0, a multivariate statistical software package developed at the University of Tennessee in the early 1990s for the evaluation of population affiliation, Angel's measurements of the cranium were analyzed. The measurements of the face indicate European ancestry, whereas the low and long shape of the braincase statistically place the individual between European and African ancestry on the graphs. The comparison of Smithson's multivariate mean to group centroids (means) indicates that Smithson's cranium does not group with either the modern white or black male samples and definitely is not part of any of the Asian groups.

To further evaluate ancestry from the cranial measurements, an updated version of the FORDISC software (FORDISC 3.0) was used; this new version allows for comparison with population groups from around the world as well as with nineteenth-century blacks and whites. The results indicated that Smithson's cranial measurements most closely associate with nineteenth-century European populations, particularly with the Norse male sample (Figure 9). In Angel's 1973 assessment of the cranium, he wrote in his report, "The long, low skull vault, narrow and aquiline face and strong chin occurs frequently around the North Sea from the Tronder region in Norway to Scotland and south to Frisia."[10] This assessment corresponds to Smithson's reported heritage of English ancestry.

PERSONAL CHARACTERISTICS

As was noted with the femora and in the cranium, some of the skeletal features of Smithson are intermediate and not strongly male in size. However, the head of the humerus (upper arm bone) measures 46 mm in diameter, which is well within the male range.[11] There are pronounced muscle insertions on the humerus, as well as the radius and ulna (lower arm bones), indicating Smithson was an active man, getting

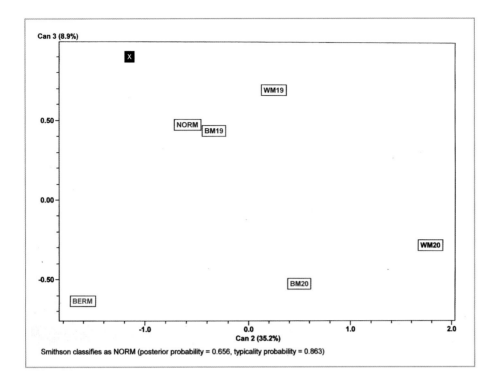

FIGURE 9. Plot of the results from FORDISC 2.0 analysis. Smithson (labeled X) is closest to Norse males (NORM) and nineteenth-century males (blacks and whites).

plenty of exercise and probably still healthy in his older age. However, he did not overdo physical activity since the joints do not exhibit excessive arthritic changes.

Smithson's hands also exhibited marked muscle insertions. Angel particularly pointed out the significant size of the hypothenar tendon attachment on the fifth metacarpal. Angel wondered whether Smithson had played the piano, harpsichord, or violin or practiced fencing. I also speculate whether these features may be a product of Smithson's research work as a chemist—for example, the use of a grinding stone for pulverizing ore samples and/or the use of the blow pipe for his scientific experiments.

Estimates of Smithson's height derived from the long bone measurements range from 5 feet 5 inches to 5 feet 6 inches tall, with a standard error of 2 to 2.5 inches.[12] These results are consistent with both Angel's estimate of 5 feet 5 inches to 5 feet 7 inches (165 to 172 cm) and Sowers's estimate of 5 feet 4 inches. However, this does not agree with the estimate of 5 feet 10 inches made by Bishop in 1904. An error in height estimation of a skeleton lying in the ground is common—when the skeleton settles in the ground, the bones shift, often giving the illusion of a much longer body.

FIGURE 10.
Left: Smithson's dentition, with an arrow pointing to the curved pipe facet. John Lawrence Angel Papers, National Anthropological Archives, Smithsonian Institution.
Right: Comparative pipe facet found in a colonial American. Photo by Chip Clark.

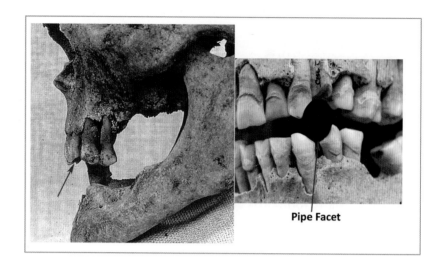

Pipe Facet

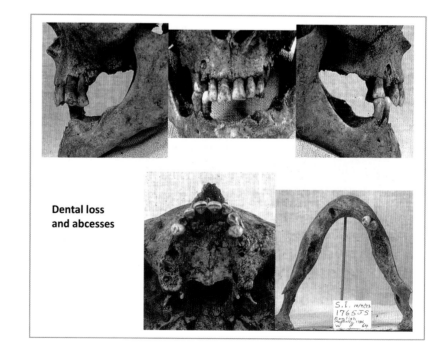

Dental loss and abcesses

FIGURE 11.
Dentition of James Smithson, with significant tooth loss from abscesses and periodontal disease. John Lawrence Angel Papers, National Anthropological Archives, Smithsonian Institution.

Angel interpreted Smithson to be right-handed because of the shape of the occipital area of the cranium and the large size of the right clavicle and humeral head. Pipe-stem wear is present on his teeth on the left side. Angel notes that this wear is consistent with a person lighting up the pipe on the left side to keep the smoke away from the right side of the face and hand. The pipe facet that Angel identified is located on the left upper second incisor and left upper canine. (The lower canine was not present for comparison.) This facet is formed by clutching a gritty clay pipe stem in the jaw, the abrasive stem wearing a groove on the teeth. This pipe facet feature is common in men of Smithson's time period (Figure 10).[13]

Early tooth loss and periodontal problems were common in the eighteenth century, and James Smithson suffered from this same lack of good oral hygiene. He had lost 17 of his teeth during his lifetime, and at the time of his death, five of his remaining teeth had abscesses (infections in the bone around the tooth roots). Four of his teeth were lost after death, possibly because of excavation activity. Recession of the alveolus (bony "gum-line" region where the teeth are rooted) and carious lesions (cavities) on the crowns of the teeth, as well as an abscess, are all apparent in the photographs taken by Angel (Figure 11).

Smithson had an osteologic variant of a sixth lumbar vertebra, with the left transverse process forming a pseudarthrosis (nonfused joint) with the sacrum. There are few additional exostoses (bony growths) on the lumbar rim to suggest abnormal movement or slippage. Nonetheless, he probably suffered from some lower back discomfort (Figure 12). The sacrum also sits at a slightly abnormal angle, and

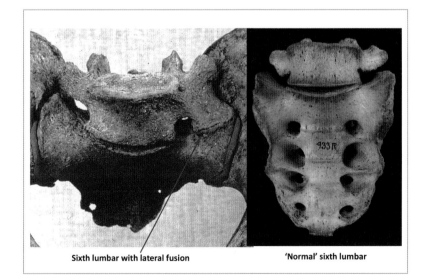

Sixth lumbar with lateral fusion 'Normal' sixth lumbar

FIGURE 12.
Left: Smithson's sacrum, with an arrow showing fusion of the sixth lumbar vertebra. John Lawrence Angel Papers, National Anthropological Archives, Smithsonian Institution. **Right:** Comparative normal anatomical sacrum with a sixth lumbar vertebra. Photo by the author.

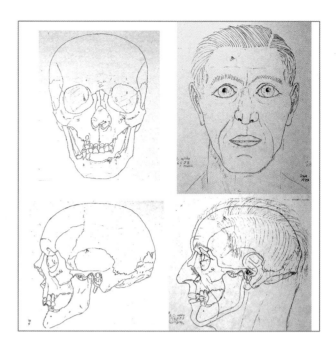

FIGURE 13.

Craniostat tracings of Smithson's skull
and facial reconstruction of Smithson
by Angel. John Lawrence Angel Papers,
National Anthropological Archives,
Smithsonian Institution.

this might have caused a noticeable deviation from the norm in Smithson's stance and gait. Arthritic changes of the cervical (neck) vertebrae in both the intervertebral facets and on the bodies indicate increased habitual activity, and Angel speculated that this occurred from sitting bent over a desk studying and increased head turning.

Angel attempted a facial reconstruction of Smithson from his skull by tracing the skull using a craniostat, an instrument used to help trace the features of the skull onto paper. Angel then sketched the soft tissue features over the skull image. He made both a front view and a lateral profile view (Figure 13).

To evaluate Angel's work in facial reconstruction, I requested the help of forensic artists Glenn Miller and Joe Mullins at the Forensic Imaging Unit of the National Center for Missing and Exploited Children (FIU). They produced a two-dimensional facial reconstructive drawing from the photograph of Smithson's skull. This new reconstruction was then compared to Angel's 1973 facial reconstruction. The FIU reconstruction is quite similar to Angel's reconstruction in the "mask" region (upper portion) of the face. The most noticeable differences between the FIU reconstruction and Angel's work are in the shape and size of the eyes (Figure 14).

I was also interested in seeing the accuracy of the 1816 portrait of Smithson, painted by Henri-Joseph Johns, compared with the bony structures of the skull. This evaluation was accomplished by superimposing the skull over the portrait (Figure 15). If we consider the skull to be the biological reality of an individual's

Hunt

40

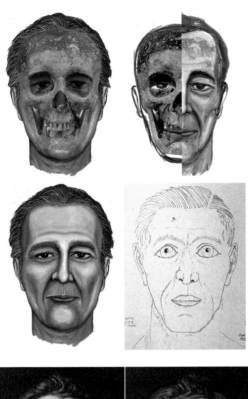

FIGURE 14.
Top: The soft tissue overlay on the photograph of Smithson's skull done by FIU. **Bottom:** Comparison of the FIU reconstruction and Angel's reconstruction.

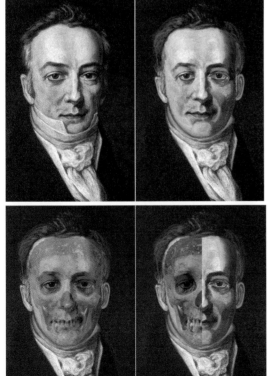

FIGURE 15.
Top left: The original Smithson portrait by Henri-Joseph Johns, National Portrait Gallery, Smithsonian Institution (NPG.85.44). **Top right:** A virtual morphing of the face by the FIU to rotate the face to be in a direct-on position. **Bottom left and right:** Superimposition of the skull into the portrait face and a split screen overlay for comparison.

face, although there is clearly some artistic license in the portrait, the likeness of Smithson is consistent with the skull morphology.

From this reassessment of Angel's 1973 report and photographs, it is evident that the results of the study of James Smithson's remains by Angel (and the other physical anthropological staff) are quite consistent with the results produced by new technology and analytical methods developed over the past 40 years. Comparative differences in the results are minor, found mostly in the stature and ancestry estimations. The more sophisticated equipment and tissue data for facial reconstruction produced a facial "visage" of Smithson that is more congruent with his portrait and a bit more pleasing to the artistic eye, but the basic aspects of the face are still in harmony with Angel's 1973 drawings.

Was all this work necessary? Was this a disturbance to Smithson's eternal rest? With our founder's avid interest in the natural sciences, it is very likely that he would have considered it only fitting that he would be scrutinized by the scientists that his bequest supports. Do we know more about Smithson? Some questions have been clarified and confirmed, but with investigation, new questions always arise. We know that the remains are almost assuredly those of James Smithson, the founder of the institution, and that he lived a relatively healthy and active life. He was a pipe smoker and suffered from dental disease. His 1816 portrait is quite representative of what he looked like in life. However, were the slight variants in his spine a problem to him? What was the habitual activity that left the evidence on his hands? On these questions we can only speculate, but we now have a somewhat better understanding of him through various nuances that were revealed in the study of his skeleton and that the archival record alone does not provide.

REINTERMENT

At 1:00 PM on October 5, 1973, a group of Smithsonian administrators assembled in the machine shop at the Museum of Natural History to witness the resoldering of the copper casket, this time without any fire problems. Smithson's remains were placed in a newly made copper box just for the skeleton along with typed reports of all the activities of 1973 (the opening of the casket and the anthropological study of the skeleton). This box was then placed into the original copper casket along with the original soil and the old coffin remnants. The box was transported back across the Mall to the Castle. The copper box was refitted back in the mahogany coffin, and at

1:45 PM, the coffin was relocated back in the base of the marble crypt. Thanks to the work of the Smithsonian's biological anthropologists, we can feel confident that it is James Smithson that rests to this day in the crypt in the Castle.

CLOSING NOTE

On the October 15, 1973, memorandum cover sheet of Angel's report that was circulated to the Smithsonian Institution upper administration there are several notes written by various people (Figure 16): "This is a fascinating report – Porter" (Porter Kier, the director of the Museum of Natural History) and "Dick Lyth should see this – RHB" (Robert H. Brooks, undersecretary of the Smithsonian). And the note by Dillon Ripley (the secretary of the Smithsonian, who was in Bhutan at the time of the disinterment) reads, "How did we get into this study? DR"

FIGURE 16.

Cover memo on Angel's study of the Smithson remains to Dillon Ripley, secretary of the Smithsonian, October 15, 1973.

1. See Stamm, "Smithson's Crypt and the Search for a Proper Memorial," this volume.

2. Heather Ewing, *The Lost World of James Smithson: Science, Revolution and the Birth of the Smithsonian* (New York: Bloomsbury, 2007).

3. W. M. Bass, *Human Osteology: A Laboratory and Field Manual*, Missouri Archeological Society Special Publications 2 (Columbia: Missouri Archeological Society, 2005), 207–218; T. D. White and P. A. Folkens, *Human Osteology* (New York: Academic Press, 2000), 365–371; D. G. Steele and C. A. Bramblett, *The Anatomy and Biology of the Human Skeleton* (College Station: Texas A&M University Press, 1988), 197–202.

4. Bass, *Human Osteology*, 81–83; White and Folkens, *Human Osteology*, 363–365; Steele and Bramblett, *The Anatomy and Biology of the Human Skeleton,* 53–54.

5. Bass, *Human Osteology*, 227–233; K. Pearson and J. Bell, *A Study of Long Bones of the English Skeleton*, pt. 1, *The Femur,* Biometric Series 10 (London: University College, 1919); T. D. Stewart, *Essentials of Forensic Anthropology* (Springfield, IL: Charles C. Thomas, 1979), 118–122.

6. Bass, *Human Osteology*, 19–21; T. D. Stewart, "The Rate of Development of Vertebral Osteoarthritis in American Whites and Its Significance in Skeletal Aging Identification," *Leech* 28 (1958): 144–151; Stewart, *Essentials of Forensic Anthropology*, 176–178.

7. T. W. Todd, "Age Changes in the Pubic Bone I: The Male White Pubis," *American Journal of Physical Anthropology* 3 (1920): 285–334.

8. G. Ascadi and J. Nemeskeri, *History of Human Lifespan and Mortality* (Budapest: Akademiai Kiado, 1970), fig. 22.

9. Bass, *Human Osteology*, 83–88; S. Rhine, "Nonmetric Skull Racing," in *Skeletal Attribution of Race: Methods for Forensic Anthropology*, ed. George W. Gill and Stanley Rhine, Anthropological Papers of the Maxwell Museum of Anthropology 4 (Albuquerque, NM: Maxwell Museum of Anthropology, 1990), 9–20; White and Folkens, *Human Osteology*, 376–378.

10. John Lawrence Angel, Preliminary Report on the Skeleton from Casket of James Smithson, October 15, 1973, John Lawrence Angel Papers 1930–1980s, Box 101, National Anthropological Archives, Smithsonian Institution.

11. Bass, *Human Osteology*, 156.

12. M. Trotter and G. C. Gleser, "A Re-evaluation of Estimation Based on Measurements of Stature Taken during Life and of Long Bones after Death," *American Journal of Physical Anthropology* 16 (1958): 79–123; Bass, *Human Osteology*, 21–30; R. L. Jantz and S. J. Ousley, FORDISC 3.0 (Knoxville: Department of Anthropology, University of Tennessee, 2005).

13. S. I. Kvaal and T. K. Derry, "Tell-Tale Teeth: Abrasion from the Traditional Clay Pipe," *Endeavour* 20 (1996): 28–30; C. Meyer, "Osteological Evidence of the Battles of Zurich, 1799: A Glimpse into Soldiery of the Past," *International Journal of Osteoarchaeology* 13, no. 4 (2003): 252–257.

BIBLIOGRAPHY

Angel, John Lawrence. Preliminary Report on the Skeleton from Casket of James Smithson, October 15, 1973. John Lawrence Angel Papers 1930–1980s. Box 101. National Anthropological Archives, Smithsonian Institution.

Ascadi, G., and J. Nemeskeri. *History of Human Lifespan and Mortality*. Budapest: Akademiai Kiado, 1970.

Bass, W. M. *Human Osteology: A Laboratory and Field Manual*. Missouri Archeological Society

Hunt

Special Publications 2. Columbia: Missouri Archeological Society, 2005.

Ewing, Heather. *The Lost World of James Smithson: Science, Revolution and the Birth of the Smithsonian*. New York: Bloomsbury, 2007.

Jantz, R. L., and S. J. Ousley. FORDISC 3.0. Knoxville: Department of Anthropology, University of Tennessee, 2005.

Kvaal, S. I., and T. K. Derry. "Tell-Tale Teeth: Abrasion from the Traditional Clay Pipe." *Endeavour* 20 (1996): 28–30.

Meyer, C. "Osteological Evidence of the Battles of Zurich, 1799: A Glimpse into Soldiery of the Past." *International Journal of Osteoarchaeology* 13, no. 4 (2003): 252–257.

Ousley, S. J., and R. L. Jantz. FORDISC 2.0. Knoxville: Department of Anthropology, University of Tennessee, 1996.

Pearson, K., and J. Bell. *A Study of Long Bones of the English Skeleton*. Pt. 1, *The Femur*. Biometric Series 10. London: University College, 1919.

Rhine, S. "Non-metric Skull Racing." In *Skeletal Attribution of Race: Methods for Forensic Anthropology*, ed. George W. Gill and Stanley Rhine, pp. 9–20. Anthropological Papers of the Maxwell Museum of Anthropology 4. Albuquerque, NM: Maxwell Museum of Anthropology, 1990.

Steele, D. G., and C. A. Bramblett. *The Anatomy and Biology of the Human Skeleton*. College Station: Texas A&M University Press, 1988.

Stewart, T. D. *Essentials of Forensic Anthropology*. Springfield, IL: Charles C. Thomas, 1979.

———. "The Rate of Development of Vertebral Osteoarthritis in American Whites and Its Significance in Skeletal Aging Identification." *Leech* 28 (1958): 144–151.

Todd, T. W. "Age Changes in the Pubic Bone I: The Male White Pubis." *American Journal of Physical Anthropology* 3 (1920): 285–334.

Trotter, M., and G. C. Gleser. "A Re-evaluation of Estimation Based on Measurements of Stature Taken during Life and of Long Bones after Death." *American Journal of Physical Anthropology* 16 (1958): 79–123.

White, T. D., and P. A. Folkens. *Human Osteology*. New York: Academic Press, 2000.

Study in Depth, Opus 152

Plate 2
Study in Depth, Opus 152

Artist: Thomas Wilfred (1889–1968)
Date: 1959
Materials: Projector, rotating reflector, translucent screen, colored glass color wheel
Measurements:
 Projector: 48.3 cm (19 in) height × 48.3 cm (19 in) width × 53.3 cm (21.1 in) depth
 Reflector: 152.4 cm (60 in) height × 78.7 cm (30.9 in) width × 83.8 cm (33 in) depth
 Screen: 182.9 cm (72 in) height × 274.3 cm (108 in) width
Catalog number: HMSG 04.2
Hirshhorn Museum and Sculpture Garden
Commissioned by Clairol Corporation for the Manhattan headquarters at 666 Fifth Avenue, New York, New York; reinstalled in 1963 at the Clairol headquarters at 1290 Sixth Avenue, New York, New York.
Donated in 1996 by Bristol-Myers Squibb to the National Museum of American History; transferred in 2004 to the Hirshhorn Museum and Sculpture Garden.

Thomas Wilfred's *Study in Depth, Opus 152*: An Artist's Experiment with Lighting

Bernard Finn

As a historian of science and technology I am attracted by relationships between these disciplines and art. And as a museum curator I have a special interest in how artifacts—the tools used by the artist as well as the finished products—provide evidence that can help us understand the nature of the relationships. In the present instance, simply being next to Wilfred's mechanical and electrical apparatus gives one the feeling—common in seeing "the real thing"—of being close to the person himself and of comprehending the work of art as a product of his creativity. Further examination allows me to make judgments on whether he was using new or well-established technologies, how he was empowered as well as limited by them, and how difficult the process may have been. Going beyond that, I might have bent the aluminum reflectors, performed chemical analysis of the color wheel, or measured the spectrum of the lamp. I might have tested how altering the speeds of the motors changed the projected image. To perform these operations would have

been difficult or impractical, and the rewards probably would have been minimal—although experience has taught me that surprising (and sometimes quite significant) findings can result from such investigations. My limited examination was, however, meaningful, which I hope will be clear in the following discussion.

In 1996 I was offered the mechanism that for 30 years had formed moving light images on a large rear-projection screen in the reception area of the Clairol world headquarters in New York City. With low light levels and comfortable seats this location was an ideal place to view a mature example of what its creator, Thomas Wilfred, called a "lumia composition": *Study in Depth, Opus 152*. Intrigued by what seemed to be a clear example of technology influencing art, I felt that the arrangement of electrical and mechanical devices would provide useful information in a study of the artist's work, and I agreed to accept it for the collections of the National Museum of American History. A few years later, Judith Zilczer, curator at the Hirshhorn Museum and Sculpture Garden, asked if she could use it in an exhibition. The apparatus was transferred to her care, where it was restored and played a prominent role in the exhibit *Visual Music* in 2005. Once it was restored and on exhibit I could see more clearly how this mechanism produced a work of art. And I was stimulated to look more closely at how an emerging electrical technology influenced Wilfred.

THOMAS WILFRED'S EARLY EXPERIMENTS WITH LIGHT

Thomas Wilfred was born (as Richard Løvstrøm) in 1889, the tenth anniversary of Edison's incandescent light bulb invention.[1] It is unlikely that there were any electric lamps in his birthplace, Næstved, Denmark (about 45 miles southwest of Copenhagen). Commercial lighting required an infrastructure of generators and distribution lines that were generally not available in small communities (in the United States fewer than one in twelve homes was lit electrically in 1900, one in three in 1920). However, by 1905, in Copenhagen, he began experimenting with colored glass transmitting light from a 100-watt incandescent lamp.

During this same period he also developed proficiency as an automobile mechanic and from November 15, 1907, at least until October 6, 1908, was employed by a Danish automobile company "as engine tuner and tester, acting at the same time as teacher of mechanisms."[2] He was recommended as "an intelligent and reliable mechanic."[3] A few years later he went to Paris and London, where he studied art and achieved modest success as a singer (see Zilczer, this volume). However, he also continued to hone his mechanical skills and to pursue

his optical investigations. In 1916 he moved to New York, where he turned his full attention to developing programs based on light projection.

His timing was fortuitous. The introduction of tungsten (replacing carbon) as a filament material had occurred earlier in the decade, with the consequence that light bulbs of up to 1,000 watts were available from General Electric and other manufacturers. In 1916, at night, 252 incandescent-lamp search lights illuminated the Statue of Liberty while from inside the torch another 21 beamed outward. Buildings were routinely outlined with electric lamps to reveal their architectural details. Although arc and carbon filament incandescent lights had been used effectively in earlier international exhibitions (notably Chicago in 1893 and St. Louis in 1904), engineers at the Panama-Pacific Exhibition in San Francisco in 1914 noted that the tungsten incandescent lamp provided the designer with much greater power and flexibility.[6]

Other technical elements were readily available to Wilfred. Structural framing units (L-shaped in cross section and predrilled every inch or two along the entire length) could be obtained from shelving suppliers. Chains and sprocket wheels, which we still associate with bicycles, had found wide use in numerous industries as a convenient way to transfer energy across short distances without slippage and to raise and lower speeds (and change directions) if desired. Electrical components in addition to the lamp—small motors, wire, switches, relays, insulators, fuses—were readily available and had been so since before the turn of the century.

By 1922 Wilfred was ready to demonstrate his concept of light art. His "Clavilux" included an elaborate control console that, mostly through wires and mechanical linkages, manipulated a complex arrangement of lenses, movable objects (for the patterns their shadows created), and color filters that in turn determined the nature and positions of images projected on a screen. Over the next two decades he composed and performed many such compositions.[7] He also developed a simplified preprogrammed version using motors and switches to run them automatically and began selling these "Clavilux Junior" models for home use in 1930.

Wilfred apparently found that the images being produced were not as ethereal as he wanted. By the late 1920s he determined that this goal could be achieved with the use of shaped mirror surfaces. He decided to use polished aluminum, which had been available in thin sheets at a reasonable price since early in the century.[8] Aluminum was especially appealing because of its light weight and because irregularities on the surface could easily be produced. Light rays from the lamp filament would be reflected with just the kind of nebulous characteristics desired. Dented aluminum reflectors became a standard

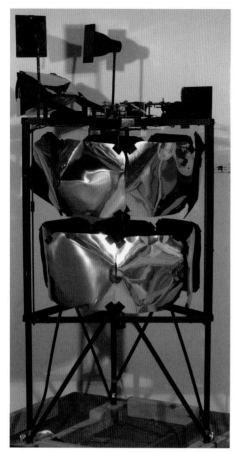

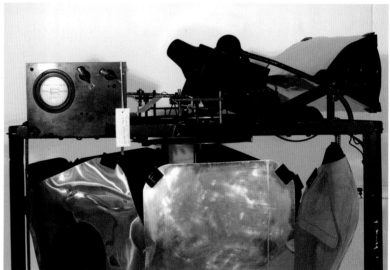

FIGURE 1.

Left: The heart of Wilfred's lumia was the reflector tower (just under 6 feet tall). This view shows the tower as it looked when unpacked prior to conservation in 2004. Notice in particular the way the reflectors have been shaped. **Right:** A close-up view from the other side of the tower (hence, the light source and screen would be to the right) shows more clearly the three-sided mirror, which in practice would have been extended away from the frame. The two lamps provided background illumination. The control box, to the left, has a dial that records elapsed time in hours up to 999.9. Hirshhorn Museum and Sculpture Garden, Smithsonian Institution; gift of Bristol-Myers Squibb by transfer from the National Museum of American History, Behring Center, 2004. Photos courtesy Conservation Department, Hirshhorn Museum and Sculpture Garden.

feature of his projectors. In the case of *Study in Depth*, constructed in 1959, the irregularities appear to have been formed by bending the aluminum manually. Light from a separate box (a few feet to the left) was projected through a cone-shaped mirror against two cylindrical arrangements of shaped reflectors that rotated around a vertical shaft in the same direction but at slightly different speeds. This design produced two separate beams directed upward, where they encountered a three-sided mirror rotating on a horizontal shaft, sending the combined beam back to the screen that was located above and behind the originating light box (Figure 1).

But the optical results could not be completely controlled, especially since they would vary with the changing angles with which the light was reflected from the surface. If the projection was unsatisfactory, he could flatten the aluminum and try again, guided by considerable experience and the fact that he was undoubtedly flexible in determining the optimum shape of the mood-inducing image, but even with much practice there was inevitably some uncertainty in the process.[9]

His automobile mechanical skills, which may not seem obvious as a prerequisite for artistic creativity, were in fact quite appropriate for this medium that he called "lumia, the art of light." His constructions were not elegant, but hidden from view they did not have to be. They were serviceable, and they were sturdy (Figure 2). This ruggedness was critical for *Study in Depth*, which operated 10 hours or more a day for over three decades with minimal attention. Typical

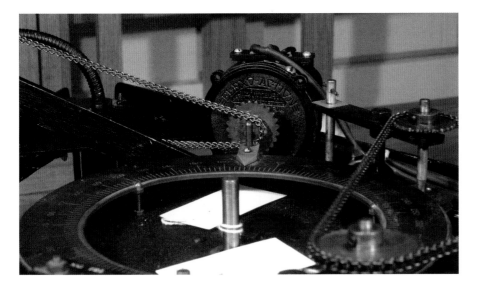

FIGURE 2.
Motors and mechanical links. The chain-and-sprocket arrangement conveyed motion from two motors, one to the rotating reflectors, the other to the three-sided mirror. Hirshhorn Museum and Sculpture Garden, Smithsonian Institution; gift of Bristol-Myers Squibb by transfer from the National Museum of American History, Behring Center, 2004. Photo courtesy Conservation Department, Hirshhorn Museum and Sculpture Garden.

instructions in the handbook, describing maintenance to be done monthly on the piece, are as follows: for the motors, "no more than one drop of oil … should be placed in the … lubrication holes"; for the drive chain, if it "appears to be loose, the tension in the spring must be adjusted"; and, for the reflective surfaces, if they become dusty they must be cleaned "very carefully."[10]

STUDY IN DEPTH, OPUS 152:
HOW DOES THIS LIGHT CONSTRUCTION ACHIEVE ITS EFFECTS?

After World War II Wilfred concentrated on works that, once started, would play automatically. Instead of a manned control board, switches and relays within the mechanism determined the sequences that were followed by motors. Because of differences in speeds and gearing ratios an exact repetition of the program might not occur for months or even years (or, since he also sometimes used belts, which can slip, it might not ever occur). Thus, for practical purposes, there were no starting or finishing points to the program as there were for those performed on the Clavilux. He could, of course, have established a beginning and an end with the introduction of appropriate switches. The fact that he did not suggests that he was content (or more likely desired) to have the composition proceed on its own, generating image sequences for viewers that the artist himself might never have seen in his studio. It was safe to predict that these images would fall within well-defined parameters, set by ranges determined by the various motors and linkages. But psychologically, for both for the artist and the viewer, one can imagine a sense of excitement in moving into the unknown. In any case, the overall rate of change in *Study in Depth* (as in other lumia compositions) is quite slow. Furthermore, there is no attempt to shock the viewer by sudden adjustments in one or more of the component elements. One reason for this would be that the viewer, having been alerted to such an unusual event, would look for it to repeat (either exactly or in modification), and it would likely be a very long wait indeed.[11]

Even a cursory examination of Wilfred's 1959 *Study in Depth* apparatus reveals that he was very conservative. The gears and chains and reflectors and color wheels remained vintage 1920s (Figure 3). Clearly, he was more than content to work within these boundaries. This confirms his stated desire "to produce in my viewers a feeling of the fundamental rhythmic flow of the universe—something beyond our little earth, our human problems."[12] He accomplished

this goal through diaphanous images, gradually changing color, floating slowly across the screen, which was comfortably achieved with the apparatus he had developed. Creativity lay within the infinite number of variables that they presented, allowing him to construct distinct compositions with different thematic undercurrents. One can easily imagine that he felt there was more than enough opportunity available for him in these mechanisms to establish his new art form, which depended on colored light and motion.

Nevertheless, it would be surprising if over the course of almost a half century (he died in 1968) Wilfred did not consider other means of creating images. Perhaps there are clues in whatever records survive from the Art Institute of Light, which he founded in New York City in 1933 and which had "research laboratories and a recital hall." He moved it to West Nyack in 1942 (without the performance space), and that is where most, if not all, of his later devices, including *Study in Depth*, were constructed.[13] Did he consider going back to his earlier process of using shadows of real objects or perhaps including text or line graphics or photographs? Was there a change in the nature of the themes he considered? A closer examination of some of his other light constructions may provide significant insights into any new directions his creative mind was

taking him. Of course, one should not rule out a careful examination of more conventional sources such as notebooks and letters and interviews with those who knew him.[14]

Zilczer points out that the projection of a lumia "transpires over time" in a manner similar to the performing arts.[15] Wilfred himself encouraged this comparison with his early Clavilux lumia, which were composed to fit a modest time span and were performed before an audience, often (especially at first) with accompanying musical performances. However, in the 1940s, when he began to focus on compositions that were controlled electrically (supersized Clavilux Juniors, if you like), there was apparently no attempt to adjust the motor speeds and gear ratios in ways that would produce a closed loop, with perhaps a beginning and an end, although on some occasions he did this for a few subsets within the overall mechanism. In *Lumia Suite, Opus 158*, which he created in 1963–1964 for the Museum of Modern Art, the light construction had "three movements lasting [a total of] twelve minutes, which are repeated continuously with almost endless variations."[16] The movements were defined apparently by coordinating the timing of direction, speed, and intensity, whereas other characteristics (colors, shapes) were allowed to follow different sequences. The result for the viewer was a few repeating patterns embedded in long-term variations that might not recur for months or even years.

The Smithsonian's work, *Study in Depth, Opus 152*, has no discernible short-term dominant recurring structure. The speeds of the motors, the number of teeth on the gears, and the lengths of the chains have been chosen so that a true repetition does not take place for more than four months of continuous operation—more than adequate to imply to any viewer a cosmic sensation, or, as quoted above, something beyond our little earth, our human problems.[18]

Thus, Wilfred's approach might be considered an attempt to develop a special form of ephemeral art. His creations were not sand sculptures or Christo-like constructions, which are meant to disappear, nor were they theater or musical performances, which can be reconstituted even if with inevitable (and often intentional) differences in content and meaning. A Wilfred lumia composition, and *Opus 152* in particular, is, for practical purposes, infinite in length, especially when one considers that over the course of 30 years, although innumerable people saw it on repeat occasions, except for an extraordinary coincidence, they always would have been seeing something new. A lumia does not disappear, but neither does it end and start over again in a slightly different

Finn

56

rendition. It is an unending series of variations on a theme—in the case of *Opus 152*, a study in depth.[19] Indeed, Thomas Wilfred provides us with a classic case study of an artist who responded to a new technology (the incandescent electric light) and created what he considered a new art form.

ACKNOWLEDGMENTS

I thank Eugene and A. J. Epstein for sharing their detailed knowledge of Wilfred and his lumia and also Gwynne Ryan and her colleagues in the Conservation Department of the Hirshhorn Museum and Sculpture Garden for their care in recording the restoration work done on *Opus 152*.

NOTES

1. For more biographical information and critical comments, see Zilczer, "Silent Music: Thomas Wilfred's *Study in Depth, Opus 152*," this volume.

2. Cornelius Steffensen, Dansk Automobilfabrik, memorandum, October 6, 1908. Copy of original in personal collection of A. J. Epstein.

3. Memorandum, signed on behalf of H. Jacobsen, Dansk "Wolverine" Motor-Fabrik, November 3, 1908. Copy of translation in personal collection of A. J. Epstein.

4. See Zilczer, "Silent Music," this volume.

5. T.[?] Delaunay, Delaunay Belleville Automobiles, memorandum, April 6, 1914. Copy of original in personal collection of A. J. Epstein.

6. Bernard Finn, "The Incandescent Electric Light," in *Bridge to the Future: A Centennial Celebration of the Brooklyn Bridge*, ed. Margaret Latimer, Brooke Hindle, and Melvin Kranzberg, *Annals of the New York Academy of Sciences* 424 (1984): 247–263. The focus of this article is on how the light bulb became associated with some of the symbolic meanings of "light." However, it also could stand for technology and industrial society (an example proposed is Picasso's use of the lamp filament in *Guernica*). Included also are examples of architectural uses. See also Evan J. Edwards and H. H. Magdsick, *Light Projection:*

Its Applications, Bulletin of the Engineering Department, National Lamp Works of General Electric Co., No. 32 (General Electric Co., 1917), especially pp. 34–39, 50–53.

7. See Zilczer, "Silent Music," this volume, for this and other biographical information.

8. Alcoa had been producing thin sheets since 1905. See Margaret Graham and Betty Pruitt, *R & D for Industry: A Center of Technological Innovation at ALCOA* (Cambridge: Cambridge University Press, 1980), 512.

9. He also employed punch-like indentations in reflecting surfaces, as described by A. J. Epstein in an e-mail message to me, May 12, 2009: "A major aspect of TW's early compositions was his 'dimples' or 'dents' in the reflectors."

10. Earl Reiback, "Operating and Maintenance Manual," March 1996, Thomas Wilfred Accession Records, 2004.2, Miscellaneous folder, 5–6, Hirshhorn Museum and Sculpture Garden Collection Archives, Smithsonian Institution. This manual was prepared for the Smithsonian prior to the work being placed on exhibition in 2005.

11. An apt analogy is found in a live musical performance, and it is notable that for most people such an experience is more enjoyable if they have heard the composition before (live or

in a recording). Short sequences can then be understood in the context of the overall composition, and dramatic portions can be anticipated. Wilfred's shorter keyboard-controlled lumia compositions had this same characteristic.

12. G. Glueck, "New Art Display 'Plays' On and On: Modern Museum to Exhibit 'Lumia' Composition," *New York Times*, July 11, 1964: 22.

13. Museum of Modern Art, "A Major Work by Thomas Wilfred Goes on Exhibit at the Museum of Modern Art," News Release No. 33, July 13, 1964. Copy in Wilfred Accession Records, Accession 2004.2, Miscellaneous folder, Hirshhorn Museum and Sculpture Garden Collection Archives, Smithsonian Institution.

14. My own research for this paper has been confined to published accounts, material available in the Hirshhorn archives, and *Study in Depth* (both the projected art work and the operating mechanism). However, I have been aided immeasurably by consultations with Eugene Epstein and his nephew A. J. Epstein, who have graciously shared with me some of their insights into Wilfred's work. Eugene knew Wilfred personally and has assembled a collection of his lumia compositions together with examples of performing Clavilux instruments; see Eugene Epstein and Carol Epstein, "Light Art Lumia," accessed 12 February 2011, http://www.lumia-wilfred.org/. A. J. has been doing research in Wilfred's papers, driven in part by his interest in theater lighting (an important but less well-known aspect of Wilfred's career). They have saved me from several egregious errors, although any that remain are fully my responsibility. The Wilfred papers have been preserved as Thomas Wilfred Papers, 1914–1993 (inclusive), 1914–1968 (bulk), Manuscripts and Archives, Yale University Library. Note that 95 images from this collection are conveniently available from Yale University Library, Manuscripts and Archives Digital Images Database, "Thomas Wilfred," accessed February 6, 2011, http://images.library.yale.edu/madid/showthumb.aspx?q1=1375&qc1=contains&qf1=subject1&qx=1004.2.

15. See Zilczer, "Silent Music," this volume.

16. Museum of Modern Art, "A Major Work by Thomas Wilfred Goes on Exhibit."

17. See Zilczer, "Silent Music," this volume.

18. Cited in Zilczer, "Silent Music," this volume.

19. A sense of this characteristic of some ephemeral art can be seen in Mary O'Neill, "Ephemeral Art: Mourning and Loss" (Ph.D. diss., Loughborough University, 2007).

BIBLIOGRAPHY

Brougher, Kerry, Jeremy Strick, Ari Wise, and Judith Zilczer, eds. *Visual Music: Synaesthesia in Art and Music Since 1900*. Los Angeles and Washington, D.C.: Museum of Contemporary Art and Hirshhorn Museum and Sculpture Garden in association with Thames and Hudson, 2005.

Delaunay, T[?]. Memorandum. Delaunay Belleville Automobiles, April 6, 1914. Personal collection of A. J. Epstein.

Edwards, Evan J., and H. H. Magdsick. *Light Projection: Its Applications*. Bulletin of the Engineering Department, National Lamp Works of General Electric Co., No. 32. General Electric Co., 1917. Reprinted from University of Pennsylvania and Illuminating Engineering Society. *Illuminating Engineering Practice: Lectures on Illuminating Engineering Delivered at the University of Pennsylvania, Philadelphia, September 20 to 28, 1916*, pp. 213–252. New York: McGraw-Hill, 1917.

Epstein, Eugene, and Carol Epstein. "Light Art Lumia." Accessed February 12, 2011. http://www.lumia-wilfred.org/.

Finn, Bernard. "The Incandescent Electric Light." In *Bridge to the Future: A Centennial Celebration of the Brooklyn Bridge*, ed. Margaret Latimer, Brooke Hindle, and Melvin Kranzberg. *Annals*

Finn

of the New York Academy of Sciences 424 (1984): 247–263.

Graham, Margaret, and Betty Pruitt. *R & D for Industry: A Center of Technological Innovation at ALCOA*. Cambridge: Cambridge University Press, 1980.

Glueck, G. "New Art Display 'Plays' On and On: Modern Museum to Exhibit 'Lumia' Composition." *New York Times*, July 11, 1964: 22.

Jacobsen, H. Memorandum. Dansk "Wolverine" Motor-Fabrik, November 3, 1908. Personal collection of A. J. Epstein.

O'Neill, Mary. Ephemeral Art: Mourning and Loss. Ph.D. diss., Loughborough University, Leicestershire, UK, 2007.

Steffensen, Cornelius. Memorandum. Dansk Automobilfabrik, October 6, 1908. Personal collection of A. J. Epstein.

Wilfred, Thomas. Accession Records, 2004.2. Hirshhorn Museum and Sculpture Garden Collection Archives, Smithsonian Institution.

———. Papers, 1914–1993 (Inclusive), 1914–1968 (Bulk). Manuscripts and Archives, Yale University Library, New Haven, CT.

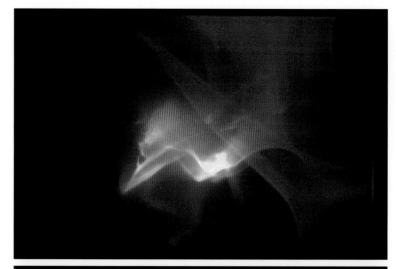

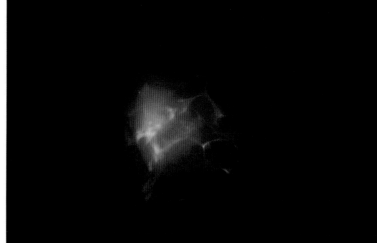

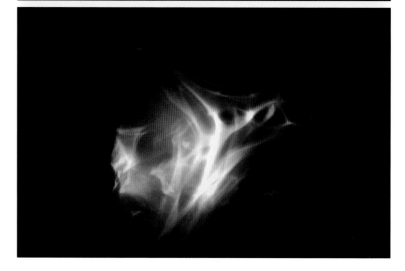

FIGURE 1.

Three still images from Thomas Wilfred, *Study in Depth, Opus 152*, 1959. Projector, 19 × 19 × 21 inches; rotating reflector, 60 × 31 × 33 inches; translucent screen, 6 × 9 feet. Hirshhorn Museum and Sculpture Garden, Smithsonian Institution; gift of Bristol-Myers Squibb by transfer from the National Museum of American History, Behring Center, 2004. Photos by Lee Stalsworth; courtesy Hirshhorn Museum and Sculpture Garden.

Silent Music:
Thomas Wilfred's
Study in Depth, Opus 152

Judith Zilczer

Kaleidoscopic swirls of glowing colored light undulate across a wide screen in a darkened museum gallery. An ever-changing pattern of abstract light forms the basis of a mesmerizing work of art unlike any conventional painting or sculpture. Words fail to capture the mysterious power of a luminous display that evokes comparisons with an aurora borealis or an intergalactic ballet of light. Such is the impact of Thomas Wilfred's *Study in Depth, Opus 152* (1959), a complex, mural-size composition in projected light, now in the permanent collection of the Smithsonian Institution's Hirshhorn Museum and Sculpture Garden (Figure 1). This unique masterwork attests to the genius of its creator, a little-known inventor-artist, Thomas Wilfred (American, born Næstved, Denmark, 1889–1968; Figure 2).

My interest in Thomas Wilfred's light art originated more than 30 years ago when I was conducting research into the role of "color music" in the genesis of

FIGURE 2.
Thomas Wilfred, Inventor of
the Clavilux. Hirshhorn Museum
accession files.

abstract painting. Although that investigation resulted in an essay for a scholarly journal, I had long believed that the subject would lend itself to a museum exhibition.[1] It was not until 2001–2002, when I began work on such a project, that I had an opportunity to pursue further work on Wilfred and to transform my idea into a major loan exhibition, co-organized by the Hirshhorn Museum and Sculpture Garden and the Museum of Contemporary Art, Los Angeles, for the 2005 season. In searching for examples of Wilfred's art for that exhibition, I was delighted to learn that a significant work of his already resided in the Smithsonian's vast collections. The story of how *Study in Depth, Opus 152* entered the Smithsonian's collections is emblematic of the Institution's role in preserving the United States' cultural heritage. At the same time, an analysis of the history of this unusual art work within the context of Wilfred's lifelong campaign to create and promote an independent art of light reveals larger issues surrounding experimental, multimedia art forms of the mid-twentieth century.

Although the compelling beauty of Wilfred's large, rear-screen projection is undeniable, the true magnitude of his achievement may be lost on twenty-first-century viewers long accustomed to all manner of visual stimulation from cinematic

special effects to music videos and screen savers on personal computers. By the standards of the current digital age, Wilfred's technological tools—incandescent light bulbs, motorized metal reflectors, light projectors, and translucent projection screens—may seem old-fashioned, if not primitive. However, as Bernard Finn explains in the companion essay in this volume, Wilfred actually employed cutting-edge technology—electric illumination—which was daring for his time. Moreover, the results he achieved with such simple, Machine Age devices rival, if not surpass, those of the twenty-first century. Working in the early to mid-twentieth century, Wilfred anticipated both the aesthetic and the dramatic possibilities of projected light; his inventions provided the foundation for modern theatrical lighting, as well as for the daring experiments of an entire generation of light artists. *Study in Depth, Opus 152*, one of three major commissions completed during the last 10 years of Wilfred's life, unfolds in a projection cycle that elapses over more than four months. The light performance on a 6 × 9 foot horizontal screen is produced by an internally programmed, multipart instrument: A rotating metal reflector and 1,000-watt colored-light projector operate behind the translucent screen to generate a continually changing light show (Figure 3).

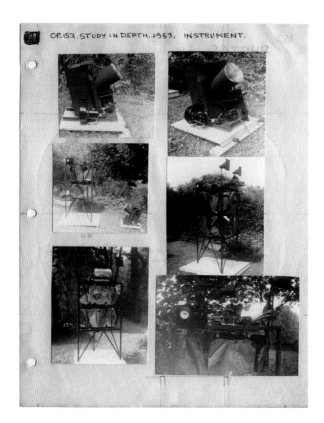

FIGURE 3.
Study in Depth, Opus 152, 1959. Instrument, including two views of projector and three views of the aluminum reflectors at Wilfred's studio in West Nyack, New York. Thomas Wilfred Papers (MS 1375). Manuscripts and Archives, Yale University Library, New Haven, CT.

Unlike many works of art, these physical components of Wilfred's piece do not constitute an aesthetic object; rather, it is their precise operation that produces the work of art—the constantly evolving light composition. Since the light projection incorporates motion that transpires over time, *Study in Depth* differs fundamentally from static visual media such as traditional painting or sculpture or those modern works that include fixed light elements, such as neon or fluorescent tubes. Although Wilfred's light projection appeals to our visual senses, its dynamic action in the temporal dimension is more akin to the experience of performing arts.

WILFRED'S EARLY EXPERIMENTS WITH COLOR AND LIGHT

The hybrid nature of Wilfred's light invention evolved directly from his experiences as an accomplished musician and performing artist. Born in Denmark and educated in Europe, Wilfred pursued his dual interests in art and music through studies in Copenhagen, Paris, and London from 1905 to 1911. In 1905 he conducted the first of his ongoing experiments with color and light. He credited that early experimentation as the source of his lifelong fascination with the aesthetic possibilities of light.[2] While studying painting in Paris, Wilfred came to believe that it would be possible to compose with colored light, just as a musical composer uses the tonal scale to create musical compositions. In pursuing this conviction, Wilfred joined a succession of artists, musicians, and inventors who had experimented with light as an artistic medium over the centuries.[3] During the eighteenth and nineteenth centuries, European and American musicians and artists had devised variants of the so-called color organ that would project moving colored lights. Although his predecessors and contemporary rivals designed their instruments to emulate musical composition through exact analogy between sound and light, Wilfred rejected as fallacious the presumed correspondence between the color spectrum and the musical scale. Instead, he conceived of a new art form, which he termed "lumia." In an unpublished manuscript, "Lumia, the Art of Light" (1945–1947), Wilfred would claim that "light is the silent universal expression of the greatest force our senses can grasp. Is it not therefore logical to conceive of the noblest esthetic use of light[?]"[4] Although Wilfred clearly envisioned a new independent art form, he modeled his initial efforts after the musical arts.

Before taking up his campaign for the art of light, Wilfred himself had achieved considerable success as a lute player and folk singer on the European

concert circuit. In 1916, he settled in the United States, where he would find the patronage and creative freedom to pursue his dream: In 1919, he abandoned a promising recital career to concentrate his efforts on the new art of light. From the 1920s until his death in 1968, Wilfred would create hundreds of lumia compositions for various light instruments of his own design, fewer than four dozen of which now survive in public and private collections in the United States.[5]

Relying on musical prototypes for his first light projection devices, Wilfred designed several increasingly sophisticated keyboard instruments for light projection. In these early efforts, he benefited from the support of art patron William Kirkpatrick Brice and architect Claude Bragdon, who had also experimented with light projection performances. In fact, Bragdon designed a laboratory-studio for Wilfred on Brice's country estate in Huntington, Long Island. Working as an artist-inventor in that new studio space, Wilfred applied his early experiences as an automobile mechanic, as described by Bernard Finn, to develop his light projection devices. Late in 1921, Wilfred perfected what he called the "Clavilux," his signature keyboard light instrument. He introduced his invention in public performance at New York's Neighborhood Playhouse on January 10, 1922.[6] Roderick Seidenberg, who attended the premiere, observed that Wilfred's "compositions are played in silence and depend for their effect entirely upon a combination of color, form and movement."[7] Wilfred coined the term "lumia" to distinguish his art from what other inventors chose to call "color music" performed on a color organ. Since he denied any physical equivalence between light and sound, Wilfred rejected musical analogy and claimed that his would be an art of silent music:

> Lumia may never be played in the manner of music—instantly, on an instrument embodying a fixed number of rigidly standardized projectors, and I see no reason at all for striving toward this goal. The two arts are so different in nature that attempts to design lumia instruments in imitation of musical ones will prove as futile as attempts to write lumia compositions by following the conventional rules laid down for music.[8]

Although he considered lumia a separate art form, Wilfred chose initially to present his compositions in performance venues, particularly concert halls, rather than in gallery settings. During the 1920s, he took his Clavilux on tour to perform successful light recitals throughout the United States and Europe. His 1924 performance at Philharmonic Hall in Philadelphia led him to collaborate with conductor Leopold Stokowski two years later.[9] Wilfred performed a light composition for Rimsky-Korsakov's *Scheherazade* with the Philadelphia

Orchestra in concerts in Philharmonic Hall and at Carnegie Hall in January 1926. In the program notes for the concert, Wilfred explicitly dismissed exact correlation between music and color and instead justified the collaborative performance on purely aesthetic grounds:

> The only way to combine the two arts will be through the conceptions of individual artists. . . . Thus, in composing a visual setting for *Scheherazade* to be played on the Clavilux, I have been striving to create an atmosphere around each movement, and not by any means to follow the music measure for measure.[10]

Notwithstanding the success of his light performances in recital, Wilfred grew concerned that his light compositions would not survive as independent works apart from his performances. His recognition that his Clavilux performances would prove ephemeral spurred Wilfred's decision to design permanent, internally programmed lumia works.

WILFRED'S ART INSTITUTE OF LIGHT

In order to promote the cause of light art, in 1930 Wilfred founded the Art Institute of Light and opened a studio-laboratory space in the Grand Central Palace in Manhattan. Although he and his protégés continued to perform lumia compositions on the Clavilux, he also built smaller, self-contained units which featured permanently programmed, light compositions. He regarded both formats as equally effective:

> A lumia composition may be recorded and repeated automatically by means of a player-attachment in place of, or in addition to, the keyboard. This method has so far been used mostly with smaller screen sizes, where screen and instrument are built together as one unit. One or more of these recorded compositions may be exhibited or installed permanently in museums, galleries, halls, waiting rooms, or in private homes.[11]

Wilfred conceived his larger Clavilux compositions and his preprogrammed models, or "Clavilux Junior" instruments, as "three-dimensional dramas in space." Accordingly, he believed that his light works had at last liberated the two-dimensional art of painting from the confines of the picture frame: "Painting remains a static art in the sense that it can only suggest motion, but abstract and non-objective directions in painting have led us to a closed gate beyond which lies the realm of motion. Lumia is the key to that gate."[12] Even before Wilfred had designed his internally programmed instrument, astute critics such as C. J. Bulliet in Chicago had recognized the implications of his work for the development

of abstract art. Writing on the occasion of Wilfred's 1928 "color recital" in Chicago, Bulliet observed:

> On the first development by Mr. Wilfred of his organ a few years ago, the "clavilux" . . . was hailed enthusiastically as the "last word" in "abstract art," then occupying so keenly the attention of modern painters. Kandinsky in Europe and Macdonald-Wright in America were putting on canvas forms purely abstract, depending for emotional "kick" on their color harmonies. Along came Wilfred with his color organ projecting pure color onto a screen, not only duplicating the work of the painters, but making the resulting vision mobile. His ideas of abstraction were as big and as important as those of the painters putting them permanently on canvas, and the critics ranked him among the geniuses.[13]

Wilfred's long campaign for the acceptance of lumia as a fine art eventually bore fruit in 1942, when the Museum of Modern Art in New York acquired one of his preprogrammed instruments, *Vertical Sequence II* (1941). At the same time, several of his "Clavilux Junior" works entered private collections.[14] Even though World War II forced the closure of the Art Institute of Light in Manhattan, Wilfred resumed work on lumia in West Nyack, New York, after his military service.

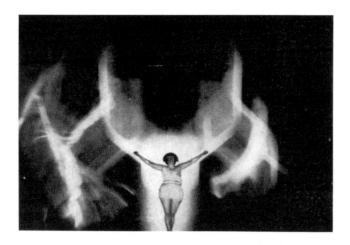

FIGURE 4.
Light projection for ballet at the Greenwich Village Theater, 1924.

While Wilfred explored the possibilities of light as a fine art medium, he also promoted practical applications for his projection inventions. His Clavilux projections served as the luminous abstract settings for a modern ballet that premiered at the Greenwich Village Theatre in 1924 (Figure 4).[15] In 1928–1929, he designed a 21 × 210 foot "projected mobile mural on a curved cyclorama" for installation in the ballroom of Chicago's Sherman Hotel, where the light mural was in continuous operation for more than 30 years (Figure 5).

FIGURE 5.
Diagram of the cyclorama light mural for the Hotel Sherman, Chicago from *Scientific American*, June 1930, p. 464. Reproduced with permission.
Copyright © 1930 Scientific American, Inc. All rights reserved.

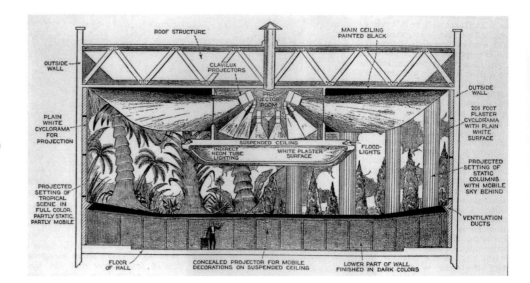

FIGURE 6.
Floor plan blue print for installation of *Study in Depth, Opus 152* at Clairol's Manhattan headquarters at 666 Fifth Avenue (left) and 1290 Avenue of the Americas (right). Thomas Wilfred Papers (MS 1375). Manuscripts and Archives, Yale University Library, New Haven, CT.

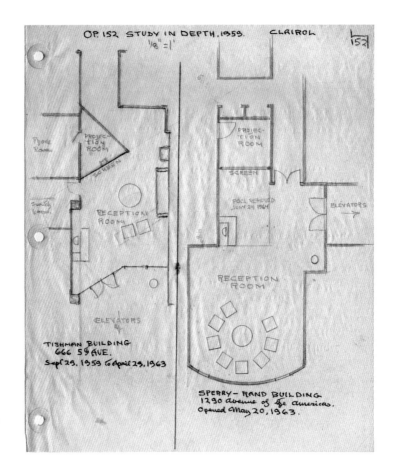

Wilfred would continue to pursue such commercial projects in tandem with his lumia research into the 1950s. His theatrical endeavors included the invention of the first projected scenery lighting equipment in the United States for the University of Washington Playhouse (1951) and a similar lighting system for the University of Georgia's Center Theater in Athens, Georgia (1957).[16] Such experiences with commercial and theatrical lighting design prepared Wilfred for the challenges of large-scale commissions for his lumia works.

THE CLAIROL COMMISSION

In the postwar period, Wilfred concentrated his efforts on increasingly ambitious, self-contained instruments. Of necessity, he sought private commissions for such major, preprogrammed works. In 1959, executives at Clairol Corporation commissioned the first such mural-scale composition, *Study in Depth, Opus 152*, for the reception room of the corporation's Manhattan headquarters at 666 Fifth Avenue (Figure 6). The rear-screen projection, measuring 6 × 9 feet, involves the interplay of two formal motifs and changing colors that unfold in a luminous choreography lasting 142 days, 2 hours, and 10 minutes before the cycle repeats. In explaining the extended thematic development of *Opus 152*, Wilfred noted that "while a near coincidence occurs about every eighteen days, the actual length of the composition is 142 days, 2 hours, 10 minutes, making it by far the longest work ever written."[17] Wilfred called *Study in Depth, Opus 152* "a mobile lumia composition." The internal mechanism of *Study in Depth* resembles the basic design of most of Wilfred's smaller instruments. Incandescent light passes through a moving, stained-glass color wheel and a moving reflecting cone aimed at rotating, shaped aluminum reflectors to form constantly changing images on a translucent screen (Figure 7).[18]

In unpublished notes on the Clairol project, Wilfred described his instrument as follows: "A 1000 watt Clavilux projector, designed and tuned by the artist, . . . operates on the compound reflector principle and its colors are fused into glass and are permanent as a stained glass window, they will never fade or lose their initial brilliance."[19] His emphasis on the permanence of his materials makes clear that Wilfred had moved beyond the transitory experience of live performances to create light art that would withstand the test of time. He also designed a compartment for the entire assembly to be installed in an architectural framework specially built for his piece in Clairol's reception lobby.

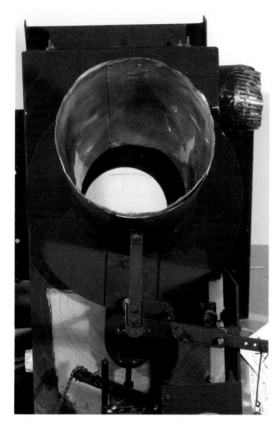
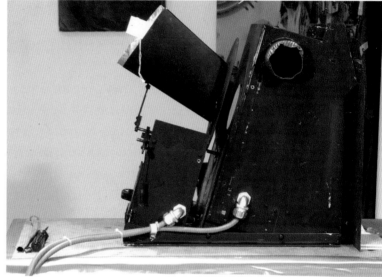

FIGURE 7.
Top (left) and side (right) views of the reflecting cone in the *Study in Depth* mechanism. Hirshhorn Museum and Sculpture Garden, Smithsonian Institution; gift of Bristol-Myers Squibb by transfer from the National Museum of American History, Behring Center, 2004. Photos courtesy Conservation Department, Hirshhorn Museum and Sculpture Garden.

As with all his work, Wilfred developed a specific formal idea for the Clairol commission:

> The basic theme of STUDY IN DEPTH is a vivid horizontal procession of abstract diaphanous form groups moving past the spectator in varying tempi, constantly changing in shape and color, receding and advancing, unfolding and resolving as they move.
>
> As a secondary theme, another form sequence moves in the opposite direction, seemingly far out in space. The basic tempo is slow, making the forms appear large and voluminous and also far away.
>
> At intervals, a third theme of rapidly ascending forms rises vertically.[20]

In designing such an elaborate, yet subtle choreography of light forms, Wilfred clearly intended to induce an all-encompassing sensory experience:

> Each time a form sequence repeats, it does so in a different constellation of other forms and with different color treatment, revealing new phases and characteristics and making the visual experience seem without beginning and end, as would the watching of clouds and other natural phenomena.[21]

Study in Depth, Opus 152 thus entails a considerable investment of time and attention on the part of the individual viewer and the patron-owner of the work.

In commissioning Wilfred's masterwork and then preserving this complex light piece for more than 35 years of continuous operation, Richard L. Gelb, president of Clairol Corporation, and his staff provided just such enlightened support. Gelb's parents, Lawrence M. Gelb and Joan Clair, who founded the company in 1931, transformed hair-coloring products from a rarefied specialty into a popular mainstream consumer product by the 1950s. Clairol's success attracted executives of the pharmaceutical company Bristol-Myers, which acquired the firm in 1959. The Wilfred commission thus coincided with the height of Clairol's marketing success and its absorption into a parent pharmaceutical corporation.[22] For the cosmetics company, *Study in Depth* became more than an amenity adorning the headquarters reception suite. Wilfred's daring light invention served as an emblem of corporate identity. Richard Gelb's personal involvement in the commission attested to Clairol's close identification with the artistic project.

However, the silent motion of the visual display in the reception suite proved challenging for Clairol's clientele and visitors. Even though Wilfred regarded *Study in Depth* as a purely visual work of light art, his corporate sponsors succumbed to the popular notion of musical analogy for presentation of the abstract light show when they solicited his suggestions for musical recordings to be piped into the reception area where *Study in Depth* was installed.

Wilfred obliged with a list of classical compositions by Beethoven, Berlioz, Bizet, Dvorak, Fauré, and Franck, among others.[23] Such ambivalence regarding musical analogy in his work ultimately obscured the independent nature of Wilfred's achievement.

Other factors arising from corporate patronage also proved problematic for the long-term survival of Wilfred's work. In 1963, when Clairol Corporation moved from its Fifth Avenue location to a new headquarters at 1290 Sixth Avenue, *Study in Depth* was disassembled and carefully reinstalled in close consultation with the artist in the new corporate reception suite (see Figure 6). From the time of its first installation in 1959 until Wilfred's death in 1968, Clairol staff ensured that *Study in Depth, Opus 152* was maintained in operating condition by the artist. When Wilfred was no longer available to tend to his light instrument, Clairol engaged Earl Reiback, his friend and also a light artist, to perform the necessary maintenance work to keep *Study in Depth* running in working order.[24] For more than three decades, Clairol sustained Wilfred's masterwork, even as Richard Gelb, Clairol's president, assumed the chairmanship of its parent corporation, Bristol-Myers in 1972. By 1989, when Bristol-Myers merged with Squibb, the corporation's devotion to the Wilfred commission seemed secure.

WILFRED'S *STUDY IN DEPTH, OPUS 152* AT THE SMITHSONIAN

Clairol's commitment to presenting and preserving Wilfred's "mobile lumia composition" ended abruptly in 1996, after Richard Gelb's retirement as chief executive of Bristol-Myers Squibb. The new management decided to move Clairol's corporate headquarters to Stamford, Connecticut. With the prospective relocation of Clairol outside Manhattan, *Study in Depth* was dismantled with no plans for its reassembly in the new corporate building. At Earl Reiback's insistence, Wilfred's masterwork subsequently was offered for donation to the Smithsonian Institution. Although the National Museum of American History initially accepted *Study in Depth, Opus 152* as an example of the application of electrical technology, the complex issues associated with its need for restoration led curators to determine that this major example of light art would be more accessible to the public in a museum of modern and contemporary art. Accordingly, in 2004, *Study in Depth* was transferred to the Hirshhorn Museum and Sculpture Garden, where it was restored to working condition by the museum's conservation staff working in consultation with Earl Reiback.[25]

The survival of *Study in Depth, Opus 152* is a testament to Thomas Wilfred's belief that light could serve as "the artist's sole medium of expression. A sculptor begins with a solid block of marble, the lumia artist with a strong beam of pure white light."[26] In shaping light by optical means to produce form, color, and motion, Wilfred aimed to express "the human longing which light has always symbolized, a longing for a greater reality, a cosmic consciousness."[27] In *Study in Depth*, Wilfred conjured such cosmic imagery, which he eloquently described in his prospectus for the Clairol commission:

> The lumia artist's aim is to transform the screen into a large window looking out on infinite space, an imaginary stage of astronomical proportions, and to perform on this stage a silent visual music of form, color, and motion.[28]

ACKNOWLEDGMENTS

I am grateful to Mary Jo Arnoldi for the opportunity to contribute to this volume and to Bernard Finn for his gracious collaboration. I give special thanks to Eugene Epstein and the late Earl Reiback for their enthusiastic generosity in sharing their extensive knowledge of Thomas Wilfred and his art. At the Hirshhorn Museum, Gwynne Ryan, sculpture conservator, and Amy Giarmo, photography permissions manager, were especially helpful in securing excellent images of *Study in Depth, Opus 152* and most of its working parts. I also thank Jessica Becker of the Manuscripts and Archives division of Yale University Library for her assistance in accessing the Thomas Wilfred Papers.

NOTES

1. Judith Zilczer, "'Color Music': Synaesthesia and the Nineteenth Century Origins of Abstract Art," *Artibus et Historiae: An Art Anthology* 8, no. 16 (1987): 101–126.

2. Biographical facts are based on Wilfred's "Biographical Notes" prepared for the curatorial files of the Museum of Modern Art, New York. See also Donna Stein, *Thomas Wilfred, Lumia: A Retrospective Exhibition* (Washington, D.C.: Corcoran Gallery of Art, 1971).

3. For an overview of the history of light art, see Judith Zilczer, "Music for the Eyes: Abstract Painting and Light Art," in *Visual Music: Synaesthesia in Art and Music Since 1900*, ed. Kerry Brougher, Jeremy Strick, Ari Wiseman, and Judith Zilczer (Los Angeles and Washington, D.C.: Museum of Contemporary Art and Hirshhorn Museum and Sculpture Garden, in association with Thames and Hudson, 2005), 24–85.

4. Thomas Wilfred, "Excerpts from an unpublished manuscript, *Lumia, The Art of Light*, by Thomas Wilfred, 1945–1947," in Stein, *Thomas Wilfred*, 6.

5. A complete accounting of Wilfred's surviving works has been compiled by Eugene Epstein,

"Catalogue Raisonné for Thomas Wilfred, Lumia Artist" (unpublished typescript). Epstein is the primary collector of Wilfred's work.

6. Thomas Wilfred, "Lumia, the Art of Light," unpublished typescript, n.d., Thomas Wilfred Papers, Ms. No. 1375, acc. 95-M-38, Box 1, Manuscripts and Archives, Yale University Library, New Haven, CT; typescript courtesy of Eugene Epstein, Los Angeles. See also Thomas Wilfred, "Light and the Artist," *Journal of Aesthetics and Art Criticism* 5, no. 4 (June 1947): 250–251.

7. Roderick Seidenberg, "Mobile Painting, Art's Newest Expression," *International Studio* 75, no. 299 (March 1922): 84.

8. Thomas Wilfred, "Composing in the Art of Lumia," *Journal of Aesthetics and Art Criticism* 7, no. 2 (December 1948): 89.

9. "Thomas Wilfred Presents His Invention: The Clavilux," program brochure, March 24, 1924, Morgan Russell Papers, Montclair Art Museum, Montclair, NJ.

10. "Thomas Wilfred, Statement," program brochure, Philadelphia Orchestra, January 2–4, 1926, Philadelphia Orchestra Archives, Academy of Music, Philadelphia. The concert was repeated at Carnegie Hall on January 5, 1926.

11. Thomas Wilfred, "Lumia, The Art of Light," unpublished typescript, Wilfred Papers, courtesy Eugene Epstein, 112.

12. Wilfred, "Composing in the Art of Lumia," 90.

13. C. J. Bulliet, "Wilfred Will Give Color Organ 'Recital,'" *Chicago Evening Post Magazine World of Art*, April 10, 1928, 12.

14. See Stein, *Thomas Wilfred*; Epstein, "Catalogue Raisonné." For Wilfred's relations with the Museum of Modern Art, see also Stephen Eskilson, "Thomas Wilfred and Intermedia: Seeking a Framework for Lumia," *Leonardo* 36, no. 1 (2003), 65–68. By 1952, Wilfred was selected by curator Dorothy Miller for inclusion in the important exhibition *15 Americans* at the Museum of Modern Art.

15. "A New Substitute for Scenery and a New Kind of Concert," unidentified clipping, Thomas Wilfred Accession Records, 2004.2, Hirshhorn Museum and Sculpture Garden Collection Archives, Smithsonian Institution.

16. Wilfred, Biographical Notes, Curatorial Files, Museum of Modern Art, New York. See also "Thomas Wilfred, Artist and Inventor, Dead at 79," *New York Times*, August 16, 1968.

17. Thomas Wilfred, "Study in Depth, Op. 152," unpublished typescript, n.d. [1959–1960?], Thomas Wilfred Papers, series II, box 13, folder 189, Manuscripts and Archives, Yale University Library, New Haven, CT.

18. Earl Reiback, "Operation and Maintenance Manual, Opus 152," 1996, Wilfred Accession Records, 2004.2, Hirshhorn Museum and Sculpture Garden Collection Archives, Smithsonian Institution; Earl Reiback to Jacqueline Serwer, April 30, 1996, Wilfred Accession Records, 2004.2, Miscellaneous folder, Hirshhorn Museum and Sculpture Garden Collection Archives. See Finn, this volume, Figure 3, for a photograph of the stained-glass color wheel.

19. Wilfred, "Study in Depth, Op. 152," handwritten manuscript, n.d., Wilfred Papers, series II, box 13, folder 189.

20. Wilfred, "Study in Depth, Op. 152," unpublished typescript, Wilfred Papers, series II, box 13, folder 189.

21. Wilfred, "Study in Depth, Op. 152," unpublished typescript, Wilfred Papers, series II, box 13, folder 189.

22. For the corporate history of Clairol, see "History," Bristol-Meyers Squibb, accessed February 15, 2011, http://www.bms.com/ourcompany/Pages/history.aspx; Patrick Healy, "Richard Gelb, 79, Executive; Was Chairman of Bristol-Myers," *New York Times*, April 5, 2004: B-7.

23. Thomas Wilfred to Miss Broder, Clairol Corporation, July 25, 1960, Wilfred Papers, series II, box 13, folder 189.

24. Earl Reiback, conversations with the author, 2004–2005.

25. *Study in Depth, Opus 152* required rewiring by Smithsonian master electricians to bring the piece up to current electrical code. The glass color wheel

in the light projector also needed restoration. With Reiback's advice, appropriate glass was procured to replace several missing glass fragments.

26. Wilfred, "Study in Depth, Op. 152," unpublished typescript, Wilfred Papers, series II, box 13,

folder 189.

27. Wilfred, "Composing in the Art of Lumia," 90.

28. Wilfred, "Study in Depth, Op. 152," unpublished typescript, Wilfred Papers, series II, box 13, folder 189.

BIBLIOGRAPHY

Bristol-Meyers Squibb. "History." Accessed February 15, 2011. http://www.bms.com/ourcompany/Pages/history.aspx.

Bulliet, C. J. "Wilfred Will Give Color Organ 'Recital.'" *Chicago Evening Post Magazine World of Art*, April 10, 1928, 12.

Epstein, Eugene. "Catalogue Raisonné for Thomas Wilfred, Lumia Artist." Unpublished typescript, n.d.

Eskilson, Stephen. "Thomas Wilfred and Intermedia: Seeking a Framework for Lumia." *Leonardo* 36, no. 1 (2003): 65–68.

Healy, Patrick. "Richard Gelb, 79, Executive; Was Chairman of Bristol-Myers." *New York Times*, April 5, 2004: B-7.

Seidenberg, Roderick. "Mobile Painting, Art's Newest Expression." *International Studio* 75, no. 299 (March 1922): 84–86.

Stein, Donna. *Thomas Wilfred, Lumia: A Retrospective Exhibition.* Washington, D.C.: Corcoran Gallery of Art, 1971.

"Thomas Wilfred, Artist and Inventor, Dead at 79." *New York Times*, August 16, 1968.

"Thomas Wilfred Presents His Invention: The Clavilux." Program brochure. March 24, 1924. Morgan Russell Papers. Montclair Art Museum, Montclair, NJ.

"Thomas Wilfred, Statement." Program brochure. Philadelphia Orchestra, January 2–4, 1926. Philadelphia Orchestra Archives, Academy of Music, Philadelphia.

Wilfred, Thomas. Accession Records, 2004.2. Hirshhorn Museum and Sculpture Garden Collection Archives, Smithsonian Institution.

———. Biographical Notes. Curatorial Files, Museum of Modern Art, New York.

———. "Composing in the Art of Lumia." *Journal of Aesthetics and Art Criticism* 7, no. 2 (December 1948): 79–93.

———. "Light and the Artist." *Journal of Aesthetics and Art Criticism* 5, no. 4 (June 1947): 250–251.

———. Papers. Ms. No. 1375. Manuscripts and Archives, Yale University Library, New Haven, CT.

Zilczer, Judith. "'Color Music': Synaesthesia and the Nineteenth Century Origins of Abstract Art." *Artibus et Historiae: An Art Anthology* 8, no. 16 (1987): 101–126.

———. "Music for the Eyes: Abstract Painting and Light Art." In *Visual Music: Synaesthesia in Art and Music Since 1900,* ed. Kerry Brougher, Jeremy Strick, Ari Wiseman, and Judith Zilczer, pp. 24–85. Los Angeles and Washington, D.C.: Museum of Contemporary Art and Hirshhorn Museum and Sculpture Garden, in association with Thames and Hudson, 2005.

Kīlauea Volcano

Plate 3
Kīlauea volcano, Hawaii, December 1965.
Photo by R. S. Fiske, Smithsonian Institution.

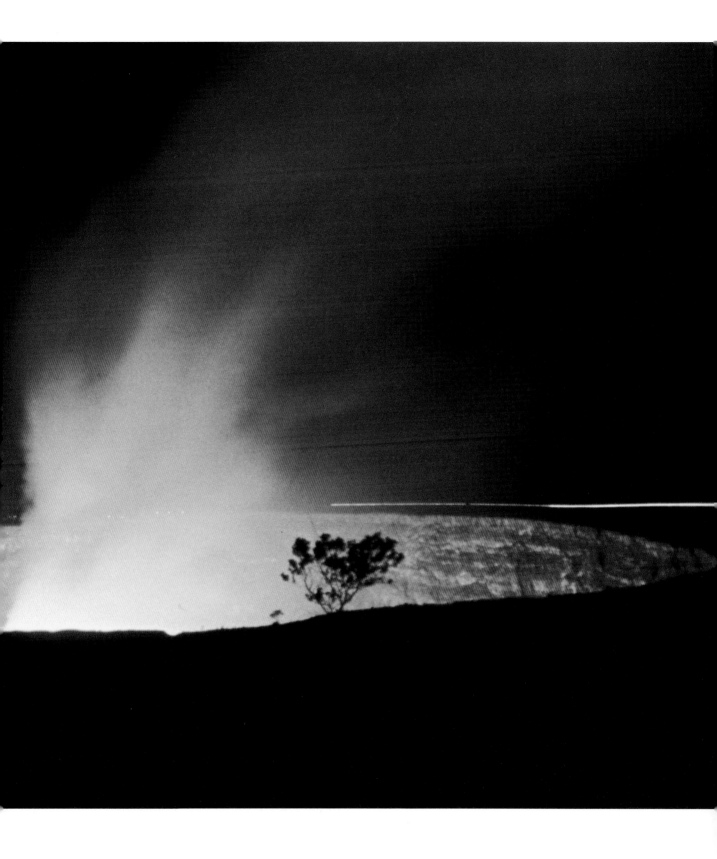

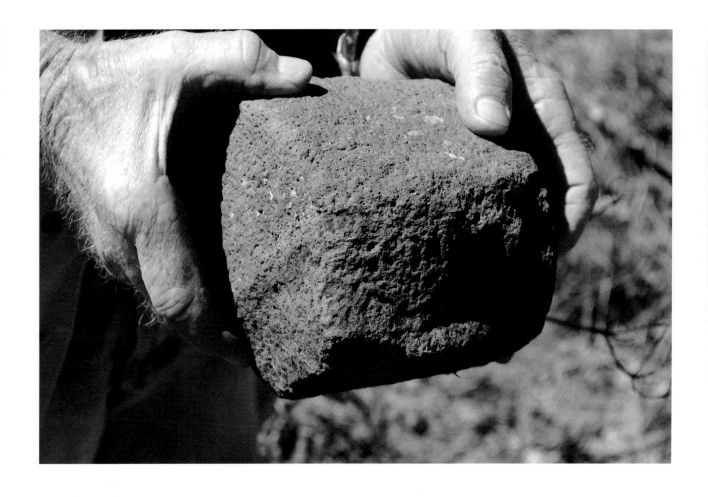

Figure 1.
Ancient lava flow specimen, Kīlauea volcano

Date: ca. 850–950 AD, from the Kulanaokuaiki-3 eruption
Materials: Plagioclase feldspar, pyroxene, and olivine
Measurements: 7 lb. weight
Uncataloged research collection
Division of Petrology and Volcanology, Department of Mineral Sciences, National Museum of Natural History
Collected in 2013 by Richard Fiske at Kīlauea volcano, Kilauea, Hawaii, 6 miles south of the volcano's summit.

A Not So Gentle History: Violent Explosions at Kīlauea Volcano, Hawaii

Richard Fiske

Scientific collections in natural history museums are active collections that are meant to serve generations of researchers. These collections do serve as libraries of the range of types and species in the natural world. However, a portion of the scientific collections is also reserved for laboratory analysis that can involve destructive sampling. Our research team's systematic collection of volcanic rocks from Kīlauea volcano on the Big Island of Hawai'i is one such collection in which a small number of the rocks are destined for destructive sampling in the laboratory while the remainder will be kept in reserve in the museum's rock and ore collections to be made available to future researchers in volcanology (Figure 1). This essay is the story of how this collection was made, the methodology that guided the team's selection of the samples, and the importance of this collection for our Kīlauea research and for future research on the long history of volcanoes.[1]

Like other active Hawaiian volcanoes, Kīlauea fed from a hot spot 50–100 miles deep in Earth's mantle. In early life, the volcano first grew in the darkness of the seafloor at an ocean depth of about 30,000 feet. In this remote and hostile environment, basalt magma erupted into cold seawater quickly quenched to form blob-like masses about the size and shape of pillows. Immense piles of pillow basalts, as they are called, and associated fragmental debris built a steep-sided edifice quite unlike the one we see today. Once its summit grew above sea level, however, the volcano's eruptive style changed. Countless lava flows of fluid basalt, often fed by high lava fountains, formed widespread stony layers that gradually enlarged the gently sloping volcano we know today.

However, Kīlauea has not always been so gentle. Explosions, some of them remarkably violent, have occasionally propelled dense pieces of rock for distances of 5–10 miles. Native Hawaiians having the misfortune of living in these areas would have been at grave risk, and some were likely killed during these events. How is it possible that a usually gentle volcano can turn so violent, and what evidence still exists today for such activity? These questions are the focus of this essay.

Relatively small explosions at Kīlauea took place in 1924, and these, observed by many people, revealed the dark side of the volcano. Groundwater gained access to shallow, very hot parts of the Kīlauea's underground magmatic system, and resulting steam explosions ripped pieces of rock from the walls of the summit vent and hurled them into the air. Some, weighing as much as 10–12 tons, crashed to the ground a half mile away, and finer pieces were showered a few miles farther downwind to the southwest. Vintage photographs captured the roiling eruption clouds that rose above the volcano's summit, and one overly curious photographer, who ventured a bit too close, was killed by falling debris. But the events of 1924 were minor in comparison with those of previous centuries, and evidence of these earlier eruptions can easily be seen.

Visitors to Hawai'i Volcanoes National Park, while driving around Crater Rim Drive, cannot fail to notice conspicuous layers of ash and blocky debris mantling the ground surface in many places. These layers are part of what is known as the Keanakako'i Ash, for the past few decades thought to have been the product of an earlier series of summit eruptions in and around 1790. D. A. Swanson of the U.S. Geological Survey's Hawaiian Volcano Observatory

has shown the story to be far more interesting. Carefully collected samples of charcoal, preserved within (or just beneath) these ash layers, have yielded radiocarbon ages showing the eruptions of the Keanakakoʻi Ash spanned more than 300 years, from about 1470 to 1790, and involved a far longer episode of explosive eruptions than previous workers had imagined. In addition, most Keanakakoʻi eruptions produced high lava fountains that showered fine debris over wide areas near the summit of the volcano, particularly in areas toward the southwest, because of the effects of the prevailing NE–SW trade winds. More conspicuous are layers of coarse, rocky debris, formed in 1790 by steam explosions similar to those of 1924 (but these rocks are a good deal larger). At least two of the Keanakakoʻi layers, containing conspicuous dark pieces of scoria (small pieces of bubbly lava rock) and small rock fragments, were produced by the most lethal of the Keanakakoʻi eruptions, which propelled debris to the southeast—an anomalous direction that produced deposits oriented perpendicular to prevailing trade wind patterns.

The same anomalous pattern of ash distribution has been recognized in still older ash deposits, but these are far more difficult to see. These deposits do not rest on the ground surface where they might be easily observed. Instead, they are concealed beneath younger deposits or have been completely eroded away. If one were to walk around almost any place on the surface of Kīlauea, the widespread original presence of these older deposits would be easily overlooked. Because Kīlauea is the world's most intensively studied volcano, this oversight implies that over the past several decades hundreds of geologists and geophysicists have walked around while carrying out their own research but have missed the evidence for one of the volcano's most violent series of eruptions.

For a number of years, our team also failed to recognize the evidence for these eruptions. Our initial research project, which began in 1992, involved the study of the Koaʻe fault system, a zone of cracking and faulting that separates the volcano's south flank from the main body of its edifice. This research, among other things, involved gathering evidence that some of the faults and cracks in the Koaʻe were what geologists call "growth features" that repeatedly shifted and enlarged as the entire south flank of the volcano moved incrementally toward the sea. In the course of this work, however, we began to notice layers of ash (2–12 inches thick) that lay beneath the youngest lava flow that covered most of our study area. Assuming that this ash was erupted during

FIGURE 2.

A single-rope descent into a deep, gaping crack permitted the author to inspect ash products of an explosive Kīlauean eruption now buried beneath lava flows 57 feet thick. Photo by D. A. Swanson, U.S. Geological Survey.

a specific period of time, we used its presence as a time marker, a useful tool for correlating lava flows from one place to another. In many places, however, the lava flow covering the ash was 10–50 feet thick, and it was impossible to look for the underlying ash while carefully leaning over and peering down into the deep gaping cracks. Therefore, we learned how to rappel down into these cracks using single-rope techniques while equipped with hard hats, miner's lamps, and appropriate hardware to control our descent down the rope. This same technique is used by those who explore caves, and it suited our needs perfectly (Figure 2).

Wide areas south of Kīlauea's summit, however, particularly those on the volcano's south flank, are not underlain by the lava flows that required the rope work described above. The next breakthrough in our research was to realize that remnants of these ash deposits actually remain on the surface of the ground. However, while walking around in this area, we saw no ash, and there appeared to be no trace of it anywhere. But this, as it turns out, was an incorrect assumption. Much of the ash had indeed been eroded away, but remnants were preserved in sandy swales on the surface of older lava flows, masked beneath a thin layer of nondescript sand and pebbles on the ground surface. We quickly learned that ignoring these debris-covered areas was a mistake. Shallow holes dug into some of this debris revealed excellent exposures of the ash and permitted us to determine the extent and makeup of the ash over much of the area it originally blanketed.

However, then our research project took another twist and turn. While studying outcrops of the ash, we could not help noticing that large dense rocks were embedded in one of the layers. Tracing this layer laterally, we found that such rocks could be found at all localities. This finding was perplexing because it is unusual for volcanic ash deposits to be made up of large pieces of dense rock associated with smaller pieces of lightweight scoria; most are the size of peas or lima beans.

The plot thickened when we looked again at areas on the volcano's south flank, where almost all of the deposits we had been studying had supposedly been eroded away. Our first impression was indeed that all vestiges of the ash were gone. The surface of the older lava flow that forms the ground surface in this area seemed completely free of ash. Then we noticed one of those large, dense pieces of rock sitting all by itself, right there on the surface of the older lava flow (Figure 3). Looking around, we found another and then still another. We

FIGURE 3.
Large dense rock sitting on the surface of an older lava flow. Parts of Kīlauea's south flank were showered with small stones. Surprisingly, some of the larger stones can easily be overlooked, especially if one is not looking for them. Photo by R. S. Fiske, Smithsonian Institution.

soon realized that numerous such rocks were present but that they were widely scattered—explaining why we at first failed to see them.

Once we discovered these rocks, it became obvious that we had to define their distribution patterns because they could tell us something about the nature of the explosion that produced them. Toward that end, we established a very unusual sampling plan. On a map of the volcano's south flank and nearby areas, we established a grid of 110 observation stations, with each station separated from the other by about 1,800 feet. Utilizing the marvels of the Global Positioning System (GPS) and handheld GPS receivers, we hiked to each of these stations and collected the rocks scattered nearby.

To avoid the temptation of picking up more rocks in grass-free areas where the collecting would be easier, we established a rigorous 18-minute protocol—exactly 18 minutes of collecting at each site. According to this plan, one person would collect for 18 minutes, but if three of us happened to be working on a particular day, then all three of us would collect simultaneously for 6 minutes (18 minutes total). After gathering the rocks at each site, we measured the diameters of the 10 largest, brought these back to the Volcano Observatory, and returned the smaller ones on the ground.

We then plotted the average diameter of three of the larger rocks on a map, and the pattern that emerged was remarkable. The diameters of the collected rocks clearly showed that the source explosion propelled debris toward the southeast—as noted above, an anomalous direction oriented perpendicular to the pattern of the prevailing NE–SW trade winds. Our interpretation of this anomalous pattern involved two important factors, one a fact and the other an assumption.

The fact is that about 12 percent of the rock samples recovered from the surface of the south flank are what geologists call gabbros, rocks derived from underground sites rather than from surface lava flows. In the underground environment, magma cools more slowly than when it is erupted onto the surface, and this slow cooling permits the growth of large crystals of the mineral plagioclase. These light-colored rocks are conspicuous, and they were easily distinguished from fragments of darker-colored lava flows that make up most of the scattered debris—once we started looking for them.

The assumption was that the eruption that produced this layer of scoria and its associated larger rocks was extremely powerful and was triggered by the sudden release of volcanic gas, likely carbon dioxide, from a source deep within the volcano or from a region in the underlying oceanic crust or mantle below. According to this assumption, pieces of dense rock, torn from deep within the volcano, were swept into the air by a roaring jet of gas. This jet, emerging at velocities of hundreds of feet per second, rose to heights of 6–10 miles into the air, carrying ash and rock with it. At those altitudes, this debris would have encountered the strong winds of the jet stream that for much of the year traveled in a NW–SE direction. This direction is almost exactly crosswise to the lower-elevation trade winds. The fallback debris was entrained in these high-altitude winds and fell along trajectories oriented toward the southeast, thus explaining the anomalous distribution pattern of the large rock fragments found on the ground.

It is fortunate that the south flank of the volcano is currently unpopulated. This area is located within the boundaries of Hawai'i Volcanoes National Park and can be reached only by park trails, not by roads. Early Hawaiians, on the other hand, had no access to well-maintained park roads (obviously, because there was no park), so those living in this hazardous area had no easy way to escape. Many were likely killed by falling debris, particularly the dense pieces of rock as large as golf balls that fell along the south coast of the island, 10 miles from the summit vents. Such events would have been terrifying for native peoples, particularly

because they had no place to hide. Some may have found refuge in lava tubes, naturally occurring caverns in the interiors of some thick lava flows. Those would have been the lucky ones. It is no wonder that Hawaiian religious beliefs involve gifts being thrown into the active crater at the summit of the volcano.

Looking broadly at our research and the unexpected findings we made, it is interesting to compare our experiences with the fundamentals outlined by David Paydarfar and William J. Schwartz in "An Algorithm for Discovery" in the journal *Science*.[2] The authors present a straightforward, five-step path toward making discoveries that we found useful for our research methodology and in thinking about its implications:

1. Slow down to explore. There is value in an unhurried approach to research (not to be confused with a laid-back approach). As seasoned (read, *somewhat older*) geologists, now largely removed from publish-or-perish pressures, I and my colleagues enjoyed the luxury of approaching our problems step by step. Beginning in 1992, we visited our Kīlauea study area at least once a year through 2006. Each visit averaged about three weeks, permitting time for reconnaissance, field measurements, and sampling—generally in one part of our study area. Returning to our Smithsonian laboratory, we looked carefully at data and samples, thinking carefully, for example, about the puzzling presence of grapefruit-size rocks in areas 3 to 5 miles from the suspected summit eruptive vents. Supposedly gentle volcanoes are not expected to behave so violently, so we approached this quandary with care. In several notable instances, our laboratory deliberations prompted us to look again in specific areas we had visited before because we realized that we had likely overlooked features that we should have seen.

2. Read, but not too much. A substantial body of literature exists on the known explosive eruptions that have taken place at Kīlauea over the past several hundred years, and we might have been tempted to rely on this earlier work for our interpretations. Fortunately, however, the ages and distributions of the ash deposits we studied were so different from the younger ones described by other workers that we did not depend on these earlier descriptions for our interpretations. Most important, prevailing trade winds, traveling from the northeast toward the southwest, strongly influenced the distribution of these younger deposits, but the deposits we studied were distributed along a nearly perpendicular pattern, reflecting winds that traveled from northwest to southeast. Had we depended too much on the earlier literature, we might not have believed the "abnormal" distribution patterns as they first emerged from our field observations.

3. Pursue quality for its own sake. We took care to develop and perfect the ways in which we obtained samples and gathered data, and three examples of this follow: (1) We took pains to construct a tephra sampling device to collect sequential samples of one of the ash layers of particular interest. Giving this device the informal name "Lincoln Logs" (because it resembled the children's toy involving wooden construction logs), we were able to collect centimeter by centimeter samples through the deposit, enabling us to identify subtle changes in chemistry and clast density that took place during the eruption. (2) Realizing that in many places the ash layers we were studying were buried by younger lava flows, we adopted single-rope descending techniques used by cave explorers. Safety (in addition to quality) was also one of our primary concerns because we obviously did not want to fall into the 15–65 feet deep cracks into which we descended. (3) We realized that the best way to observe subtle features in soft ash deposits was *not* to observe them after scraping an outcrop smooth with a trowel (the technique used by others) but to sculpt out a small brick of undisturbed ash and then, while holding it with two hands, carefully break it open. Remarkably delicate features can be revealed with this technique instead of blurring them through the scraping and smearing motions of a trowel.

4. Look at the raw data. As noted by Paydarfar and Schwartz, there is no substitute for looking firsthand at raw data. In a geology context, raw data include field observations, samples collected, and analytical data generated in a chemistry laboratory. Data presented in papers authored by earlier workers are often sketchy, and there is no substitute for firsthand inspections. The same holds for samples returned to the museum for detailed study. Not having the luxury of research assistants in the museum, we carry out all lab functions ourselves. After first complaining about this, we soon realized that being required to repeatedly inspect samples (our "raw data") in the lab yielded important insights not previously recognized.

5. Cultivate smart friends. We are blessed by having some very smart friends, but contrary to the suggestion of Paydarfar and Schwartz, these friends had limited influence on our research at Kīlauea. This is not to say that we are know-it-alls or that we resisted the input of others. It is just that our research, the ways we went about it, and the anomalies we discovered are virtually unique—not previously recognized at Kīlauea or at any other large basaltic volcano worldwide. Our smart friends were interested in our research as it took place, but they had only a minor role in gathering data and the resulting interpretations of them.

Looking at our Hawaiian research within the context of a natural history museum, it is obvious that our field work, unsuitable per se for a museum collection, has yielded volcanic samples that definitely are. Consider, for example, the following two types of rocks we collected and their value to our current research and to future research in understanding the history of volcanoes:

1. Volcanic scoria (the small pieces of dense pumice). The sequential samples of scoria we collected from the layer of ash we call Kulanaokuaiki-3 document subtle (actually, cryptic) evidence of compositional changes that took place during the eruption that showered scoriae over areas south and southeast of the summit. Such changes have never before been recognized, and it is likely that other geologists will request "splits" of these samples to familiarize themselves with the subtle changes involved and to help them recognize similar features in other areas.

2. Large, dense fragments of volcanic rock. Remembering that the Kulanaokuaiki-3 eruption ejected large pieces of rock, in addition to the much smaller (and lightweight) pieces of scoria, it should come as no surprise that many scientists will be interested in these unusual samples. Particular attention will be paid to the coarse-grained rocks called gabbro that contain large crystals of the minerals plagioclase feldspar, pyroxene, and olivine. Gabbros are coarse grained because the basalt magma from which they crystallize cools very slowly underground, permitting the crystals to grow to large size. During this remarkable eruption, however, a mass of slowly cooling gabbro was abruptly torn from the hot interior of the volcano and propelled to altitudes of 3–5 miles into the cold, thin air. Some of the gabbros were only partly crystallized when this happened, and yet to be crystallized patches of magma quenched to a dense, black glass. Some of this glass contains tiny air bubbles, or vesicles. Are bizarre rocks such as these even possible? Ask this question of almost any geologist, and he or she will look at you strangely and shake his or her head. The bottom line is that the Kulanaokuaiki-3 gabbros will be of great interest to earth scientists, and our collection of them will be much sought after.

It is interesting, then, to consider the strategic, practical aspects of our work, particularly how our research relates to volcano hazards and their effects on people. Looking backward in time, the Kulanaokuaiki-3 eruption, which took place sometime during 850–950, would have had devastating effects on the early Hawaiians living south and southeast of the summit when dense rocks suddenly began to fall out of the sky. Direct evidence for this human tragedy has been lost,

but Hawaiian legends and dance may contain relevant clues. Looking into the future, the hazards posed by violent eruptions threaten nearby communities as well as passing aircraft. Dense rock fragments and associated pieces of scoria, propelled to heights of 3–8 miles, would pose serious hazards to the high-flying jet aircraft that pass daily over the Big Island. Being able to anticipate such events would be of obvious benefit. I close this essay by emphasizing that materials collected and interpreted in the museum environment will likely play crucial roles in interpreting many aspects of life on this planet.

NOTES

1. The field team for the Kīlauea research project included R. Fiske, T. Rose, and D. Swanson. The laboratory team for the project included B. Andrews, R. Dennen, J. Herrick, S. Lynton, and A. Nichols.

2. David Paydarfar and William J. Schwartz, "An Algorithm for Discovery," *Science* 292, no. 5514 (2001): 13, doi:10.1126/science.292.5514.13.

BIBLIOGRAPHY

Paydarfar, David, and William J. Schwartz. "An Algorithm for Discovery." *Science* 292, no. 5514 (2001): 13. doi:10.1126/science.292.5514.13

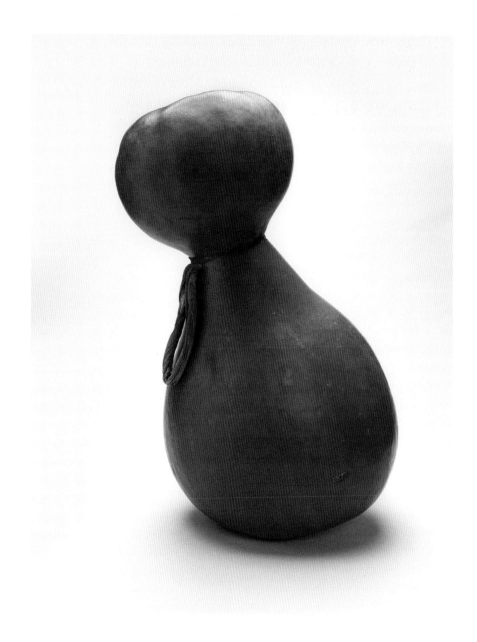

Figure 1.
Ipu heke (gourd idiophone)

Culture: Hawaiian
Date: Mid- to late nineteenth century
Materials: Gourd and European cloth
Measurements: 62 cm (24.5 in) height; 36 cm (14.7 in) diameter
Catalog number: E222177-0
Department of Anthropology, National Museum of Natural History
Acquired 1903 in an exchange from the Bishop Museum, Honolulu.

Objectifying Pele as Performance, Material Culture, and Cultural Landscape

Adrienne L. Kaeppler

The volcano goddess Pele is the landscape artist of the island of Hawai'i, with its five volcanoes, Mauna Loa, Mauna Kea, Hualālai, Kohala, and Kīlauea. Pele's artistry sculpted the island, and she remains the artist who updates her creation in volcanic performances. Human performances recount her creations with aesthetic movements of the body and musical instruments made of gourds as men and women perform near the edge of a steaming or erupting volcano or in her honor in venues from classrooms to festivals (Figure 1).

Just as Pele has become objectified in the landscape of Hawai'i Island, she has also become objectified in the Smithsonian Institution. Although hulas about Pele are intangible cultural heritage and treasures, the poetry has been recorded and written down and can be found on papers filed at the National Anthropological Archives, along with tapes and recorded discs in the sound

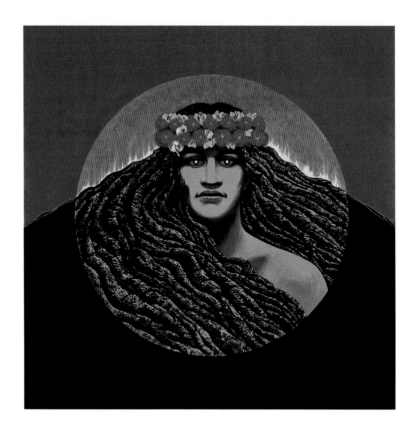

FIGURE 2.
Painting of Pele-honua-mea (Pele of the sacred land) by Herb Kane. Copyright Herbert K. Kane, LLC. Courtesy Deon Kane, Trustee for the Herbert K. Kane Family Trust.

archives. Moving images of hulas, dating as early as the 1930s to more contemporary times, are found in the Human Studies Film Archives.

Musical instruments, like the *ipu heke* idiophone, used to accompany the sung poetry and bodily movement, along with clothing and ornaments worn during performances, take honored places in the storage areas at the Smithsonian's Museum Support Center in Suitland, Maryland, and all of these material objects take part in special exhibitions at the National Museum of Natural History and during Folklife Festivals on the National Mall. I have been studying all of these materials for more than three decades at the Smithsonian and in Hawaii, especially during the Merrie Monarch Festivals when hulas for and about Pele live again each year. All of this material culture along with the intangible cultural heritage needs to be explored in order to understand volcanoes, the landscape, and Pele's importance to Hawaiian culture.

The home of Pele in Kīlauea volcano on the Big Island of Hawai'i has been actively erupting since 1983. The geological and other scientific aspects of this eruption have been studied by Richard Fiske, who authored the companion

article to this one, as well as by many other geologists and physical scientists. Their research has been incorporated in the Jaggar Museum on the edge of Kīlauea, along with cultural aspects of Pele, including a contemporary visual conceptualization of Pele as the living female goddess of the volcano (Figure 2).

Why *do* volcanoes erupt? Is it because of plate tectonics as geologists proclaim? Or is it because the goddess Pele is angry or jealous? Answers to this question are culturally constructed. A Western scientific construction about the movement of the Pacific tectonic plates and other geological considerations is considerably different from the cultural construction of Hawaiians, which is essentially an explanation for the destruction and regeneration of the Hawaiian islands by Pele and her sister Hiʻiaka. Indigenous knowledge about Pele's creation of the landscape and place-names embedded within it, as well as poetry for human performances about Pele, is presented in this essay.[1]

THE ORIGIN OF PELE

The goddess Pele traveled to Hawaiʻi from Kahiki (the homeland) from where she was expelled because of insubordination, disobedience, and disrespect to her mother (the sacred land). Arriving at the Hawaiian archipelago, looking for a home, she stopped first at Kaʻula, where she tunneled into the earth, but the ocean poured in. The same thing happened on Lehua, Niʻihau, Kauaʻi, Oʻahu, Molokaʻi, and Lānaʻi. Then she dug the immense pit of Haleakalā on Maui, but she still was unsuccessful until she finally made her home in Kīlauea, on the island of Hawaiʻi. Pele brought with her some of her sisters and brothers, who also took up residence in Kīlauea caldera. Because of her tempestuous nature and her extraordinary supernatural powers, Pele's siblings always did as she asked. Only her brother Kamapuaʻa, the pig god, provided an erotic masculine counterpoint to Pele's domineering ways. This history is enshrined in oral literature as an important epic based on adventures of Pele and her sister Hiʻiaka. Here, the natural, the supernatural, and the everyday events of nature are interwoven with Hawaiian knowledge and aesthetics.

In the epic, Pele, in her spirit form, met and loved a handsome chief named Lohiʻau on the island of Kauaʻi and wanted him to be brought to her. Pele sent her youngest sister Hiʻiaka to bring Lohiʻau from Kauaʻi to her home in Kīlauea. Before Hiʻiaka left, however, she made Pele promise that her own forests of lehua and the life of her best friend Hōpoe would be safeguarded during her absence. Hiʻiaka had a long series of adventures on her way to Kauaʻi, where she found

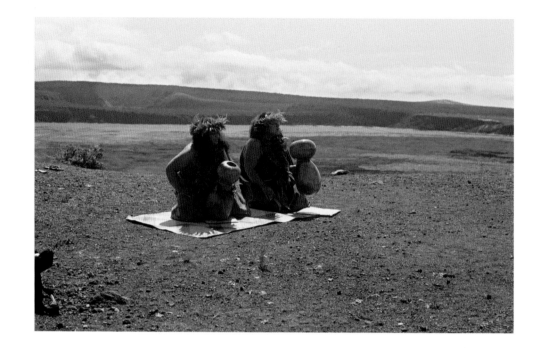

FIGURE 3.
Pua Kanahele and
Nalani Kanaka'ole
perform with *ipu
heke* at the edge
of Kīlauea crater.
Photo by Adrienne L.
Kaeppler, 1982.

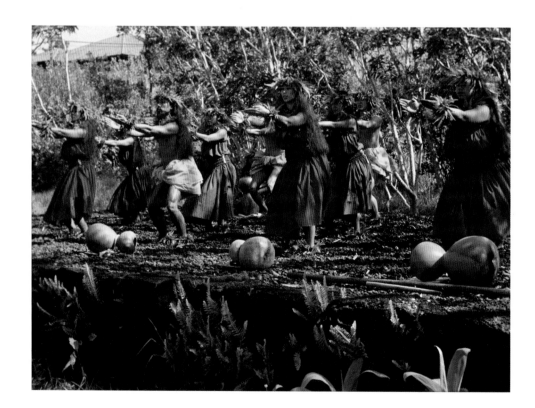

FIGURE 4.
Dancers from
Hālau o Kekuhi
with *ho'opa'a* at the
rear perform at the
hula mound facing
Kīlauea Crater.
Photo by Adrienne L.
Kaeppler, 1982.

Lohiʻau dead. After some days, Hiʻiaka managed to bring him back to life, and they began the long trek back to Hawaiʻi Island.

All of this took much longer than Pele had anticipated, and she became jealous and angry. Breaking her promise, Pele devastated the lehua forests of Hiʻiaka and sacrificed Hiʻiaka's friend Hōpoe. On seeing this on her arrival in Kīlauea, Hiʻiaka attempted to defy the power of Pele. She and Lohiʻau seated themselves on the brink of Kīlauea and showed their love for each other in full view of Pele. In a frenzy of passion, Pele overwhelmed Lohiʻau with fiery lava and burned him into a pillar of rock. At the same time she convulsed the earth and the sea. Only the great god Kāne could stop Pele's destruction.

This dramatic story is one of the main sources of Hawaiian poetry, music, and dance. One of the most famous hula schools from the island of Hawaiʻi, Hālau o Kekuhi, takes almost all of its source material from this epic. On special occasions they perform on the edge of Kīlauea or the nearby hula mound (Figures 3 and 4).

PERFORMING PELE

One of the great Polynesian performance traditions, Hawaiian hula is alive and well both in Hawaii and elsewhere. The origin of hula is associated with Hiʻiaka and her friend Hōpoe. At the bidding of Pele, Hiʻiaka was the first dancer, after having been taught by Hōpoe.[2] The movement sequences performed for or about Pele are based on poetry and are usually performed either in conjunction with hand clapping or with an *ipu heke,* an idiophone made of two gourds.[3] To make the *ipu heke,* a long lower gourd and a squat upper gourd are joined together with tree gum and a cloth wrist loop is attached. Sometimes a single large gourd is used. The left hand is inserted through the loop and the *ipu* is held with the left hand at the neck where the two gourds are joined. A bark cloth pillow called *pale* (to protect) is placed in front of the seated chanter/musician, who is known as *hoʻopaʻa.* Three sounds are characteristic: (1) striking the *ipu* with the palm of the right hand, (2) striking it with the thumb and rippling fingers of the right hand, and (3) holding it with both hands and striking it on the pillow placed on the ground. These sounds are combined into three named motifs, *kāhela, pā,* and *kūkū,* and are combined into phrases that fit the rhythm of the poetry. The dancer(s), today called *ʻōlapa,* performs at the front, side, or back of one or more *hoʻopaʻa.* Or one or a group of dancers using *ipu* performs standing or sitting, thereby creating their own chant and music.[4]

A well-known Hawaiian hula entitled "Aia la o Pele" has been in the repertory of most "traditional" dance schools for many years. Indeed, it is one of the first hula *kahiko* (traditional dances) learned by many students of hula. Its origin is from the area of the volcano on the Big Island of Hawai'i. However, as noted above, the epic from which it derives ranges widely over the Hawaiian Islands, moving from the island of Hawai'i to Kaua'i and back again.

The following is the danced poem as known by many Hawaiian dancers. This version is from Mary Kawena Pukui and Pat Bacon, who taught the dance to me in the 1970s:

Aia la o Pele

Aia la o Pele i Hawai'i 'ea	Pele is in Hawai'i [island]
Ke ha'a mai la i Maukele 'ea	She is dancing at Maukele
'Uhī, 'uhā, mai ana 'ea	She rumbles and mutters
Ke nome a e la iā Puna 'ea	As she devours the land of Puna
Ka mea nani ka i Paliuli 'ea	Her beauty rises to Paliuli
Ke pulelo a'e la i nā pali 'ea	Reflecting over the cliffs
Aia ka palena i Maui 'ea	It is seen on far away Maui
'Āina o Kaulula'au 'ea	Land of the chief Kaulula'au
Ihea kāua e la'i ai 'ea	Oh where can we find peace
I ka 'ale nui a'e li'a nei 'ea	On the great billows we love so well
Ha'ina ia mai ka pūana 'ea	This is the end of my chant
No Hi'iaka no he inoa 'ea	In honor of Hi'aka.
(call) He inoa no Hi'iaka-i-ka-poli-o-Pele	A name song for Hi'iaka-i-ka-poli-o-Pele

In each of the first four couplets a place-name is mentioned—Maukele, Puna, Paliuli, and Maui—and the fifth couplet embeds a hope that Pele will stop her rampage.

In a well-known 1960/1961 film called *Hula Ho'olaulea: Traditional Dances of Hawai'i*, "Aia la o Pele" is performed by the famous Hawaiian dancer 'Iolani Luahine and her *ho'opa'a* Tom Hiona. This film can be considered a baseline for performance in the style associated with Keahi Luahine (an aunt of 'Iolani Luahine) and the island

96

of Kaua'i. A more bombastic style is associated with Edith Kanaka'ole from Hilo, Hawai'i, and the hula school that descends from her, Hālau o Kekuhi. Another style is associated with the Zuttermeister Hālau. In each of these schools (and many others) Pele is objectified in a different way.

"Malulani"

Research has not yet revealed a specific lava flow that "Aia la o Pele" commemorates, but a hula collected in the island of Kaua'i by Helen Roberts in 1923–1924 is associated with a well-remembered lava flow in 1880–1881. The text was given to Roberts by Kamahaitu Helela from Hanapepe Valley, Kaua'i. The hula is usually known as "Malulani," the name of a boat that traveled interisland in the 1880s. This version is from the *mele* collection at Bishop Museum; the translation is by Mary Kawena Pukui.[5]

Malulani

Taulana e ka holo o ka Malulani	Famous is the sailing of the ship Malulani
Ti aniani i ka 'ili o e kai	Sailing proudly on the surface of the sea.
Eake a ike i ka mea hou	All were eager to hear the news
I kea hi kaulana a ka wahine	Of the Woman's famous fire.
A waho maua o kapohue	Outside of the shore of
	Kapohue [in Hana, Maui],
'Ike ia ka uahi poi ka lua	We saw the dark smoke over the Pit.
O ka wena o kea hi ka'u i 'ike	I saw the red glow of the fire,
Ua ho'i e ke ahi i ka mawae	As the lava retreated into a furrow.
Ho'ike a o Pele i kona nani	Pele was showing off her beauty
Ka wena 'ula i ka maka o ke ao	Till the face of the clouds was a ruddy glow.
He lohe 'olelo wale mai kou	I had merely heard a rumor
Aia ka Pele i kai a o Hilo	That Pele had gone down to Hilo,
Ke kahe ae la i Waiakea	And was flowing in Waiakea
Ke ku'ono kaulana a ka lahui	That famous nook of the land.
Ei a'e ka wahine ai pohaku	Here came the rock-devouring woman,
Ke noke mai nei la a ke one	Making havoc on the sands.
Ha'ina ia mai ana kapuana	This is the end of my song
Ao Hi'iaka-i-ka-poli-o-Pele	In honor of Hi'iaka-in-the-bosom-of-Pele.

In addition to mentioning Pele's fury and beauty, the poet records the actual movements of the 1880–1881 flow that threatened the town of Hilo and Waiakea. The flow was described by missionary Titus Coan, who noted that Hilo was in immediate danger and that on August 10 it was only a half mile from Hilo town and a mile from the sea. One arm of the flow headed directly for the Waiakea sugar mill, but after it climbed the protective wall, it stiffened as it poured over it and hung there like "a sheet of vitreous drapery, marking the limit of the flow in that direction."[6] A literary volcanologist, Clarence Dutton, described the flow the following year:

> Within a half mile of the termination the thickness of the lava sheet appears to be very small, not exceeding, I imagine, 20 feet, and generally less. The numberless mounds or bosses of pahoehoe were all formed in detail in the manner already described, by repeated outshoots of streamlets from underneath the hardened crust behind. As these belches of lava cool they exclude the occluded steam, and the mass swells up by the formation of myriads of vescicles, and often also by the formation of great hollow blisters underneath. The supply of fresh lava during the last part of the eruption seems to have been quite copious, for the advance of the stream was nearly 300 yards per day.[7]

The new landscapes crafted by Pele in 1880–1881 still form the artistic and cultural landscape just inland of Hilo. The flow entered parts of what is now Hilo, and one tongue of it stopped about a mile upslope from what is now Hilo International Airport.

Although these dances are still performed in various versions as passed through generations from composers and choreographers of the nineteenth and twentieth centuries, in recent years Pele has become the subject of many new "contemporary traditional" hula, performed at the Merrie Monarch Festival and other hula competitions, stage plays, and television presentations. In each of these compositions, old or new, the many locations and place names from Pele stories are expressed and perpetuated in danced poetry associated with Pele and her family as the prime visual and aural element of the cultural landscape of the island of Hawai'i.

HULA, A SYSTEM OF KNOWLEDGE

Traditional Hawaiian music and dance were, and are, multifaceted phenomena that include, in addition to what we see and hear, the "invisible" underlying systems of sound and movement, the processes that produce both the system and the product, and the sociopolitical contexts in which they are embedded. The basis of this integrated system of poetry, rhythm, melody, and bodily movement is poetry.

The performer is a storyteller (not an actor) who conveys the text orally and accompanies the text with movements of the hands and arms. The shoulders and upper body do not make significant movements. The dances are often performed seated, and when the performer is standing, the movements of the legs and hips are essentially timekeeping devices and seldom add to the storytelling function. This system of knowledge is the product of action and interaction as well as processes through which action and interaction take place. The knowledge is socially and culturally constructed, is created by, known, and essentially agreed upon by a group of people, and is primarily preserved in memory. Although transient, the hula music and movement systems have structured content, are sound and visual manifestations of social relations, are the subject of an elaborate aesthetic system, and can assist in understanding cultural values. The system cannot be observed; it is invisible and carried in people's heads. Its structure exists in memory and can be recalled as sound and movement motifs and imagery, used to create compositions that produce social and cultural meaning in performance.

AESTHETICS OF PELE PERFORMANCES

Aesthetics—a socially constructed way of thinking that focuses on evaluation—is part of a system of knowledge. Each society has standards for the production and performance of cultural forms, and these can be said to constitute an aesthetic for that society. Standards or canons of taste arise out of cultural values and often intensify the values that serve as guides in everyday life. After aesthetic principles and symbolism have been understood, we can decide if a specific item conforms to or fails to meet the standards recognized by that society.

Relationships among artifacts, landscapes, performances, and the social order are constantly modeling, modifying, and shaping each other over time. Arts and aesthetics do not just mirror or reflect social activities but help to construct fundamental cultural values. The Hawaiian concept *kaona* (indirectness) is most important for understanding Hawaiian ways of thinking. *Kaona* refers to the layered or hidden meaning used to evaluate cultural forms that requires skill based on cultural knowledge to carry out. Encoding hidden meanings, which may not be apprehended by simply examining the product of performance, and unraveling them layer by layer until they can be understood requires considerable creative skill and imagination.

A series of movement motifs is the basis of Hawaiian dance choreography and is familiar to the audience. Evaluation is made on the use of these motifs in

the design of the staging and choreography. Women are traditionally evaluated in terms of gracefulness, softness of hands and arms, and subtle hip movement. Men are judged on virility and how they transform movement motifs by using fisted hands and strong use of the lower body. The upper body is held straight and with little movement for women and men.

Hawaiian dances are often composed for a specific place or person, in this case Pele and/or her sister Hi'iaka. Texts suggest what may be distinctive about the place in its history, such as a visit by Hi'iaka on her way to Kaua'i, as well as how a visit of a god or chief fits into the overall history of Hawai'i. These distinctions lie in references to place-names and their origins, special sceneries and places for which the area is famous, and its important chiefs and their lineages. Eloquent poetic speeches are transformed into performance art. Poetry about Pele and Hi'iaka is preserved orally and in texts that were composed in Hawaiian during the nineteenth century. New compositions are based in these traditions and are revived and restaged as identity markers. The compositions about Pele and Hi'iaka reveal their visits to specific places, battles between gods, and features of the land. Duties to the chiefs, such as catching birds, and petroglyph designs might be referred to, and special fishing techniques might be mentioned. The textual references and their performance are a combination of metaphors and allusions realized through *kaona*.

Hula has become an important component of Hawaiian cultural and ethnic identity, primarily conveyed at festivals and competitions. A renaissance of Hawaiian dance began in the late 1960s, and hula has played an important role as *the* visual manifestation of Hawaiian identity. Performances have become part of Hawaiian politics—for example, protests against the nineteenth century takeover of Hawaii by the American military, reactions against statehood, and protests against the geothermal plant in Puna that generates a good deal of the electric power from the volcanoes for the island of Hawai'i. Many Hawaiians also object to the astronomical observatories on Mauna Loa and Haleakalā in Maui and feel that these modern devices are harming Pele and the environment.

The most spectacular venue for performing Hawaiian identity is during the Merrie Monarch Festival. Named after King Kalākaua, the Merrie Monarch Festival hula competition has taken place in Hilo, Hawaii, each year since 1971. The competition takes place the week after Easter and is judged by a panel of seven highly regarded members of the hula community. However, at the Merrie Monarch hula competition and throughout Hawaii, there is a collision of ideas over questions of tradition and innovation. Whereas some Hawaiian dancers and choreographers feel

that hula should not be radically changed and that "traditional" has the meaning of retaining various restrictions, other choreographers focus on innovation and feel that "traditional" can also be "contemporary." These innovative choreographies are often about Pele and volcanoes and can illustrate how aesthetic principles are being transformed. Dramatic stories may be announced beforehand, and performances become dramatizations more similar to Asian and Western theater, where dancers become actors rather than story tellers. The new format and drama engages audiences that need not have competence in or knowledge of traditional Hawaiian dance or understand the Hawaiian language. By dramatization and mentioning place-names, we are transported to various places on the island of Hawaiʻi, to other islands in the archipelago, and sometimes to the homeland of Kahiki.

To connoisseurs of Hawaiian dance, some of these performances have little or no association with tradition. Others feel that these innovative theatrical performances serve to bridge the traditional and the modern. For example, a Merrie Monarch presentation of Glenn Vasconcellos hula school, Hālau o Ke ʻAnuenue, dramatized an encounter between Pele and NāmakaoKahaʻi (a sister of Pele associated with the sea). The dancers wore costumes of red/orange and shades of blue to symbolize fire and water and necklaces that symbolized the supernatural form of the goddesses. The dance was built primarily from well-known Hawaiian movement motifs but added movements for pulling the hair of opposing dancers, open fingers, the incorporation of the torso, and others. In this presentation, performers began in prescribed group style, lines and columns facing the audience. They then divided into two groups, with fire and water performing different sets of movements. The dramatic battle portrayed the contemporary event of lava flowing into the sea.

At another Merrie Monarch festival performance, dancers from the hula school of Johnny Lum Ho, wearing red dresses with a black strip at the hem, became a dramatic representation of Pele herself. Movements portrayed the fierceness of Pele, using facial grimaces and shaking of shoulders. At the end of the performance Pele appeared, and the dancers placed themselves on the steps leading to the stage and turned up their skirts to reveal underskirts of yellow and orange and became flowing lava.

In both of these female performances, old aesthetic principles were violated. Women performed with the virility of men, the torso became part of the movement system, facial grimaces and fists became prominent, and the feeling of the performance was entirely different.

FIGURE 5

In spite of the stop sign, lava advances at Kalapana on July 2, 1983. Photo by J. D. Griggs, U.S. Geological Survey.

The traditionalists were not happy, especially as the dances were performed in the *kahiko* (traditional) competition.[8] To them these dances were not *kahiko*. But the audience, accepting the new aesthetic, loved it. Most relevant here, however, is that both performances—embodying this contemporary aesthetic—honor Pele as she continues her artistry in changing the landscape during her present 30-year flow from Kīlauea to the sea.

Even more dramatic are the theatrical performances of Hālau o Kekuhi, which has staged the epic of Pele and Hiʻiaka for three-hour performances called "Holo Mai Pele." This was filmed for a one-hour program in the PBS *Great Performances* series and was shown on U.S. national television at the end of 2002. In this performance, Pele was placed within a dramatic overall storyline, making it possible for an audience to appreciate the spectacle without understanding the spoken or movement languages.

The epic of Pele perpetuates the origin and continuity of the physical and cultural landscapes of the island of Hawaiʻi, as well as the intangible heritage of sung poetry and material culture of musical instruments and costume. The continued popularity of Pele stories bodes well for the perpetuation of local place-names, which are an important part of the sung poetry. Each year at Kīlauea volcano, performances and sacrifices are given to Pele. Sacrifices may consist of a whole pig or, more common, a bottle of gin, the preferred gift of dancer ʻIolani Luahine and others who continue to dance in honor of Pele. But, as mere mortals, we cannot stop Pele dancing the landscape—she holds the upper hand (Figure 5).

ACKNOWLEDGMENTS

The first version of this paper was presented in conjunction with Richard Fiske at a Senate of Scientists dinner focusing on volcanoes at the National Museum of Natural History on October 18, 2006. I thank Richard Fiske, Noenoelani Zuttermeister, Patricia Couvillon, and Randi Schneider for comments on this written version. I owe special thanks to Kauʻi Zuttermeister, Noenoelani Zuttermeister Lewis, Patience Namaka Bacon, Mary Kawena Pukui, and Pat Couvillon.

NOTES

1. My hula music and dance teachers include Kauʻi Zuttermeister and her daughter Noenoelani Zuttermeister Lewis, Mary Kawena Pukui, and Patience Namaka Wiggen Bacon. See Adrienne L. Kaeppler, *Hula Pahu: Hawaiian Drum Dances*, vol. 1, *Haʻa and Hula Pahu: Sacred Movements* (Honolulu: Bishop Museum, 1993), for their biographies.

2. In contrast to the origin of ritual performances known as *haʻa*, which are associated with Laʻamaikahiki; see Kaeppler, *Hula Pahu: Hawaiian Drum Dances*.

3. This *ipu heke* was exchanged from the Bishop Museum in Honolulu in 1903.

4. *Ipu heke* are not used only for dances in honor of Pele. Another important hula relevant here is "Kawika" ("David"), in honor of King David Kalākaua, for whom the Merrie Monarch Festival is named, and is a hula taught in many Hawaiian hula studios.

5. "Malulani," manuscript, Bishop Museum Archives, MS SC Roberts, Book 6, Box 2.9, p. 15–16.

6. Titus Coan, *Life in Hawaii* (1882; Edward J. Coan, 1997), chap. 23, accessed June 10, 2015, http://www.soest.hawaii.edu/GG/HCV/COAN/coan-intro.html.

7. Clarence Edward Dutton, *Hawaiian Volcanoes* (1883; Honolulu: University of Hawaiʻi Press, 2005), 154.

8. The *kahiko* (traditional) competition is held separately from the *ʻauana* (modern) competition. The modern competition is held the evening after the traditional one.

BIBLIOGRAPHY

Coan, Titus. *Life in Hawaii*. Digital reprint of the 1882 New York print edition: Edward J. Coan, 1997. Accessed June 10, 2105. http://www.soest.hawaii.edu/GG/HCV/COAN/coan-intro.html.

Dutton, Clarence Edward. *Hawaiian Volcanoes*. Annual Report of the U.S. Geological Survey. Washington, D.C.: U.S. Geological Survey, 1883. Reprinted with foreword and appendixes by William R. Halliday. Honolulu: University of Hawaiʻi Press, 2005.

Hoʻoulumāhiehie. *The Epic Tale of Hiʻiakaikapoliopele.* Trans. M. Puakea Nogelmeier. Honolulu: Awaiaula Press, 2006.

Kaeppler, Adrienne L. *Hula Pahu: Hawaiian Drum Dances*. Vol. 1, *Haʻa and Hula Pahu: Sacred Movements*. Honolulu: Bishop Museum, 1993.

———. "Recycling Tradition: A Hawaiian Case Study." *Dance Chronicle* 27, no. 3 (2004): 293–311.

"Malulani." Manuscript. MS SC Roberts, Book 6, Box 2.9, pp. 15–17. Bishop Museum Archives, Honolulu, HI.

Pukui, Mary Kawena, and Samuel H. Elbert. *Hawaiian Dictionary*. Honolulu: University of Hawaii Press, 1965.

Stradivarius Stringed Instruments

Plate 4
Violin (the Ole Bull)

Maker: Antonio Stradivari (1644–1737), Cremona, Italy
Date: 1687
Materials: One-piece table of spruce; one-piece back of maple; ribs of maple; modern maple neck terminating in the original maple pegbox and scroll. Designs incised into ribs are inlaid with resinous black (unrefined) shellac.
Measurements:

	Table	Back
Body length	35.3 cm (13.9 in)	35.65 cm (14.1 in)
Width		
Upper bout	16.85 cm (6.6 in)	17.0 cm (6.7 in)
Center bout	11.4 cm (4.5 in)	11.4 cm (4.5 in)
Lower bout	20.65 cm (8.1 in)	21.0 cm (8.2 in)
Rib height	Treble	Bass
Top block	2.95 cm (1.2 in)	2.9 cm (1.1 in)
Upper corner	3.05 cm (1.2 in)	3.0 cm (1.2 in)
Lower corner	3.05 cm (1.2 in)	3.06 cm (1.2 in)
Bottom block	3.08 cm (1.2 in)	3.08 cm (1.2 in)
F-hole length	7.64 cm (3 in)	
Table measure	19.4 cm (7.5 in)	
Vibrating string length	32.7 cm (12.9 in)	

Catalog number: 2000.0013.02
Division of Culture and the Arts, National Museum of American History
Donated in 2000 by Herbert and Evelyn Axelrod.

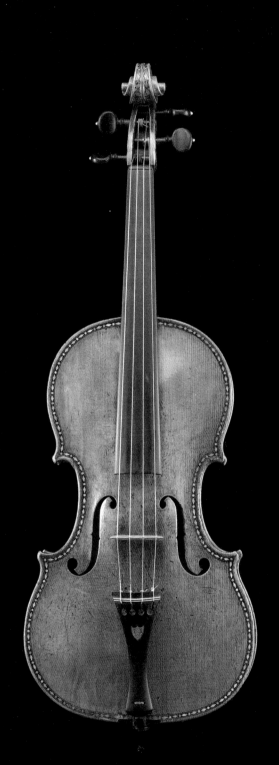

How to Identify a Stradivarius Stringed Instrument

Gary Sturm and Bruno Frohlich

So you think you found a Stradivarius violin. By the seventeenth century Italians had established the size and shape of a violin, and the traditions of making them have remained essentially unchanged into the present. All violins look the same. How then do you know it's a Strad? Like paintings, the authenticity of a Stradivarius violin is based on stylistic treatment of details, the materials employed, the known provenance of the instrument and technical methodology, and an often thin trail of archival documents. Antonio Stradivari's Latinized printed labels that read "Antonius Stradivarius, Cremonensis, faciebat anno" have been duplicated in hundreds of thousands of violins and are not reliable proof of his instruments' origins.[1] Moreover, his refined model of a violin has been adapted by generations of makers as the blueprint for an ideal instrument, resulting in thousands of seemingly identical copies.[2] To know a Strad, you need the eye and knowledge of a connoisseur.[3]

The Smithsonian Institution is the home of two violins, a viola, and two cellos, all members of the larger violin family, that were made in Cremona, Italy, by Antonio Stradivari (Plate 4). There is no machine, a mythical "Stradometer," that with the wave of a wand can certify these instruments. Instead, we get to know them through a rich collaboration of social and cultural studies mixed with technical analysis.[4]

During his life, which spanned 93 years, Stradivari is thought to have made as many as 1,100 musical instruments, primarily violins.[5] Many were lost over time to the ravages of war and natural disasters, but several hundred have survived.[6] Only a few can be traced in direct ownership back to his workshop, and no shop inventory, serial numbers, or sales receipts account for Stradivari's output. However, fragments of shop tools, drawings, and correspondence, as well as parish church archives, provide insight into his productivity and clientele.[7] Comparative study of the instruments then becomes a critical primary resource. Since a large body of extant violins exists, instrument makers, historians, and connoisseur have been able to scrutinize these instruments and corroboratively create the basis to identify the hand of Stradivari.[8]

Written certification of a Stradivari instrument became commercially important in the nineteenth century, nearly 100 years after his death in 1737. The fanaticism of violin aficionados and dealers coupled with endorsement by leading musicians fueled the public fascination in "old" Italian violins, wrapped in mysterious qualities unmatched by contemporary fiddles.[9] It became critical to demonstrate authenticity in the marketplace as highly desired Italian violins, in limited supply, grew in value. Firms like W. E. Hill and Sons in England and J. B. Vuillaume in France promoted and attracted a lively commerce in the violin trade.[10] At a time when there was little interest in old violins in southern Europe, Paris and London became the major cities for this new collectors' enterprise.[11]

In addition to the insatiable desire by dealers to acquire and trace the history of these instruments, two personalities are especially notable in rescuing lost Italian traditions. Two centuries of Cremonese dominance in violin making faded soon after the death of Antonio Stradivari, and its practices were largely left abandoned around the middle of the eighteenth century. About that time, Count Ignazio Alessandro Cozio di Salabue became infatuated with the violin, and his family wealth provided him with the means to pursue his intense curiosity. In 1775–1776, at the age of 21, he acquired 10 Stradivari violins, together with

the remaining tools and designs of the workshop, from Antonio's son, Paolo. From then until his death in 1840, whenever possible, Cozio avidly traced and purchased fine Cremonese violins. Moreover, he scrupulously noted and documented the details of their construction and their history.[12]

The second enthusiast and a fellow Italian, Luigi Tarisio (ca. 1790–1854), acquired Count Cozio's collection in 1827. Unlike the count, Tarisio was born into humble surroundings and was an unlikely candidate to carry the torch of Italian violinmaking history. However, he surpassed Cozio in his dedication to the subject, and he clearly loved violins with every ounce of his existence. He nurtured his connoisseurship and honed his business skills as he scoured villages to acquire fine Cremonese instruments from homes throughout Italy. He then ventured to Paris to resell some of his treasures to dealers while hoarding his most prized possessions.[13] Unlike Cozio, Tarisio did not document his sources and was secretive in discussing his acquisitions. This cloak of mystery over these acquisitions only piqued his clients' interests and perhaps enhanced the value of these instruments. His most famous ploy was to claim to have a pristine Stradivari violin from the Cozio collection, made in 1716, which he never brought with him for sale. Always promised, but never appearing, the violin was coined the Messiah. After Tarisio's death, J. B. Vuillaume negotiated the purchase of the remaining violins owned by Luigi and stored in Italy. In a single moment, Vuillaume acquired not only the Messiah but also 30 Stradivaris and another 120 fine Italian masterpieces.[14]

Nineteenth-century transactions like these are the origins for documentation, scholarship, and study of violins that have continued up into the present. A framework was created that launched a more systematic approach over generations to track, identify, and study original Stradivari violins. As an instrument passed from one owner to the next, its history was recorded. The Smithsonian's Stradivari cello of 1701, once the property of the Belgian cellist Adrian Francois Servais, arrived as a gift from Miss Charlotte Bergen in 1981 (Figure 1). A brief history of the cello was given to the Smithsonian in a letter from W. E. Hill and Sons, the highly respected British firm of violin dealers and experts. The letter illustrates how the provenance of the Strad was established.[15]

> We first learned of the Stradivari cello dated 1701 when it was acquired by J. B. Vuillaume in the 1840s from a family by the name of Raoul. Vuillaume offered the cello to Servais, then living in Petrograd, who persuaded Princess Youssapoff to purchase it for him. Servais died in 1866 and the instrument passed to his son Joseph, and on his death in 1885 it was sold to a Belgian by the name of Auguste

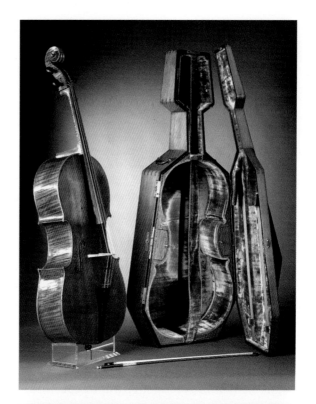

FIGURE 1.
The Servais (1701) violoncello by Antonio Stradivari, Cremona. Division of Culture and the Arts, National Museum of American History, Smithsonian Institution Collections.

FIGURE 2.
Decorated violins, Antonio Stradivari, Cremona (left to right): the Hellier (1679), the Ole Bull (1687), and the Greffuhle (1709). Division of Culture and the Arts, National Museum of American History, Smithsonian Institution Collections.

Couteaux (?). The family experienced some domestic problems and we purchased the cello, and in 1895 sold the cello to Prince Pierre de Chimay, who was a personal friend of Vuillaume, and whose violin is the frontispiece in our book on Vuillaume. The Prince died in 1913. After the War we learned that the cello had been sold through Caressa, a well-known Parisian dealer, to Ferdinand Pollain, a gifted cellist. We were approached by him in 1928, and we subsequently sold the cello through Rembert Wurlitzer & Company to Miss Bergen in July, 1929.

Certified provenance, then, is one type of assurance that an instrument is a Strad. It has a historical pedigree that conveys that it is indeed from the hand of Antonio Stradivari. It is nearly impossible that an authentic Stradivari instrument would be uncovered today as a new find, without documents of a known history. Nonetheless, people still believe they have found a forgotten Strad in their family attic or in the dusty bin of a local sale. Musicians and collectors have played a role in the reputation of Stradivari instruments and, by association, complement their attribution. As prominent players, patrons, investors, and fanciers might gain fame for possession of a particular Strad, it, in turn, would earn a moniker referencing the owner. For example, the violin (the Betts) once owned by the English dealer John Betts has been identified from one generation to the next as one of Stradivari's finest. The nineteenth-century Belgian cellist Adrian Francois Servais gained an enormous reputation for concertizing on his Stradivari cello (the Servais). Over the years these named instruments then gained a public reputation. If the instrument itself acquires fame for its qualities of sound, the reputation only grows exponentially. Servais was once complimented by the Czar of Russia for his astounding performance. He replied that it was not him but the Stradivarius cello that created such a great sound, and so that cello became legendary for its musical qualities. Celebrity endorsement by great musicians over generations thus reinforces an instrument's reputation as a Stradivarius. It is often this endorsement that bolsters the value of a violin at auction but may also lead to the false assumption that the authenticity of a violin can be determined by its sound.[16]

Comparative technical and stylistic analysis is the most convincing proof that a violin is indeed a Strad. Several of the Smithsonian Stradivaris are counted as special treasures since they are among the few ornamented instruments produced between 1677 and 1709. The decorations around the sides of the Ole Bull and the Greffuhle violins are looping grapevine designs inlaid into maple. Alternating circular and diamond-shaped bone or ivory is embedded in black material around the perimeter of the top and back (Figure 2).

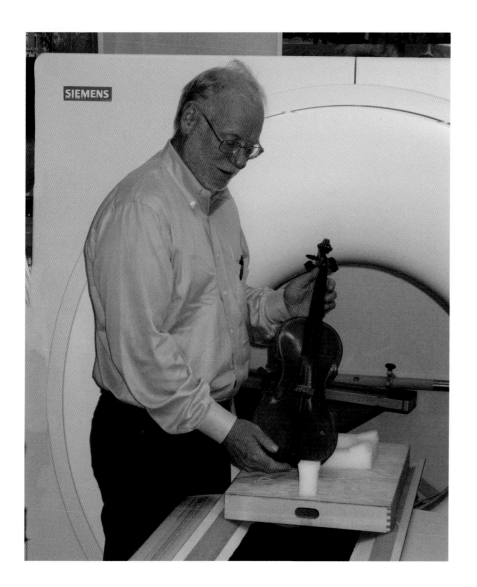

FIGURE 3.

The computed tomography laboratory, Department of Anthropology, National Museum of Natural History, Smithsonian Institution, Washington, D.C. Siemens Somatom scanner operated by Bruno Frohlich and Gary Sturm. Photo by Bruno Frohlich.

A direct link to Stradivari is made by connecting these designs to cartoons that survive from his workshop. More importantly, these instruments illustrate how the physical, material description of a known body of Stradivaris leads to verification and dating of others. As they can be directly linked to surviving materials from Stradivari's workshop, the technical study of these instruments is paramount in assessing conformation of other violins to trends, geometries, and working methods to establish criteria for characteristic traits of Stradivari's workmanship.[17]

In the nineteenth century, the comparative study of Stradivari violins began with relatively simple observation and an accumulation of detailed measurements. Repair experience at the workbench provided critical insight into materials and into the working methods of Stradivari as his instruments were dismantled and reassembled. Documentation of interior construction and finishing was under the purview of violin makers and dealers, who, with these data, were among the first to gain expertise. As photographic techniques unfolded, imagery was added to the arsenal of tools used to confirm a violin's identity and became a primary resource for connoisseurship in the field. Furthermore, as radiographs, microscopes, and endoscopes became accessible and affordable, conservators, curators, and historians could apply technology to observe hidden construction, repairs, and damage and perhaps to detect fraudulent work with a noninvasive device. Together, all of these tools have provided the sum total of technical data applied in knowing a Stradivari violin.

Today there is yet another apparatus that yields new ways to measure and document a known violin: the use of three-dimensional X-rays, especially computed tomography (CT scan; Figure 3). Since 2000, the Smithsonian's National Museum of American History, the National Museum of Natural History, and the Library of Congress have been collaborating on studying their combined large collections of stringed instruments, especially the violin family. To date, we have scanned more than 50 instruments, and those data are now being processed, evaluated, and analyzed. We are focusing on engineering and construction principles, especially variation between instrument makers. This study includes identifying variation within the professional career of a single instrument maker, comparing instrument makers of the same generation, and looking at variation across time among instrument makers.[18] Our initial project, which focused on a few Cremonese instruments, was programmed to take only a few weeks or month. We are now in the tenth year of the project, and we are still gathering

data. We have had the pleasure of working with musicians, music instrument makers, artists, curators, and many private owners of instruments ranging from German and Czechoslovakian instruments imported to the United States in the second half of the nineteenth and first half of the twentieth centuries to very fine copies of Stradivari and Guarneri instruments.[19] Needless to say, in light of the fact that our study has so greatly expanded, we envision that it will continue for a few more years before we reach our goal of identifying the range of variations and we call our study complete.[20]

NOTES

1. Ernest N. Doring, *How Many Strads? Our Heritage from the Master; a Tribute to the Memory of a Great Genius, Compiled in the Year Marking the Tercentenary of His Birth, Being a Tabulation of Works Believed to Survive Produced in Cremona by Antonio Stradivari between 1666 and 1737, Including Relevant Data and Mention of His Two Sons, Francesco and Omobono* (Chicago: W. Lewis & Son, 1945).

2. Bruno Frohlich, Gary Sturm, Janine Hinton, and Else Frohlich, *The Secrets of the Stradivari String Instruments: A Non-destructive Study of Music Instruments from the Smithsonian Institution, the Library of Congress, and Private Collections; a Pilot Study of Seven Violins Made by Antonio Stradivari in Cremona, Italy, between 1677 and 1709*, Mimics Innovation Awards (Leuven, Belgium: The Materialise Group, 2011).

3. Doring, *How Many Strads?*

4. See Frohlich and Sturm, "Violins from the Smithsonian Institution, the Library of Congress, and Private Collections: A Pilot Comparative Study," this volume.

5. Doring, *How Many Strads?*

6. W. Henry Hill, Arthur F. Hill, and Alfred E. Hill. *Antonio Stradivari: His Life and Work (1644–1737)* (1902; repr. New York: Dover Publications, 1963).

7. Doring, *How Many Strads?*

8. Frohlich et al., *The Secrets of the Stradivari String Instruments*.

9. Stanley Sadie, ed., *The New Grove Dictionary of Music and Musicians*, 2nd ed., vol. 26, *Violin, History and Repertory*, (Oxford: Oxford University Press, 2001), 713.

10. W. E. Hill and Sons, *A Short Account of a Violin by Stradivari, Dated 1690* (London, 1889); Roger B. Millant, *J. B. Vuillaume; sa vie et son oeuvre (Vuillaume, Jean Baptisite, 1798–1875)* (London: W. E. Hill & Sons, 1972).

11. Sadie, *New Grove Dictionary of Music and Musicians*.

12. Hill et al., *Antonio Stradivari: His Life and Work (1644–1737)*.

13. Millant, *J. B. Vuillaume; sa vie et son oeuvre*.

14. Sadie, *New Grove Dictionary of Music and Musicians*.

15. W. E. Hill and Sons, *A Short Account of a Violin by Stradivari, Dated 1690*.

16. See Frohlich and Sturm, "Violins from the Smithsonian Institution," this volume.

17. Frohlich et al., *The Secrets of the Stradivari String Instruments*.

18. Frohlich et al., *The Secrets of the Stradivari String Instruments*.

19. Tom Wilder, ed., *The Conservation, Restoration, and Repair of Stringed Instruments and Their Bows* (Montreal: IPCI-Canada, 2010).

20. Frohlich et al., *The Secrets of the Stradivari String Instruments*.

BIBLIOGRAPHY

Doring, Ernest N. *How Many Strads? Our Heritage from the Master; a Tribute to the Memory of a Great Genius, Compiled in the Year Marking the Tercentenary of His Birth, Being a Tabulation of Works Believed to Survive Produced in Cremona by Antonio Stradivari between 1666 and 1737, Including Relevant Data and Mention of His Two Sons, Francesco and Omobono.* Chicago: W. Lewis & Son, 1945.

Frohlich, Bruno, Gary Sturm, Janine Hinton, and Else Frohlich. *The Secrets of the Stradivari String Instruments: A Non-destructive Study of Music Instruments from the Smithsonian Institution, the Library of Congress, and Private Collections; a Pilot Study of Seven Violins Made by Antonio Stradivari in Cremona, Italy, between 1677 and 1709.* Mimics Innovation Awards. Leuven, Belgium: The Materialise Group, 2011.

Hill, W. Henry, Arthur F. Hill, and Alfred E. Hill. *Antonio Stradivari: His Life and Work (1644–1737).* 1902. Reprinted with a new introduction by Sydney Beck and new supplementary indexes by Rembert Wurlitzer. New York: Dover Publications, 1963.

Millant, Roger. *J. B. Vuillaume; sa vie et son oeuvre (Vuillaume, Jean Baptisite, 1798–1875).* London: W. E. Hill & Sons, 1972.

Sadie, Stanley, ed. *The New Grove Dictionary of Music and Musicians.* 2nd ed. Volumes 1–29. Oxford: Oxford University Press, 2001.

W. E. Hill and Sons. *A Short Account of a Violin by Stradivari, Dated 1690.* London, 1889.

Wilder, Tom, ed. *The Conservation, Restoration, and Repair of Stringed Instruments and Their Bows.* Montreal: IPCI-Canada, 2010.

Violins from the Smithsonian Institution, the Library of Congress, and Private Collections: A Pilot Comparative Study

Bruno Frohlich and Gary Sturm

All instrument makers would love to make a "real" copy of a Stradivarius violin and recreate the wonderful Stradivarius sound, which time and again has been recognized as superior to all others. So why can't they? Because they all believe the reason they do not and cannot succeed in any of this is some secret understanding that only Stradivari knew and that he took with him to the grave. That would be the end of story if it were true or even partially true, but luckily, it is not, as our scientific inquiry illustrates.

In 2001, at the request of the Division of Culture and the Arts at the National Museum of American History, Smithsonian Institution, we initiated a pilot study of string instruments using nondestructive and noninvasive methods. Our Siemens Somatom CT scanner, located in the Department of Anthropology, National Museum of Natural History, was our most important tool. It gave us the opportunity to scan a large collection of instruments, both those made by Stradivari and those made by others, in the Smithsonian, the Library of Congress, and private collections (Figure 1).

BACKGROUND AND OBJECTIVES

This pilot study focused on stringed instruments within the violin family, which includes the violin, viola, and cello. The physical size variation is evident, but differences among these instruments can also be refined by defining how the various instruments are tuned. For example, the viola is tuned one musical fifth lower than the violin, and the cello is tuned one octave lower than the viola. All of them, however, apply four strings. Other kinds of variation include substantial size and shape differences, especially in the violas and cellos. Size variations in the violin, however, have been minimal over time.[1] In fact, the metric dimensions of the violin's body have been consistent over the last 350 years.[2] Changes have focused on elements such as bridges, necks, tailpieces, scrolls, strings, and bows. These changes and variations are a reflection of the shifting requirements in music over time.[3]

A significant analytical objective of our study was to identify and examine various engineering and manufacturing principles found in the string instruments produced by Antonio Stradivari (1644–1737) in the Smithsonian Institution's National Museum of American History, at the Library of Congress, and in several private collections. Over his lifetime Stradivari may have produced more than 1,100 instruments, of which around 650 have survived, and some of which are still being played and treasured by some of the world's leading string players.[4] Stradivari produced all his instruments within the Baroque period (1600 to 1760). Unlike the viola and cello, the body of the violin did not change radically over time, and this constancy made it the ideal instrument for our study. The basic metric dimensions of the violin body remain the same, although we did find changes and variations in the curvature and thickness of the top and back. Minor changes over time occurred in the size and shape of the neck, the type of strings (from gut strings to metal strings or combinations of the two), and there were changes in the bow

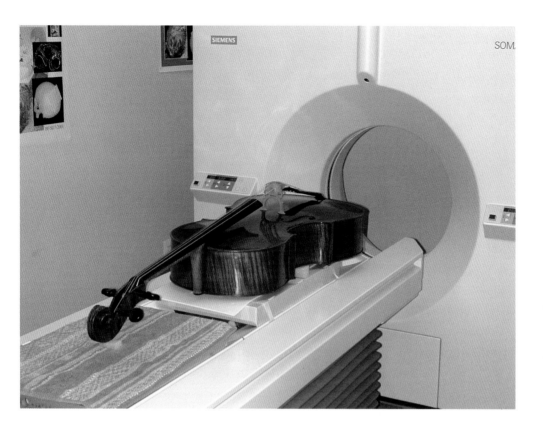

FIGURE 1.
Cello (the Servais) by Antonio Stradivari (1701) in the Siemens Somatom medical scanner located in the Department of Anthropology, National Museum of Natural History, Smithsonian Institution. Photo by Bruno Frohlich.

(added curvature of the bow stick and more horse hair possible with the effect of producing a fuller and louder sound). In some cases, we also noticed that throughout the years the wood of the various elements of the body had been thinned, and the size and shape of the bass bar in a number of instruments had been altered.

It is noteworthy that some of the instruments that are identified as having been made by Antonio Stradivari have been altered by others over time, as they now have less or possibly very little similarity to the instruments manufactured, tuned, and originally presented by Antonio Stradivari about 300 years ago. The original Stradivarius instrument would not only have different dimensions and components, but it may also have produced a significantly different sound.[5]

The secret of the sound of the Stradivarius violin is said to include the choice of specific wood densities, soaking the wood in some magic chemical solution, and special and secret varnish formulas, among other things.[6]

Many publications describing the genius of Stradivari claim that he managed "to take his secrets with him into the grave." One author simply decries the lack of knowledge by modern instrument makers and predicts that what today's instrument making needs is a "new Antonio Stradivari."[7] We strongly disagree with such statements, which are, in general, based on mere opinions and unproven assumptions and not on systematic observation, research, and/or study of his instruments.

AN ANALYSIS OF NINE VIOLINS MADE BY STRADIVARI

For this study our sample included the majority of the best and most recognizable violin makers from 1640 to modern times. As a baseline comparison, we also scanned a series of typical factory-produced and low-cost imitations mostly dating from around 1850 to the early twentieth century. These latter instruments are owned by families in Vermont and were, for the most part, brought to the United States by immigrants during the nineteenth century.

We hypothesize that the majority of all well-made instruments can produce a high tone quality. However, it takes a good musician to produce the tone, and if the musician feels good playing the instrument, then he or she is more likely to produce a high tone quality. If this premise is accepted, then the instrument maker would have certain conditions that he or she would need to satisfy, which include (1) the instrument being capable of producing a superior sound and (2) the instrument pleasing the musician. Good tone quality can be represented by different tones, and tones are defined and evaluated differently by individual musicians. Thus, two excellent instruments played by the same musician would not sound the same, and two musicians would not produce the same tone playing the same instrument, although both easily could be understood as having very high tone quality.

In fact, evaluating tone and tone quality is extremely difficult. The study of the perception of sound or the field of psychoacoustics (a subfield of psychophysics) separates sound into two related concepts: frequency and pitch. Frequency is the objective, physical property of a tone, which could be expressed as a value in hertz or cycles per second.[8] Pitch, on the other hand, is the perceived basic frequency of a given sound. Thus pitch is not an objective physical entity but rather represents a subjective attitude.[9] Pitch is the outcome of how frequency or frequencies are being processed by the brain, which brings us into the field of psychophysics, defined as the relationship between physical stimuli (sound,

for example) and their subjective correlates (how sound is "translated" and perceived by the brain).[10] Therefore, evaluating sound as a purely quantitative entity is very difficult, and for that reason, we focus on mechanical engineering, construction principles, variation between instrument makers over time, and variation within the production of a single instrument maker.[11]

RESEARCH PROTOCOLS

In designing our research protocols certain conditions were nonnegotiable. Our examination could not in any way be invasive or destructive. We could not use any kind of equipment that would harm the instruments or change their present configuration. We decided to copy the instruments into digital two- and three-dimensional models that would allow us unlimited access to study internal as well as external features. This digitization was accomplished by the use of computed tomography (CT scanning). It also required an analytical-based software package that would allow us to study the digital copy in detail and ensure that the obtained results would be a true representation of the original data (Figure 2). After using and evaluating several software packages, we found that Mimics and 3-matic, produced by the Materialise company in Belgium, fulfilled all our requirements.

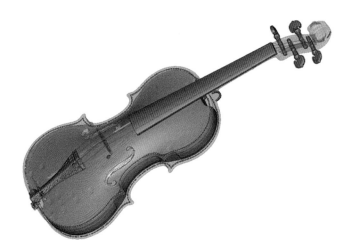

FIGURE 2.
Three-dimensional model of a Stradivari violin (the Betts, 1704). Created by the author using Mimics/3-matic software from Materialise, NV.

FIGURE 3.
The Hellier by Antonio Stradivari (1679). Color graph depicting wood thickness variation in the back plate. Red: thick; green: thin. Created by the author using Mimics/3-matic software from Materialise, NV.

FIGURE 4.
The Ole Bull by Antonio Stradivari (1687). Color graph depicting wood thickness variation in the back plate. Red: thick; green: thin. Created by the author using Mimics/3-matic software from Materialise, NV.

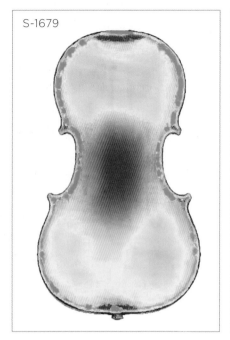

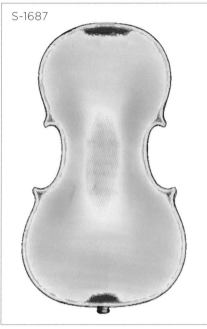

FIGURE 3

FIGURE 4

FIGURE 5.
The Hellier by Antonio Stradivari (1679). Color graph depicting wood thickness variation in the top plate. Red: thick; green: thin. Note the bass bar (red) and repair patches (red). Created by the author using Mimics/3-matic software from Materialise, NV.

FIGURE 6.
The Sunrise by Antonio Stradivari (1677). Color graph depicting wood thickness variation in the top plate. Red: thick; green: thin. Note the location of the bass bar (yellow) and the sound post (red). Created by the author using Mimics/3-matic software from Materialise, NV.

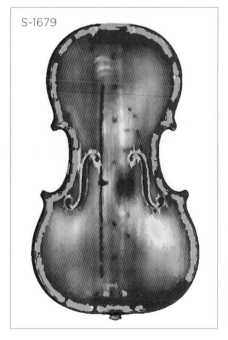

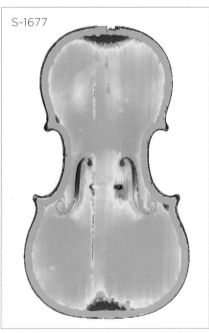

FIGURE 5

FIGURE 6

OBJECTIVES AND PRELIMINARY RESULTS OF THE PILOT STUDY

On the basis of our preliminary results and reviewing several criteria contemplated by musicians and instrument makers when deciding what comprises a superior instrument, we found the weight of the instrument to be very important. A lighter instrument is more pleasing than a heavier instrument. Given that criterion, we initially decided to focus on how changes in engineering principles could be related or correlated to the weight of the violin.

In our pilot study we selected seven violins manufactured by Antonio Stradivari from 1677 to 1709. During the early period of Stradivari's production (1677 to 1684), he was influenced by his mentor Nicolo Amati (1596–1684) and did not fully develop his own style until after Amati's death.[12] Historical studies of surviving instruments show similarities in size and shape between the Amati instruments and the earlier Stradivari instruments. We recognize Stradivari subsequently changed the violin's shape from higher and fuller curves (arching) to a more "flat" design, which was a turning point in his production and which would influence other instrument makers over time.

In our original research design we identified three major factors to be studied: wood density, wood curvature, and wood thickness. We were interested in seeing how these factors correlated, especially in the top and back of the violins. In our pilot study we focused on wood thickness. Our primary methodology was to display the data on wood thickness in a graphic manner, which would give us a clear overview of the variability among the instruments. By using the powerful statistical and analytical tools in the Materialise software, we were able to graphically display variability in all three factors (thickness, curvature, and density). Furthermore, these factors can be correlated, thus producing new color displays depicting various degrees of correlations.

Our study, to date, has yielded information on variations in wood thickness. For example, distinctive wood thickness variations between instruments have been found to be considerable in the top of the violin, which is normally made from spruce, and to a lesser degree in the back, which normally is made from a wood of higher density, such as maple (Figures 3–6). In fact, no two Stradivari instruments that we scanned had a similar thickness pattern. This is especially true in the top (made from spruce). We hypothesized that wood thickness and wood density would correlate, thus enabling weight reduction by thinning the wood where the density was higher. However, wood thickness has also

A Pilot Comparative Study of Violins

been associated with tone quality, thus the decision on how much to thin the top and back (to keep the weight down) becomes an assessment based on multiple factors. Therefore, a master instrument maker would modify the thickness of the top differently in order to produce the best possible sound amplification and to keep the weight as low as possible (see Figures 5 and 6).

How did Stradivari and other instrument makers of the Cremonese school identify the density of wood? The obvious solution is to study the distances between growth rings and correlate this with wood strength. Thus, small distances may suggest more dense wood presenting higher strength values, whereas larger distances between growth rings may suggest lower strength. Using CT scanning, we recorded the density of the wood in Hounsfield units (HU). As part of this ongoing study, we will correlate HU values with the growth ring interspacing and ultimately the wood strength. We solved the problem of graphically displaying wood thickness variation by using different colors (see Figures 5 and 6). We hypothesize that the thickness of the top of the violin is, to a certain extent, related to the wood density. Where the density is higher, the instrument maker could decrease the thickness without compromising the strength. Where the wood density is lower, he would choose not to extensively modify or thin the wood.

The third factor is the curvature of the top and the back, and this factor may also correlate with wood density and thickness. Thus, adding curvature may result in lower strength and would require a thicker construction. If this hypothesis is correct, then one way of lowering the weight of the instrument would be to decrease the amount of curvature in its top and back. A trend over time among instrument makers has been to move from higher curvature to lower curvature. This change began primarily during the time of the Cremonese school, thus in Stradivari's lifetime. For example, one instrument by Nicolo Amati displays around 5 mm wood thickness in the back at the centerline just below the midpoint between the f-holes. However, in other and later instruments the range is between 2 and 4 mm, and in a few instruments it is closer to 1 mm. The difference between the Amati instrument and later instruments, including Stradivari's later productions, is that the Amati violin depicts a distinct arching of the top and back rather than the flat design we find in later instruments. Basically, by decreasing the arching, later instrument makers were able to maintain the needed strength even when using thinner wood. For example, understanding the basic geometric principle that the shortest distance between two points is a straight line would allow the instrument maker to minimize the volume (and weight) of wood to be used.

RESULTS

We have shown through this pilot study that it is possible to define and measure various components of the violins, including thickness, density, and curvature, by using nondestructive methods such as CT scanning. The models we produced using CT data are an accurate reflection of the original instrument (see Figure 2). However, the correlations between the components are not as simple as originally anticipated. This outcome is most likely a result of the variability we found between instruments, which relates to thickness, density, and curvature of the wood. However, a fourth and subjective factor pertains to the selected woods' distinctive physical characteristics as they relate to the amplification of tone. Thus, the thinning of the wood is also a function of the specific wood's tone characteristics. All these factors help one understand that two instruments will never be completely alike and that this variance is a product of the natural variability found in wood, making no two pieces of wood the same. Thus, it could be argued that the degree of variability found in the wood becomes the instrument's unique "fingerprint."

On the basis of these findings we conclude that recent attempts to find a common formula for making an exact copy of a Stradivari instrument based on X-rays or CT scanning data are predestined to fail because there is no single formula covering multiple instruments. The variability in these violins is related to the variability of the wood itself, with no two pieces of wood being alike, so no two instruments will ever physically be the same or sound the same.

Our research provides new insights into violin making over time and space that can be put to good use by modern instrument makers, art historians, scientists, and especially musicians. Given the fact that each instrument's unique features can partially be identified through CT scanning, we are now able to create a distinctive fingerprint for each instrument. Among other criteria, this distinction may assist in the identification of instruments and thus prevent theft and fraud.

The findings in this study are based on a small sample and are clearly preliminary. Our goal is to expand our research and refine our analysis by using CT data we have acquired from more than 55 violins, violas, and cellos, produced by more than 24 instrument makers from more than 10 different countries and representing a time span of almost 350 years. Our future work will continue to focus on the similarities and variations in violins that were made by different instrument makers who worked in different regions and during different time periods.

ACKNOWLEDGMENTS

We thank and express our appreciation to Blaise Falkowski (Siemens Healthcare), Janine Hinton (National Museum of Natural History, Smithsonian Institution), Kenneth Slowik (National Museum of American History, Smithsonian Institution), and Carol Ward-Bamford (Library of Congress). We also thank the Materialise Company for help and support.

NOTES

1. Tom Wilder, ed., *The Conservation, Restoration, and Repair of Stringed Instruments and Their Bows* (Montreal: IPCI-Canada, 2010).

2. Bruno Frohlich, Gary Sturm, Janine Hinton, and Else Frohlich, *The Secrets of the Stradivari String Instruments: A Non-destructive Study of Music Instruments from the Smithsonian Institution, the Library of Congress, and Private Collections; a Pilot Study of Seven Violins Made by Antonio Stradivari in Cremona, Italy, between 1677 and 1709*, Mimics Innovation Awards, (Leuven, Belgium: The Materialise Group, 2011).

3. Toby Faber, *Five Violins, One Cello, and Three Centuries of Enduring Perfection: Stradivari's Genius* (New York: Random House, 2004).

4. W. Henry Hill, Arthur F. Hill, and Alfred E. Hill, *Antonio Stradivari: His Life and Work (1644–1737)* (1902; Digital repr., Marshall C. St. John, 2001), accessed June 10, 2015, http://www.cello.org/heaven/hill/.

5. Robert Barclay, *The Preservation and Use of Musical Instruments* (London: Earthscan, 2004).

6. Wilder, *Conservation, Restoration, and Repair of Stringed Instruments*.

7. Faber, *Five Violins, One Cello*.

8. Charles Taylor, *Exploring Music: The Science and Technology of Tones and Tunes* (Bristol, UK: Institute of Physics Publishing, 1994).

9. George A. Gescheider, *Psycophysics: The Fundamentals*, 3rd ed. (Mahwah, NJ: Lawrence Ehrlbaum Associates, 1997).

10. Gustav T. Fechner, *Elemente der Psychophysic* (Leipzig: Breitkoph und Haertel, 1860).

11. Gareth Loy, *Musimathics, the Mathematical Foundations of Music*, vol. 1 (Cambridge, MA: MIT Press, 2011).

12. David Schonbaum, *The Violin: A Social History of the World's Most Versatile Instrument* (New York: W. W. Norton, 2013).

BIBLIOGRAPHY

Barclay, Robert. *The Preservation and Use of Musical Instruments*. London: Earthscan, 2004.

Faber, Toby. *Five Violins, One Cello, and Three Centuries of Enduring Perfection: Stradivari's Genius*. New York: Random House, 2004.

Fechner, Gustav T. *Elemente der Psychophysic*. Leipzig: Breitkoph und Haertel, 1860.

Frohlich, Bruno, Gary Sturm, Janine Hinton, and Else Frohlich. *The Secrets of the Stradivari String Instruments: A Non-destructive Study of Music Instruments from the Smithsonian Institution, the Library of Congress, and Private Collections; a Pilot Study of Seven Violins Made by Antonio Stradivari in Cremona, Italy, between 1677 and 1709*. Mimics Innovation Awards. Leuven, Belgium: The Materialise Group, 2011.

Gescheider, George A. *Psycophysics: The Fundamentals*. 3rd ed. Mahwah, NJ:

Lawrence Ehrlbaum Associates, 1997.

Hill, W. Henry, Arthur F. Hill, and Alfred E. Hill. *Antonio Stradivari: His Life and Work (1644–1737)*. Digital reprint of the 1902 print edition: Marshall C. St. John, 2001. Accessed June 10, 2015. http://www.cello.org/heaven/hill/.

Loy, Gareth. *Musimathics, the Mathematical Foundations of Music*. Vol. 1. Cambridge, MA: MIT Press, 2011.

Schonbaum, David. *The Violin: A Social History of the World's Most Versatile Instrument*. New York: W. W. Norton, 2013.

Taylor, Charles. *Exploring Music: The Science and Technology of Tones and Tunes*. Bristol, UK: Institute of Physics Publishing, 1994.

Wilder, Tom, ed. *The Conservation, Restoration, and Repair of Stringed Instruments and Their Bows*. Montreal: IPCI-Canada, 2010.

Huey 65-10126 Helicopter

Plate 5
Bell UH-1H Iroquois "Huey" helicopter (serial number 65-10126)

Manufacturer: Bell Helicopter Corporation, Fort Worth, Texas
Date: 1966
Materials: Metal airframe, plexiglass windows
Measurements:
 Rotor diameter: 14.7 m (48.2 ft)
 Length: 12.6 m (41.3 ft)
 Height: 4.2 m (13.8 ft)
Catalog number: A19960005000
National Air and Space Museum
Transferred in 1995 from the U.S. Army Aviation Museum.
Photo by Dane Penland, Smithsonian National Air and Space Museum
(NASM 2004-17767).

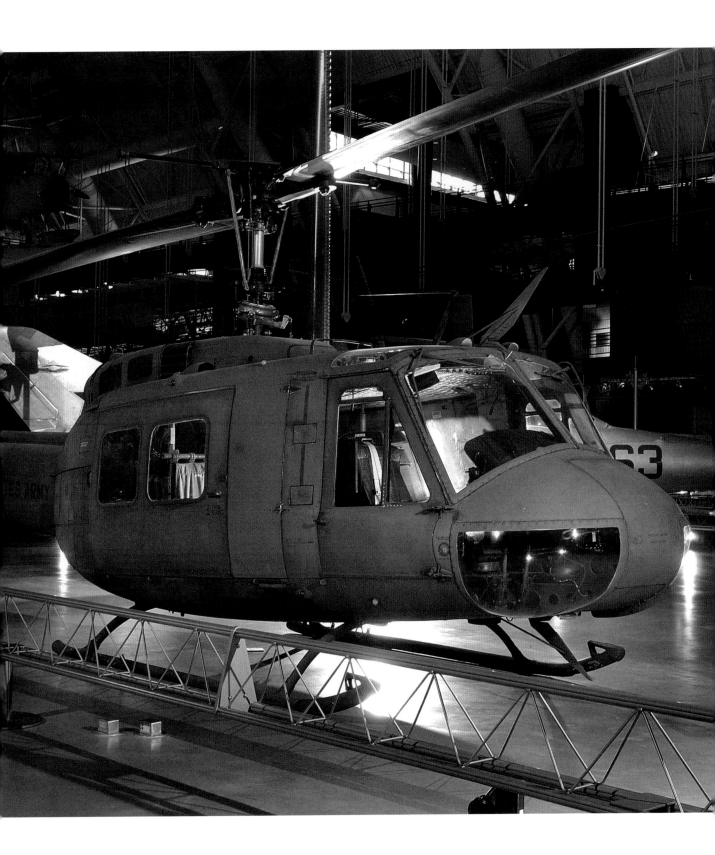

Huey Helicopter:
Steed for the "Sky Cavalry"

Roger Connor

The Huey helicopter has persisted as one of the most indelible symbols of the Vietnam War in American culture. Like the Jeep of World War II, its sheer ubiquity and versatility meant that it played critical roles in the everyday lives of those who were drawn into the Southeast Asian conflict. For soldiers in the field, the Huey represented salvation when wounded or cut off by hostile forces. For troops under fire it was a fearsome weapons platform that brought the air war down to nearly treetop level. For field commanders, the Huey was the only reliable means of monitoring engagements in difficult terrain. In the minds of policy makers, it represented the best chance of avoiding the missteps made by France a decade earlier in the same terrain in which overland troop movements were easily ambushed. If the Viet Cong and their North Vietnamese allies were tenacious foes superbly adept at jungle warfare, the Huey could return initiative to American and allied forces. Most importantly for its enduring status as a cultural artifact, the Huey was a dynamic prop for news broadcasts and print reporters' narratives, appearing more frequently than any other piece of military hardware

as it could equally represent ongoing operations (troop lift), the trauma of war (medevac), and stark military aggression (gunship). Hueys operated virtually everywhere in South Vietnam, and even if they could not be seen, their distinctive "whomp-whomp" could be heard from afar in all corners of the combat theater.

This helicopter, known to its manufacturer—Bell Helicopter—as the Model 204 and later to the U.S. military services as the UH-1 but universally known by its nickname, Huey, served in all of the branches of the American military deployed to Southeast Asia as well as in the armies of South Vietnam and Australia.[1] However, the Huey's wartime service was not limited to purely military operations. One of the most enduring images of the Huey is that of a CIA-operated Air America example during the evacuation of Saigon perched atop a narrow rooftop landing pad about to be overwhelmed by South Vietnamese personnel desperate for escape.

The Huey is a common artifact, with hundreds displayed in museums or mounted on poles at VFW halls and military posts. Aesthetically, the Huey is distinctive and is small (by aircraft standards), making it readily adaptable to exhibition spaces, further increasing its attractiveness as an artifact. Given that the U.S. procured more Hueys than any other combat aircraft besides the B-24 bomber of the World War II era, there is little incentive for a curator to select another helicopter type for a Vietnam War exhibition. However, despite its ubiquity and iconic status, the Huey usually sits on display with minimal interpretation.

By virtue of being a slow-flying transport aircraft that routinely bridged the boundaries of the sanctified aerial combat arena and the wretched world of the lowly "grunt," the low-flying Huey often disappears into the background noise of aviation museums with higher and faster progressivist narratives of technology. The Huey also invokes a largely opaque technology, as those with an interest in aviation often express befuddlement at the apparent complexity of rotary-wing aircraft relative to their fixed-wing brethren, a situation that is further exacerbated in museums without experience in nuanced narratives of aeronautical technology. Helicopters are, indeed, more mechanically complex than airplanes. Although the principles of airfoils and lift apply equally to fixed- and rotary-wing aircraft, concepts such as cyclic and collective pitch control, dissymmetry of lift, and retreating blade stall discourage all but the most ardent historians to engage with the Huey as a technological artifact.

The Smithsonian Institution has two Hueys on display, one at the National Air and Space Museum's Steven F. Udvar-Hazy Center (Chantilly, Virginia) and the other at the National Museum of American History (NMAH) on the National Mall (Figure 1). Both aircraft have extensive, if not exceptional, records

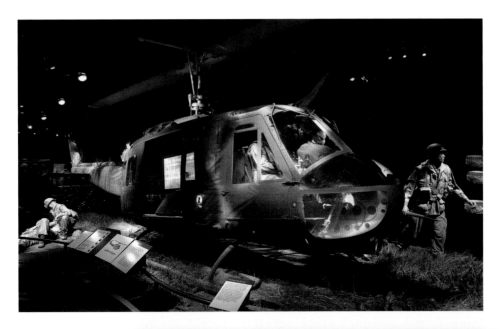

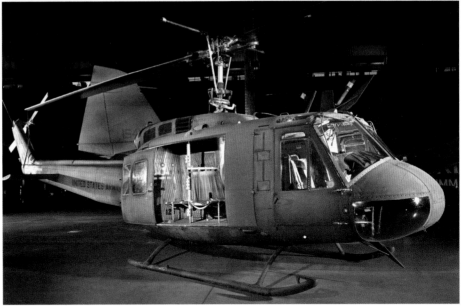

FIGURE 1.

The two Huey helicopter displays at the Smithsonian Institution utilize significantly divergent interpretive approaches. **Top:** The *Price of Freedom* exhibition at the National Museum of American History features the air craft as a sacred relic of Vietnam experience. Armed Forces History Division, National Museum of American History, Smithsonian Institution. **Bottom:** The display at the Steven F. Udvar-Hazy Center places the Huey in a grouping of military aeronautical technology of the period but does nothing more. Photo by Dane Penland, Smithsonian National Air and Space Museum (NASM 2013-01560).

of Vietnam service, but Smithsonian curators have placed them in widely divergent modes of presentation. The example at NMAH is in a large contextualized exhibition—*Price of Freedom: Americans at War*—where it sits in an evocative environment of a battlefield evacuation. As the largest artifact in the gallery, it is the cornerstone of the "Reconciliation and Remembrance" subsection of the Vietnam War unit, but dominates the section as a whole, thus serving as the exhibit's principle artifact of Vietnam military experience. A television monitor in the helicopter's cabin plays a series of interviews with veterans while a text label of around 300 words ("Workhorse of the War") supports the statement, "During the war in Vietnam, helicopters flew patrols, attacked enemy positions, delivered supplies, carried troops into combat and retrieved the wounded and the dead."

In contrast, we have placed the Huey at the Udvar-Hazy Center without an evocative diorama-style environment in an "enclosure" of Vietnam era and "modern" military aircraft. As with the other aircraft at the Udvar-Hazy Center, including the B-29 *Enola Gay* that carried the first atomic bomb used in warfare to Hiroshima, we have interpreted the Huey with only a 150-word label focused principally on the combat service of the specific example that notes, "In 1956, the Iroquois, commonly known as the Huey, first flew as an Army replacement for the H-13 medevac helicopter of Korean War fame. … Superbly suited to air mobility and medical evacuation missions in Vietnam, the Huey became an indelible symbol of the conflict."[2] Further interpretations include a label for a free-standing display of a Huey engine and an "exhibit station" devoted to the Korea and Vietnam conflicts that states, "The helicopter came into its own during these conflicts. It excelled at evacuating wounded ground troops, and in Vietnam the Bell UH-1 Huey provided battlefield mobility in a new type of maneuver warfare. The Huey became the modern-day cavalry for the ground forces."

Given that the Udvar-Hazy Center represents the interpretive limitations of an open-storage approach to the material culture of the technological state and *Price of Freedom* showcases a specific avenue of curatorial representation that precludes a broad spectrum of interpretations, is there something missing in these displays? Like many highly successful military technologies, the Huey represented a confluence of fundamental improvements in performance and capability combined with a pressing operational requirement brought about by national policy and evolving military doctrines. But it would be the geography of Southeast Asia that would really allow the Huey to validate the faith of its advocates. In the minds of operators and policy makers, it was not simply an

evolutionary improvement, but rather something fundamentally new on the battlefield. Understanding why the Huey altered the American way of war requires an examination of technology and doctrine in the decade before Vietnam.

Although many aviation historians have come to regard the 1920s and 1930s as aviation's "golden age," for helicopter development, the early phases of the Cold War marked a period of unparalleled innovation resulting in dramatic increases in performance and capability, combined with a rapidly growing demand in the military services for vertical lift technology. By the time of America's entry into Vietnam, the helicopter, after only two decades of development, had evolved from a purely experimental form, with only vague prospects for military prominence, to a key element of American military power. Many helicopter models entering service at the start of the Vietnam War are still flying in one form or another, but no other airframe better represents the maturation of the helicopter during the 1950s than the Huey. Its latest incarnation entered Marine Corps service in 2008 with its service life projected well into the mid-twenty-first century, although the Army continued to operate some of its Vietnam era Hueys until 2009.[3]

The helicopter in practical form has always been first and foremost a military technology, largely because of its limited civil niche market and its high degree of mechanical complexity. Between 1944 and 1950, production helicopters evolved from limited machines capable of lifting only a pilot and passenger to models that had the internal capacity for 10 soldiers. World War II and the Korean War served as the tinder to ignite the helicopter industry into a sustainable entity. Like Vietnam, Korea had little internal infrastructure combined with terrain features that greatly inhibited overland movements and made offensive operations highly problematic. This environment pushed adoption of the helicopter on a broad scale, and the medical evacuation and the legacy of 40,000 wounded personnel transported by helicopter in the Korean War silenced its skeptics.[4]

Most Army helicopters fielded in Korea were small two- or three-seat models on which the wounded had to ride outside on exposed stretchers or, in the best case, coffin-like containers. What the Army desperately wanted was a helicopter with surplus lifting power, ample internal capacity for wounded, and a rugged design that could comfortably operate in unprepared environments, and by 1952, it was stating a requirement for a multirole helicopter capable of medical evacuation, instrument training, and general utility missions. In January 1954, the Air Force, acting on behalf of the Army, announced a design competition for a utility helicopter suitable for medical evacuation. The missions that were to be the Vietnam

era hallmarks of the Huey—troop lift and aerial fire support—were not initial requirements. Bell Aircraft won the competition on the basis of its Model 204 design. It was built around a technology that gave the aircraft its form and defined its function—the turboshaft engine. Bell's design was to become the first American helicopter produced with this technology. From that point on, all frontline combat helicopters would be built with this type of power plant (Figure 2).

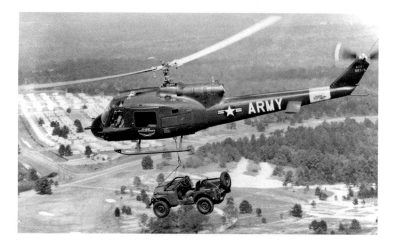

FIGURE 2.
The marriage of the gas turbine to the simple Bell rotor system provided the Army with a highly successful aerial jeep in what was the first purpose-built aircraft for Army ground forces. Photo: U.S. Army.

The Lycoming T53 that powered the H-40 (as the Army first called the 204) allowed it to have performance and payload similar to those of its piston engine–powered predecessors that were larger, less maintainable, and more expensive to operate. Because the roof-mounted T53 was much smaller than reciprocating engines of the same power, the H-40's fuselage was almost entirely available for its passengers and crew, unlike the hulking Sikorsky H-34 that it would replace.[5]

Like any aircraft, the H-40 (the Huey nickname did not enter the public lexicon until 1963) represented compromises between size, performance, and cost. These compromises (especially moderate size and simple components) proved ideal in the Southeast Asian environment, even if unintentionally so. It was rugged, versatile, easy to maintain and operate, relatively inexpensive, and simple to manufacture, and it possessed excellent performance for its size, even in the hot and humid conditions of Southeast Asia. For political leaders, the Huey's attributes had a darker implication: the ability to endure significantly higher losses. Because the Huey was both easier to produce and easier to fly than either the preceding or succeeding models of transport helicopters, much higher materiel and personnel losses could be sustained in support of military objectives. In the Korean War, the Army had less than 100 helicopter pilots in theater for the majority of

the conflict, and only a handful were killed. In Vietnam, the number of Huey pilots and crewmembers killed in action exceeded 2,000, and the number of Hueys destroyed surpassed 3,300 (meaning that most crewmembers survived the destruction of the robust airframe). By comparison, for the recent wars in Afghanistan and Iraq, the total number of principal combat helicopters in the entire Army inventory was less than the number of Hueys lost in Southeast Asia. In 2007, Secretary of Defense Robert Gates expressed significant concern that helicopter resources were stretched with a loss rate only 10 percent of what the Huey suffered in Vietnam.[6] Previous transport helicopter designs would not have allowed such a high throughput in training or been as survivable in combat.

Beyond incorporating groundbreaking technologies, the H-40 represented a highly significant milestone for the Army. It was the first aircraft designed from the ground up for Army Aviation since the founding of the Air Corps as a semiautonomous branch of the Army in 1926. From the 1930s, the Army ground forces had been embroiled with its aerial counterparts (the Air Corps and, subsequently, the Air Force) over control of small support airplanes and helicopters that the ground forces saw as integral to their operations. The Korean War ultimately resulted in a minor victory for the Army in that it could have free reign to employ helicopters as it saw fit, provided it did not stray far into the realm of fixed-wing aviation. For the Army, the advent of the Huey thus represented a new doctrinal independence as much as it did technical achievement.

The Army began thinking about helicopters as the basis for a new form of tactical doctrine —"air mobility"—quite late, particularly in regard to their brethren in the Marine Corps, who had been developing their own "vertical envelopment" concepts starting in the late 1940s. The critical moment in Army policy came in 1954, just as Bell was beginning to draw up plans for the 204. General Mathew Ridgeway, Army chief of staff, ordered development of a comprehensive aviation plan centered on the helicopter in response to the announcement by Secretary of State John Foster Dulles of his doctrine of "massive [nuclear] retaliation" as part of his "New Look" strategy, which minimized roles for conventional ground forces.[7] The ensuing internal debates included discussions over the role of close support (attack) aviation, which the Air Force seemed to have forsaken in its quest to lead the charge toward nuclear bombardment as America's core military capability. An Air Force ban on Army employment of armed airplanes did much to ensure that the Army would have to rely more on armed helicopters in Vietnam (and subsequent conflicts) than it might otherwise have.

The debates within Army leadership took public form in some unusual venues. In an article for the April 1954 issue of *Harper's Magazine* entitled "Cavalry, And I Don't Mean Horses," the assistant chief of staff of the Army, Major General James Gavin, made a very public statement in which he stated that "the most casual awareness of the historical lesson should suggest that in ground combat the mobility differential we lack will be found in the air vehicle."[8] Gavin's notions of making the Army once again relevant with "sky cavalry" on the nuclear battlefield as defined by Dulles and the Air Force quickly gained traction and were put in effect by Major General Hamilton Howze, who would define air mobility as a new mode of warfare. The concurrent experience of the French in the Algerian War (1954–1962) with helicopters deployed extensively in the counterinsurgency role reinforced the new doctrine, and thus the American experience of Vietnam was defined by the doctrine of Cold War nuclear combat and the colonial experience in northwest Africa. Like other displays of the Huey, *Price of Freedom* does not draw a link between Cold War policy, colonial brushfire wars, and the dominance of the helicopter in Vietnam. Rather, the exhibit draws on the emotional touchstone of experience.

Soldiers in Vietnam loved and loathed the Huey. The Huey brought them to the very gates of hell, but it also delivered food, potable water, and ammunition and provided deliverance in the form of protective fire support and rapid medical evacuation (Figure 3). Although helicopters had evacuated 40,000 wounded in Korea, Army "Dust Off" crews (dedicated medical evacuation units that flew the Huey exclusively) evacuated over 900,000 wounded in 496,573 missions flown between 1962 and 1973.[9] Add the number of wounded retrieved by the thousands of Hueys not assigned to Dust Off and one can see that helicopters, and the Huey in particular, participated in the saving of literally millions of lives in Southeast Asia. The exact number will never be known, and although in the cold calculus of war the number of those killed by Hueys can never be known either, the balance appears overwhelmingly on the side of the preservation of life rather than its taking—a remarkable statement for a weapons platform (Figure 4).

When middle-aged or older museum visitors "read" the Huey as an artifact, they tap into powerful preconceptions regarding the Vietnam War formed either by living through the period or by coming of age in its shadow. However, with younger visitors having no recollection of the conflict, museums will have to come to terms with a majority of visitors whose perception of the Vietnam War is now shaped solely by popular culture. Although a plethora of films and other media brought the war home to the generation who came of age in the Reagan

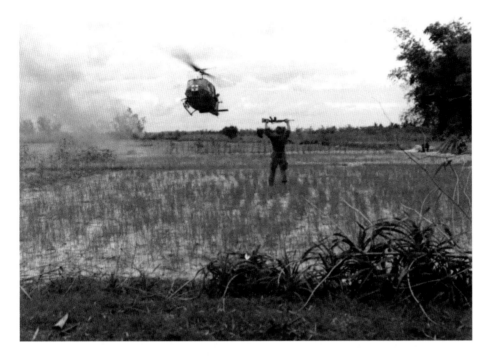

FIGURE 3.
The Huey in a traditional depiction: a medevac to remove the severely wounded from the battlefield (Quang Ngai Province, September 1967). Helicopters reduced the previous American military fatality rates by half over previous conflicts. Photo: U.S. Army.

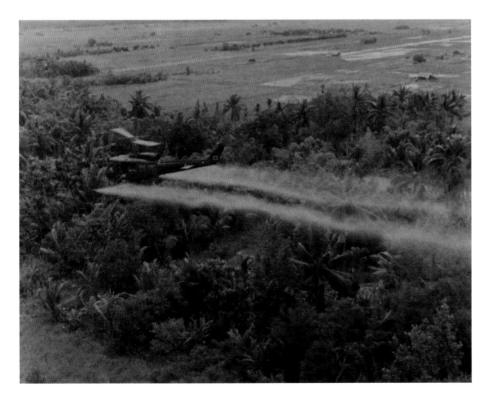

FIGURE 4.
The nature of the Huey as both a taker and saver of lives is convoluted by its role in one of the most enduring legacies of the war: environmental devastation and its coincident human costs. Here, a UH-1D of the 336th Aviation Company sprays the infamous and highly toxic Agent Orange defoliant in the Mekong Delta. Photo: U.S. Army.

era, since then Vietnam has largely faded from the cultural consciousness to be replaced by new conflicts. What does the Huey mean to those visitors? It is simply another piece of hardware, somewhat antiquated when viewed in comparison to the UH-60 Black Hawk, its successor in both Army service and in the consciousness of the so-called millennial generation.

The easy solution for curators seeking to give meaning to their artifact is to drop the Huey into some faux jungle foliage and evoke a war fading from the public consciousness. Given the strength and quantity of dramatic veterans' narratives available to buttress such a display, the appeal is obvious. However, these interpretations invariably overlook the significance of the Huey as a milestone of Cold War defense policy that has since fundamentally altered the way America goes to war. The Huey was more than an aerial version of the World War II jeep. It represented a fundamentally new approach to combat. Vietnam policy could well have been enacted with other helicopter types, yet the Huey possessed a combination of capabilities that enabled American policy to unfold in a scale, scope, and efficiency that would not have been possible with existing alternatives. Indeed, with an adjusted dollar acquisition cost only two percent that of the Black Hawk as well as greatly simplified construction and ease of production relative to its successor, the scale and scope of warfare undertaken in Vietnam would simply not be possible today—that many helicopters could not be built by the industry as it exists today, nor could the nation afford it (Figure 5).

The number of Black Hawks in service today with the Army is only 25 percent of the number of Hueys employed by the Army in Southeast Asia.[10] Although it is true that the Air Force could never again field the numbers of bombers it had fielded in World War II, it is also true that the performance of current generation bombers is such that the operational effectiveness is vastly greater today than before. With helicopters, this is not the case, and the United States could not presently engage in the same form of warfare that it employed in Vietnam, draft or no draft. Thus, the Huey represents a fundamental departure, not only from what came before it but also from what came after.

However, we must also be careful. Assessments of this nature without context are an argument for technological exceptionalism centered on one manufacturer's product, and museum interpretations must avoid the trap of overstating the significance of specific pieces of military hardware. The Huey was indeed a key element in American Southeast Asian strategy, but this raises the counterfactual question of what would have happened if a different type was predominant. Would it have altered American policy? The Marine Corps utilized the Huey in much smaller

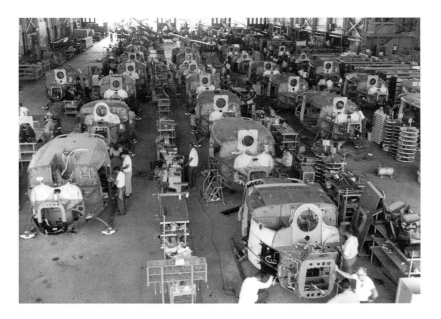

FIGURE 5.

Unlike the increasingly complex airplanes operating over the skies of Southeast Asia, the Huey helicopter harkened back to the production paradigm of World War II: relatively low-cost and simple aircraft that were rugged and easily replaced. The Vietnam War was the last time the U.S. employed this procurement strategy. Photo: U.S. Army.

numbers than the Army and employed them principally for fire support rather than the transport of aerial assault forces. Instead, the Marines employed Sikorsky UH-34 and Boeing-Vertol CH-46 assault helicopters in a manner that could hardly be characterized as ineffective. However, Marine helicopter operations generally formed a much smaller piece of the force structure than those of the Army, and the cost and complexity of these types would have prevented their employment on the scale of the Army Hueys. There were also other models for penetrating into the interior of South Vietnam. For instance, in the Mekong Delta, riverine forces utilized specialized patrol boats for movement and access. However, underlying the use of helicopters in general practice is the doubt as to whether the air mobility strategy was as wildly successful as portrayed by many historians.

The idea that Vietnam was lost politically but not militarily has largely excused the Army emphasis on the helicopter-centered air mobility concept for the failure of American intervention in Southeast Asia. However, this perception has undergone revision, such as in Andrew Krepinevich's study *The Army and Vietnam*, which emphasizes the weaknesses of the helicopter-borne airmobile strategy, best illustrated in the statement by an airmobile commander: "we should have done less flittin' and more sittin'". He concludes that "the Army's willingness to accept the airmobility provided by helicopters for counterinsurgency operations in lieu of what is now termed 'boots on the ground' is another example of the Army's failure to adapt its forces and doctrine to the requirements of a new conflict environment."[11] He argues that myriad helicopters milling about the countryside did nothing to counter the Viet Cong insurgency in the towns and

cities, which held the great bulk of the South Vietnamese population and that chasing ghosts in the jungles and rice paddies was a poor use of resources.

Consideration of these aspects of the Huey's service goes well beyond the typical visitor's reading of the artifact. With the de-emphasis on the technological or institutional construction of artifacts in favor of social construction based on individual experience, much of the military and political significance is lost in the interpretation. The deconstruction of iconic popular culture narratives is perhaps the greatest challenge for multivalent interpretations in museum exhibitions. This essay has pinpointed a number of questions, such as why the Huey was so iconic, that lead to an understanding of its historical context rather than simply forming an awareness of its ubiquity. However, regarding its status as a technological artifact, interpreters must beware of falling into the trap of simply proclaiming the narrative of its development as triumphal progressivism (i.e., American successes were due to Yankee ingenuity and failures to political or cultural weakness). The Huey is a fantastic museum artifact because it ties geopolitical strategy, military doctrine, technological progress narratives, popular culture, and individual experience into a wonderfully rich and tidy package. Unfortunately, for the interpreter, a single museum label cannot unpack all of these diverse threads. The challenge for future displays will be to employ new strategies and techniques to do more than simply let the artifact speak for itself.

NOTES

1. For the Army, the Bell 204 became the H-40 in 1955 and was redesignated HU-1 (Helicopter, Utility) in 1958 and UH-1 in 1962 when the military services standardized their aircraft designation systems. The HU-1 designation gave rise to the "Huey" nickname, although this appears not to have become common until around the time of the HU-1's initial deployment to Vietnam in 1962. In 1957, the Army adopted a convention of naming its aircraft after Indian tribes and selected *Iroquois* for the H-40. This name persisted in official correspondence but did not catch on among the troops or aviation observers, almost all of whom preferred Huey.

2. I drafted this label.

3. "UH-72A Fact Sheet," National Guard Association of the United States, March 2008.

4. Most secondary sources put the number of wounded evacuated in Korea at 20,000, but an exhaustive search of unit histories of the Army, Marine Corps, and Air Force unit histories reveals 40,000 as an accurate figure.

5. In addition to the T53, the Huey employed Bell's trademark teetering rotor system that was rugged, lightweight, and easy to maintain. It could be dangerous in excessive maneuvering but posed little hazard in operations relative to its enormous benefits. The Huey had its share of teething troubles, but the six years between its first flight in 1956 and its deployment to Vietnam in 1962 gave enough time for the design to fully mature.

6. Charles Holley and Mike Sloniker, *Primer of the Helicopter War* (Grapevine, TX: Nissi Publishing, 1997), 175; Gary Rousch, "Helicopter Losses

during the Vietnam War," Vietnam Helicopter Pilot Association, accessed January 10, 2014, http://www.vhpa.org/heliloss.pdf; Howard K. Butler, *The Restoration of the Army Air Corps* (St. Louis: U.S. Army Aviation and Troop Command, 1995), 1053; Congressional Budget Office, *Replacing and Repairing Equipment Used in Iraq and Afghanistan: The Army's Reset Program* (Washington, D.C., 2007), XI; U.S. Department of Defense, "DoD News Briefing with Secretary of Defense Gates and the Chairman of the Joint Chiefs of Staff Adm. Mullen from the Pentagon Briefing Room, Arlington, Va.," transcript, November 15, 2007, accessed January 10, 2014, http://www.defense.gov/transcripts/transcript.aspx?transcriptid=4089.

7. Richard P. Weinert, *A History of Army Aviation, 1950–1962, Phase II: 1955–1962* (Fort Monroe, VA: Historical Office, Office of the Chief of Staff, U.S. Army Training and Doctrine Command, 1976), 6.

8. James M. Gavin, "Cavalry, and I Don't Mean Horses," *Harper's Magazine*, April 1954, 54–60.

9. John L. Cook, *Dust Off* (New York: Bantam, 1988), 153.

10. As of 2007, the Army had slightly over 1,700 Black Hawks, and according to extensive research conducted by Gary Roush of the Vietnam Helicopter Pilots Association, the Army operated nearly 7,000 Hueys in Southeast Asia (nearly 60% of the 12,000 helicopters operated in the theater of war and about 70% of all Hueys procured for the U.S. military). U.S. Army Hueys accumulated more than 7.5 million flight hours in Southeast Asia, vastly more than any other combat aircraft type employed there. Rousch, "Helicopter Losses during the Vietnam War."

11. Andrew F. Krepinevich, Jr., *The Army and Vietnam* (Baltimore: The Johns Hopkins University Press, 1986), 121–122.

BIBLIOGRAPHY

Bergerson, Frederic A. *The Army Gets an Air Force: Tactics of Insurgent Bureaucratic Politics*. Baltimore: The Johns Hopkins University Press, 1978.

Butler, Howard K. *The Restoration of the Army Air Corps*. St. Louis: U.S. Army Aviation and Troop Command, 1995.

Butterworth, W. E. *Flying Army: The Modern Air Arm of the U.S. Army*. New York: Doubleday, 1971.

Chinnery, Philip D. *Vietnam: The Helicopter War*. Annapolis, MD: Naval Institute Press, 1991.

Congressional Budget Office. *Replacing and Repairing Equipment Used in Iraq and Afghanistan: The Army's Reset Program*. Washington, D.C., 2007.

Cook, John L. *Dust Off*. New York: Bantam, 1988.

Galvin, John R. *Air Assault: The Development of Airmobile Warfare*. New York: Hawthorn Books, 1969.

Gavin, James M. "Cavalry, and I Don't Mean Horses." *Harper's Magazine*, April 1954, 54–60.

Holley, Charles, and Mike Sloniker. *Primer of the Helicopter War*. Grapevine, TX: Nissi Publishing, 1997.

Krepinevich, Andrew F., Jr. *The Army and Vietnam*. Baltimore: The Johns Hopkins University Press, 1986.

Rousch, Gary. "Helicopter Losses during the Vietnam War." Vietnam Helicopter Pilot Association. Accessed January 10, 2014. http://www.vhpa.org/heliloss.pdf.

Spencer, Jay P. *Whirlybirds: A History of the U.S. Helicopter Pioneers*. Seattle: University of Washington Press, 1998.

U.S. Department of Defense. "DoD News Briefing with Secretary of Defense Gates and the Chairman of the Joint Chiefs of Staff Adm. Mullen from the Pentagon Briefing Room, Arlington, Va." Transcript. November 15, 2007. Accessed January 10, 2014. http://www.defense.gov/transcripts/transcript.aspx?transcriptid=4089.

Weinert, Richard P. *A History of Army Aviation, 1950–1962. Phase II: 1955–1962*. Fort Monroe, VA: Historical Office, Office of the Chief of Staff, U.S. Army Training and Doctrine Command, 1976.

Huey 65-10126: A Curator's Journey of Discovery

Peter L. Jakab

In the early 1990s, I was developing a large exhibition on the air war in Vietnam at the Smithsonian National Air and Space Museum (NASM). A gallery on so broad, complex, and potentially controversial a subject as the Vietnam War presented enormous conceptual challenges. I spent a great deal of time sorting through approaches, themes, and issues in an effort to create a useful and meaningful presentation of this pivotal episode in American history. However, as I considered the daunting task before me, there was always one thing of which I was certain: no exhibition on the air war in Vietnam could be mounted without the inclusion of a Huey helicopter. From both historical and cultural perspectives, it was essential to the story. When I set out to collect a Huey for the exhibition, I had no idea of the curatorial journey this artifact had in store for me.

The Huey, properly identified as the Bell UH-1 Iroquois, was, and remains, a powerful symbol of the Vietnam War. From a technical, operational point of view, it was everywhere and did everything. It carried troops in and out of battle zones, retrieved wounded, served as a gunship attack vehicle, and was

used for scouting, supply, and an endless number of other logistical tasks. All these roles, collectively known as the *airmobile* concept, were facilitated by the Huey. It was used by all the U.S. military services and the South Vietnamese. The Huey's ruggedness and adaptability made it the right vehicle, at the right time, in the right place. Of course, the Bell UH-1 was not the only helicopter in Vietnam. For downed airmen, the Sikorsky HH-3, the famous "Jolly Green Giant," was the critical search and rescue machine, and there were many other helicopter types, large and small, that contributed to making Vietnam the "first helicopter war." But it was the Huey that provided the backbone to airlift for the ground war.[1]

The Huey became much more than a versatile vehicle for combat and transport. It emerged as one of the most enduring cultural representations of the American presence in Southeast Asia. Nearly everyone who served in Vietnam flew on a Huey at some point. The distinctive "whomp-whomp" sound of the rotor blades is forever ingrained into the memory of every Vietnam veteran. For troops being inserted into a hot landing zone, it was their chariot into danger and their ride back to safety. For the attack helicopter pilots, it was their aerial steed. For the wounded on the battlefield, the image of a Huey settling nearby meant a chance at survival. For the ground forces, the Huey and the war were inextricably linked. It was both critical hardware and emotional symbol.

The Huey was also a ubiquitous component of the so-called living room war fought on television screens across America. Night after night in the news coverage of the battlefront, an image of a Huey was always on the screen some-where in the report. Be it combat footage, scenes of medical evacuation, or even carrying the reporter himself, the Huey was always there. Even the last, trau-matic scenes of the war, as desperate evacuees were scurried away from rooftops as Saigon fell, featured the ever-present Huey. In no small measure, the Huey became visual shorthand for the long, complex, painful episode in American history we call the Vietnam War.[2]

As I struggled, as any curator does, with balancing what major artifacts should be in the exhibition with what could practically fit into the available gallery space, clearly the inclusion of a Huey helicopter was essential to the success of my Vietnam exhibition and extremely important for the museum's collection in general.

When collecting a historical object, all curators seek to find examples with rich specific histories with which they can tell compelling and varied stories.

Documenting an object type or technology is just the beginning. The most sought-after artifacts say much more. When searching for a Huey for the National Air and Space Museum's collection, I tried to find one that had a long and distinguished service in Vietnam, the most famous and historically relevant setting in which the Huey operated. And, of course, I was looking for a good candidate for my Vietnam War exhibition. As this was coincidentally the time period when most remaining Hueys were being retired from the active U.S. Army inventory, I worked with the Army to find one with a rich history as the last Hueys were being dispersed. The one I settled on was a Bell UH-1H model, serial number 65-10126 (Plate 5).

From aircraft records obtained from the Army, I learned Huey 65-10126 was manufactured in 1965, starting life as a D model. It first served in Vietnam from November 1966 to April 1969, then spent five months in Texas for maintenance and modifications to an H model, and then served back in Vietnam for another nine months until June of 1970. After its wartime service it was with a National Guard unit until 1974 and then remained in the U.S. Army inventory until it was transferred to the Smithsonian in 1994. During its Vietnam service, 65-10126 flew more than 2,500 combat hours and was operated by four different units, including the famous 1st Cavalry Division (Airmobile), well known for, among other things, its famous horse head emblazoned yellow shield and the black cowboy hats worn by its members. With the "Air Cav," it served with the 229th Assault Helicopter Aviation Battalion. It also was flown by the headquarters company of the 11th Combat Aviation Battalion, the 128th Assault Helicopter Company, and the 118th Assault Helicopter Company.[3]

Upon delivery of the helicopter to Washington, I was quite happy that I had acquired a "good" Huey. It would have been hard to find a specimen with a better history. However, there was so much more I was to learn about it based on the memories of those who flew it, both from a cultural point of view and from the perspective of the technical history of the object.

Working through veterans' organizations, I was able to locate several individuals with a connection to Huey 65-10126. One was Tom Johnson, who piloted 10126 in 1967 with the 229th Assault Helicopter Battalion, 1st Cavalry Division.[4] Tom learned to fly at age 14, married his high school sweetheart at 16, and at 19 answered his country's call to duty. As he told me, "The government gave me a choice. I could be a soldier who walked or a soldier who flew, but either way I was going to Vietnam." He chose to fly (Figure 1).

Tom Johnson served one tour of duty in Vietnam flying Hueys in combat. Like so many war veterans, especially those who served in Vietnam, Tom had carried his

FIGURE 1.
Twenty-year old Tom Johnson in the cockpit of his Huey in 1967. Photo courtesy of Tom Johnson.

combat experiences deep within himself, not often sharing them in the decades that followed, during which he ran the family electric motor repair business and raised a family in his native Georgia. I found Tom not long after acquiring Huey 10126 and invited him to come to Washington for a reunion with the old helicopter that had been such an important part of his youth. He and his wife, Pat, arrived at NASM's storage facility in Suitland, Maryland, with a palpable mix of enthusiasm and nervousness, sensing the journey his memories were about to send him on.

As I escorted Tom to 10126, his delight at seeing his old combat machine engendered unbridle excitement, unleashed in a quickened banter unlike his normally soft southern drawl. He asked if he could sit in the pilot's seat and I assented. As he touched the door handle to hoist himself into the craft, he suddenly froze and fell silent. It was apparent that he had been instantly transported to a faraway place in the distant past. No doubt his face-to-face encounter with this object had triggered memories in ways simple reminiscing never would.

After a few moments, Tom climbed into the pilot's seat and scanned the environment much the same way any of us might when returning to our childhood home after many years. He started pointing things out that had changed since he last sat in his bird and things that were as he left them—and then the stories began to flow, stories of battles fought, comrades lost, and the excitement of a young man's daring exploits with this very machine. As a curator at NASM

since the early 1980s, I have had the opportunity to meet many famous aerospace personalities as they visited to see their aircraft and spacecraft displayed in the museum. Larger-than-life figures such as Neil Armstrong, Chuck Yeager, Jimmy Doolittle, John Glenn, and dozens more have thrilled the museum staff with personal visits and conversations about their history-making aerospace exploits. But in more than three decades at NASM, I have never been part of a more powerful encounter between an object and memory than the day Tom Johnson and Huey 65-10126 were reunited. That object came to life for me as a curator in ways I never could have gleaned from archival documentation alone.

In addition to the cultural history of the Huey that emerged from Tom Johnson's encounter with the NASM artifact, there are aspects of the technical history of this object that I would never know without the memories of others associated with 10126. My networking among Vietnam veterans turned up others who served in Vietnam on this particular Huey. Van Ponder and Jim Palmer were both crew chiefs on 10126 when it flew with the 11th Combat Aviation Battalion from October 1967 to June 1968 (Figure 2).[5]

The crew chief is on board the aircraft in flight and is the person responsible for making sure all the systems on the helicopter are in working order, contributes to manning the weapons as troops are dropped off in the combat zone, and is generally in charge of everything involved with keeping the helicopter in operation. As to the practice of having the crew chief on board the helicopter during combat missions, Palmer suggested, "I think in the Army's wisdom they say, 'Well, make the guy who fixes [the helicopter] fly it every time, and that way there's a good

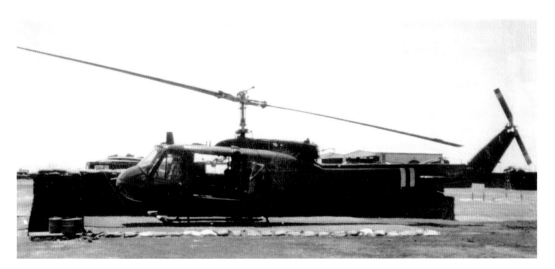

FIGURE 2.
Huey 65-10126 in Vietnam while serving with the 11th Combat Aviation Battalion, 1968. Photo courtesy of Jim Palmer via Robert Stidd.

chance it will work.'" As a result of this practice, the helicopter "belongs" to the crew chief, not the pilot. This status hierarchy is reinforced by the fact that the crew chief's name, not the pilot's, is typically painted on the aircraft.

Van Ponder and Jim Palmer visited NASM together to see their old Huey. They had met only once before for a few minutes in March of 1968 when Ponder turned over 10126 to Palmer when he became the new crew chief on it. The memory of their brief encounter more than 30 years before was vague, but their individual recollections of 10126 were as clear as if they had just stepped out of it after a mission in Vietnam.

Among the many things they shared about their knowledge of this artifact, two in particular were revelations. Like all military aircraft that stay in service for a long period, Huey 65-10126 had undergone many modifications between the time it was in Vietnam and when it arrived at NASM. Interviewing Palmer revealed that initially the twin M-60 machine guns mounted on 10126 had a tendency to misfeed or jam. To solve the problem he fitted the guns with a custom-made, motor-driven ammunition feed system that he had designed and built himself. He even shared photographs of it documenting the details that were taken by his door gunner, Bob Stidd.[6] This system had been removed long ago. Without Palmer and Stidd's photographs, I never would have known about this unique aspect of the technical history of the artifact.

Also in the pictures of Palmer's armament system, I noticed that the metal post upon which the machine gun was mounted had a curious bend in it. I speculated that maybe this was done to get a more convenient angle when operating the gun. Normally the gun mount was straight. Palmer informed me that the mounting post was bent during a mission when they flew too close to a tree and it hit the gun mount, nearly knocking the Huey out of the air. He just left the bent mount in place rather than having it repaired. Again, this information was unknowable without the benefit of Palmer's recollection (Figure 3).

Another even more significant aspect of the technical history of 10126 revealed by Ponder and Palmer was that it was a smoke ship during the time it was with the 128th Assault Helicopter Company. A smoke ship was a helicopter fitted with a system that could spew out a heavy trail of dense, white smoke that was then used as visual cover for troops being dropped off in the combat zone by other helicopters. On board was an oil-filled rubber bladder. When the oil was pumped into the hot exhaust of the turbine engine, it produced a large plume of white smoke (Figure 4).

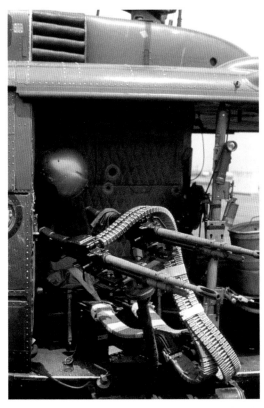

FIGURE 3.
Huey 65-10126 was fitted with a custom-made motor-driven ammunition feed system designed and built by crew chief Jim Palmer. Note the bent machine gun mount that resulted from striking a tree. Photo courtesy of Jim Palmer via Robert Stidd.

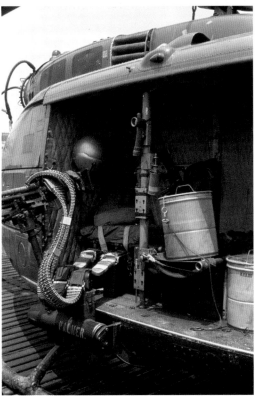

FIGURE 4.
Components of the smoke system fitted to Huey 65-10126 can be seen attached to the engine exhaust (upper left). Note Palmer's name painted on the helicopter just below the ammunition belt. Robert Stidd's name appears on the other side in the same location. Photo courtesy of Jim Palmer via Robert Stidd.

The "smoker," as it was called, would fly in ahead of the main assault and lay down a smoke screen for the helicopters loaded with ground troops following close behind. The smoke ship would fly repeatedly through the landing zone in a figure eight pattern, laying fresh smoke and continuously firing its machine guns until all the troops had been inserted. It was very dangerous because the smoker was the first aircraft to arrive and had to fly very low to put down an effective smoke screen and was therefore very vulnerable to enemy ground fire. The maneuver was dramatically illustrated by a series of photographs provided by another of 10126's pilots the museum located, Al Watkins. The images show Watkins laying down smoke in 10126 in May 1968, while Palmer was crew chief (Figure 5).[7] Only a very few Hueys were fitted with a smoke system and used in this way during the entire war. The concept produced mixed results and thus was not widely employed. Nonetheless, that 10126, in addition to all its other important history, was also a smoker made it an even more significant artifact than I had imagined.

Like the custom-made machine gun feed, the apparatus for generating the smoke had been removed many years before. I had no idea 10126 had this additional significance when I collected it. Ponder and Palmer, along with Stidd's and Watkins' photographs, were able to expand my knowledge of 10126 by sharing their experiences of it being used as a smoker, further documenting the unique nature of this particular Huey.

The role of memory has played an enormous part in my understanding of this artifact. I know crucial aspects of its history that would have been otherwise unrecoverable. Beyond that, the relationship of memory and objects has changed the way I relate to this particular one. Huey 10126 is no longer just an assemblage of metal that flew and fought in a long-ago conflict. For me, 10126 now has come to life. Through the encounters with Johnson, Ponder, Palmer, Stidd, and Watkins, 10126 has taken on a personality and an individual history that is inextricably bound up with the personal experiences of these men. I cannot look at this artifact without thinking of them and what they did in this machine.

The Vietnam War exhibition for which I collected this Huey helicopter never opened, a victim of the culture wars of the 1990s.[8] However, Huey 10126 has made it onto public display at the National Air and Space Museum's Steven F. Udvar-Hazy Center, the National Mall museum's companion facility in Chantilly, Virginia. I may not have been able to realize the artifact's full exhibition potential as yet, but Huey 65-10126 still remains among the most significant and personally meaningful acquisitions of my career.

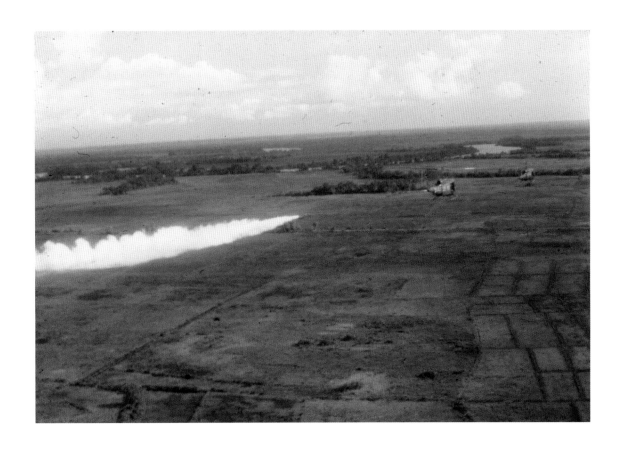

FIGURE 5.
With Al Watkins at the controls, Huey 65-10126 lays down smoke with troop-carrying Hueys ready to drop in behind. Photo courtesy of Al Watkins.

ACKNOWLEDGMENTS

The core insights of this essay were based on the recollections, information, and images provided by Vietnam veterans Tom Johnson, Jim Palmer, Robert Stidd, Van Ponder, and Al Watkins, who flew on board Huey 65-10126. I and the Smithsonian are in their debt for illuminating our understanding of this important object.

NOTES

1. For details on the uses of the Huey helicopter in Vietnam, see Philip D. Chinnery, *Vietnam: The Helicopter War* (Annapolis, MD: Naval Institute Press, 1991); John L. Cook, *Rescue Under Fire: The Story of Dust Off in Vietnam* (Atglen, PA: Schiffer, 1998); John R. Galvin, *Air Assault: The Development of Airmobile Warfare* (New York: Hawthorn Books, 1969).

2. For a discussion of the cultural history and context of the Vietnam War and the Huey helicopter, see Philip D. Beidler, "The Last Huey," in *The Vietnam War and Postmodernity*, ed. Michael Bibby (Amherst: University of Massachusetts Press, 1999), 3–16; John Carlos Rowe and Rick Berg, eds., *The Vietnam War and American Culture* (New York: Columbia University Press, 1991); Owen W. Gilman, Jr. and Lorrie Smith, eds., *America Rediscovered: Critical Essays on the Literature and Film of the Vietnam War* (New York: Garland Publishing, 1990).

3. Details on the history and acquisition by NASM of Huey 65-10126 can be found in Curatorial File, Bell UH-1H Iroquois, Aeronautics Division, National Air and Space Museum, Smithsonian Institution, Washington, D.C.

4. Details regarding Tom Johnson's experiences with Huey 65-10126 are from an oral interview with Johnson at the National Air and Space Museum, Smithsonian Institution, Washington, D.C., November 15, 1996. See also Tom Johnson, *To the Limit: An Air Cav Huey Pilot in Vietnam* (Washington, D.C.: Potomac Books, 2006).

5. Details regarding Van Ponder's and Jim Palmer's experiences with Huey 65-10126 are from an oral interview with Ponder and Palmer at the National Air and Space Museum, Smithsonian Institution, Washington, D.C., June 12, 2001, and numerous other oral interviews with Palmer between 1996 and 2003. See also Diane Tedeschi, "Smokers Welcome," *Air & Space/Smithsonian*, October/November 2001, 16–17. After the Vietnam War, Ponder became a successful farmer in Whigham, Georgia, and Palmer worked for the Veterans Administration for 30 years in rehabilitation of blind combat veterans.

6. Bob Stidd, after serving with Jim Palmer as a door gunner on Huey 65-10126 in 1968, returned home to work for a company that produced artificial joints in Oregon.

7. Details regarding Al Watkins's experiences with Huey 65-10126 are from an e-mail message from Watkins to me, September 24, 2010, Curatorial File, Bell UH-1H Iroquois, Aeronautics Division, National Air and Space Museum, Smithsonian Institution, Washington, D.C.

8. The NASM Vietnam War exhibition was scheduled to open in 1997. It was to follow in the same gallery space of the now infamous NASM *Enola Gay* exhibition, which was to open in 1995. The museum's exhibition on the Boeing B-29 *Enola Gay* and the bombing of Hiroshima came under enormous criticism from veterans and was canceled amid months of controversial press. The original exhibition was replaced by a trimmed-down version exhibiting the aircraft with a

summary of the events of August 1945 and information about the 18-year restoration of the *Enola Gay* by NASM staff. Although no specific criticism was leveled against the proposed Vietnam exhibition, Smithsonian officials decided to shelve the project after the tumultuous *Enola Gay* experience, given the innately controversial nature of the Vietnam War and the potential for problems with the exhibition coming so soon after the *Enola Gay* project.

BIBLIOGRAPHY

Beidler, Philip D. "The Last Huey." In *The Vietnam War and Postmodernity,* ed. Michael Bibby, pp. 3–16. Amherst: University of Massachusetts Press, 1999.

Chinnery, Philip D. *Vietnam: The Helicopter War.* Annapolis, MD: Naval Institute Press, 1991.

Cook, John L. *Rescue Under Fire: The Story of Dust Off in Vietnam.* Atglen, PA: Schiffer, 1998.

Galvin, John R. *Air Assault: The Development of Airmobile Warfare.* New York: Hawthorn Books, 1969.

Gilman, Owen W., Jr., and Lorrie Smith, eds. *America Rediscovered: Critical Essays on the Literature and Film of the Vietnam War.* New York: Garland Publishing, 1990.

Johnson, Tom. *To the Limit: An Air Cav Huey Pilot in Vietnam.* Washington, D.C.: Potomac Books, 2006.

Rowe, John Carlos, and Rick Berg, eds. *The Vietnam War and American Culture.* New York: Columbia University Press, 1991.

Tedeschi, Diane. "Smokers Welcome." *Air & Space/ Smithsonian,* October/November 2001, 16–17.

Central African Throwing Knife

Plate 6
Throwing knife

Culture: Ngbandi or Mbanja
Date: Mid- to late nineteenth century
Materials: Iron, dressed skin
Measurements:
 Overall: 43 cm (16.9 in) maximum length × 34.5 cm (13.6 in) maximum width
 Handle: 9.7 cm (3.8 in) length × 3 cm (1.2 in) maximum width
 Stem: 12.2 cm (4.8 in) length × 2.3 cm (0.9 in) maximum width
Catalog number: E322652-2
Department of Anthropology, National Museum of Natural History
Collected in the Congo (Democratic Republic of the Congo) between 1884 and 1889 by Herbert Ward.
Donated in 1921 by Sarita Ward, the widow of Herbert Ward.
Photo by Donald Hurlbert, Smithsonian Institution.

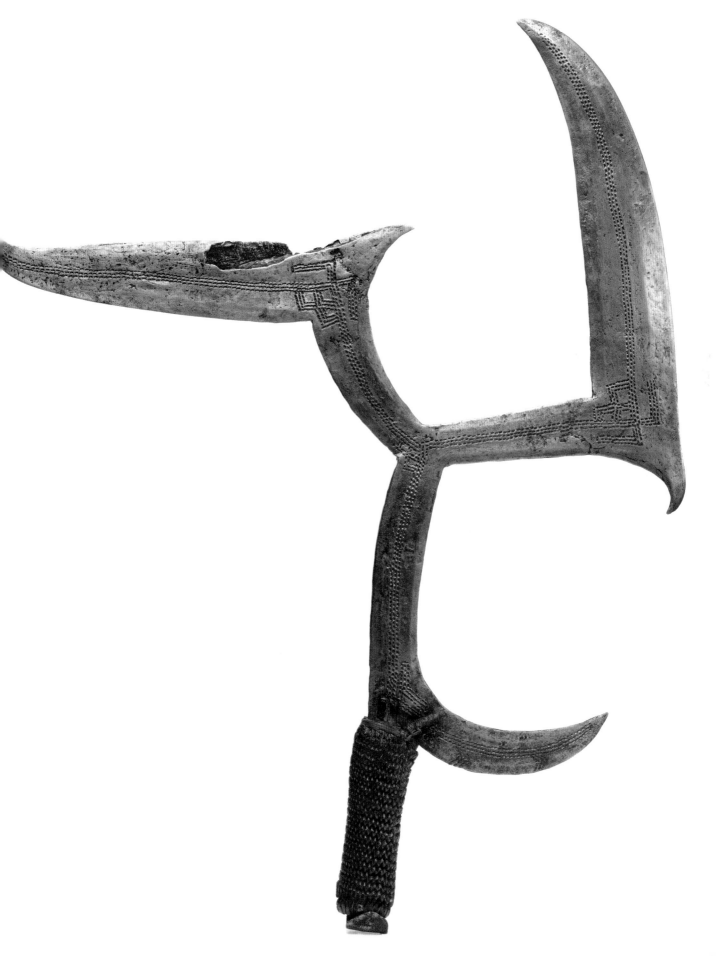

A Throwing Knife through Production and Use

S. Terry Childs

Throwing knives from a wide area of the Central African region and the Sudan are unique in the world; nowhere else did blacksmiths make well-balanced, multibladed knives in such intricate shapes. As a result, these knives were widely sought after in the late nineteenth and early twentieth centuries and were collected by Western military, explorers, and others traveling in this region. Throwing knives as well as large numbers of other locally crafted iron weapons from this region found their way into public museums during this same period. By the closing decades of the nineteenth century the Smithsonian had acquired only two Central African throwing knives.[1] In 1921, however, the National Museum added appreciably to its collection of throwing knives with the donation of 70 throwing knives as part of the larger Herbert Ward collection of 1,700 Central African iron weapons. Ward had acquired most of these weapons while living and working in the Congo from 1884 to 1889. Throughout the ensuing years the throwing knives have continued to fascinate scholars, and in 1993 I began a multiyear collaborative study of the throwing knives with Mary Jo Arnoldi. As

an archaeologist and archaeometallurgist, I particularly focused on studying the technology of the production and use of these knives.

Historic museum collections, like the Ward collection, present particular challenges for the researcher. We know from ethnographic accounts that the Central African smith used tools, fire, and several pieces of iron metal to produce iron objects that had functional value within his society. We also know that blacksmiths in this region were men because women never forged iron objects, although women may have assisted smiths in some of the local cultures.[2] The smith was recognized as a skilled craftsman and was trained in the technical, social, and ritual aspects of his trade through a long apprenticeship.[3] His tools were an anvil on which to pound out the iron, several types of hammers, chisel-like tools, and materials or tools to appropriately prepare the surface of the object. Iron was a highly valued material in African life for its luminosity, color, malleability, and durability. It was first reduced from ore into functional metal in an iron smelting furnace some 3,000 years ago in the west central parts of Africa and later spread throughout the continent because of its many values.[4]

In this focus on historic objects, unlike my previous field studies with contemporary smiths in Uganda, I was never able to interview or work alongside the Congo smiths who had created these throwing knives. I needed to develop a methodology that depended primarily on the close examination of the knives themselves. Indeed, I was able to learn much about this collection and knife E322652-2, particularly aspects of manufacture and use, by using analytical approaches that integrate style and technology to elucidate identity in the past (Plate 6).

A BRIEF OVERVIEW OF STYLE AND TECHNOLOGY

Style and technology share two key features: particular ways of doing things and choices between alternatives. Style has been fundamental to the scholarship of archaeologists, anthropologists, and art historians for over a century because it helps to establish some control over the unknown (e.g., a museum collection with uncertain or poor provenience such as the Ward Collection) and makes it comprehensible. A style, whether relating to time-space systematics, social communication, or human cognition, is usually defined by a specific set of formal attributes on the surface of an object that are generally separate from the physical actions that produced them. Style analysis has involved grouping objects by a selection of similar attributes or assigning newly found objects to previously constructed groups

based on similarity. Recent debates and reviews of style, however, have refined its basic definition through consideration of its relationships to object function, object production, and various sociocultural processes and contexts.

The attributes that describe a technology—a system of materials, tools, skills, knowledge, and behaviors involved in the production of objects—may be on the surface of or intrinsic to an object as a product of physical action. Technology, defined as a material and social process, has only recently become the subject of direct study. Efforts to combine aspects of style and technology have yielded important theoretical approaches, including technological style, an anthropology of technology, and the sociotechnical system.[5] Although each has a different emphasis, these concepts all incorporate the ideas that (1) patterned behavior derived from choices made during manufacture is stylistic and (2) styles of behaviors and material products actively communicate information about the social groups and systems of meaning that helped structure them.

AFRICAN THROWING KNIVES
AND THE WARD COLLECTION OF CENTRAL AFRICA

Most scholarship on African throwing knives to date has focused largely on the diffusion and evolution of knife shapes rather than their production, function, and meaning in African lifeways. The temporal and spatial origins of these throwing knives, however, are currently unknown. There is very little evidence for their occurrence in the archeological record, although undated rock art in the Sudanic region shows a rider on horseback with a throwing knife.[6] Throwing knives are mentioned in the oral traditions of many ethnic groups, but it is virtually impossible to assign a time frame around these past accounts.

It is possible to map out a large area in Sudanic and Central Africa where throwing knives were produced, used, arrived through trading, or appeared through a combination of these activities. This distribution is based on the records of collectors, such as Ward, and ethnographic accounts that, unfortunately, rarely included detailed eyewitness descriptions of knife use or production.[7] The total area extends from southeastern Nigeria across to southern Sudan at the northern border down to Zambia and Angola at the southern border. The throwing knives in the Ward collection are most likely from the central area of distribution, including the Republic of the Congo, the Central African Republic, and the Democratic Republic of the Congo.

African throwing knives were almost always made of iron with two or more blades that project out from a central stem made up of a neck and handle of varying lengths and widths. The configuration of multiple blades on a knife yielded intricate and unusual shapes. The 70 throwing knives in the Ward Collection can be placed in most of the knife shape categories that have been devised by collectors and scholars.

It is possible, although not known for sure, that throwing knives were originally constructed as weapons to be thrown with force either horizontally from the hip or vertically in a way similar to throwing a spear.[8] Some of the larger throwing knives were used in hand combat, as well as to hack at and cut up meat or wood. Ethnographic accounts also reveal that many throwing knives were used for a variety of other purposes, such as symbols of office, wealth, and prestige and as special-use currency, and were physically altered to function appropriately in those roles rather than to be thrown. Scholars, such as Christopher Spring, question whether the function of most knives in collections and museums today was as weaponry or for a wide variety of other purposes related to status, ritual, and trade.[9]

According to Peter Westerdijk, the attribute that distinguishes throwing knives as weapons is the handle, a functional and stylistic attribute. Only knives without a cover over the iron on the handle or a cover made of nonsolid material, such as fiber, reptile skin, animal hide, or metal wire, would be aerodynamically balanced.[10]

IDENTITY AND THROWING KNIVES

Given this brief introduction to throwing knives and especially those in the Ward Collection, I believe it is clear that assigning identity to these knives is not straightforward. It also begs the question, what kind of identity? Most of the work on African throwing knives to date has involved assigning ethnic identity using a particular set of stylistic attributes in conjunction with some ethnographic information. These attributes include overall shape, number, length, and width of blades; presence and shape of a midrib; type and angle of the knife edges; presence or absence of surface blackening (usually an organic substance applied to the metal surface); location and size of beveling; weight; and decoration.

However, the functional identity of the knife in relation to the needs and desires of individual consumers and the identity of the individual producer

Childs

also can and should be examined through technological analysis of attributes resulting from the manufacture and use of the object. The functional and manufacturing identities may or may not fit or overlap with an ethnic identity primarily based on formal stylistic attributes. Patterns of social and economic distribution, technological transfer, and other factors must be mined from the ethnographic record and, someday perhaps, from the archaeological record to help render tighter conclusions about identity. Toward this distant end, the best understanding of the identity of knives in the Ward collection must involve integrating data on the manufacturing process, the functional options created during production, evidence of use, decoration, and symbolism, as well as formal stylistic attributes.

Examination and identification of the technological attributes of the knives contribute to this endeavor. In the following discussion, I highlight the primary technological attributes that help identify the function and the production of a throwing knife. Since function informs the process of production, function will be considered first.

Function

As I mentioned above, a function of many African throwing knives was as a weapon that was thrown horizontally or vertically at an enemy or at an enemy's horse. To be an effective weapon, it required the following characteristics:

- a particular height-width ratio to maintain balance during a throw
- a standardized weight to ensure effective use by different warriors
- carefully sharpened blades and other selected edges
- well-executed welds to prevent the blades from cracking or breaking during use
- good-quality iron or low-carbon steel with minimal slag to maintain sharpened edges and minimize bent or cracked blade edges
- some degree of surface finish, such as polishing or an applied material
- a handle shape and covering that facilitates throwing by not detracting from the knife's balance

In order to elicit fear as a knife was thrown at an enemy, the blade edges may have been polished to maximize reflection in the sunlight. Use of a dark

color on various parts of a knife could accentuate the polished blades and blade edges whether in flight or as the weapon was carried (Figure 1). Also, evidence of use should be visible in the location, number, and size of nicks and cracks along the blade edges; breaks in the metal on the blades; stress cracks at the juncture of a blade to the stem; and striations from resharpening (Figure 2).

FIGURE 1.
Throwing knife (E322652-9), Herbert Ward Collection, Department of Anthropology, National Museum of Natural History, Smithsonian Institution. Blackening is seen in the middle of the three blades.

FIGURE 2.
Throwing knife (E322652-3), Herbert Ward Collection, Department of Anthropology, National Museum of Natural History, Smithsonian Institution. Detail of cracks in the iron along the blade.

Throwing knives had other specialized functions in some African societies, including symbols of office or prestige, bride-price, regalia for dances, initiation or other ritual performances, and specialized currency. Factors such as socioeconomic status, age, and gender may have determined who used these objects in such contexts. Also, functional changes in a type of knife identified by stylistic attributes may have evolved over time within a society or across ethnic or social boundaries. Or the function of a particular knife may have changed during its life history. If the function of a type of throwing knife changed over time, particularly from a weapon to a nonweapon, it might be possible to find the following characteristics:

- blade or projection features that were either enlarged or made smaller
- minimal or no sharpening of the blade edges
- blade or stem surfaces that were handled in different ways (e.g., unpolished where formerly polished, no use of blackening where formerly blackened, and more elaborate decoration or surface beveling)
- differences in the placement and/or types of decorative motifs and features on a knife, on both the obverse and reverse sides

On the other hand, it may be very difficult to determine if the function of a particular throwing knife changed over its lifetime by analyzing either its stylistic or technological attributes.

Manufacture

The role of the blacksmith is critical to the identity of a throwing knife. Since technology is a material and social process that involves raw materials and tools, as well as trained skills and acquired knowledge of the producer, many of these components can be traced in the resulting object. Many researchers of African throwing knives have assumed that the craftsmen who made the objects were among the best, particularly given the complicated, exotic shape of the knives and the important functions they played in society. Is this assumption reasonable?

It is possible to reconstruct various skills and decisions of the smith, including the quality and degree of standardization of his technical process, the tools and materials he used, and any innovation he might have developed through detailed technical analysis of the objects. A number of methods are available, which are either noninvasive or invasive.

The most common, but highly informative, noninvasive technique is low-powered binocular microscopy. It is often possible to see hammer marks and flow lines in the metal surface caused when it was hot in the forge and the smith hammered the metal out, as well as subsequent cracks that were caused by use (Figure 3). Welds or joins in the metal between the blades and the stem may be visible, which provides information on both the expertise of the smith in welding iron and the number of pieces of iron used to create an individual knife (Figure 4). If no evidence of welding is visible on a knife with several blades, it is likely that the blacksmith was a master craftsman, not an apprentice, who could adeptly hide the welds as he manipulated the knife's surface. There is, however, another analytical technique to look for signs of welds that I discuss below.

Given that the function of many throwing knives necessitated sharp edges, it is possible to determine the degree of blade sharpening and resharpening with the microscope. Other surface-finishing methods that may also be observable include polishing and applying materials to the iron surface to create different colors (e.g., black, white, and red) and patterns. Notably, a black surface material of iron scale can also be left from the forging process, whether by intention or by poor craftsmanship, and should be apparent under a microscope. Also, the metal surface of many throwing knives was decorated, often in intricate patterns. A smith's toolkit can be discerned by looking for distinctive features caused by different types of hammers, chisels, and various other tools used to manipulate and decorate a knife's surfaces.

X-ray analysis is another noninvasive method that can assist us in understanding the construction of a knife from its internal features, such as welds. It can also be used to discern surface features that may be obscured by such things as a handle cover.

Metallography, the study of a metal's internal grain structure, is invasive because it requires removing a portion of the object to view it under a high-powered reflected light microscope. It is a very powerful analytical technique, however, because it explores the microstructure on the inside of a metal object. For example, it can be used to determine if the metal used was locally smelted bloomery iron or recycled European iron, the degree to which the metal was worked to remove slag and other inclusions that could cause cracking and instability of the metal, and the quality of the folding, layering, and welding of the metal. All of these technological features speak to the craftsman's mastery of the forge.

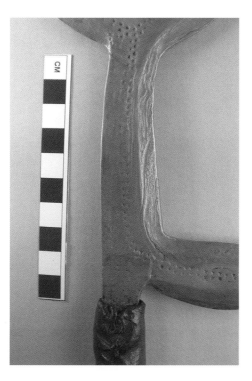

FIGURE 3.
Throwing knife (E322652-3), Herbert Ward Collection, Department of Anthropology, National Museum of Natural History, Smithsonian Institution. Detail of flow lines of the metal visible in the neck of the throwing knife.

FIGURE 4.
Throwing knife (E322652-3), Herbert Ward Collection, Department of Anthropology, National Museum of Natural History, Smithsonian Institution. Detail of a visible weld between the stem and the blade.

Another insightful technique, which can utilize the sample removed for metallography, is hardness testing. The application of measured pressure on the iron metal as an indentation or a scratch reveals information about the quality of metal in the object, such as carbon steel versus softer bloomery iron. The resistance of the metal correlates to its strength, so that the harder the iron is, the better it can retain a sharp blade edge and resist bending during use.

Chemical analysis may also be used to learn more about the function and use of throwing knives. There are many different techniques used for chemical analysis that are either invasive or noninvasive. Noninvasive use of a portable X-ray florescence machine could provide information on the nature of the black residue on knives, whether it is an organic substance or iron scale left by the smith. Red and white pigments found on a few knives could also be analyzed.

SMITHSONIAN AFRICAN THROWING KNIFE E322652-2

The primary analytical techniques I used to study this object were low-power binocular microscopy and X-ray (Figure 5). Although I would have gained useful insights through using metallography, hardness testing, and chemical analysis, the permanent damage to the museum object that would have been necessary to conduct these analyses was not deemed sufficiently defensible.

FIGURE 5.
Throwing knife (E322652-2), Herbert Ward Collection, Department of Anthropology, National Museum of Natural History, Smithsonian Institution. X-ray of the knife.

The evidence shows that the three-bladed knife was ably forged to function as a weapon and quite possibly was used for this purpose. Although no weld lines were clearly visible under the microscope, suggesting mastery of that production stage by the smith, the X-rays taken on both sides of the knife suggest that several high-temperature welds were made. One was at the intersection of the two long blades with the stem and another was possibly made above the elbow of the left blade where the density of the metal was greater. The X-rays also

FIGURE 6.
Throwing knife
(E322652-2),
Herbert Ward
Collection,
Department of
Anthropology,
National Museum
of Natural History,
Smithsonian
Institution. Detail
of the pattern
of dashes at the elbow
of one of the two
long blades.

revealed that the short blade was not welded onto the lower knife stem but was cut out of and bent out to the left side of the stem from a wider piece of iron that extended to the handle end.

Evidence of use came from microscopic examination of the tips of the two long blades, which showed striations from resharpening. X-raying the right blade revealed that the pattern of dashes on the tip surface was truncated by use and resharpening. The tip of the short blade was pointed but dulled, probably from use. Also, the fiber woven handle cover was very well made to facilitate throwing the knife, although the fiber is not well worn enough to suggest extensive use. It is possible, however, that a new handle cover was put on the knife before Ward acquired it. The presence of a thin piece of wood lodged between the iron handle and the fiber cover is unusual and served no obvious purpose other than possibly improving the handle grip, especially if the handle cover was loose when it was first put on.

The smith, however, did several things to this knife that did not enhance its use as a weapon. First, he hammered out curved extensions at the elbows of the long blades, instead of making them pointed, and did not sharpen them. Later in the production sequence, he carefully executed a pattern of three parallel dashed lines on the obverse surface of the knife that extended along the center of each blade to its tip and along the stem to the handle. He repeated a much more elaborate pattern of dashes at both elbows of the two long blades and also placed some recurring arrow-like shapes on the short blade (Figure 6). I believe the smith used a small, thin chisel blade to patiently tap in the dash marks, probably

when the throwing knife was only warm from the forge fire since high temperatures were not needed to do this work. I do not know if the design has symbolic meaning, although that would be a useful line of inquiry in order to understand the full identity of this knife. Notably, the smith did not apply a black coating on the blades of this knife, which would have covered up the carefully executed patterning.

Although the smith who forged this knife was adept, I doubt that he was a full master at his craft because of the significant loss of iron near the elbow of the left long blade. There, a sizeable layer of iron oxidized and then broke off the blade (Figure 7). It is likely that the smith made the blade by folding over a wider piece of iron under high temperatures and hammered the fold to join the two layers into a thin blade, which he later welded onto the knife stem. The join was not as complete as it should have been, so air and moisture eventually penetrated the blade to initiate the process of oxidation or rusting. Once rust set in, which could have happened after the knife was collected by Ward, the iron was severely weakened, and a layer fell off. In fact, microscopy revealed a number of cracks on the blade extending toward its tip, which I suspect will probably continue to degrade the knife unless conservation work is performed. I need to examine the microstructure of the blade using metallography to confirm this interpretation, a method that would permanently damage the knife.

Childs

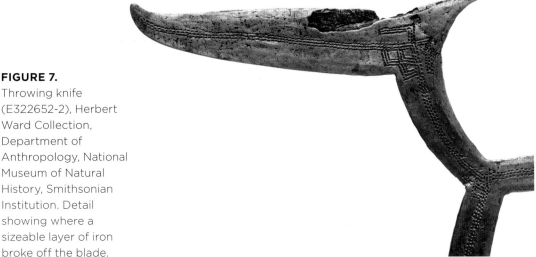

FIGURE 7.
Throwing knife (E322652-2), Herbert Ward Collection, Department of Anthropology, National Museum of Natural History, Smithsonian Institution. Detail showing where a sizeable layer of iron broke off the blade.

CONCLUSION

I was able to use the stylistic studies of collectors and scholars to tentatively iden-
tify the ethnic group from which this throwing knife was made. The studies by
Westerdijk and Elsen suggest that the knife was forged by the Ngbandi or Mban-
ja, who lived in what is now the northern Democratic Republic of the Congo
and southern Central African Republic, just north of the Congo River on which
Ward traveled.[11] The tendency for master smiths to copy the styles of craftsmen
from other cultural groups; the influences of trade, particularly involving in-
terested white travelers and traders at the time that Ward was in this area; and
other social factors make it difficult for me to pinpoint the exact derivation of
the throwing knife. A future line of inquiry that should be pursued toward this
end is a study of the designs on the blades, which may mimic patterns used in
scarification or to decorate other significant material culture from the region.

Insights into the life history of the knife through the skills of the blacksmith
who forged it and the person(s) who used it were also of great interest to me. I
used an array of materials analysis techniques in conjunction with standard sty-
listic methods to achieve a reasonable glimpse into this life history. Through the
use of binocular microscopy and X-rays, I know that throwing knife E322652-2
was made by a blacksmith skilled in hammering out and cutting pieces of iron to
create an elaborate shape. He clearly controlled high temperatures and appropri-
ate atmospheres in his forge to enable him to fold and firmly weld several pieces
of iron together because the weld joins never cracked or became bent, which
would have rendered the knife unusable.

The large section of iron that broke off the left blade, however, suggests to
me that the smith was not perfect (Figure 7). He did not fully fold and hammer
the iron to form the blade because a portion eventually separated and broke off.
On the other hand, it is possible that the oxidation process occurred well after
Ward collected the knife, and therefore the smith's mistake would not have been
noticeable during use. I searched for notes on and/or photographs of the con-
dition of the throwing knife at the time it was acquired by the Smithsonian or
during any subsequent conservation procedures but could not find any to help
in this interpretation.

Materials analysis also gave me insights into the function of the throwing
knife. How much was it used, and was it predominately used as a weapon? Clear-
ly the tips of the two long blades were repeatedly sharpened, which suggests that

it was repeatedly used to cut something, such as meat or wood. The edges of the blades, however, were not clearly sharpened, which would have enhanced the effectiveness of the knife as a thrown weapon. The woven fiber handle cover indicates that the knife was meant to be handled in a way that required balance, but the fabric on the handle was not worn down from extensive use. Also, the smith carefully curved the elbows of the two long blades, which diminished their use for cutting or penetrating, and spent time and effort tapping an elaborate pattern onto the entire surface of the knife with a chisel. These attributes suggest that the knife functioned in cultural spheres other than just warfare. Unfortunately, talking to the original craftsmen and owners of these historic throwing knives is impossible. However, using a combination of a close material analysis and information gleaned from written accounts and photographs from the colonial period sheds light on the multiple ways that these objects were used and valued by Congolese in the nineteenth century.

ACKNOWLEDGMENTS

All the knives illustrated here are in the Herbert Ward Collection, Department of Anthropology, National Museum of Natural History, Smithsonian Institution.

The views expressed here are the author's and do not necessarily reflect the views of the U.S. Department of the Interior.

NOTES

1. The two earliest throwing knives in the National Museum collection are E072729, which was acquired in an exchange with the Museum für Völkerkunde in Leipzig in 1883, and E130935, which was acquired from J. H. Camp in 1889.

2. Eugenia W. Herbert, *Iron, Gender, and Power: Rituals of Transformation in African Societies* (Bloomington: University of Indiana Press, 1993).

3. Patrick McNaughton, *The Mande Blacksmiths* (Bloomington: Indiana University Press, 1988); Colleen E. Kriger, *Pride of Men: Ironworking in 19th Century West Central Africa* (Portsmouth, NH: Heinemann, 1999).

4. S. Terry Childs and David Killick, "Indigenous African Metallurgy: Nature and Culture," *Annual Review of Anthropology* 22 (1993): 317–337; David Killick, "Cairo to Cape: The Spread of Metallurgy through Eastern and Southern Africa," *Journal of World Prehistory* 22 (2009): 399–414.

5. Heather Lechtman, "Style in Technology—Some Early Thoughts," in *Material Culture: Styles, Organization, and Dynamics of Technology,* ed. H. Lechtman and R. Merrill (St. Paul, MN: West Publishing, 1977), 3–20; Pierre Lemonnier, *Elements for an Anthropology of Technology,* Anthropological Papers 88 (Ann Arbor: Museum of Anthropology, University of Michigan, 1992); Bryan Pfaffenberger, "Social Anthropology of

Technology," *Annual Review of Anthropology* 21 (1992): 491–516.

6. Christopher Spring, *African Arms and Armor* (Washington, D.C.: Smithsonian Institution Press, 1993), 75.

7. Robert W. Felkin, "Notes on the For Tribe of Central Africa," *Proceedings of the Royal Society of Edinburgh* 13 (1884–1886): 205–265; Joseph Maes, "Armes de jet des populations du Congo belge," Congo 1, no. 2 (1922): 181–193; Edward E. Evans-Pritchard, *The Azande: History and Political Institutions* (Oxford: Oxford University Press, 1971); Peter Westerdijk, "The African Throwing Knife: A Style Analysis" (Ph.D. diss., Rijksuniversiteit Utrecht, 1988), 31.

8. Westerdijk, "The African Throwing Knife," 22–23.

9. Spring, *African Arms and Armor*, 69.

10. Westerdijk, "The African Throwing Knife," 16–18.

11. Westerdijk, "The African Throwing Knife," 290–291; Jan Elsen, "Aperçu par Complexe Ethnique," in *Beauté Fatale: Armes D'Afrique Centrale* (Brussels: Crédit Communal, 1992), 153.

BIBLIOGRAPHY

Childs, S. Terry, and David Killick. "Indigenous African Metallurgy: Nature and Culture." *Annual Review of Anthropology* 22 (1993): 317–337.

Elsen, Jan. "Aperçu par Complexe Ethnique." In *Beauté Fatale: Armes D'Afrique Centrale*, ed. J. Elsen, pp. 142–254. Brussels: Crédit Communal, 1992.

Evans-Pritchard, Edward E. *The Azande: History and Political Institutions*. Oxford: Oxford University Press, 1971.

Felkin, Robert W. "Notes on the For Tribe of Central Africa." *Proceedings of the Royal Society of Edinburgh* 13 (1884–1886): 205–265.

Herbert, Eugenia W. *Iron, Gender, and Power: Rituals of Transformation in African Societies*. Bloomington: University of Indiana Press, 1993.

Killick, David. "Cairo to Cape: The Spread of Metallurgy through Eastern and Southern Africa." *Journal of World Prehistory* 22 (2009): 399–414.

Kriger, Colleen E. *Pride of Men: Ironworking in 19th Century West Central Africa*. Portsmouth, NH: Heinemann, 1999.

Lechtman, Heather. "Style in Technology—Some Early Thoughts." In *Material Culture: Styles, Organization, and Dynamics of Technology*, ed. H. Lechtman and R. Merrill, pp. 3–20. St. Paul, MN: West Publishing, 1977.

Lemonnier, Pierre. *Elements for an Anthropology of Technology*. Anthropological Papers 88. Ann Arbor: Museum of Anthropology, University of Michigan, 1992.

Maes, Joseph. "Armes de jet des populations du Congo belge." Congo 1, no. 2 (1922): 181–193.

McNaughton, Patrick. *The Mande Blacksmiths*. Bloomington: Indiana University Press, 1988.

Pfaffenberger, Bryan. "Social Anthropology of Technology." *Annual Review of Anthropology* 21 (1992): 491–516.

Spring, Christopher. *African Arms and Armor*. Washington, D.C.: Smithsonian Institution Press, 1993.

Westerdijk, Peter. The African Throwing Knife: A Style Analysis. Ph.D. diss., Rijksuniversiteit Utrecht, Netherlands, 1988.

A Throwing Knife in Motion: The Journey from the Congo to the Smithsonian

Mary Jo Arnoldi

The weapon cataloged as E322652-2 (formerly 322652c) in the collections of the Department of Anthropology at the National Museum of Natural History is a locally forged multibladed throwing knife originally collected by Herbert Ward between 1884 and 1889 in the Congo in the present-day Democratic Republic of the Congo (Plate 6). The knife's three blades and its stem are engraved with a series of geometric patterns, and its handle is wrapped with a woven fiber casing. This knife came into the Smithsonian as part of a larger collection of 2,714 objects from Central Africa donated to the National Museum in 1921 by Sarita Ward, the widow of Herbert Ward. The story of its journey from the Congo to the Smithsonian is a dynamic one, and this essay follows this knife from Africa into the national collections. Throughout its journey the knife accumulated different meanings and values as it circulated within ever-wider world systems. Some of the values and interpretations that accrued to it outside of Africa resonated with

those held by the object's original creators and owners in the Congo region. Others reflected very different orientations and regimes of value.[1]

S. Terry Childs's companion essay provides a material analysis of the knife and other throwing knives in the Herbert Ward Collection, and it includes a discussion of their production in Africa, where they were valued for their iron, for the technology of their metalworking, and as efficient and aerodynamically sophisticated weapons. This essay takes up the story of the throwing knife from its acquisition by Herbert Ward in the Congo to the present. It examines the definitions and values that accrued to this knife as weapon, a commodity, a collectible, a scientific specimen, and a fine art sculpture. These definitions and the values associated with this throwing knife are profoundly shaped by the political and historical context of colonialism in the Congo region, by the personal biography of Herbert Ward, the collector, and by the Smithsonian's National Museum's own history of acquisitions and displays. Never static, these values are reflected in the scholarly research on this and other throwing knives from the Ward Collection.[2] They are also encoded in the knife's museum history and in its display over the past century, as well as in the more recent insertion of Central African throwing knives into the fine arts market.

THROWING KNIVES AND THE MAKING OF THE
HERBERT WARD CONGO COLLECTION

The throwing knife (E322652-2) is one of 55 throwing knives that were acquired by Herbert Ward when he traveled and worked in the Congo Free State (now the Democratic Republic of the Congo) in the mid- to late 1880s. Ward's employment in the transportation division of the Association Africaine Internationale and later with the Sanford Exploring Company took him north and south along the navigable stretch of the Congo River from Pool Malebo (formerly Stanley Pool) to Boyoma Falls (formerly Stanley Falls). Transporting goods up and down the river and stopping along this route at various trading and mission stations provided Ward with many opportunities to acquire objects through both purchase and trade from other Europeans and from Congolese.

In the Upper Congo region throwing knives were a regular part of local tool kits and were used for hunting and warfare. Ward noted in an 1895 journal article, "In the far interior, iron forms the principle element of trade; and iron is a necessity to the Upper Congo natives for the manufacture of their weapons. . . . Every man

in the Upper Congo tribes is more or less able to manufacture his own weapons."[3] Ward's amassing of over 1,700 locally produced weapons and his particular interest in acquiring a broad range of different types, including 55 throwing knives, would also have been made easier by the fact that by the late nineteenth century a well-established system of trade in these weapons within the Congo already existed.

Local manufactured weapons, such as the throwing knives, were potent symbols of manhood and prowess in hunting and warfare among Congolese groups, and their symbolism made them a highly desirable category of collectible for Europeans in the Congo who fashioned themselves as intrepid explorers and adventurers. Although Ward may have shared similar sentiments with other European men in the Congo, the sheer number and variety of weapons that he collected strongly suggest that his collecting impulses went far away and beyond merely accumulating mementoes or securing the material symbols of warfare and the colonial pacification of this African region.

In addition to his collection of weapons, Ward also assembled more than 800 other objects. He acquired over 30 carved figures along with hundreds of objects from well-established categories of material culture. These include costumes and textiles, jewelry and ornamentation, musical instruments, basketry, pottery, and other domestic wares. An analysis of his collection in its entirety supports the interpretation that Ward's collecting philosophy was intended to be a typological exercise in line with broader scientific interests of his day. Ward appears to have consciously set out to document variations in form, multiple techniques of manufacture, and the full range of local materials used in Central African material culture assemblages, including metal, ivory, stone, wood, clay, leather, gourd, feathers, bark, grasses and other fibers.[4]

Ward's family biography gives us a clue to his collecting philosophy. Ward's great-grandfather was a leading London taxidermist, and his grandfather, Henry Ward, was a taxidermist who traveled with James Audubon on collecting expeditions to the United States in 1828 and 1831.[5] Edwin Ward, Herbert's father, was described in the family accounts as a distinguished naturalist.[6] Considering the Ward family's long-standing interest and involvement in the field of natural history and in collecting, it would not be at all surprising that the young Herbert Ward would have already had a working familiarity with the basic principles of natural history taxonomy and a methodology for collecting when he arrived in the Congo. That Ward's philosophy embraced a loosely defined scientific purpose is also supported by the fact that he kept

notes on where he had acquired objects, and he later created a summary catalog that organized the objects into lots.[7]

For Ward, making the collection of weapons was clearly a typological exercise. But focusing on weapons also had a practical dimension. Iron weapons, unlike other objects he collected made of wood, clay, and other more fragile materials, are relatively durable and less subject to destruction or extensive damage from various pests, local environmental conditions, or the vagaries of shipping the collection down to the coast and overseas back to London.

Finally, and not insignificantly, Ward, who was an artist, paid attention to the formal attributes of the objects he collected, which was clearly a factor in his interest in acquiring throwing knives. In an 1895 article he wrote, "In the manufacture of weapons, the Upper Congo tribes display a remarkable artistic taste and mechanical ingenuity. Most of the fighting knives manufactured by the tribes far distant from the coast possess an infinite grace of form; and display a high sense of decorative art."[8] Indeed, Ward shared with Central Africans themselves a deep appreciation for the craftsmanship of these weapons. In the Congo especially fine examples of throwing knives were highly prized, and they were regularly used as prestige objects and carried by high-ranking men as part of their sartorial displays.

THE THROWING KNIFE ENTERS
THE SMITHSONIAN NATIONAL COLLECTIONS

It was Ward's scientific purpose above all that convinced the Smithsonian to accept the donation of his collection in 1921. Writing about the collection, Walter Hough, curator in the Department of Anthropology, noted that Ward "had the prescience almost to gather from the Congo natives abundant examples of their weapons and other objects of their arts and industries at a time when such specimens would be of the utmost value to science. That he did not regard these as mere bizarre trophies is shown by his catalogue of the material, preserving them in this way for the studies of ethnologists."[9]

In his object catalog Ward numbered the pieces individually or in lots. He identified them primarily by geographic location and rarely by ethnic group. For Ward and many other Europeans working in the Congo in the 1880s, the Congo River and its tributaries along with trading and mission stations constituted the European cognitive map of the Upper Congo region. It was not until

several decades later that Belgians and others carried out research in the Upper Congo so that the colonial government could classify peoples by ethnic and/or language groups as a strategy to better administer local populations.[10] When the Ward Collection arrived at the Smithsonian in 1921, the throwing knife was listed as a single lot along with 17 others. None of these 18 knives were identified with any specific ethnic group. When the collection was cataloged, the museum staff created a single catalog record for this lot (322652) and then assigned a unique number to each of the 18 throwing knives. The throwing knife that is the focus of this story was cataloged as 322652c, and its unique number was painted on the knife handle itself.

In the mid-1960s Gordon Gibson, the curator for African ethnology, recataloged many of the Central African weapons, including 322652c. He reclassified it as belonging to the Ngbandi ethnic group, and he had a new catalog card created for the knife itself. Gibson based the ethnic attribution on a formal comparison of this knife with similar knives that had been published as Ngbandi in early Belgian colonial ethnographies. An attribution as to origin made by the comparative method is a standard and well-accepted practice in most museums, although it can, as we will see in this case, be problematic. The museum's electronic catalog, which went online in the 1980s, retains the knife's museum history. It includes the original catalog number and scanned images of the 1921 catalog card and the 1960s catalog card created by Gibson. However, the record does not include any mention of what authoritative sources Gibson used to assign this knife to the Ngbandi. Indeed, more recent scholarship on these weapons throws the attribution into question. In his 1988 study of Central African throwing knives, Peter Westerdijk notes that in the Ngbandi case the ethnographic evidence points to the fact that the main users of the type of throwing knife represented by 322652-2 were Mbanja and Ngbandi groups. The historical record is ambiguous about what group actually produced this type of throwing knife. In Westerdijk's analysis of the various sources he suggested that smiths from the Yakoma, a subgroup of Ngbandi-speaking peoples who are well known in the Upper Congo for their ironwork, may actually have produced this type of throwing knife.[11] Scholars of Central African weapons generally agree that both the production and circulation of throwing knives were very fluid in this larger Upper Congo area. Local assemblages among Ngbandi-speaking peoples often included a variety of different throwing knife shapes that were either copied from other groups or acquired through trade with neighbors.[12] The ambiguity about who made the knife

and who used it, as well as how it circulated within the region, is not unique to Central African weapons. It is certainly a challenge when museums set about researching minimally or undocumented objects in their collections. Ambiguity often creates uneasiness among the museum staff trained to assign a precise identification to each object in their collection. Indeed, most museum catalogs, which function primarily as management tools rather than research tools, regularly exclude critical metadata about the object that would underscore any of these historical ambiguities.

CONGO WEAPONS ON DISPLAY: FROM WARD'S PARIS EXHIBIT TO THE SMITHSONIAN'S AFRICAN HALLS

Ward's personal artistic invention of the Congo was graphically revealed in his 1906 installation of his collection in his private exhibit in Paris. Sarita Ward, his widow, explained that her husband arranged "each trophy carefully and symmetrically, with an infinite amount of patience, carrying out his idea with such arresting effect that no one who had ever seen this studio, a veritable museum in itself, could forget the impression of its mystery, its subtle suggestion of the darkness of Central Africa. The sinister poison arrows, the barbaric knives and spears, glinting in a cunningly subdued light against the grey-green walls."[13] Decorative weapon displays dominated three of the gallery's walls and the stairway leading up to the gallery (Figure 1). These weapon displays, which included the throwing knife, are part of a much longer tradition of weapon displays that date back to medieval great halls in Europe. In Ward's weapon installation his aim was to achieve a totalizing aesthetic effect where the individual object is subsumed into the larger decor.[14]

When his collection was donated to the Smithsonian, a condition of the bequest was that the entire collection be put on permanent display (Figure 2). In installing the collection the Smithsonian curators consciously intended to evoke some of the drama that Ward had achieved in his Paris gallery. They hung curtains over the windows to create a somber atmosphere that would be evocative of the atmosphere of the Paris installation. They also mounted animal head trophies on the walls that they then surrounded with decorative displays of African weapons that included the 55 throwing knives. However, despite this nod to the sensory values that had shaped Ward's Paris installation, the museum strove to tame his vision, to impose on it a new scientific order, and to create a more

FIGURE 1.
Herbert Ward's studio museum in Paris (upper floor), prior to 1911. NAA INV 09710100, Photo Lot 4, National Anthropological Archives, Smithsonian Institution.

FIGURE 2.
Installation of the Herbert Ward Collection in the U.S. National Museum (now the National Museum of Natural History) circa 1922. Smithsonian Institution.

pedagogical display. To this end the curators organized the different Central African materials into separate museum cases according to the prevailing categories of material culture study: dress and ornamentation, carved wooden and ivory figures, weapons, and musical instruments (Figure 3).

In each of these typological displays the individual object did retain some of its singular identity as the curators intended visitors to compare like categories of objects with one another. Labels in each of the cases also completed the pedagogical exercise. Texts explained the broad relationships among the objects and gave the visitor a framework within which to interpret these objects as examples of primitive industry.[15]

Despite the overlay of a pedagogical interpretation, the transformation from Ward's private display to the museum's public one was not wholly complete. Although the curators gave a nod to Ward's aesthetic in the decorative wall displays of weapons, the museum displays were much more minimal, and they tamped down the exuberance and cacophony of the original Paris installation. The correspondence between the 1921 anthropology exhibit and Ward's private vision of the Congo is complex. Ward and the Smithsonian anthropologists did share a fundamental belief in the intellectual, moral, technological, and artistic superiority of their late nineteenth-century society. They also shared the same social evolutionary theories about the "primitives," yet their inventions of the "Congo," although parallel, were not identical. Ward's Congo was overtly romantic, impressionistic, deeply personal, and intimate. In contrast, the Congo created by the Smithsonian anthropologists was naturalized, typed, ordered, and classified, and the museum's presentation was stamped with the imprimatur of science. The implied standard of comparison was always modern Western society, and the Congo was clearly defined as developmentally inferior in every category. In the museum's 1921 exhibit the authority of science was invoked to legitimize this interpretation about Africa.

In 1962 the original Ward exhibition was finally dismantled, and in 1969 a new Hall of African Cultures was opened. In the new permanent exhibit a number of Ward's Central African objects were integrated with other African collections from elsewhere on the continent. The exhibit presented a continent-wide narrative, and the decorative displays of weapons, such a striking feature in both Ward's Paris exhibit and in the 1921 Smithsonian installation of his collection, were jettisoned and replaced by a more pedagogical display. In a section titled "Weapons of Central Africa," science won out over decorative display (Figure 4).

FIGURE 3.
Weapons case in the Herbert Ward exhibit in the U.S. National Museum (now the National Museum of Natural History) circa 1922. Smithsonian Institution.

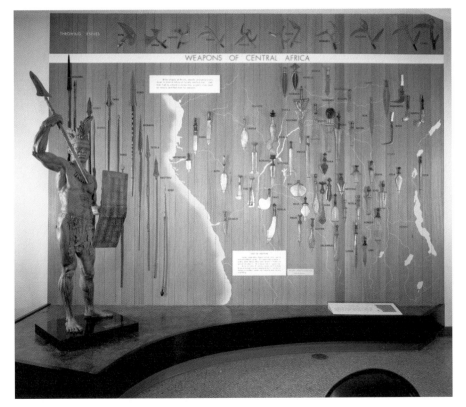

FIGURE 4.
Central African weapons in the Hall of African Cultures, 1969. Smithsonian Institution. Throwing knife E322652-2 is installed on the top row, the fourth knife from the left.

The typological display consisted of a large map of the Central African region on which were drawn the Congo River and its tributaries. Mounted onto this map was a selection of knives and swords, many from Herbert Ward's collection. Beside each object was a label that identified it with a specific ethnic group. Interestingly, the map itself combines the late nineteenth-century European cognitive map of Central Africa with its emphasis on the physical features of river systems with later colonial era maps that highlight the physical location of ethnic groups.

In the case of the throwing knives from the Upper Congo region Gibson installed 11 knives, including 322652-2, in a row above the map. Each type of throwing knife was identified with a specific ethnic group. Presumably, the choice to install the throwing knives above the map was a practical and not a pedagogic decision. Given the scale of the map display and the size and shapes of the throwing knives, it would have been difficult to fit 11 throwing knives in the area of the Upper Congo territory. As a result then, because of their compelling and intricate shapes and their placement off and above the map, the row of throwing knives retains some of the aesthetic effect of the earlier decorative weapons displays.

In 1991 the Hall of African Cultures was dismantled, and in late 1999, a new permanent exhibit, *African Voices*, opened to the public. The former typological display of Central African weapons was abandoned, and the story of African metallurgy was more broadly imagined. A case about metallurgy is included in the section devoted to "Work in Africa," but throwing knife E322652-2 was not selected for inclusion in this case. The case includes objects from throughout the continent, both historic and contemporary objects. On the back wall of the metallurgy case four nineteenth-century Central African prestige knives, including one throwing knife, are juxtaposed against Central African tools from this same time period, including an adze and an axe. Also on display in this case are silver, bronze, brass, and gold objects. The main case labels draw the visitor's attention to the long history of metallurgy on the continent and to the important role that blacksmiths and metalworkers have played in both the past and present in many African societies in the development and transmission of metalworking technology (Figure 5).[16]

CONCLUSION: EVOLVING REGIMES OF VALUE

By the late nineteenth century when this knife's story first began, multibladed throwing knives were still being forged by highly skilled blacksmiths living in the Upper Congo River Basin in what is now the Republic of the Congo, the Central

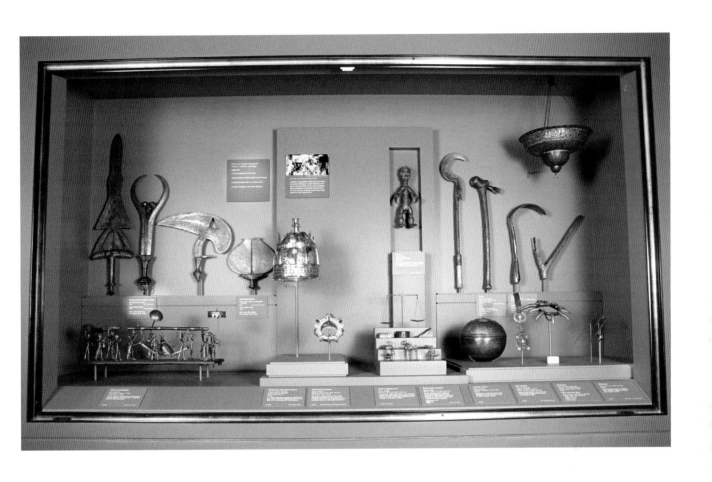

FIGURE 5.
Metallurgy case in the *African Voices*
exhibit. Photo by Donald E. Hurlbert,
Smithsonian Institution, 2000.

African Republic, and the Democratic Republic of the Congo. By the first decades of the twentieth century most of the local production of throwing knives had greatly slowed, although even today older knives from this period retain their value as important symbols of prestige and as ceremonial and ritual weapons. During the late nineteenth and early twentieth centuries large numbers of locally produced weapons, including throwing knives, were acquired by Europeans and Americans who were living and working in the region. Outside of Africa these throwing knives' unique forms excited a certain curiosity and a desire among Western private collectors, like Herbert Ward, and museums, including the Smithsonian, to acquire these knives for study and for ethnographic displays.

Throwing knives entered many museums from officially sponsored scientific expeditions, from donations of private collectors, and from museum purchases. In museums these weapons were often classified and placed in developmental sequences in a social evolutionary paradigm. Outside the public sphere of museums, throwing knives, such as 322652-2, circulated among private collectors as both ethnographic objects and exotic weapons. Although recent studies have attempted to sort out the origins and circulation of the throwing knives, many unanswered questions remain concerning the relationship of colonial ethnic terminology to the populations living in the region, the role of itinerant smiths in the manufacture of these knives, and the circulation of throwing knives more generally among the different groups in the Upper Congo Basin. In the rush by museums to give ethnic labels to particular knife forms, these ambiguities often go unremarked in the records and are regularly ignored in exhibit labels and accompanying catalogs.

Beginning in the late 1980s, African art collectors, dealers, auction houses, and museum curators have elevated Central African throwing knives and other weapons to the status of fine art sculpture.[17] Many art museums, including the Smithsonian's National Museum of African Art, have added a few select weapons to their permanent collections, choosing objects for their form, the quality of their workmanship and finishing, and the fineness of their decoration. Although these highly decorated knives are based on their more utilitarian forebears, they are generally distinguished from them in particular ways. These prestige knives, which were used in the Congo for ceremony and rituals, often have handles made of precious materials like ivory, brass, and copper, or their wooden handles are intricately carved. All of these decorative features would render them impractical as projectile weapons for use in hunting or warfare. When put on display in the museum, they are most often elegantly mounted and presented as fine art sculpture (Figure 6).

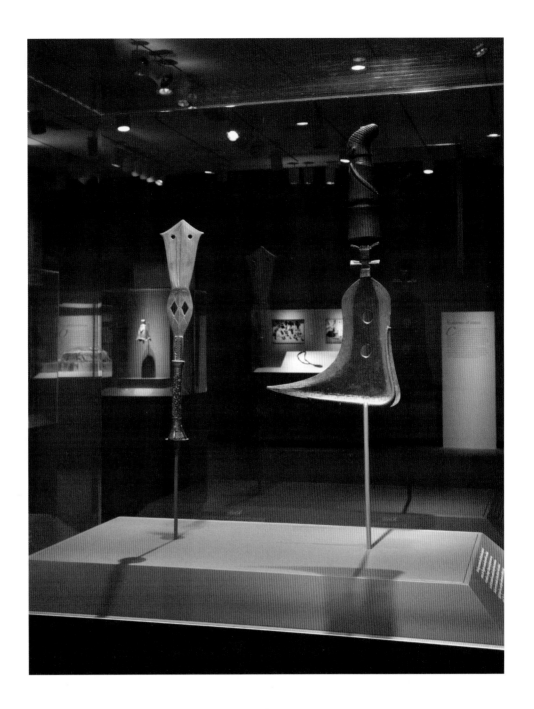

FIGURE 6.
Two knives from the Democratic Republic of Congo (Mangbetu and Yakoma/Ngbandi) in the exhibition *African Mosaic: Selections from the Permanent Collection*, 2013. Photo by Franko Khoury, National Museum of African Art, Smithsonian Institution.

The increasing number of exhibitions over the past 20 years featuring Central African throwing knives as art works and their insertion into the African art market has blurred the lines between these knives' classifications as ethnographic objects and their new identities as fine art sculptures. Not surprisingly, their reclassification as fine art objects has increased their monetary value in the marketplace while simultaneously muting their former identities as utilitarian objects, mementos, artificial curiosities, and scientific specimens. Although this new reading of the throwing knives privileges form over function, it also reflects the very dynamics of an expanding African art market in which similar types of objects once classified as craft, such as tools, furniture, pottery, and textiles, are also being marketed as fine art works. The aesthetic appreciation of Central African throwing knives by fine art museums and African art collectors is not without historical precedence. It resonates with the original Congolese blacksmiths' and owners' appreciation of these knives' manufacture and finishing, and it echoes the appreciation of the aesthetic qualities of the knives felt by early collectors, like Herbert Ward. Throwing knife E322652-2 is elegant and carries decorative patterns on its three blades and stem, but the flaw on its upper blade would most likely have disqualified it for acquisition by many art museums. However, for a material scientist, it is this very flaw that makes the knife of particular interest and that contributes to a better understanding of the technological processes and pitfalls that the blacksmith encountered when forging this knife.[18] E322652-2 is an efficient projectile weapon, a valued commodity, an exotic curiosity and memento, a scientific specimen, and an art work. All of these are legitimate ways of knowing this throwing knife, and when taken together, these different regimes of value reflect the complex cultural biography and life history of this knife as it moved within and out of Africa.

ACKNOWLEDGMENTS

I acknowledge Donald E. Hurlbert and Kristen Quarles of the Imaging Department, National Museum of Natural History for original photography and for their help in locating and digitizing historical exhibition images. I also thank Franko Khoury, National Museum of African Art photographer, and Amy Staples and Hakimah Abdul-Fattah of the Eliot Elisofon Photographic Archives, National Museum of African Art.

1. See Arjun Appadurai, ed., *The Social Life of Things* (Cambridge: Cambridge University Press, 1986), and Nicholas Thomas, *Entangled Objects: Exchange, Material Culture and Colonialism in the Pacific* (Cambridge, MA: Harvard University Press, 1991), for extended case studies of the social life of objects and the ways that objects accumulate values and meanings as they circulate through ever widening world systems.

2. See Childs, "A Throwing Knife through Production and Use," this volume.

3. Herbert Ward, "Ethnographical Notes Relating to the Congo Tribes," *Journal of the Anthropological Institute of Great Britain and Ireland* 24 (1895): 297.

4. Herbert Ward, Drawings, Photo Lot 99-23, National Anthropological Archives (NAA), Smithsonian Institution. In addition to this object collection, Ward made original drawings of objects and included notations in the margins on where he had collected the objects. Ward also made drawings of Africans he worked with or encountered on the river. These sketches were generally full face or in profile and were apparently intended to be records of "racial types" in line with popular anthropological thinking of his day. In the drawings he paid particular attention to details of coiffure and scarification, which he saw as the critical features for distinguishing among the different groups living along the Congo River. A group of 50 of Ward's Congo drawings were given to the National Anthropological Archives by Sir Colville Barclay, Ward's grandson, in 1999. Some of these drawings were used as illustrations in books that Herbert Ward wrote about his time in the Congo and about his observations of local peoples and customs.

5. Alice Ford, *John James Audubon* (Norman: University of Oklahoma Press, 1964), 246; Alexander Adams, *John James Audubon: A Biography* (New York: G. P. Putman's Sons, 1966), 385.

6. Sarita Ward, *A Valiant Gentleman* (London: Chapman and Hall, 1927), 4.

7. Catalog of Ward's Congo collection, box 80, series 4, Gordon Davis Gibson Papers, NAA, Smithsonian Institution.

8. Ward, "Ethnographical Notes."

9. Walter Hough, "An Appreciation of the Scientific Value of the Herbert Ward African Collection," in *The Herbert Ward African Collection* (Washington, D.C.: United States National Museum, 1924), 37–38.

10. Benedict Anderson, *Imagined Communities: Reflections on the Origin and Spread of Nationalism,* rev. ed. (London: Verso, 1991), 164–170. In his discussion of the census Anderson shows the process by which the colonial census in Malaysia and Java codified ethnicity and classified groups in relationship to each other and to the colonial state. Similar processes of census taking in colonial Congo and elsewhere in Africa standardized ethnic group names, and these names continue to be used locally as part of groups' self-identification within and beyond the contemporary postcolonial nation state.

11. Peter Westerdijk, "The African Throwing Knife: A Style Analysis" (Ph.D. diss., Rijksuniversiteit Utrecht, 1988), 268–295.

12. Jan Elsen, "Aperçu par Complexe Ethnique," in *Beauté Fatale: Armes d'Afrique Centrale* (Brussels: Crédit Communal, 1992), 157, 164.

13. Ward, *A Valiant Gentleman*, 165.

14. Harry C. Ellis, photographs of Herbert Ward's sculptor's studio in Paris, 1911, Photo Lot 75-52, NAA, Smithsonian Institution.

15. The text label for the display of wooden sculpture for the U.S. National Museum's 1921 exhibit of the Ward Congo collection read as follows:

Native Fetiches and Wood Carvings

The African native displays much skill in carving wood. He does not hesitate to boldly attempt the fashioning of the human form in his fetiches and this barbaric sculpture achieves what to him are

satisfying works of art and which convey their interest to civilized man. Stools, headrests, and domestic utensils are worked with a view to pleasing forms and decoration.

16. Text labels on metallurgy for the National Museum of Natural History's 1999 *African Voices* exhibit read as follows:

African Metalworkers

Most African metalworkers are men. Skilled craftsmen, they are esteemed for their knowledge of ores and fuels and for their technical command of complex physical processes. In the past, many Africans viewed smelting as a powerful act of creation. The smelter controlled the fire's intense heat to transform ore into useful metals, an act that was likened to human fertility and birth. Although industrial processes have replaced the smelter, modern smiths still work metals to provide essential goods.

Precious Metals Past and Future

Beginning around 2,500 years ago, iron tools revolutionized African agriculture. Over the last thousand years, Africans transmitted iron technologies continentwide. Today, Africa has a majority of the world's chrome, platinum, cobalt, and gold reserves and is stepping up exploration. Mining, refining, and manufacturing go hand in hand with tapping into energy resources and extending transportation and communication networks. African countries are expanding their industrial infrastructure at different rates. One multimillion dollar project will soon link mining, agriculture, and industry along a high-technology corridor extending from Mozambique to South Africa.

17. See Marie-Thérèse Brincard, *The Art of Metal in Africa* (New York: The African American Institute, 1982); Barbara W. Blackmun and Jacques Hautelet, *Blades of Beauty and Death: African Art Forged in Metal* (New York: Oceanie-Afrique Noire, 1990); Crédit Communal, *Beauté Fatale: Armes d'Afrique Centrale* (Brussels: Crédit Communal,1992); William Dewey and Allen Roberts, *Iron, Master of Them All* (Iowa City: University of Iowa Museum of Art, 1993); Marc Leo Felix, *Kipinga: Throwing-Blades of Central Africa* [in English and German] (Munich: Verlag F. Jahn, 1991); Marc Leo Felix, *Beauty in the Blade* (Kansas City: Gallery of Art, University of Missouri–Kansas City, 1998); Christie's, *Tribal Art*, Sale 2443, lots 278, 279, 280, Congo weapons (Amsterdam: December 6, 1999); Marc Ginzberg, *African Forms* (Milan: Skira, 2000); Christie's, *Tribal Art*, Sale 2506, lots 95, 96, 97, Northern Congo knives (Amsterdam: May 29, 2001); Sotheby's, *The Marc and Denyse Ginzberg Collection, African Forms*, Sale PF7027, lots 17 and 26 (Paris: September 10, 2007); Sotheby's, *Important American Indian, African, Oceanic and Other Works of Art from the Studio of Enrico Donati*, Sale N08685, lot 41 (New York: May 14, 2010).

18. See Childs, "A Throwing Knife through Production and Use," this volume.

BIBLIOGRAPHY

Adams, Alexander. *John James Audubon: A Biography*. New York: G. P. Putman's Sons, 1966.

Anderson, Benedict. *Imagined Communities: Reflections on the Origin and Spread of Nationalism*. Rev. ed. London: Verso, 1991.

Appadurai, Arjun, ed. *The Social Life of Things*. Cambridge: Cambridge University Press, 1986.

Arnoldi, Mary Jo. "A Distorted Mirror: The Exhibition of the Herbert Ward Collection of Africana." In *Museums and Their Communities*, ed. Ivan Karp and Steven Lavine, pp. 428–457. Washington, D.C.: Smithsonian Institution Press, 1992.

Blackmun, Barbara W., and Jacques Hautelet. *Blades of Beauty and Death: African Art Forged in Metal*. New York: Oceanie-Afrique Noire, 1990.

Brincard, Marie-Thérèse. *The Art of Metal in Africa*. New York: The African American Institute, 1982.

Christie's. *Tribal Art.* Sale 2443, lots 278, 279, 280. Congo weapons. Amsterdam: December 6, 1999.

———. *Tribal Art.* Sale 2506, lots 95, 96, 97. Northern Congo knives. Amsterdam: May 29, 2001.

Crédit Communal. *Beauté Fatale: Armes d'Afrique Centrale.* Brussels: Crédit Communal, 1992.

Dewey, William, and Allen Roberts. *Iron, Master of Them All.* Iowa City: University of Iowa Museum of Art, 1993.

Ellis, Harry C. Photographs of Herbert Ward's sculptor's studio in Paris, 1911. Photo Lot 75-52. National Anthropological Archives, Smithsonian Institution.

Elsen, Jan. "Aperçu par Complexe Ethnique." In *Beauté Fatale: Armes d'Afrique Centrale*, pp. 142–254. Brussels: Crédit Communal, 1992.

Felix, Marc Leo. *Beauty in the Blade.* Kansas City: Gallery of Art, University of Missouri–Kansas City, 1998.

———. *Kipinga: Throwing-Blades of Central Africa.* [In English and German.] Munich: Verlag F. Jahn, 1991.

Ford, Alice. *John James Audubon.* Norman: University of Oklahoma Press, 1964.

Gibson, Gordon Davis. Catalog of Ward's Congo collection. Gordon Davis Gibson Papers, box 80, series 4. National Anthropological Archives, Smithsonian Institution.

Ginzberg, Marc. *African Forms.* Milan: Skira, 2000.

Hough, Walter. "An Appreciation of the Scientific Value of the Herbert Ward African Collection." In *The Herbert Ward African Collection*, pp. 37–38. Washington, D.C.: United States National Museum, 1924.

Sotheby's. *Important American Indian, African, Oceanic and Other Works of Art from the Studio of Enrico Donati.* Sale No8685, lot 41. New York: May 14, 2010.

———. *The Marc and Denyse Ginzberg Collection, African Forms.* Sale PF7027, lots 17 and 26. Paris: September 10, 2007.

Thomas, Nicholas. *Entangled Objects: Exchange, Material Culture and Colonialism in the Pacific.* Cambridge, MA: Harvard University Press, 1991.

Ward, Herbert. Drawings. Photo Lot 99-23. National Anthropological Archives, Smithsonian Institution.

———. "Ethnographical Notes Relating to the Congo Tribes." *Journal of the Anthropological Institute of Great Britain and Ireland* 24 (1895): 285–299.

———. *Five Years with the Congo Cannibals.* London: Chatto and Windus, Piccadilly, 1890.

———. *My Life with Stanley's Rear Guard.* New York: C. L. Webster and Company, 1891.

———. *A Voice from the Congo.* New York: Charles Scribner's Sons, 1910.

Ward, Sarita. *A Valiant Gentleman.* London: Chapman and Hall, 1927.

Westerdijk, Peter. The African Throwing Knife: A Style Analysis. Ph.D. diss., Rijksuniversiteit Utrecht, Netherlands, 1988.

Iron Lung

Plate 7
Iron lung

Manufacturer: John Haven Emerson Company, Cambridge, Massachusetts
Date: 1931
Materials: Painted metal, rubber, cotton, leather
Measurements: 170.18 cm (67 in) height × 86.36 cm (34 in) depth × 228.6 cm (90 in) length
Catalog number: M-04998
Division of Medicine and Science, National Museum of American History
First used in the summer of 1931 at the Providence City Hospital, Providence, Rhode Island.
Donated in 1941 by John Haven Emerson.
Photo courtesy of Division of History of Medicine and Science, National Museum of American History, Smithsonian Institution.

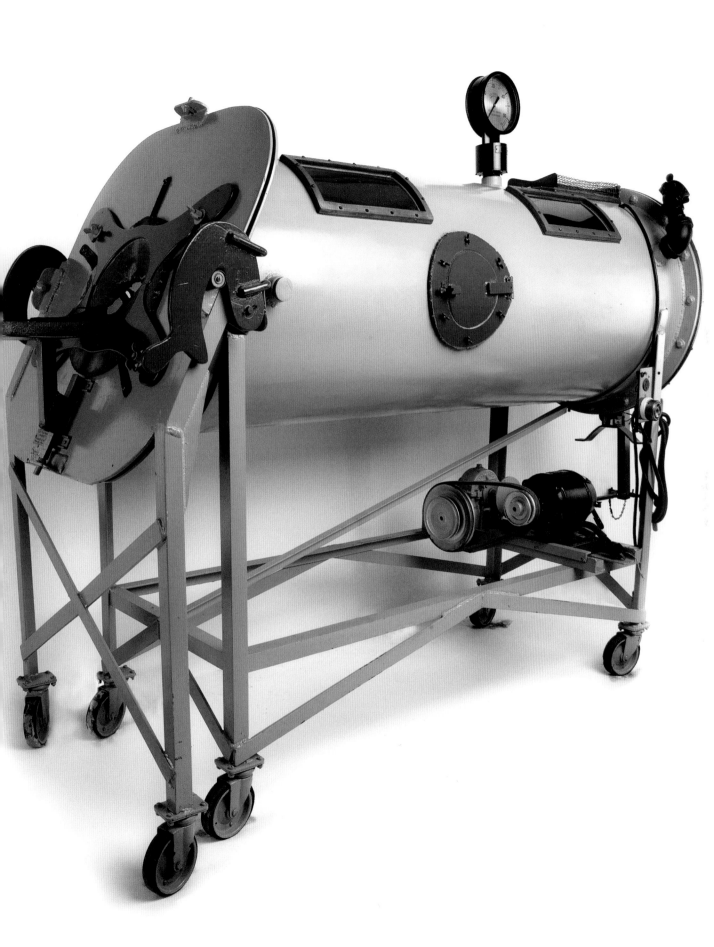

The Iron Lung in History and Cultural Memory

Katherine Ott

The National Museum of American History has three tank respirators and has been offered a dozen or more over the years, each of which was responsible for saving an unknown number of lives.[1] Although the tank respirator, nicknamed the iron lung, figured prominently in the dramatic history of poliomyelitis, it is now an object of mystery and misunderstanding.[2] Both an influential twentieth-century medical device and an iconic artifact related to one of the most dramatic epidemics of the twentieth century, the tank respirator is inextricable from bodies at risk and deep cultural memories of crises. A few years ago, the National Museum of American History mounted an exhibition to mark the 50th anniversary of the Salk polio vaccine. A tank respirator was included. This essay examines how historical interpretation of an object unfolds through research, material examination, and recovery of popular knowledge and folklore. An object itself, such as an iron lung, is basically the same through time. Despite a bit of fading and wear, the iron lung in question was the same in 1931 as it is today. Our need to make sense of it is largely unchanged as well. The accumulation of what we know about this

object, its historical context, and the needs of the passing generations of visitors who have encountered it have added layers of interpretation. My curatorial work depends upon the curators who collected this object long before me, the historians who have added information and context through their scholarship, and the records left by people who used tank respirators.

In material terms, the tank respirator was one piece of a large network of material culture and actions that developed around polio, from splints, casts, and countless surgeries to crutches, wheelchairs, rehabilitation regimens, adapted living techniques, ramps, rocking beds, and more. For the tank itself, there were such things as electrical socket plates marked with "Iron Lung—Do Not Unplug," pillows, diapers for around the neck to prevent sores, sponge bath materials, mirrors, mouth sticks, graffiti, and ephemera taped at eye level. Understanding it within its material community was essential to its gallery interpretation, yet a small gallery in 2005 could never do justice to the larger history.

Poliomyelitis, also called infantile paralysis, is a viral infection that destroys the motor neurons that signal muscles to move. Paralysis is the main consequence of infection, most often of the limbs, swallowing, and breathing. The disease occurred cyclically in the United States at epidemic levels during warm weather from 1894 until the late 1950s. Polio epidemics became progressively worse over the twentieth century, such that in 1952, a record 57,628 cases were reported. There is no cure, and treatment is primarily focused on symptoms. Jonas Salk and Albert Sabin created vaccines in the 1950s that effectively ended polio in the United States through mass immunization. Today, global polio control efforts have reduced its existence to a handful of countries.[3]

The history of the tank respirator actively begins with late nineteenth century devices for resuscitation. In the early twentieth century, versions of the respirator were employed to revive workers accidentally electrocuted or in shock or who had nearly drowned. These tank mechanisms, such as the pulmotor, were sporadically used and unreliable. In 1928, industrial and public health instructor Philip Drinker and colleagues at Harvard University created the first practical respirator and used it to sustain the breathing of an eight-year-old girl with poliomyelitis.[4]

The tank respirator from the museum collections pictured here was designed and built in 1931 by Jack Emerson, also in Boston (Plate 7). Coincidentally, Emerson was the son of the New York City health commissioner who served during the 1916 polio epidemic. The 1916 epidemic wave panicked the East Coast, activating quarantine regulations and mandatory isolation. Emerson dropped out of high

school before graduation and set out to be an inventor. He was an engineer by nature and, after seeing Drinker's respirator, redesigned aspects to make it more efficient and less expensive. He himself had had polio and experienced swallowing difficulty throughout his life as a result. Emerson, as had Drinker, climbed inside and tested his apparatus. The museum's device was first used in Providence, Rhode Island, to save the life of a priest who had contracted polio.[5]

A tank respirator worked by creating negative pressure within the airtight tank, followed by increased pressure from the patient's inspiration. The person's head and neck remained outside the tank. The alternating pressure action maintained respiration artificially until the person resumed breathing independently, usually after one or more weeks. The machine was powered by an electric motor with two vacuum cleaner pumps that simulated a normal breathing rate. An operator used a manual bellows on the foot end when the power was interrupted.

Although most people only spent a few weeks or months in a tank respirator, a few people used them throughout their lives.[6] People with neural damage sufficient to require a tank respirator might also use a rocking bed for periods during the day. A rocking bed tipped the person up and down at an inclined angle like a teeter-totter. Gravity took over during the tipping motion and was sufficient to aid the person's diaphragm in breathing. Some people also used a portable chest device, called a cuirass. It was a miniature, portable respirator that fit tightly over the upper body and created rhythmic breathing while the person was out and about.

A tank respirator was costly, hard to acquire, and cumbersome, weighing over 750 pounds. In the 1930s, one tank respirator cost about $1,500—the average price of a home. Initially, the devices were purchased directly from the manufacturers. Emerson marketed his by traveling around the country with a demonstration tank in a house trailer, stopping at hospitals and taking orders (Figure 1).

The National Foundation for Infantile Paralysis, founded in 1938 by Franklin Roosevelt, began mass distribution of tank respirators in 1939. The March of Dimes, as the foundation was later named, supplied tank respirators to all who needed them, free of charge, and subsidized maintenance of them. They also coordinated rapid mobilization of the devices from one location to another during an outbreak. In 1959, there were 1,200 people using tank respirators in the United States. In 2004, there were 39. Today, portable oxygen tanks with a mask or inhaling tube serve the same purpose. These work through positive pressure, injecting oxygen directly into the body. Tank respirators are still occasionally used for people with ALS disease (Lou Gehrig's disease).

FIGURE 1.

Jack Emerson rigged up a house trailer with an exhibit that included the device as a way to explain its purpose and generate sales. Courtesy of National Museum of American History, Smithsonian Institution, Division of History of Medicine and Science.

The experience of being in a lung and in need of emergency life support was initially all-consuming. Once the crisis abated, the person's relationship with the respirator gradually unfolded. They learned to breathe with a new rhythm, speak on the exhale, eat lying down, sleep through the loud pumping noise, and psychologically adjust to a suddenly altered body and surroundings. Loss of autonomy and the dangers of such complications as over-ventilation, bed sores, airway obstruction, and power outage took a psychological toll. For adults, life in a tank respirator had a negative effect on erotic life and dramatically displaced one's sexual role and behavior as well. The list of emotional responses to dependency on a tank respirator is long and evocative, including panic, anxiety, anger, grief, fear, depression, shame, guilt, gratitude, hopelessness and helplessness, boredom, and determination to live.

One woman explained, "I looked where he pointed and a wave of horror poured over me as I realized *respirator* was another name for what was popularly called an iron lung. … I thought it would be like being in a coffin while you were still alive."[7] After relaxing from the strain of breathing, once the respirator took over, most people fell asleep.

Another person wrote that "no one, not even doctors, can realize the devastation of trying to preserve sanity while living in a lung, drifting through the days, without doing anything, anything of value or even of no value … the total suspension of human being-ness."[8]

Accompanied by anxiety and fear, the device played the central role in staying alive during the acute stage of polio. "I saw the huge gleaming tank, and I cried out in soundless thanks. I had never seen anything more beautiful or more perfectly formed."[9]

The tank respirator also affected the role of the nurse in caring for patients and monitoring their condition. Nurses became the mechanic who managed the machine and the mediator between it and the human inside.[10] Nurses both enforced hospital regimens and rules and exercised compassion in tense circumstances. Interaction between patient and hospital staff also could be brutal: "I would cry a lot. The nurse told me that she would turn off my iron lung if I didn't stop."[11]

Besides its intimate role in the lives of people directly involved with polio, the tank respirator has a unique place in the history of medicine and the role of technology. It was the first effective means of mechanical life support. Before the tank respirator, a person with poliomyelitis that severely impaired his or her breathing would die. It was one of the first devices with which twentieth century medicine was forced

to confront the issues that developed more fully with such later technologies as the heart-lung machine, heart transplants, and other high-tech innovations.[12]

As a life-sustaining technology, its use introduced complicated ethical questions about the distribution of limited resources, quality of life, caregiving, and the responsibility of the state and community that are still debated today. For example, in its infancy, the tank respirator figured at the center of a patent dispute. As a technology entangled with a frightening and unpredictable disease, economic control of the device became contested. Drinker, Collins (the manufacturer of the Drinker model), and Harvard University sued Jack Emerson for patent infringement when Emerson began marketing his version of the apparatus in the early 1930s. Emerson successfully argued that similar devices for artificial ventilation had been in the public domain for decades. Equally important, his allies also claimed that it was morally wrong to patent and restrict use of or profit from such life-saving devices.[13]

The American Medical Association criticized the March of Dimes for its distribution of the devices and assistance for free. Their chief objection was that it was a form of "socialized medicine." Such a system undermined medical practice in its fee-for-service structure.

An issue that doctors and nurses faced during an epidemic was how to choose who to put in the lung. When there were several needy patients and only one or two machines or when hospital staffing and facilities were in short supply, a patient in need of a tank respirator made allocations dramatically difficult. In 1971, physician Lewis Thomas wrote an influential essay on the negative consequences of medicine's "half-way technologies," such as the iron lung.[14] He argued that where medicine fell short of a cure, technology stepped in to create tolerable circumstances and save lives, producing a kind of half-way cure. Thomas questioned whether applying limited resources to half-way measures was efficient and wise, especially if patients had a poor prognosis.

Given the many components of the history of the tank respirator, interpreting it as a material object in a gallery setting required careful deliberation about the purpose and method of its display (Figure 2). Several kinds of information were potentially relevant, including design and technical details of the object, the history of its invention and use, the historical context of the disease, the experiences of those who deployed and maintained the devices, the lives of those who were in them, and the impact of their use on medicine, ethics, and popular culture.

FIGURE 2.
In the museum's 2005 exhibit, the iron lung was flanked by a rocking bed, film clip, poetry, and other supporting materials. A mirror allowed visitors to see the far side (note the illusion of a double iron lung in this photograph). Courtesy of National Museum of American History, Smithsonian Institution, Division of History of Medicine and Science.

There was never doubt that an iron lung would be displayed. Deciding how to interpret it became the issue. The team created the section with enhanced content and assigned more resources to it, which made a sharp contrast to display of the same object some 35 years prior (Figure 3). In the 1970s, when historical memory of tank respirators was fresher and more extensive, curators showed the Emerson respirator in its relationship to resuscitation, with minimal labeling (as was the contemporary style). The most interesting educational piece for visitors to the Museum of History and Technology (as the National Museum of American History was then named) back then was its mechanical lineage. In 2005, visitors' relevant knowledge base was much reduced. Consequently, the exhibition team decided to create a miniature device into which visitors could insert their forearms (Figure 4). The lead designer of the interactive, Vince Rossi, consulted with respirator mechanics in Colorado at the only company still servicing them. The interactive used a vacuum pump and created a sound and sensation similar to those of an actual working respirator. To sensitize visitors to the relationship between the person in the lung and air itself, we used a poem by Mark O'Brien in which he described breathing. A video interview clip of disability activist Ed Roberts, who also spent much of his time in a tank respirator, illustrated an actual device in action, how Roberts breathed in sync with it, and his remarks on his work. Adjacent to the lung, we displayed a working rocking bed. When Jack Emerson first exhibited the lung in a traveling house trailer back in the early 1940s, his purpose was to market it. In the 1970s, its display was in service to a chronology of technological progress. For more recent visitors, the people who used it and why dominated the interpretation. The factual history had not significantly changed in the intervening decades, but the visitors and exhibition style definitely had.

NOTES

1. For more on exhibiting the iron lung discussed in this chapter and the history of polio, see "Whatever Happened to Polio?," National Museum of American History, accessed June 10, 2015, www.americanhistory.si.edu/polio.
2. The origin of the nickname is unknown.
3. Histories of polio include David Oshinsky, *Polio: An American Story* (New York: Oxford University Press, 2005); John Paul, *A History of Poliomyelitis* (New Haven, CT: Yale University Press, 1971); Kathryn Black, *In the Shadow of Polio* (Reading, MA: Addison-Wesley, 1996); Tony Gould, *A Summer Plague: Polio and Its Survivors* (New Haven, CT: Yale University Press, 1995). For the tank respirator, see Howard Markel, "The Genesis of the Iron Lung," *Archives of Pediatrics and Adolescent Medicine* 148 (1994): 1174–1176; David Rothman,

FIGURE 3.
When the iron lung was displayed in the 1970s, curators placed it within the development of resuscitation and oxygen delivery systems. The march of progress in technology dominated interpretation. Courtesy of National Museum of American History, Smithsonian Institution, Division of History of Medicine and Science.

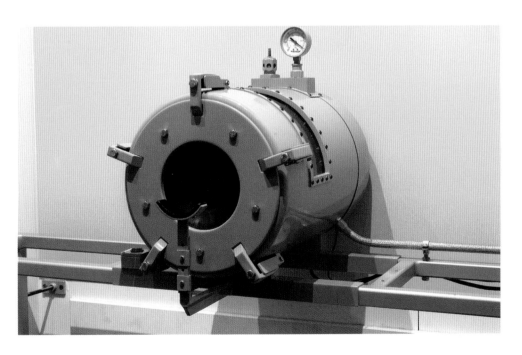

FIGURE 4.
A miniature interactive "iron lung" device created for the 2005 exhibit allowed visitors to place an arm in the device to simulate the suction and pressure experience of an iron lung. Courtesy of National Museum of American History, Smithsonian Institution, Division of History of Medicine and Science.

Beginnings Count: The Technological Imperative in American Health Care (New York: Oxford University Press, 1997), 42–66.

4. Philip Drinker and Charles McKhann, "The Use of a New Apparatus for the Prolonged Administration of Artificial Respiration," *Journal of the American Medical Association* 92, no. 20 (1929): 1658–1660; Philip Drinker and J. Wilson, "A Room-Sized Respirator," *New England Journal of Medicine* 299 (1933): 227–230.

5. See John H. Emerson, "Some Reflections on Iron Lungs and Other Inventions," *Respiratory Care* 43, no. 7 (1998): 574–583.

6. For an account of lifelong use of a lung, see Martha Mason, *Breath: Life in the Rhythm of an Iron Lung* (Asheboro, NC: Down Home Press, 2003); Leonard Hawkins, *The Man in the Iron Lung: The Frederick B. Snite, Jr., Story*, with Milton Lomask (Garden City, NY: Doubleday, 1956).

7. Peg Kehret, *Small Steps: The Year I Got Polio* (Morton Grove, IL: Albert Whitman & Company, 1996), 30–31.

8. Mimi Rudolph, *Inside the Iron Lung* (Bourne End, UK: Kensal Press, 1984), 134.

9. Larry Alexander, *The Iron Cradle*, as told to Adam Barnett (New York: Thomas Y. Crowell Co., 1954), 19.

10. For more on the nurse's relationship to the iron lung see, Lynn Dunphy, "Suffering and Growth in the Shadow of Machines: Nursing and the Iron Lung, 1928–1955," in *Advancing Technology, Caring, and Nursing*, ed. Rozzano Locsin (Westport, CT: Auburn House, 2001), 106–121.

11. Rudolph, *Inside the Iron Lung,* 134.

12. See also Rothman, *Beginnings Count,* 48–60.

13. Stewart Griscom, "Paralysis and Profits," *The Nation* 136 (1933): 225–226; Joseph Rossman, "Drinker Respirator Patents Held Invalid," *Science* 82 (1935): 221–222.

14. Lewis Thomas, "Notes of a Biology-Watcher: The Technology of Medicine," *New England Journal of Medicine* 285 (1971): 1366–1368; see also James Maxwell, "The Iron Lung: Halfway Technology or Necessary Step?" *Milbank Quarterly* 64, no. 1 (1986): 3–29.

BIBLIOGRAPHY

Alexander, Larry. *The Iron Cradle*. As told to Adam Barnett. New York: Thomas Y. Crowell Co., 1954.

Black, Kathryn. *In the Shadow of Polio*. Reading, MA: Addison-Wesley, 1996.

Drinker, Philip, and Charles McKhann. "The Use of a New Apparatus for the Prolonged Administration of Artificial Respiration." *Journal of the American Medical Association* 92, no. 20 (1929): 1658–1660.

Drinker, Philip, and J. Wilson. "A Room-Sized Respirator." *New England Journal of Medicine* 299 (1933): 227–230.

Dunphy, Lynn. "Suffering and Growth in the Shadow of Machines: Nursing and the Iron Lung, 1928–1955." In *Advancing Technology, Caring, and Nursing*, ed. Rozzano Locsin, pp. 106–121. Westport, CT: Auburn House, 2001.

Emerson, John H. "Some Reflections on Iron Lungs and Other Inventions." *Respiratory Care* 43, no. 7 (1998): 574–583.

Gould, Tony. *A Summer Plague: Polio and Its Survivors*. New Haven, CT: Yale University Press, 1995.

Griscom, Stewart. "Paralysis and Profits." *The Nation* 136 (1933): 225–226.

Hawkins, Leonard. *The Man in the Iron Lung: The Frederick B. Snite, Jr., Story*. With Milton Lomask. Garden City, NY: Doubleday, 1956.

Kehret, Peg. *Small Steps: The Year I Got Polio*. Morton Grove, IL: Albert Whitman & Company, 1996.

Markel, Howard. "The Genesis of the Iron Lung." *Archives of Pediatrics and Adolescent Medicine* 148 (1994): 1174–1176.

Mason, Martha. *Breath: Life in the Rhythm of an*

Iron Lung. Asheboro, NC: Down Home Press, 2003.

Maxwell, James. "The Iron Lung: Halfway Technology or Necessary Step?" *Milbank Quarterly* 64, no. 1 (1986): 3–29.

National Museum of American History. "Whatever Happened to Polio?" Accessed June 10, 2015. http://www.americanhistory.si.edu/polio.

Oshinsky, David. *Polio: An American Story.* New York: Oxford University Press, 2005.

Paul, John. *A History of Poliomyelitis.* New Haven, CT: Yale University Press, 1971.

Rossman, Joseph. "Drinker Respirator Patents Held Invalid." *Science* 82 (1935): 221–222.

Rudolph, Mimi. *Inside the Iron Lung.* Bourne End, UK: Kensal Press, 1984.

Rothman, David. *Beginnings Count: The Technological Imperative in American Health Care.* New York: Oxford University Press, 1997.

Thomas, Lewis. "Notes of a Biology-Watcher: The Technology of Medicine." *New England Journal of Medicine* 285 (1971): 1366–1368.

Whatever Happened to the Iron Lung? Visitor Memories of an Iconic Medical Object

Matthew A. White

My grandmother got polio in 1953. She was in the hospital for a year and was a quadriplegic when she came out. The iron lung she used only in the hospital, but the rocking bed was a feature in her house for the last 15 years of her life. To me these are not artifacts, but family stories.

—Jessica, a visitor to Whatever Happened to Polio?

Objects on display in a museum setting often appear sterile and detached of context and human dimension. Although this perceived detachment often works for some artifacts and visitors, it is important to be aware that many objects of contemporary history occupy a powerful place in the collective and individual memories, myths, and imaginations of an individual, country, or community. The "museumification" of these objects can often lead to political or emotional pushback by visitors and a public not ready to relegate their cherished memories to didactic displays and labels.[1] Although recent history suggests that institutional histories enshrined in museums can often conflict with popular memories, museums can also accommodate such memories and incorporate them into their interpretation.[2] When dealing with iconic objects of contemporary history, it is important for museums to be aware of the emotional space certain artifacts occupy in personal and

public memories and even incorporate personal stories into the interpretation when possible. Passionate engagement with objects by visitors can be especially strong for medical and assistive artifacts that interact with our bodies in very intimate and emotional ways, especially those that are part of a larger story of epidemic, disabled children, fear, and threatened communities.[3]

This essay is about memories and stories inspired by one such emotionally sensitive object, the iron lung, and the National Museum of American History's (NMAH) strategy to not only present these stories as part of a their interpretation but also to capture and share visitor memories in the exhibition *Whatever Happened to Polio?* (*WHTP?*). This essay will also explore some of the content of the stories that were shared by those that remembered the polio plague years and the impact that the iron lung had on their lives.[4]

Although *WHTP?* opened on the 50th anniversary of the original vaccine announcement, it was an exhibition about more than just a discovery narrative of the Salk and Sabin vaccines. The exhibition did contain this story, but it also included discussion of the disease's effect on communities; efforts to treat polio victims; long-term effects on communities, individuals, and nations; polio's legacy in the disabled rights political movement; and continuing efforts at global control and eradication of the disease. The exhibition also explicitly confronted many of the relevant ethical issues raised by a close reading of the polio story, including medical experimentation on animals and humans, weighing individual versus community rights when considering issues related to quarantining patients and entire towns, and the issues related to patenting scientific discoveries. It was intended to be a wide-ranging exhibition to engage the tastes, experiences, memories, and learning styles of a number of different types of museum visitor.[5]

The *WHTP?* exhibition team decided early to include the voices of those most closely affected by the disease and those involved in the fight against the virus. This decision was reached after a series of front-end and formative evaluations, under the guidance and leadership of the Smithsonian Institution's Office of Policy and Analysis, suggested that people who lived through the polio epidemic and the announcement of a successful vaccine in 1955 had strong memories of what the disease meant to their families and communities and had a strong desire to tell those stories. Of these evaluations, perhaps the most informative was a series of interviews conducted with visitors to the National Museum of American History to determine their knowledge of the disease and epidemic years and their expectations for an exhibition.[6] This survey was conducted

among 21 visitors to the National Museum of American History a year before the exhibition. As is typical of such surveys, there was a wide range of knowledge and interest exhibited among those questioned. Much of the differences broke along age lines, with visitors old enough to remember the epidemic years knowing a great deal about polio and very interested in attending an exhibition on the topic. As the age of people grew younger and younger and their experience with the epidemic years was less and less, interest and knowledge of the topic also shrank, with our youngest respondents having little or no knowledge of polio.

Throughout the early studies and research conducted by the exhibition team, iron lungs featured prominently in people's memories of polio and in expectations for the exhibition because they are among the most well-known images from the epidemic years. Those old enough to remember the disease recalled seeing images of people in iron lungs each summer as local and national media reported the latest outbreaks. Regardless of age or experience, visitors reported a strong desire to know how they worked and what it was like to depend on an iron lung for breath. Some reported having friends who lived in iron lungs, and others reported a deep fear of ending up in an iron lung, with one visitor explicitly ranking it among the horrors of the twentieth century along with lynching and the Holocaust.

Memories from polio survivors were especially intense. Many survivors reported strong memories of their time in an iron lung, with one consultant refusing a tour of NMAH's storage areas for fear of seeing one again. Other former iron lung users quickly put the brakes on the exhibition team's plans to include an immersive area that would include the sounds of an iron lung ward and the smell of boiled wool used in therapy. Some memories are just too close to the surface to engage lightly. However, those who did not contract polio wanted to hear about those memories and stories. All of the surveys and evaluations demonstrated a strong desire by potential visitors to hear the personal stories of those who lived through the plague years of the mid-twentieth century, especially those who had lived through contracting the disease and experienced an iron lung first hand and were well acquainted with, in the words of one respondent, "the grim fact of living your life in an iron lung."

Whatever Happened to Polio? ultimately featured a number of different components related to the iron lung, including an iron lung, a working rocking bed, a positive pressure respirator, photos and labels explaining the history of the apparatus, and artifacts and explanations related to various therapies and treatments for polio. The exhibition even featured a hands-on miniature iron

lung–like device that used compressed air to demonstrate how these devices worked on a visitor's arm. A staffed interpretive cart included a build-your-own iron lung demonstration model using a balloon, rubber band, and soda bottle with written instructions on how to make your own at home. Every section of the exhibition was augmented by oral histories and quotes from those who lived during the epidemic years, giving a personal introduction to each section and a number of oral histories and films of polio survivors.

Although these personal touches to the exhibition proved popular during a series of prototyping sessions with NMAH visitors, the exhibition team also found that people had a strong desire to share their own experiences of the epidemic years to make sure their stories and the stories of people they knew who were affected by polio were not forgotten. Therefore, the team was determined to provide a space both for visitors to record their stories and for those stories to be shared with other visitors. Toward this end, the exhibition included a comment station that encouraged visitors to share their stories (Figure 1). Staff was hired and volunteer docents were recruited to work in the gallery at an interpretive station in part to elicit these stories and post the more poignant or informative memories prominently in the gallery.[7] The volunteers were often polio survivors, health professionals who had worked with polio sufferers or on research, and Rotary International officers and volunteers who had worked on inoculation campaigns around the world (Figure 2).

Over 10,000 of these cards were created during the 18-month run of the exhibition. As with any exhibition element that invites anonymous visitor feedback, we received a considerable variety of responses. A number of visitors, although many fewer than we had hoped, provided captions for the photographs we provided for prompts. Many visitors, especially those with a personal connection to the narrative, complained that their favored portion of the story did not receive the attention they felt it was due. Many visitors would have preferred more treatment for Rotary International, the March of Dimes, Sister Kenny, and even for Jonas Salk and Albert Sabin, although they were featured prominently. Of course, we also received a number of doodles, many relevant to the exhibition, but most not (Figure 3). However, many more visitors, whether of their own volition or at the prompting of museum staff, decided to share their personal memories of polio and what it meant to them. Among those stories, the iron lung played a starring role. The quotes in the following sections are all taken from the comment cards collected during the run of the exhibition.

FIGURE 1.

A station was provided in the *Whatever Happened to Polio?* exhibition for visitors to provide their own stories and opinions. Visitors were invited to share their own stories or provide a caption for one of the six photos on the wall. National Museum of American History. Courtesy of National Museum of American History, Smithsonian Institution, Division of History of Medicine and Science.

FIGURE 2.

A full-time, professional gallery interpreter was hired to sort through visitor responses and to post them in the gallery. Courtesy of National Museum of American History, Smithsonian Institution, Division of History of Medicine and Science.

FIGURE 3.

An example of a comment card in the exhibition. Not everyone took the task as seriously as others, but even doodles such as this can help museum staff understand its visitors' experiences. Courtesy of National Museum of American History, Smithsonian Institution, Division of History of Medicine and Science.

When considering the place of an artifact like the iron lung in American history, an object that looms as large in our collective and individual memories of the post–World War II era as the coonskin cap and fallout shelters, it is important to consider these stories alongside scholarly studies and academic research. These short stories provide a glimpse at where objects like the iron lung reside in the American imagination.

FEAR

Memories of the polio years are dominated by fear. Commenters reported being taught to be afraid of swimming in pools (called "polio water" by one commenter) and recalled parents who panicked at the least pain or muscle stiffness and enforced "polio naps" to stave off fatigue in the middle of the summer. Central to the fear of polio was the image of people, especially children, in iron lungs and other assistive devices. Some parents, according to a few respondents, even used images of children in iron lungs to enforce hygiene and discipline.

> I was born in 1954 & remember my mother not allowing us to swim in public pools or ponds (ocean only) and never, never drinking from a water fountain. . . . The "iron lung" was enough to bring fear into the minds of all us young children at the time.

> I grew up in Brooklyn NY during the 50's. I remember our periodically being lined up by class and taken to the auditorium in PSS 138 for our polio shots. It was only when we saw kids on TV who were in iron lungs and heard our parents whisper about people who'd been exposed to the disease did we get it.

> This exhibit reminds me of my childhood in the '50's and my mother's great fear of us getting polio—she kept us away from crowds—no public swimming—showed us pictures of children in iron lungs. She tells the story of after dressing me as a toddler one a.m., I was unable to walk. She was in terror I had polio. To her great relief she discovered she put both of my legs in one leg of my underwear!

FRIENDS IN IRON LUNGS

Although dominated by fear, stories of interaction with people in iron lungs elicited a broad range of often contradictory emotions and memories, not all of them negative. Many times familiarity bred yet more fear, other times respect.

My dad's best friend and best man in his wedding got polio in the early 1950's and was paralyzed. I remember going to visit him as a child (early 1960's) and seeing his iron lung and motorized wheel chair. It scared me to death and I remember it well today.

The minister who baptized me contracted polio shortly thereafter. My parents took me to see him for many years as he lay in his mechanical bed & iron lung. He had only been ordained for a few months. An immobile & "disembodied" voice coming to me from his tall bed helped me overcome the anxiety of being in conversation with a voice belonging to someone I couldn't see—an apt description of prayer.

NEIGHBORS AND IRON LUNGS

One theme of *WHTP?* was the power of community to cope with the disease whether that community was a small quarantine town or a nation raising money for research. Many of the stories shared in the exhibition included memories of communities reacting to a member inflicted with polio and recovering from life in an iron lung.

One of my best friends was a polio victim and was not predicted to live. He was taken to an isolation hospital away from everyone and placed in an iron lung. Our community pitched in when he was allowed to return to Dripping Springs, TX, and helped with physical therapy, feeding, clothing, and education.

I had a neighborhood friend contract polio in the early 50's. He was paralyzed & in an iron lung for a year. When he came home he had to learn to walk again, so we all made up games George could play—Throw the Crutch etc. etc.

LIVING FROM AN IRON LUNG

The desire to continue living a normal life, even with a family member in an iron lung, was strong. Commenters shared a number of stories of parents and other loved ones trying to continue living a normal life while requiring the use of an iron lung on a daily basis.

My mom loved FDR! She contracted polio in Arlington, VA in August, 1946. I was the first baby born in an iron lung—Nov. 29, 1946 at D.C. General (then Gallinger Hospital). Dr. John P. delivered me, I was 7 lbs. My mom by then was only 70 lbs. She remained in an iron lung for 2+ years.

My mother used an iron lung from when she was stricken with polio at 9 years old until her death at age 19. My father also was dependent on an iron lung from a young

age. They met at a therapy meeting and were married a year later. They had a happy but short marriage. My mother passed away due to complications after my birth. My father is now 58 and very vigorous.

THE MARCH OF DIMES AND IRON LUNGS

The March of Dimes figures prominently in any collection of memories of the polio years. They paid not only for the research that culminated in the vaccine announcement of 1955 but also for treatment of those afflicted with the disease.

> My mother, Loreta W., came down with polio when she was 3–4 months pregnant with me in 1953. I was born in Waco, TX and was named after 2 children who were in the polio ward with her. I was born in an iron lung. She already had 1 daughter & though she never walked again, she and my dad raised us. The March of Dimes paid for someone to come to our house during the day.

However, not all the memories of the March of Dimes are uniformly positive or warm. Some polio survivors and their friends and family recall being forgotten when the organization declared victory and moved on to other causes.

> My friend Doris contracted polio in 1955. She visited me in Louisville and became ill. I put her on a plane to Detroit and she was put in an iron lung that night. She had a one-year-old son. Her devoted husband Leonard never left her side. She lived for 30 years paralyzed from the neck down. The March of Dimes stopped all aid to her financially and her nurse's aid when they changed to just helping birth defects. . . . She gave me her autograph collection when she knew she was dying without the meds she needed. It included the autograph of Jonas Salk.

FAMILY MEMBERS IN IRON LUNGS

Family members and ancestors who contracted polio, survivors and nonsurvivors alike, are remembered as heroes, and visitors were quick to seek out staff in the exhibition to tell their stories.

> My father contracted the polio virus when he was young. My grandfather (his dad) thought that the "iron lung" would only teach my dad to be weak so he forced my dad to ride one mile a day on his tricycle to strengthen his legs and lungs. He never talks about it.

> My father, a military man, contracted polio in late 1948–early 1949. He was treated in an iron lung but with determination and support from his commander, he remained in the Air Force and returned to flying duty completing 34 years of service in 1974.

In addition to stories of surviving iron lungs, some people shared stories of parents and other relatives who helped in the treatment of those in iron lungs and were equally remembered as heroes.

> My mother was a nurse who worked at one of the few polio wards with an iron lung in Massachusetts. Just two days ago she was talking to me about how the power went out one evening (early 1960's I think) and she rushed back to her patient's room so she could work the iron lungs by hand until the power returned. She remembered her arms burning from the work but she talked him through it, letting him know she wasn't going to leave his side until the power returned.

> My uncle, Raymond A., M.D. was a pediatrician in Muncie, Ind. An epidemic struck, I believe around 1950, there were no available iron lungs. His friend, a clever auto mechanic, & uncle Ray quickly assembled makeshift iron lungs from beer barrels, canvas used as the diaphragm, and vacuum cleaners.

HEALTH CARE WORKERS AND IRON LUNGS

Health care workers also visited the exhibition, sometimes in organized trips from local hospitals or retiree groups. Many of these visitors shared stories of treating patients in iron lungs.

> I was a student nurse in Ann Arbor on April 12, 1955. I worked on a polio ward iron lung unit. I thought that the patients would be depressed with the announcement but they were elated. No one else would suffer.

> As a young student nurse in 1950 I helped care for patients confined to the Drinker respirators in my hospital. Seeing those machines again in this exhibit evoked the feeling of apprehension I had each day as I approached the isolation ward where infectious diseases were treated. I cared for these people each day while I was scared stiff that I might be the next victim.

Not all memories or stories of health care during this period were positive. Poor care in some facilities was central to many stories shared in this exhibition.

> My mother had polio as a child, she told me about the iron machine she endured for nearly 4 years. While in the iron lung, the neck pad wore thin & cut her neck. Nobody believed her. The nurse finally found it when the blood puddled on the floor. This left a scar (physical and emotional) for the rest of her life.

> My father died of polio in September of 1959, shortly before my younger sister's 4th birthday. He came down with "the flu" over Labor Day weekend. When he developed acute breathing problems, he was taken to the local hospital. This hospital had an iron

lung, but ironically no one knew how to use it. He was finally transported by ambulance to the state's university hospital, where he remained for 12 days until his death.

CHILDHOOD MEMORIES OF LIFE IN AN IRON LUNG

Among the hundreds of stories of reaction and interaction with the iron lung, those who actually lived in an iron lung shared very few. Of those survivors who did share their stories, it is not surprising that many of those who needed an iron lung were children at the time, given the time that had elapsed. It is an interesting perspective from those who did not always understand what was happening to them. Most were proud of their recovery and attribute it to hard work, luck, or divine intervention. These stories were among the most detailed, poignant, and popular with other visitors.

> At age 5 I contracted polio the same year the Salk vaccine was developed. I missed being inoculated by 3 months. I spent 9 months at Children's Hospital in Baltimore—2 of them in an iron lung. In my ward were 20+ or − children similarly affected and I thought *all* children had to go through this; like a rite of passage.

> In August 1955 while I was vacationing at my Grandfather's farm in central, PA I contracted polio. On my Birthday, August 3th, I was diagnosed as the 13th area victim of polio. Once I was diagnosed my Aunt drove to Pittsburgh to pick up enough vaccine at the University of Pittsburgh to inoculate all my brothers, sisters and cousin who might have been exposed. I spent the next 6 months in Spangler General Hospital in an "iron lung" and packed in steaming hot towels. My mother, who was very religious, got the nun's to pray for my health because the doctors told her I would never recover. My next recollection was in a crib with a cage on top at night. I pulled my self up to a standing position and started to cry because my legs felt as if a million needles were puncturing them. Suddenly the lights were turned on and a nurse came in and was all excited that I was standing. My mother told me it was a miracle. In 1970 I was playing football for Langley High School and blocked a punt as the newspaper said, "I raced thirty yards for a touchdown." For years I had both articles in my wall together until they fell apart. As a reminder of how far I had come.

RESPONSES OF YOUNGER VISITORS

Although the exhibition resonated with a large number of NMAH visitors, the exhibition team initially failed to address the concerns of those who were born well after the Salk and Sabin vaccines. These younger visitors had no experience or memory of iron lungs and just wanted to know how they worked. The

White

FIGURE 4.
Gallery interpreter Elisabeth Kilday (left) works with volunteer Nancy Savignac (middle) and intern Ashley Carr (right) to answer visitors' questions, demonstrate hands-on activities, and listen to visitors' stories. Putting a trained interpreter in the gallery was successful in eliciting memories from many visitors and helped raise the quality of the feedback cards. Courtesy of National Museum of American History, Smithsonian Institution, Division of History of Medicine and Science.

exhibition team worked with staff of NMAH's Hands On Science Center to create a simple device docents used to demonstrate how the iron lung worked through negative pressure and placed it on the interpretive cart (Figure 4). The popularity of this improvised teaching tool was a reminder that no matter how powerful an object looms in our collective memories, sometimes people just want to know how things work.

> Seeing the iron lung was really amazing—I had heard of them from my mom, who grew up in the 50's—but could never picture it. I couldn't get my head around anything that seemed so unbelievably sci-fi.

CONCLUSION

When the Smithsonian's National Museum of American History created a team to develop the exhibition that would ultimately be titled *Whatever Happened to Polio?*, it was with the mission to "tell the story of polio, primarily from the perspective of the patient, the story of the vaccine development that ended it, and the story of the survivors and the changes they have made in American society."[8]

From the very beginning, stories were at the heart of *WHTP?*, whether those stories were part of the exhibition research and design, supplied through oral histories in various AV presentations, or shared between visitors at the interpretation cart or comment station in the exhibition. Although there was a surplus of research into polio, the vaccines, and the iron lungs surrounding the 50th anniversary of the Salk vaccine, this research could only go so far in presenting a

full narrative of what the polio epidemics meant to America and the space medical and assistive artifacts, especially iron lungs, occupy in our memories and imagination. Truly understanding these objects and interpreting them for our visitors required us to listen to our visitors, especially those most closely touched by our objects, and to allow them a voice to help us frame a narrative and context for the artifacts we displayed. Ultimately, the exhibition team may have learned as much, if not more, from visitors as the visitors learned from the exhibition.

NOTES

1. For consideration of the process of museumification, see Susan A. Crane, "Memory, Distortion, and History in the Museum," *History and Theory* 36, no. 4 (1997): 44–63; Barbara Kirshenblatt-Gimblett, *Destination Culture: Tourism, Museums, and Heritage* (Berkeley: University of California Press, 1998).

2. Arguably the most famous controversy of this type was the National Air and Space Museum's planned *Enola Gay* exhibition. See Edward Tabor Linenthal and Tom Engelhardt, *History Wars: The Enola Gay and Other Battles for the American Past* (New York: Metropolitan Books, 1996). For a broader discussion of the exhibition of iconic objects at the Smithsonian, see Amy Henderson and Adrienne Lois Kaeppler, eds., *Exhibiting Dilemmas: Issues of Representation at the Smithsonian* (Washington, D.C.: Smithsonian Institution Press, 1997).

3. For a broader discussion of the use of memory in museums, see Susan A. Crane, ed., *Museums and Memory,* Cultural Sitings (Stanford, CA: Stanford University Press, 2000); Selma Thomas, "Private Memory in a Public Space: Oral History and Museums," in *Oral History and Public Memories*, ed. Paula Hamilton and Linda Shopes (Philadelphia: Temple University Press, 2008), 87–100.

4. For more on the exhibition *Whatever Happened to Polio?,* see the virtual version of the exhibition at www.americanhistory.si.edu/polio (accessed July 2, 2015); see also David Serlin, "Making Disability Public: An Interview with Katherine Ott," *Radical History Review* 2006, no. 94 (2006): 197-211.

5. For the most complete recounting of the story of polio in America and the development of the two vaccines, see David M. Oshinsky, *Polio: An American Story* (Oxford: Oxford University Press, 2005); Jeffrey Kluger, *Splendid Solution: Jonas Salk and the Conquest of Polio* (New York: G. P. Putnam's Sons, 2004).

6. Andrew J. Pekarik, "Coded Excerpts from Interviews with Visitors to the National Museum of American History, Behring Center Regarding Plans for an Exhibition on Polio" (report, Office of Policy and Analysis, Smithsonian Institution, Washington, D.C., 2004). All evaluations were supervised by Andrew Pekarik, a staff member of the Smithsonian's Office of Policy Analysis and a core member of the *Whatever Happened to Polio?* exhibition team. In addition to the interviews discussed here, evaluations included title testing, formative evaluations of exhibition elements during design and construction, prototyping of interactives, remedial evaluation of the interpretive cart, tracking studies in the completed exhibition, and other less formal studies. Of all the evaluations, only the title test report was formally written and published. See Office of Policy and Analysis, "Polio Exhibition Title Test" (Smithsonian Institution, Washington, D.C., 2004), http://www.si.edu/content/opanda/docs/Rpts2004/04.07.Polio.Final.pdf.

7. This was a very traditional implementation of a comment station. Since this exhibition was closed in 2006, the use of visitor-generated content has become more popular and creative. For more information and recent examples, see Nina Simon, *The Participatory Museum* (Santa Cruz, CA: Museum 2.0, 2010), http://www.participatorymuseum.org/read/; Ben Gammon and Xerxes Mazda, "The Power of the Pencil: Renegotiating the Museum-Visitor Relationship through Discussion Exhibits at the Science Museum, London," *Exhibitionist* 28, no. 2 (2009): 26–35. For an example of a more rigorous analysis of comment cards see Andrew J. Pekarik, "Understanding Visitor Comments: The Case of Flight Time Barbie," *Curator* 40, no. 1 (1997): 56-68.

8. This quote is taken from the original exhibition proposal used for planning and fundraising: Patricia Gossel, "Exhibition Proposal for 'WHATEVER HAPPENED TO POLIO? [Tentative title]," internal memorandum, National Museum of American History, Smithsonian Institution, December 2, 2002.

BIBLIOGRAPHY

Crane, Susan A. "Memory, Distortion, and History in the Museum." *History and Theory* 36, no. 4 (1997): 44–63.

———, ed. *Museums and Memory*. Cultural Sitings. Stanford, CA: Stanford University Press, 2000.

Gammon, Ben, and Xerxes Mazda. "The Power of the Pencil: Renegotiating the Museum-Visitor Relationship through Discussion Exhibits at the Science Museum, London." *Exhibitionist* 28, no. 2 (2009): 26–35.

Gossel, Patricia. "Exhibition Proposal for 'WHATEVER HAPPENED TO POLIO? [Tentative title]." Internal memorandum, National Museum of American History, Smithsonian Institution. December 2, 2002.

Henderson, Amy, and Adrienne Lois Kaeppler, eds. *Exhibiting Dilemmas: Issues of Representation at the Smithsonian*. Washington, D.C.: Smithsonian Institution Press, 1997.

Kirshenblatt-Gimblett, Barbara. *Destination Culture: Tourism, Museums, and Heritage*. Berkeley: University of California Press, 1998.

Kluger, Jeffrey. *Splendid Solution: Jonas Salk and the Conquest of Polio*. New York: G. P. Putnam's Sons, 2004.

Linenthal, Edward Tabor, and Tom Engelhardt. *History Wars: The Enola Gay and Other Battles for the American Past*. New York: Metropolitan Books, 1996.

National Museum of American History. "Whatever Happened to Polio?" Accessed July 2, 2015. http://www.americanhistory.si.edu/polio.

Office of Policy and Analysis. "Polio Exhibition Title Test." Smithsonian Institution, 2004. http://www.si.edu/content/opanda/docs/Rpts2004/04.07.Polio.Final.pdf.

Oshinsky, David M. *Polio: An American Story*. Oxford: Oxford University Press, 2005.

Pekarik, Andrew J. "Coded Excerpts from Interviews with Visitors to the National Museum of American History, Behring Center Regarding Plans for an Exhibition on Polio." Report, Office of Policy and Analysis, Smithsonian Institution, Washington, D.C., 2004.

———. "Understanding Visitor Comments: The Case of Flight Time Barbie." *Curator* 40, no. 1 (1997): 56-68.

Serlin, David. "Making Disability Public: An Interview with Katherine Ott." *Radical History Review* 2006, no. 94 (2006): 197-211.

Simon, Nina. *The Participatory Museum*. Santa Cruz, CA: Museum 2.0, 2010. http://www.participatorymuseum.org/read/.

Thomas, Selma. "Private Memory in a Public Space: Oral History and Museums." In *Oral History and Public Memories*, ed. Paula Hamilton and Linda Shopes, pp. 87–100. Philadelphia: Temple University Press, 2008.

Portrait of John Brown

Plate 8
Portrait of John Brown (1800–1859)

Artist: Augustus Washington (1820/1821–1875)
Date: ca. 1846/1847
Materials: Quarter-plate daguerreotype; silver-plated copper sheet
Measurements: 10.1 cm (4 in) height × 8.2 cm (3.2 in) width
Catalog number: NPG.96.123
National Portrait Gallery
Purchased in 1996 with funds donated by Betty Adler Schermer in honor of her great grandfather, August M. Bondi.

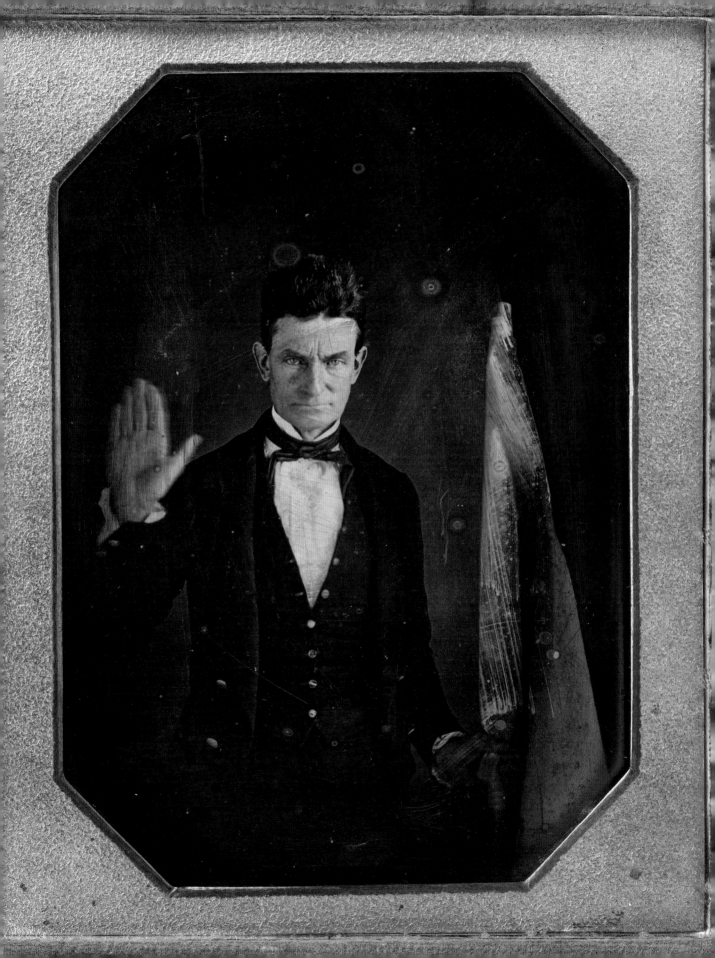

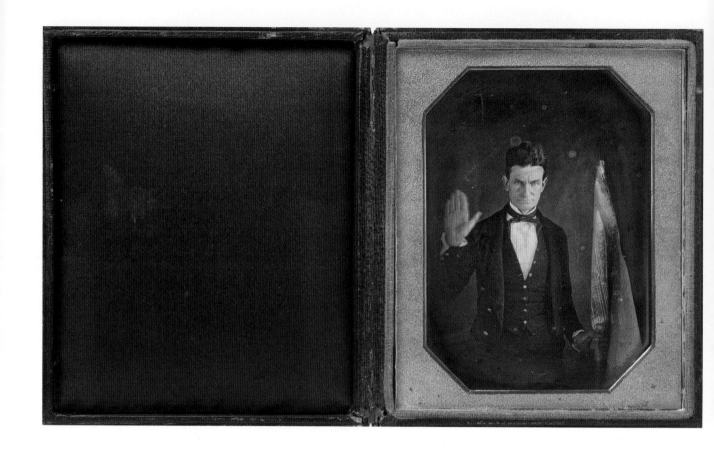

FIGURE 1.
John Brown (1800–1859) by Augustus
Washington (1820/1821–1875). Quarter-plate
daguerreotype, ca. 1846/1847. National Portrait
Gallery, Smithsonian Institution. Purchased with
major acquisitions funds and with funds donated
by Betty Adler Schermer in honor of her great-
grandfather, August M. Bondi. NPG.96.123.

Augustus Washington: Daguerreotypist of John Brown

Ann M. Shumard

In October 1996, the National Portrait Gallery acquired an extraordinary daguerreotype of the radical abolitionist John Brown (Figure 1). It is now one of the most familiar likenesses of Brown, but for nearly a century the unattributed daguerreotype was known solely through poor-quality copy images until the long-lost original was rediscovered at a Pittsburgh auction in April 1996. Believed to be one of the earliest portraits of John Brown, the daguerreotype's riveting image is rivaled only by the fact that its maker was Augustus Washington, one of the nation's first African American photographers. Numerous biographers have chronicled John Brown's life, but when his daguerreotype entered the Portrait Gallery's collection, relatively little was known about its creator. The desire to learn more about Augustus Washington and to understand how he came to produce this iconic daguerreotype sparked the Portrait Gallery's intensive effort to document Washington's life and career. The biography that emerged was one of a remarkable individual.

Augustus Washington was born 1820 or 1821 in Trenton, New Jersey, where he was raised by his father and stepmother, both of whom had been slaves in their youth.[1] A bright and diligent student, Washington attended school with white children until the age of 12 or 13, when his opportunities for such schooling ended abruptly—a consequence of growing white hostility to the abolition movement. Left to continue his studies on his own initiative, Washington drew inspiration from antislavery newspapers, including Benjamin Lundy's *Genius of Universal Emancipation* and William Lloyd Garrison's *The Liberator*, which fueled his passion for learning and instilled in him a profound hatred of slavery and prejudice. After working for his father for several years and studying intermittently, Washington briefly conducted a small school for black children in Trenton before renewing his efforts to continue his formal education.

Acting on the advice of a prominent abolitionist, Washington enrolled in the Oneida Institute in Whitesboro, New York, in 1837. One of the few institutions of higher learning then actively engaged in recruiting African Americans to join its predominantly white student body, this progressive academy and college offered a curriculum that combined academics with a program of manual labor. Washington remained at Oneida for nearly a year and a half, completing both the preparatory course and his freshman year before a shortage of funds compelled him to leave school and find steady employment.

Washington soon settled in Brooklyn, New York, where he assumed teaching responsibilities for the African Public School in 1838. He also served as a subscription agent and correspondent for the influential black weekly newspaper the *Colored American* and began to take part in a host of reform movements. Like many African American abolitionists, Washington voiced strong opposition to the American Colonization Society's campaign to send free blacks and manumitted slaves to Africa, and in January 1839 he participated in a major anticolonization meeting held in New York City. The following year, he attended the annual meeting of the American Anti-Slavery Society and also served as a delegate to the Convention of the Colored Inhabitants of the State of New York held in Albany. He subsequently organized mass meetings in support of a petition drive to secure unrestricted suffrage for New York's black residents and assisted in founding a temperance society.[2]

Although Washington earned praise for his work as a teacher in Brooklyn, he was eager to resume his own education. For assistance in finding a school that would "receive and prepare for College, a colored student, without distinction on

account of color," he turned to friends in the abolitionist community. Inquiries were made on his behalf, and in 1841, Washington was accepted by the Kimball Union Academy in Meriden, New Hampshire. After successfully completing his studies there, he was admitted to Dartmouth College in 1843, becoming the only African American member of the student body at that time.[3]

When Washington entered Dartmouth, the cost of attending that college could reach as much as $200 per year. Although he received $25 each quarter from a benefactor, he faced the difficult challenge of paying the balance himself and was already in arrears by the time Dartmouth's three-month vacation commenced in the winter of 1843. Washington hoped to secure a teaching post during this break, but he was rejected by white schools on racial grounds and by black schools because of their reluctance to hire a teacher on a short-term basis. After his parents proved unable to assist him financially, Washington became one of the first African Americans to enter the promising new field of photography when he "was favored in learning the Daguerrean [sic] Art, merely as a means to an end—for profitable employment during [school] vacations."[4]

The first practical method of photography, the daguerreotype revolutionized picture making when it was introduced to the world by its originator, Frenchman Louis-Jacques-Mandé Daguerre, in 1839. The first American daguerreotype was produced in late September 1839, and by February 1840, the nation's first commercial daguerreotype studio had opened for business in New York City.[5] It took several more years to refine and improve the daguerreotype process, but by 1843—when Augustus Washington acquired his first camera—daguerreian studios were springing up in cities large and small. On February 24, 1843, a New York correspondent for the *Daily National Intelligencer* newspaper reported that "a Frenchman has opened a shop in Fulton street for the sale of apparatuses for daguerreotyping so that any pedlar [sic] can take up the trade."[6]

To produce a daguerreotype, a highly polished plate of silver-clad copper was exposed to vapors of iodine and bromine to produce light-sensitive silver salts on the surface of the plate. After the sensitized plate was exposed in the camera, the latent image was developed by fuming it with heated mercury. The resulting image was "fixed" by immersing the plate in a solution of sodium chloride or sodium thiosulfate, after which it was washed in distilled water and dried. To heighten the image's contrast and permanence, daguerreotypes were typically toned with gold chloride.

Upon returning to Dartmouth, Washington quickly parlayed his newly acquired skill into a successful enterprise by daguerreotyping members of the college's faculty and residents of the town of Hanover, but he later put his camera aside when the business interfered with his studies. Without the means to pay a college debt now totaling $120, Washington withdrew from Dartmouth at the close of his freshman year, fully intending to resume his studies at a later date. He left behind a personal library of 150 books, as well as his daguerreian apparatus, when he moved to Hartford, Connecticut, in the autumn of 1844, to take charge of one of that city's schools for black students.[7]

The Connecticut capital offered more to Washington than just employment, for as one of New England's principal cities, it was a thriving center of commerce and culture. Although Hartford's African American community was then relatively small, it was energized by the presence of activists such as Reverend James W. C. Pennington—a depot master on the Underground Railroad and himself a fugitive slave—whose Talcott Street (Congregational) Church served as a hub of regional antislavery activity.[8] The church's basement was also home to the North African School, where Washington taught classes from the autumn of 1844 until sometime in 1846. Despite a meager salary, he managed to repay the debts incurred at Dartmouth, and in the summer of 1845, he sent for the books and daguerreian equipment he had left behind in Hanover. Although Washington continued to express the desire to resume his college career, by the close of 1846 he had returned not to Dartmouth but to the practice of daguerreotypy.

On December 17, 1846, Washington advertised the services of his new daguerreian gallery in the *Hartford Daily Courant* newspaper and soon placed long-running advertisements in both the *Charter Oak*, the weekly newspaper of the Connecticut Anti-Slavery Society, and the *Ram's Horn*, an African American newspaper published in New York City.[9]

If Washington hoped those sympathetic to the cause of abolition would find their way to his studio, he must have been gratified when the opportunity to photograph John Brown presented itself soon after Brown opened a wool brokerage business in Springfield, Massachusetts, just up the Connecticut River from Hartford. Brown was already an ardent abolitionist by the time he settled in Springfield in 1846, but once there, his activism intensified. He immersed himself in abolitionist literature emanating from Boston, frequented antislavery meetings, and became well acquainted with many free blacks residing nearby.[10]

The circumstances that brought Brown and Washington together are un-documented, but sometime in the latter part of 1846 or the early months of 1847, Washington created several daguerreotypes of Brown, including the singular image now in the collection of the National Portrait Gallery. Washington was not the only daguerreotypist working in Hartford at the time, but he was the city's only African American daguerreotypist.[11] In light of John Brown's eagerness to engage with members of the black community, his decision to patronize Washington's studio rather than that of a white competitor is not surprising. Together, the photographer and his subject succeeded in creating a portrait that gave tangible expression to Brown's antislavery fervor. Brown is pictured with one hand raised, as if repeating the public pledge he made in 1837 to consecrate his life to the destruction of slavery. Washington intentionally posed Brown with his left hand held aloft so that in the daguerreotype's laterally reversed, or "mirror," image, Brown's gesture reads as his right hand raised in oath taking. With his other hand, he grasps what is believed to be the standard of his Subterranean Pass Way—the militant alternative to the Underground Railroad that Brown sought to establish in the Allegheny Mountains more than a decade before his ill-fated raid on the federal arsenal at Harpers Ferry.

Decades later, John Brown Jr. would recall this daguerreotype's origin, noting that "the [portrait] with [the] flag . . . was taken by a Colored daguereian [*sic*] artist at Hartford, named Washington."[12] It is evident that the association between Brown and Washington did not end with their portrait studio encounter, for when Frederick Douglass traveled to Springfield in February 1848 to promote his fledgling newspaper *The North Star*, he reported that the most interesting part of his visit was a private meeting with John Brown and Augustus Washington. After remarking on the fervency of Brown's antislavery sentiments, Douglass shifted his focus to "Mr. Washington . . . from Hartford, Connecticut," noting, "I found him an amiable, educated, and talented young man, thoroughly imbued with the spirit of reform, and determined to labor for the elevation of his race."[13]

At a time when African American businessmen faced tremendous obstacles, Washington made a success of his Hartford gallery by offering quality daguerreotypes at competitive prices and marketing them to a diverse clientele. In addition to newspaper advertising, he promoted his centrally located studio in ads that ran alongside those of white-owned businesses in Hartford's racially segregated city directories.[14] He also packaged his daguerreotypes in such a way that they became miniature advertisements for his studio. After initially stamping the

gallery's name and location in ink on the silk pad within each daguerreotype's presentation case (as he did with John Brown's portrait), Washington later employed customized cases and framed his portraits with die stamped brass mats bearing the name and address of his Main Street gallery (Figure 2).

FIGURE 2.
Washington Gallery sixth-plate daguerreotype case, ca. 1850. Collection of the Smithsonian National Museum of African American History and Culture (case for 2010.52.1).

Surviving daguerreotypes from Washington's Hartford studio represent a cross section of that city's population, from its most affluent members to those of modest means. Although the vast majority of those portraits represent white sitters (Figure 3), several Washington daguerreotypes of African Americans or those of mixed race have been discovered recently (Figure 4).

Further testament to the popularity of Washington's studio and the broad-based nature of its clientele can be found in the words of the black activist and newspaper editor Martin Delany, who observed, "Augustus Washington, an artist of fine taste and perception, is numbered among the most successful Daguerreotypists in Hartford, Connecticut. His establishment is said to be visited daily by large numbers of the citizens of all classes."[15]

Although Washington's business prospered, John Brown's wool brokerage venture faltered. Despite his efforts to keep it afloat, the business ultimately collapsed, and Brown closed it in the autumn of 1850; he left Springfield the following spring.[16] There is no indication that Brown and Augustus Washington were ever in contact again.

Despite the demands of his daguerreian enterprise, Washington continued to participate in efforts aimed at securing rights and opportunities for African

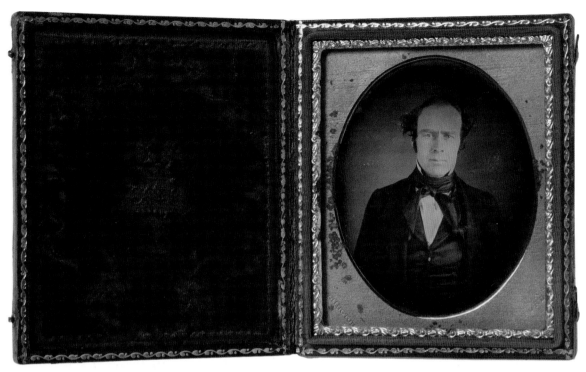

FIGURE 3.
Unidentified man by Augustus Washington (1820/1821–1875). Sixth-plate daguerreotype, ca. 1850. Collection of the Smithsonian National Museum of African American History and Culture, 2010.52.1.

FIGURE 4.
Unidentified young woman by Augustus Washington (1820/1821–1875). Ninth-plate daguerreotype, ca. 1850. Collection of the Smithsonian National Museum of African American History and Culture, 2010.16.

Americans. He served as an occasional correspondent for several black newspapers, including Henry Highland Garnet's *National Watchman* and Thomas Van Rensselaer's *Ram's Horn*. In September 1849, when the first State Convention of Colored Men of Connecticut was held in New Haven, Washington was appointed to its Correspondence Committee for Hartford.[17]

In July 1850 Washington touted the longevity of his Hartford gallery by advertising that it was "now the oldest Daguerrean [*sic*] establishment in [the] city." On September 9, the federal census taker for Hartford recorded the names of Augustus Washington, "Dagarian [*sic*]" (aged 29), and his wife Cordelia (aged 19) and noted in the appropriate column that the couple had married within the year. Although at this juncture Washington's own fortunes were clearly on the rise, those of the African American population at large sustained a severe setback on September 18, 1850, when the U.S. Congress approved the newly strengthened Fugitive Slave Law. This draconian measure jeopardized not only the hard-won liberty of all fugitive slaves but also that of free blacks, who suddenly found themselves vulnerable to seizure as presumed slaves on the slimmest evidence.[18]

On September 30, Washington joined members of Hartford's African American community who gathered in the Talcott Street Church, where they vowed to resist the enforcement of the Fugitive Slave Law and passed a series of strongly worded resolutions condemning it. When those resolutions were later published in the *Hartford Daily Courant*, Washington appeared as a signatory.[19]

In the months that followed, Washington grew increasingly apprehensive about the future. In a long and carefully reasoned letter published in July 1851, he expressed his newfound conviction that within the United States it was "impossible for [African Americans] to develop our moral and intellectual capacities as a distinct people under our present social and political disabilities; and judging from the past and present state of things, there is no reason to hope that we can do it in this country in the future." Declaring his belief that if black Americans were "ever [to] find a home on earth for the development of their manhood and intellect, it [would] first be in Liberia or some other part of Africa," Washington withdrew his longstanding opposition to the African emigration program sponsored by the American Colonization Society and declared his intention to emigrate to Liberia within two or three years.[20]

On March 29, 1853, Washington placed a lengthy advertisement in the *Hartford Daily Courant* announcing that he had completed the arrangements for closing his original studio and a branch gallery in the coming autumn and would

retire "not from a want of any further success or patronage but for the purpose of foreign travel, and to mingle in other scenes of activity and usefulness." Accompanied by his wife and two small children and carrying more than $500 worth of daguerreian supplies, he sailed for Liberia in November 1853.[21]

Upon reaching Monrovia, Washington immediately opened a daguerreian studio and, in doing so, became one of the first resident photographers in West Africa. Within a few weeks he was reported to be doing a brisk business. As he had in Hartford, Washington sought to foster broad-based patronage by inviting the public to call as patrons or visitors at his gallery, where all would "equally receive his polite attention."[22] The few surviving examples of his Liberian portraiture confirm that he succeeded in attracting the patronage of some of the republic's most prominent citizens, such as the wealthy merchant Urias Africanus McGill (Figure 5).

Despite recurring bouts of the malarial (or so-called acclimating) fever that plagued nearly every newcomer to Liberia, Washington persevered with his portrait business. For some months, however, he found it impossible to undertake a series of scenic views of Monrovia commissioned by the American Colonization

FIGURE 5.
Urias Africanus McGill (ca. 1823–1867) by Augustus Washington (1820/21–1875). Sixth-plate daguerreotype, c. 1854. Prints & Photographs Division, Library of Congress.

Society. In the summer of 1854, he at last succeeded in taking several daguerreotypes of the city (now unlocated) that later were reproduced as engravings in publications issued by the Colonization Society.[23]

Washington is also credited with producing a group of 11 carefully posed daguerreotype studies (ca. 1857) of members of the Liberian Senate and their associates, including Liberia's vice president, Beverly Page Yates (Figure 6). These daguerreotypes provide an extraordinary visual record of the young West African republic's elected leadership.[24]

Having expected to earn his livelihood as a daguerreotypist and by operating a small store, Washington soon concluded that these endeavors would be insufficient to secure his future in his new homeland. To generate additional income, he assumed teaching duties at the Alexander High School, built two rental properties in Monrovia, and began cultivating a few acres of the farmland he had acquired some 20 miles from the capital.[25] This modest farm would later become one of Liberia's principal sugarcane-growing concerns.

As Washington strove to balance the demands of his various enterprises, he also expanded the scope of his daguerreian business by extended stays in

FIGURE 6.
Beverly Page Yates (1811–1883) by Augustus Washington (1820/1821–1875). Sixth-plate daguerreotype, ca. 1854. Prints & Photographs Division, Library of Congress.

the neighboring colony of Sierra Leone. In 1857 he advertised his services in Freetown's *New Era* newspaper and noted that his experience included "six years of constant and extensive practice in America, previous to a residence of three years with occasional practice in Liberia." He would later cite his efforts as a daguerreotypist in Sierra Leone, Gambia, and Senegal as contributing significantly to his economic success during his first decade in Liberia.[26]

References to Washington's work as a daguerreotypist became less frequent as his other ventures grew in profitability. By 1860, when the *Hartford Daily Courant* published excerpts from a letter in which Washington discussed his commercial and agricultural pursuits, the newspaper prefaced the text with a brief biographical sketch, observing that Washington "made money enough in Hartford, by daguerreotyping to take his family and self to Africa; there he continued his practice of taking daguerreotypes . . . until he had accumulated money enough to buy and stock a sugar plantation on the St. Paul's river."[27] Washington most likely laid his camera aside when revenue from his daguerreian enterprise was no longer needed to finance his other endeavors. As a daguerreotypist, Augustus Washington had been welcomed as a valuable addition to Liberia. However, expectation remained high that ultimately he would occupy a loftier position in the fledgling republic. He began to play an active role in the public affairs of Liberia and was appointed to a judgeship (1858) before winning a seat in the House of Representatives in 1863. Twice reelected to the House and chosen as its Speaker, Washington won election in 1871 to the Liberian Senate, where he served a single term.

The successes Augustus Washington achieved in his public career paralleled those in his private ventures. His landholdings grew to encompass 1,000 acres, and he also operated several stores and trading factories, as well as a vessel for conducting coastal trade. In 1873, he added newspaper editing to his roster of activities. Then, in October 1875, the *African Repository* reported his death at Monrovia on June 7, noting, "Mr. Washington was favorably known in the New England States, where he was prominently identified with various schemes for the elevation of his race. He acquired a high reputation as a skillful daguerreotypist at Hartford, Conn., from which city he removed to Liberia in 1853. Nothing could induce him to return to [the United States], having acquired a handsome property and freedom and a home in his ancestral land."[28]

Although the practice of daguerreotypy did not figure in his later years, Washington retained justifiable pride in his earlier daguerreian accomplishments

and saw them as an integral part of his identity. In the inaugural issue of his *New Era* newspaper in 1873, he introduced himself to his readers by citing the endeavor that had first brought him acclaim: "We were once an artist, without name, without business, and with an unpopular complexion. We toiled night and day, and in a short time it was said we stood at the head of the profession, with the largest gallery in Hartford, Connecticut."[29] Clearly, the skill once acquired merely as a means to an end had become one of the defining features of Washington's life. It was by means of daguerreotypy that he had earned sufficient funds to finance his emigration to Liberia and to ensure that, once there, he and his family could begin their new lives under agreeable circumstances. In Africa, income from his daguerreian enterprise supported his family and, more important, provided the seed money that launched his successful agricultural and commercial ventures. In daguerreotypy Augustus Washington had found not just the means to an end, but the means to begin anew.

ACKNOWLEDGMENTS

I acknowledge the research assistance of Svend E. Holsoe, Carol Johnson, Christopher A. Saks, and Kimberlee Staking, as well as the support of Smithsonian colleagues Mark Gulezian, Deb Sisum, and Sara Ickow (National Portrait Gallery) and Michèle Moresi, Greg Palumbo, and John Weingardt (National Museum of African American History and Culture).

NOTES

1. Portions of the material contained in this essay can also be found in Ann M. Shumard, *A Durable Memento: Portraits by Augustus Washington, African American Daguerreotypist* (Washington, D.C.: National Portrait Gallery, 1999); Augustus Washington to Reverend Theodore Sedgwick Wright, January 15, 1846, *Charter Oak* (Hartford, CT), n.s., February 12, 1846: 2.

2. "Agents for the American," *Colored American* (New York), January 13, 1838: 4; "Great Anti-Colonization Meeting in New York," *Liberator* (Boston), January 8, 1839: 17; "American Anti-Slavery Society: Roll of Members and Delegates, Present at the Late Annual Meeting of the American Anti-Slavery Society," *Liberator* (Boston), May 29, 1840: 86; "Convention of the Colored Inhabitants of the State of New York . . . Abstract of the Proceedings," *Colored American* (New York), September 12, 1840: 1–2; "Brooklyn Mass Meeting," *Colored American* (New York), January 23, 1841: 3; "Temperance Meeting in Brooklyn," *Colored American* (New York), July 24, 1841: 81–82.

3. Washington to Wright, January 1, 1846, *Charter Oak* (Hartford, CT), n.s., February 5, 1846: 1–2; Washington to Wright, January 15, 1846, *Charter Oak* (Hartford, CT), n.s., February 12, 1846: 2.

4. Washington to Wright, January 15, 1846, *Charter Oak* (Hartford, CT), n.s., February 12, 1846: 2.

5. Keith F. Davis, *The Origins of American Photography, 1839–1885: From Daguerreotype to Dry-Plate* (New Haven, CT: Yale University Press, 2007), 16–18.

6. "From Our New York Correspondent," *Daily National Intelligencer*, February 24, 1843: 3.

7. David O. White, "Hartford's African Schools, 1830–1868," *Connecticut Historical Society Bulletin* 39, no. 2 (April 1974): 47–53.

8. David E. Swift, *Black Prophets of Justice: Activist Clergy before the Civil War* (Baton Rouge: Louisiana State University Press, 1989), 238.

9. Augustus Washington, advertisements, *Hartford Daily Courant*, December 17, 1846: 3; *Charter Oak* (Hartford), December 24, 1846: 3; *Ram's Horn* (New York), November 5, 1847: 4.

10. Stephen B. Oates, *To Purge This Land with Blood: A Biography of John Brown* (Amherst: University of Massachusetts Press, 1984), 58.

11. Elihu Geer, *Geer's Hartford City Directory for 1846* (Hartford, CT, May 1846), 27.

12. John Brown Jr. to Frank B. Sanborn, March 27, 1885, West Virginia State Archives, John Brown/Boyd B. Stutler Collection.

13. Frederick Douglass to William C. Nell, February 5, 1848, *North Star* (Rochester), February 11, 1848: 2.

14. Elihu Geer, *Geer's Hartford City Directory for 1851* (Hartford, CT, May 1851), 144.

15. Martin Robison Delany, *The Condition, Elevation, Emigration, and Destiny of the Colored People of the United States* (1852; repr., New York: Arno Press, 1968), 126.

16. David S. Reynolds, *John Brown Abolitionist: The Man Who Killed Slavery, Sparked the Civil War, and Seeded Civil Rights* (New York: Alfred A. Knopf, 2005), 91.

17. Philip S. Foner and George E. Walker, eds., *Proceedings of the Black State Conventions, 1840–1865* (Philadelphia: Temple University Press, 1980), 2:25.

18. 1850 Census, Hartford, Connecticut, Records of the Bureau of the Census, RG 29, microfilm publications M432, roll 41, National Archives. For the full text of the Fugitive Slave Act (1850) and a discussion of its consequences, see Delany, *Condition, Elevation, Emigration,* 147–159.

19. "For the Courant," *Hartford Daily Courant*, October 24, 1850: 2.

20. Augustus Washington, "African Colonization," *New-York Daily Tribune*, July 9, 1851: 6.

21. "List of Emigrants Who Sailed in Barque 'Isla de Cuba,' from New-York, November 10, for Monrovia, Liberia," *New-York Colonization Journal*, November 1853: 2.

22. J. B. Jordan to Reverend John B. Pinney, January 9, 1854, *New-York Colonization Journal*, March 1854: 2; Augustus Washington, advertisement, *Liberia Herald*, September 3, 1856: 1.

23. Washington to Dr. James W. Lugenbeel, August 30, 1854, Library of Congress, Manuscript Division, American Colonization Society Collection, reel 156, frame 609.

24. Carol M. Johnson, "Faces of Freedom: Portraits from the American Colonization Society Collection," *The Daguerreian Annual,* 1996, 265–278.

25. Washington to unidentified recipient, June 18, 1855, *Hartford Daily Courant*, September 3, 1855, 2.

26. Augustus Washington, advertisement, *New Era* (Freetown, Sierra Leone), June 29, 1857; Washington to unidentified recipient, October 3, 1863, *African Repository* 40, no. 3 (March 1864): 91.

27. "Augustus Washington…" Editorial #4, *Hartford Daily Courant*, February 10, 1860: 2.

28. "Late From Liberia," *African Repository* 51, no. 4 (October 1875): 118.

29. "Interesting Correspondence," *African Repository* 50, no. 8 (August 1874): 225 (reprinted from *New Era*, Monrovia, n.d.).

BIBLIOGRAPHY

1850 Census, Hartford, Connecticut. Records of the Bureau of the Census, RG 29, microfilm publications M432, roll 41. National Archives.

American Colonization Society Collection. Manuscript Division, Library of Congress.

Brown, John, Jr. Letter to Frank B. Sanborn. March 27, 1885. John Brown/Boyd B. Stutler Collection. West Virginia State Archives, Charleston.

Davis, Keith F. *The Origins of American Photography, 1839–1885: From Daguerreotype to Dry-Plate.* New Haven, CT: Yale University Press, 2007.

Delany, Martin Robison. *The Condition, Elevation, Emigration, and Destiny of the Colored People of the United States.* 1852. Reprint, New York: Arno Press, 1968.

Foner, Philip S., and George E. Walker, eds. *Proceedings of the Black State Conventions, 1840–1865.* Vol. 2. Philadelphia: Temple University Press, 1980.

Geer, Elihu. *Geer's Hartford City Directory for 1846.* Hartford, CT, May 1846.

———. *Geer's Hartford City Directory for 1851.* Hartford, CT, May 1851.

"Interesting Correspondence." *African Repository* 50, no. 8 (August 1874): 225.

Johnson, Carol M. "Faces of Freedom: Portraits from the American Colonization Society Collection." *The Daguerreian Annual,* 1996: 265–278.

"Late From Liberia." *African Repository* 51, no. 4 (October 1875): 118.

Oates, Stephen B. *To Purge This Land with Blood: A Biography of John Brown.* Amherst: University of Massachusetts Press, 1984.

Reynolds, David S. *John Brown Abolitionist: The Man Who Killed Slavery, Sparked the Civil War, and Seeded Civil Rights.* New York: Alfred A. Knopf, 2005.

Shumard, Ann M. *A Durable Memento: Portraits by Augustus Washington, African American Daguerreotypist.* Washington, D.C.: National Portrait Gallery, 1999.

Swift, David E. *Black Prophets of Justice: Activist Clergy Before the Civil War.* Baton Rouge: Louisiana State University Press, 1989.

Washington, Augustus. Letter to unidentified recipient. October 3, 1863. *African Repository* 40, no. 3 (March 1864): 91.

White, David O. "Hartford's African Schools, 1830–1868." *Connecticut Historical Society Bulletin* 39, no. 2 (April 1974): 47–53.

Newspaper Sources

Colored American (New York). "Agents for the American." January 13, 1838: 4.

———. "Brooklyn Mass Meeting." January 23, 1841: 3.

———. "Convention of the Colored Inhabitants of the State of New York . . . Abstract of the Proceedings." September 12, 1840: 1–2.

———. "Temperance Meeting in Brooklyn." July 24, 1841: 81–82.

Daily National Intelligencer (Washington, D.C.). "From Our New York Correspondent." February 24, 1843: 3.

Douglass, Frederick. Letter to William C. Nell. February 5, 1848. *North Star* (Rochester), February 11, 1848: 2.

Hartford Daily Courant. "Augustus Washington…" Editorial #4. February 10, 1860: 2.

———. "For the Courant." October 24, 1850: 2.

Jordan, J. B. Letter to Reverend John B. Pinney. January 9, 1854. *New-York Colonization Journal,* March 1854: 2.

Liberator (Boston). "American Anti-Slavery Society: Roll of Members and Delegates, Present at the Late Annual Meeting of the American

Anti-Slavery Society." May 29, 1840: 86.

Liberator (Boston). "Great Anti-Colonization Meeting in New York." January 8, 1839: 17.

New-York Colonization Journal. "List of Emigrants Who Sailed in Barque 'Isla de Cuba,' from New-York, November 10, for Monrovia, Liberia." November 1853: 2.

Washington, Augustus. Advertisement. *Hartford Daily Courant*, December 17, 1846: 3.

———. Advertisement. *Charter Oak* (Hartford), December 24, 1846: 3.

———. Advertisement. *Liberia Herald*, September 3, 1856: 1.

———. Advertisement. *New Era* (Freetown, Sierra Leone), June 29, 1857.

———. Advertisement. *Ram's Horn* (New York), November 5, 1847: 4.

———. "African Colonization." *New-York Daily Tribune*, July 9, 1851: 6.

———. Letter to Reverend Theodore Sedgwick Wright. January 1, 1846. *Charter Oak* (Hartford, CT), n.s., February 5, 1846: 1–2.

———. Letter to Reverend Theodore Sedgwick Wright. January 15, 1846. *Charter Oak* (Hartford, CT), n.s., February 12, 1846: 2.

———. Letter to unidentified recipient. June 18, 1855. *Hartford Daily Courant*, September 3, 1855: 2.

In the Service of Abolitionism: Augustus Washington's Daguerreotype Portrait of John Brown

Frank H. Goodyear III

Augustus Washington's quarter-plate daguerreotype portrait of John Brown from late 1846 or early 1847 functioned to formalize a bond between two men dedicated to the cause of abolitionism. Despite the novelty of photography, Washington and Brown understood this new visual technology and the ritual of portraiture as capable of bringing together their two lives. As Ann M. Shumard explains in her companion essay, each had traveled a different path before their meeting, and although they shared common political goals, each grappled with a specific set of personal challenges. For Washington, securing an education, financial stability, and a sense of belonging as a free African American in the antebellum North were priorities. Brown, having recently moved east to Springfield,

Massachusetts, where he and a partner founded a wool brokerage, longed also for financial security and a more progressively minded community. Although each had his own distinct past, they sought on this occasion in Washington's Hartford studio to assert an uncommon relationship and to affirm their commitment to the struggle to end slavery. The material object that resulted from this exchange in the Connecticut capital—Washington's daguerreotype portrait of Brown now in the collection of the National Portrait Gallery (Plate 8)—was similar to other photographic portraits of the day in its direct frontal, three-quarter-length pose and its featureless backdrop. Given the participants and the composition itself, however, it marks an extraordinary moment in the relationship between the new medium of photography and a reform movement such as abolitionism.

The fact that the two men turned to portrait photography to further their relationship indicates both photography's increasing desirability and the power that portraits wielded within nineteenth-century American society. Unlike a print or a painting that might take days or weeks to complete, a daguerreotype was an efficient medium for producing a portrait. It was also especially effective in conveying likenesses. The rich detail and lifelike immediacy of the resulting image fascinated audiences, and the relative cheapness of the process put it within the reach of a majority of Americans. At midcentury, the growing demand for daguerreian likenesses prompted thousands to take up the camera, including African Americans who traditionally had been marginalized from such artisan trades.[1] Although American daguerreotypists created thousands of individual portraits, the medium had its limitations. Of particular note, it was difficult to produce copies of a specific image. Because each daguerreotype is a unique likeness, creating a copy required that the original image be rephotographed. This practice did occur, especially with highly marketable likenesses; however, the challenges associated with making multiple copies severely limited the circulation of these images. In the case of Washington's portrait of Brown, no other copies of this image are known. Furthermore, it seems never to have been reproduced by an engraver and circulated in the form of a print, another practice employed to increase an image's number.[2]

Regrettably, the specific circumstances behind the creation of this image are little known. Given its uniqueness, however, it can be assumed that it was a private image meant for select audiences. Brown is thought to hold in one hand the standard of the Subterranean Pass Way, an organization that he hoped would convey Southern slaves to freedom and break apart the institution of slavery. Holding up

his other hand as though taking an oath, he presents himself as a soldier in the abolitionist army. However, his pledge before Washington's camera is largely a personal gesture made as much for himself and for Washington as for the larger movement of which they were a part. The daguerreotype's significance to Brown and the manner in which he kept or exhibited it are largely mysteries today. Although it is likely that few would have seen the image in Brown's lifetime, the occasion arguably marked an important private moment in the lives of these two men—one that they felt merited the creation of this object. Face to face in the presence of Washington's camera, they affirmed their mutual respect and their commitment to abolitionism.[3]

The example of Washington's daguerreotype suggests also the capacity of museums and curators to transform the life and meaning of an object. Through display and reproductions, what was once a private image that scarcely circulated has become, since its acquisition by the Smithsonian's National Portrait Gallery in 1996, one of the most iconic images of the famous reformer and of the movement of which he was a part more generally. As a photographic historian, I am reminded often that images have their own lives and that an image's significance is never static, but constantly evolving.

Although this daguerreotype had a limited public life at the time of its creation, abolitionists—not unlike individuals in other commercials enterprises or cultural endeavors during this period—did see photography as a potentially valuable new tool by which to advance their cause. Previous studies of the role that images played in the antislavery movement have centered mostly on the nonphotographic arts. Scholars have demonstrated that paintings, sculptures, and especially popular prints were frequently the vehicle for pointed commentary about slavery's injustices and cruelties. With the expansion of the American art scene and the advent of new printing technologies in the years before the Civil War, artists did create many works meant to elicit support for this campaign.[4] In my research on visual culture in nineteenth-century America, I have been struck that less has been written on the role of photography in this same effort. What function did this new visual medium play? What could it achieve that a painting, sculpture, or print could not? How successful were such images? This essay aims to insert photography into the history of abolitionism and to suggest that Washington's portrait of Brown represents one of the earliest examples of photography in the service of a political cause.

In the early years of photography after its introduction in 1839 select abolitionists came to understand the daguerreotype's potential to affect change.

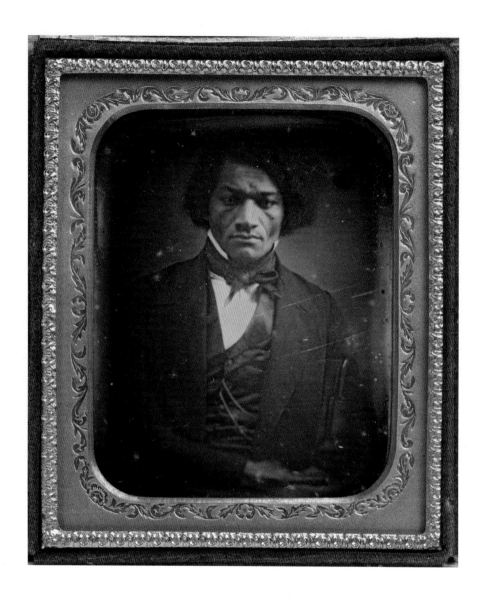

FIGURE 1.
Frederick Douglass by unidentified artist, daguerreotype,
ca. 1850 after ca. 1847 daguerreotype by unidentified artist.
Image: 3 ⅛ × 2 ¹¹⁄₁₆ inches (8 × 6.9 cm). National Portrait Gallery,
Smithsonian Institution. NPG.80.21.

The Amazing Ruby Slippers and Their Magical Travels

Ellen Roney Hughes

From a pair of off-the-shelf shoes to iconic national treasure, the Ruby Slippers in the Smithsonian's National Museum of American History collections have traveled a winding yellow brick road of their own, changing status, location, and meaning along the way. The original magical silver shoes went from L. Frank Baum's imagination to the pages of his novel, where they were given shape by the illustrator in the 1900 *The Wonderful Wizard of Oz* book.[1] Baum's silver slippers were recreated on paper almost four decades later as ruby-red pumps by Hollywood film makers; they materialized from mass-produced footwear purchased and glamorized to sparkle in Technicolor by MGM's costume department, and finally, they were worn by a movie star as a central prop in the 1939 film *The Wizard of Oz*. Their film work done, these red pumps were banished for many years to studio storage and much later were auctioned off for a considerable profit. In the hands of their new owner they existed as personal property and possibly a status symbol before being presented as a (tax-deductible) donation to the museum in 1979.[2] A permanent home at last!

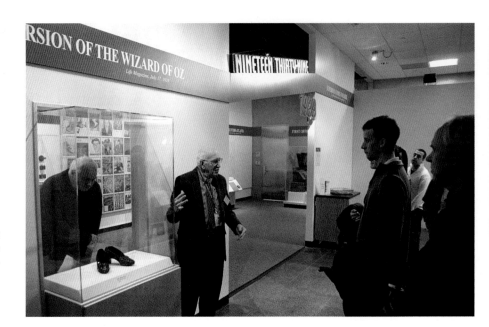

FIGURE 1.
Museum docent Leonard Rodwin giving a tour of the exhibition *1939*. Photograph by Hugh Talman, National Museum of American History, 2011. Ruby Slippers from *The Wizard of Oz* used courtesy of Warner Bros. Entertainment Inc. ™ and © Turner Entertainment Co. (s15)

At the museum the Ruby Slippers' status rose again when they were exhibited as a symbol of movies as a unifying American experience in a diversifying nation. They became highly touted tourist attractions, were enmeshed in academic controversy, starred in their own exhibition cases on the MGM film, and recently traveled around the nation and world as one of America's national treasures (Figure 1). Over the course of this amazing journey, these lovely shoes were handled by manufacturers, costumers, actors, auctioneers, fans, collectors, technicians, and curators. From the beginning, they were seared into the imagination of millions of Oz book and film fans. Inevitably, they also came under the scrutiny of scholars, writers, and museum curators.

The following words from the paper and celluloid lips of the Good Witch instigated a cottage industry of scholars analyzing the 1900 book and 1939 film, including the magical shoes of silver or ruby red:

> The Silver Shoes have wonderful powers. And one of the most curious things about them is that they can carry you to any place in the world in three steps, and each step will be made in the wink of an eye. All you have to do is to knock the heels together three times and command the shoes to carry you wherever you wish to go.[3]

> Then close your eyes and tap your heels together three times.[4]

This analysis did not, however, happen right away. For decades the book and film were largely left alone to be enjoyed by children and adults. Neither format was taken terribly seriously as art or allegory until the 1960s when American scholars

strayed from traditional focus on Milton and Shakespeare and Jefferson and Roosevelt and began looking critically at popular culture. This new social and cultural history promoted the study of events, artifacts, and cultural expressions closer to ordinary Americans' experiences in both the distant and more recent past, including Baum's turn of the century book, *The Wonderful Wizard of Oz,* and the 1939 film it inspired, MGM's *The Wizard of Oz.* The storied shoes came to the Smithsonian just as this new trend in scholarship was unfolding. It was a shift in perspective that significantly changed, even revolutionized, what was studied and collected in museums including at the Smithsonian. In 1980, the National Museum of History and Technology officially changed its name to the National Museum of American History. This name change reflected the new trend in museums, academia, and the history profession at large away from focusing exclusively on customary subjects such as political, military, and technological history toward opening up to the examination of issues of immigration, community life, work, education, sports, and entertainment.

The acceptance of the movie prop shoes during this same period as part of the national collections was part of the museum's refocusing.[5] These shifts were made clear in the choice of museum objects for the expansive 1976 bicentennial exhibition *A Nation of Nations.* On permanent display until 1991 this exhibition of some 5,000 artifacts portrayed America's immigrant heritage. Among the artifacts were such iconic objects as George Washington's Revolutionary War uniform, two rooms of an early colonial house, a windmill, a schoolroom from Cleveland, Ohio, Abraham Lincoln's handball, Muhammad Ali's gloves, a Model T Ford, Thomas Edison's light bulbs, and the Ruby Slippers.[6] This exhibition was the first time that they were displayed at the Smithsonian.

Positioned in the prominent glass case in the "Shared Experiences" section of this exhibit, the artifacts were tersely identified as being worn by Judy Garland as Dorothy Gale in the MGM film. It was here that the magical appeal of these artifacts to visitors was first felt.[7] Their placement in the context of an exhibition that argued for the importance of American entertainment as a unifying experience for most Americans regardless of age, race, or national origin suggested a significance larger than that of a mere film prop. They were featured along with a pantheon of entertainment history artifacts: circus posters, Irving Berlin's transposing piano, a George M. Cohan costume, Minnie Madden Fiske's glittering stage costume, and Howdy Doody and Kermit the Frog puppets, among others. This exhibition was also the beginning of a series of interpretations by various curators that often drew upon the work of film and literary scholars.

By definition, museums' responsibilities include interpreting artifacts, along with collecting, preserving, studying, and displaying them. Without study and interpretation, museums are a muddle of things. Objects usually have meaning for us only through a framework of concepts and assumptions with which we, both curators and audience, approach them. This framework is precisely why interpretation is often the most contested of the scholarly pursuits. We all have our own cherished assumptions about the things and stories we love, and when museums challenge these assumptions, it can be perilous.[8] Over their life history in the museum, our curatorial staff has placed the Ruby Slippers in several different interpretive contexts, and our visitors have reacted both positively and negatively to these new intepretations.[9]

The first exhibition where the shoes were the featured object, *The Ruby Slippers and the Wizard of Oz*, opened in 1991, just after the exhibition *Nation of Nations* closed. This small show, which I curated, featured additional objects that had been added to the collections since 1979: one of the original Baum books, a movie poster and stills, the Scarecrow costume pieces, a page from the movie script (showing a change from Baum's silver slippers to red shoes), and various fan materials such as an Oz lunch box . The exhibition text retold the fundamental fairytale of the book and film, that of a youthful Dorothy Gale and her dog Toto swept away by a storm to a magical land where she meets three other lost souls. The four characters band together, and Dorothy leads them on a quest to find what is most dear to each of them, encountering both enchanted helpers and frightening foes. In the end they find that they each already possessed what they sought. The Tin Woodsman learns that he has emotions, the Lion realizes he is brave, the Scarecrow understands he has brains, and Dorothy finds that she can get back to her home by clicking the heels of the shoes she has been wearing since the beginning of the film's dream sequence. The Ruby Slippers are the bit of magic needed to pull off the impossible. The tale is also in many ways a version of the American story of the rugged individualist, the self-sufficient and exceptional hero or heroine, one who takes on and defeats evil and suspect technology.[10] This straightforward interpretation also highlighted the obvious gender implications, especially because all of the strong main characters— Dorothy, the Wicked Witch of the West, and Glinda, the Good Witch—are female. The flawed characters are male, including the Wizard, who is exposed in the end as a fraud. The exhibition case, with these simple interpretations, remained on public view, and the slippers continued to gain in popularity with the museum's audience.

A few years later, this same exhibition case was reinterpreted by a curatorial colleague at the museum employing basically the same group of artifacts but drawing

upon the work of several prominent historians who argued that Baum's story and its characters were a parable of monetary populism (the failed agrarian revolt in the 1890s) and that the magical silver slippers represented the silver currency favored by William Jennings Bryan's Populist Party.[11] The populist allegory theory was not universally accepted, and it had many critics. A prominent Baum biographer presents evidence that the idea was baseless. Others found no compelling evidence for such an interpretation but suggested that perhaps Baum's tale could have been an unconscious allegory. In any case, the theory makes a memorable (if flawed) explanation of the complicated monetary issues of the Progressive Era that most people today little remember.[12] Regardless, the scholarly debate surrounding these various theories was important for taking Baum seriously as a writer and for viewing his work as social criticism.

In the museum, this economic reinterpretation did not sit well with our audiences, and this exhibit case provoked much comment and consternation. Most visitors were keen on the Ruby Slippers, and few could relate to the little-remembered slice of history that involved only the original silver shoes in the book. Many scholars, and even a Baum descendant, strongly criticized the museum for focusing attention on such a controversial theory.[13] The outcry prompted the museum to return the exhibit text to the more universally accepted theme of the quest, and so the red shoes remained in this case until they began their international travels as an American icon.

Smithsonian's America: An Exhibition of American History and Culture, an exhibit created specifically for Japan, was envisioned by its sponsors as a means to promote understanding and friendship between the two countries. It opened in Chiba, Japan, in 1994.[14] The curatorial staff and I, as senior, selected over 250 important artifacts from the National Museum of American History and the National Air and Space Museum. The artifacts included, among others, a Wright brothers' airplane, an Apollo space capsule, George Washington's mess kit, Edison's earliest light bulbs, a Conestoga wagon, the earliest Levis, the Jim Henson puppet Kermit the Frog, and the Ruby Slippers. All the artifacts were flown to Japan in a jumbo cargo plane and were carefully assembled in a 40,000 square foot exhibition space. Placed in the section on American popular culture, the Ruby Slippers represented the power of American movies to reach across cultures. Although the shoes were exhibited for only six weeks, they were visited by over a million and a half people, many of whom were quite familiar with the *Wizard of Oz* film. The slippers supported the exhibit's goal of mutual understanding among the people of the two countries, and through their international exposure the Ruby Slippers' fame and iconic status increased.

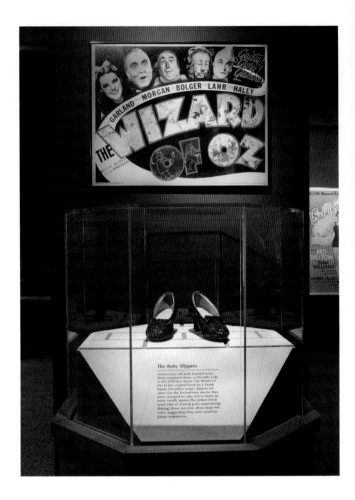

FIGURE 2.

The Ruby Slippers installed in the exhibit *Thanks for the Memories, American Popular Culture.* Photo by Hugh Talman, National Museum of American History, 2008. Ruby Slippers from *The Wizard of Oz* used courtesy of Warner Bros. Entertainment Inc. ™ & © Turner Entertainment Co. (s15)

Once the shoes returned to the United States, the Ruby Slippers began to star in a series of exhibitions that featured objects considered to be American treasures. Because of their popularity, they were included in the exhibition *America's Smithsonian*, a two-year (1995–1997) traveling show created to celebrate the institution's 150th anniversary. In 2008 the museum reopened after a two-year renovation, and the Ruby Slippers went back on view in the exhibition *Thanks for the Memories, American Popular Culture,* curated by Dwight Blocker Bowers (Figure 2). In 2012, the shoes were reinstalled in a new exhibition, *American Stories,* which examined the people, inventions, issues, and events that shape America. Here the Oz story was characterized as a tale of American ingenuity, another notable reinterpretation of these slippers.

What makes the Ruby Slippers and the Oz story so compelling? According to Baum biographer Rebecca Loncraine, the Oz book (and the film it inspired) is a masterpiece of interpretative openness and psychological depth allowing readers

and film fans to construe the fantastical story, its characters, and props in so many different and personal ways.[15] Salman Rushdie did not read the book as a child but was introduced to the story through the film. In his essay "A Short Text About Magic" in his book *The Wizard of Oz*, he interprets *The Wizard of Oz* as an anarchic "film whose driving force is the inadequacy of adults, even of good adults, and how the weakness of grown-ups forces children to take control of their own destinies, and so, ironically, grow up themselves."[16] With regard to Dorothy, "by her adventure's end [she] has certainly grown to fill those shoes, or, rather those Ruby Slippers."[17] The Ruby Slippers, for Rushdie, are a symbol of Dorothy's youthful power, and the movie had a powerful effect on him. He said, "It made a writer of me."[18] In the second half of this book of critical analysis, personal reminiscences, and technical details about the film, he gives us a short story, "At the Auction of the Ruby Slippers," in which he fictionalizes the auction of a pair of Ruby Slippers that were found on the MGM lot and sold for $15,000 to an anonymous bidder. He describes the frenzied atmosphere in the auction salesroom, the circus of attendees, some of whom are dressed as characters from the movie, and the desire that fuels the escalating bidding for the slippers.[19] Indeed, who would not want to possess this symbol of youthful power that can magically transport us at a click of the heels?

If history is a joke that the living play on the dead, as Voltaire suggested, then many of us have had a good laugh at Baum's expense. Baum himself called his work not an allegory, not a history, not reality, but a fairy tale for children, pure and simple. He would most likely be most amused by all the interpretative hullabaloo around the slippers. Although perhaps his tale should stand on its own as an artistic work, it is time and again judged by scholars as either a statement of the author or a representation of some other reality. In fact, most everyone who cares about the magical slippers and the book and film in which they appear has their own personal reasons for loving them and their own interpretations that incorporate the magical shoes into their own dreams and realities. This personalization may be why the Ruby Slippers continue on their journey around the nation, around the world, and in the thoughts of their fans everywhere, shoes no more but icons of our American culture.

ACKNOWLEDGMENTS

I thank Richard Strauss, Alicia Cutler, and Vanessa Pares of the National Museum of American History and Marguerite Roby of the Smithsonian Institution Archives

for their help in locating photographs of historical exhibitions of the Ruby Slippers at the National Museum of American History.

NOTES

1. L. Frank Baum, *The Wonderful Wizard of Oz* (Chicago: George M. Hill Company, 1900). William Wallace "W. W." Denslow (May 25, 1856–May 27, 1915) illustrated the first Oz book.

2. The accession file holds files of correspondence, photographs, and museum forms tracing the history of the acquisition and museum use of the objects. Ruby Slippers accession file, accession 1979.1230, National Museum of American History, Smithsonian Institution, Washington, D.C.

3. Baum, *The Wonderful Wizard of Oz,* 176.

4. *The Wizard of Oz* (MGM, 1939).

5. On these trends within the Smithsonian, see Ellen Roney Hughes, "The Unstifled Muse: The 'All in the Family' Exhibit and Popular Culture at the National Museum of American History," in *Exhibiting Dilemmas: Issues of Representation at the Smithsonian*, ed. Amy Henderson and Adrienne Kaeppler (Washington, D.C.: Smithsonian Institution Press, 1997), 156–175.

6. See Peter C. Marzio, ed., *A Nation of Nations: The People Who Came to America as Seen through Objects and Documents Exhibited at the Smithsonian Institution* (New York: Harper and Row, 1976).

7. So popular were the shoes that the visitors wore holes in the carpet in front of them, and it had to be replaced several times. For the museum, it was a graphic demonstration of the shoes' power as an attraction.

8. Stephen E. Weil, "The Proper Business of Museums: Ideas or Things," in *Rethinking the Museum and Other Meditations* (Washington, D.C.: Smithsonian Institution Press, 1990), 45–56.

9. According to Susan Sontag in her provocative essay, to interpret is to translate for an audience. Interpretation "presupposes a discrepancy between the clear meaning of the text and the demands of the (later) readers. It seeks to solve this discrepancy." Modern criticism looks for the subtext to expose. She calls these contemporary interpretive tactics the "revenge of the intellect upon art." Susan Sontag, "Against Interpretation," in *Against Interpretation and Other Essays* (New York: Farrar, Straus and Giroux, 1961), 3.

10. William R. Leach wrote in an edition of the Baum book, "It helped make people feel at home in America's new industrial economy, and it helped them appreciate and enjoy, without guilt, the new consumer abundance and way of living produced by that economy." His interpretation is based not on the author's unknowable intent but on the circumstances and emotions of the audience. It works just as well for the 1939 film, coming at the end of the Great Depression as it did. William R. Leach, "The Clown from Syracuse: The Life and Times of L. Frank Baum," in L. Frank Baum, *The Wonderful Wizard of Oz* (repr., Belmont, CA: Wadsworth, 1991), 2.

11. Martin Gardner alluded to Baum's politics in his essay "The Royal Historian of Oz": "Aside from marching in a few torchlight parades for William Jennings Bryan, Baum was as inactive in politics as in church affairs [which is to say, pretty inactive]. He consistently voted as a democrat, however, and his sympathies always seem to have been on the side of the laboring classes." See Martin Gardner, "The Royal Historian of Oz," in *The Wizard of Oz and Who He Was*, ed. Martin Gardner and Russell B. Nye (East Lansing: Michigan State University Press, 1957), 29. Henry M. Littlefield built on Gardner's statement in fashioning his compelling argument for a Populist interpretation of the book that remains widely accepted today despite the many scholars who have debunked it; see Henry M. Littlefield, "The Wizard of Oz: Parable on Populism," *American Quarterly* 16, no. 1 (Spring 1964): 47–58.

12. Embellishers include Hugh Rockoff, "The Wizard of Oz as Monetary Allegory," *Journal of Political Economy* 98, no. 4 (1990): 739–760; and Gretchen Ritter, "Silver Slippers and a Golden Cap: L. Frank Baum's 'The Wonderful Wizard of Oz' and Historical Memory in American Politics," *Journal of American Studies* 31, no. 2 (August 1977): 171–202.

13. Ruby Slippers accession file, accession 1979.1230, National Museum of American History, Smithsonian Institution.

14. The exhibition was sponsored by *Yomiuri Shimbun*, a newspaper, and NHK, the Japanese Broadcasting Corporation, and was created by the National Museum of American History with the National Air and Space Museum.

15. Rebecca Loncraine, *The Real Wizard of Oz: The Life and Times of L. Frank Baum* (New York: Gotham Books, 2009), 173. Other interpretations include the shoes as magical healers as in the 2003 Broadway musical *Wicked*, itself interpreted as a "queer and feminist" play; see Stacy Ellen Wolf, "'Defying Gravity': Queer Conventions in the Musical *Wicked*," *Theatre Journal* 60, no. 1 (March 2007): 1–21.

16. Salman Rushdie, "A Short Text About Magic," in *The Wizard of Oz,* Film Classics Series (London: British Film Institute, 1992), 10.

17. Rushdie, "A Short Text About Magic," 10.

18. Rushdie, "A Short Text About Magic," 18.

19. Salman Rushdie, "At the Auction of the Ruby Slippers," in *The Wizard of Oz,* Film Classics Series (London: British Film Institute, 1992), 58–65.

BIBLIOGRAPHY

Baum, L. Frank. *The Wonderful Wizard of Oz.* Chicago: George M. Hill Company, 1900.

Gardner, Martin. "The Royal Historian of Oz." In *The Wizard of Oz and Who He Was,* ed. Martin Gardner and Russell B. Nye, pp. 19–46. East Lansing: Michigan State University Press, 1957.

Hughes, Ellen Roney. "The Unstifled Muse: The 'All in the Family' Exhibit and Popular Culture at the National Museum of American History." In *Exhibiting Dilemmas: Issues of Representation at the Smithsonian*, ed. Amy Henderson and Adrienne Keappler, pp. 156–175. Washington, D.C.: Smithsonian Institution Press, 1997.

Leach, William R. "The Clown from Syracuse: The Life and Times of L. Frank Baum." In L. Frank Baum, *The Wonderful Wizard of Oz*, pp. 1–34. Reprint, Belmont, CA: Wadsworth, 1991.

Littlefield, Henry M. "The Wizard of Oz: Parable on Populism." *American Quarterly* 16, no. 1 (Spring 1964): 47–58.

Loncraine, Rebecca. *The Real Wizard of Oz: The Life and Times of L. Frank Baum.* New York: Gotham Books, 2009.

Marzio, Peter C., ed. *A Nation of Nations: The People Who Came to America as Seen through Objects and Documents Exhibited at the Smithsonian Institution.* New York: Harper and Row, 1976.

Ritter, Gretchen. "Silver Slippers and a Golden Cap: L. Frank Baum's 'The Wonderful Wizard of Oz' and Historical Memory in American Politics." *Journal of American Studies* 31, no. 2 (August 1977): 171–202.

Rockoff, Hugh. "The Wizard of Oz as Monetary Allegory." *Journal of Political Economy* 98, no. 4 (1990): 739–760.

Ruby Slippers accession file. Accession 1979.1230. National Museum of American History, Smithsonian Institution.

Rushdie, Salman. *The Wizard of Oz.* Film Classics Series. London: British Film Institute, 1992.

Sontag, Susan. "Against Interpretation." In *Against Interpretation and Other Essays*, pp. 1–10. New York: Farrar, Straus and Giroux, 1961.

Weil, Stephen E. "The Proper Business of Museums: Ideas or Things." In *Rethinking the Museum and other Meditations*, pp. 45–56. Washington, D.C.: Smithsonian Institution Press, 1990.

Wolf, Stacy Ellen. "'Defying Gravity': Queer Conventions in the Musical *Wicked*." *Theatre Journal* 60, no. 1 (March 2007): 1–21.

September 11, 2001

Plate 10
ID badge, Commander Patrick Dunn

Date: ca. 2001
Materials: Plastic
Measurements: 5.08 cm (2 in) height × 3.81 cm (1.5 in) width
Catalog number: 2004.0141.04
Armed Forces History Division, National Museum of American History
Donated in 2004 by Stephanie Dunn, widow of Commander Dunn.

Robert J. Terry Anatomical Skeletal Collection (not pictured)
Date: ca. 1920–1960s
Accession number: 279084
National Museum of Natural History
1,728 specimens (of known age, sex, ethnic origin, cause of death, and pathological condition)
Transferred in 1967 from the Washington University Medical School, St. Louis, Missouri.

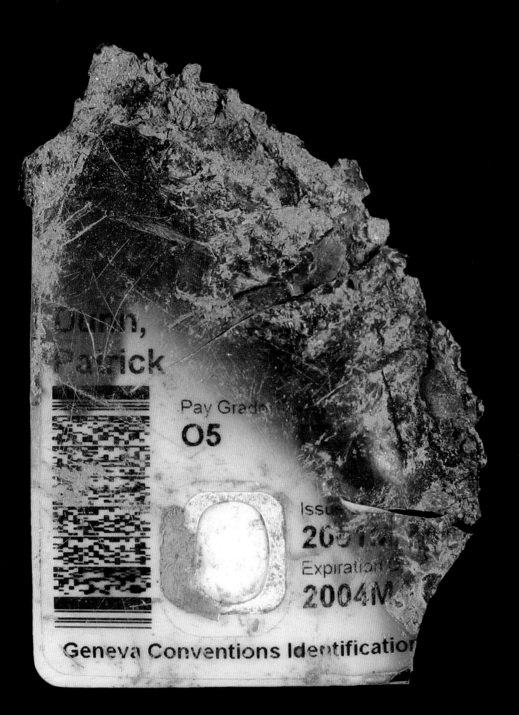

Collecting a National Tragedy: The National Museum of American History and September 11

James B. Gardner

The military ID in Plate 10 belonged to Commander Patrick Dunn, a victim of the terrorist attack on the Pentagon on September 11, 2001. Commander Dunn was the watch commander of the Navy Command Center on the first floor in the D ring of the Pentagon, and was one of 29 people who died in the center when the hijacked American Airlines Flight 77 slid directly into it. His heavily burned ID card was given to the National Museum of American History by Stephanie Dunn, his widow, and was one of many donations to the museum's collections in the weeks and months that followed the attacks of September 11 (Plate 10).[1] It was not, however, a given that the museum would accept this or any donation—contrary to popular belief, the Museum of American History does not collect

anything and everything and really never has, and the decision to collect objects was not made easily.

The Smithsonian has long been known as the "nation's attic," and no museum is more closely identified with that epithet than the National Museum of American History (NMAH). There is an unfortunate popular assumption that, just like one's own attic, the museum is filled to the brim with this and that, with everything imaginable—that it is one of those museums that function, in the words of former Smithsonian Secretary Dillon Ripley, "as storehouses, as catch-alls."[2] More bluntly, in their 2001 book *Legacies: Collecting America's History at the Smithsonian*, Steven Lubar and Kathleen M. Kendrick contend that "despite its familiar and affectionate overtones, the nickname implies mustiness and cobwebs, oddities and castoffs, forgotten and obsolete gadgets, useless junk."[3] They argue that although such a characterization may apply to some of the museum's collections, it does not apply to the majority. While previous generations of curators may have methodically built collections in some areas, the reality is that history collecting today is not so much a systematic science as a subjective art: using their scholarly knowledge and expertise, curators make careful and difficult decisions every day about what to collect and what not to collect. Although one might be able to find instances of "vacuum cleaner" collecting at moments in the past, NMAH's curators today are very selective, focusing on collecting objects with compelling stories that help us make meaning of the past.

Thus, NMAH did not simply go out and start collecting indiscriminately in the wake of the tragic events of September 11, 2001.[4] Despite some initial opportunistic collecting, the curatorial staff recognized the necessity of carefully thinking through what to collect, of making sure that we had a strategy for collecting the larger story, not simply fragments of it. And we realized that moving forward in the usual way within traditional collecting specializations would not work—September 11 was a moment more complicated than could be accommodated under the usual collecting rubrics. We needed to address it not as individual curators or curatorial units but as a museum, working collaboratively toward a larger collecting agenda. The museum's Collections Committee had already scheduled a "conversation on collecting" for that week, so we used that venue to begin discussing how to tackle our collecting roles and responsibilities. In that and later conversations, we tried to sort out what public expectations and professional challenges we would face. What sort of collection would we be expected to build? Would we face pressure to do more than our usual measured collecting? What should a September 11 collection include? How would we, as a history museum, establish and maintain

the historical perspective or distance critical to our work when we were in the middle of unfolding events? How would we deal with the emotions that would certainly frame collecting in this area? Could we do good history at a moment when anger and grief were obscuring perspectives, even our own? But no matter what doubts and questions we had, in the final analysis we did not really have a choice. Although the museum cannot and does not collect everything, we are stewards of the nation's memory and were obligated to collect September 11 materials to ensure that the events of that day were represented in the nation's collections. If any doubt remained, in December 2001 the U.S. Congress formally charged NMAH with collecting and preserving artifacts relating to the terrorist attacks.

But when should we collect? As history curators, we recognize that often the best collecting strategy is to simply wait and see what is valued and held on to through the passage of time, rather than focus on what curators think at the moment is important. But could we really wait in this context? Or was it our responsibility to move in quickly? We soon recognized that between the rescue efforts, the cleanup, and the elements, some things might simply not be available later—not to mention what might disappear in the course of official investigations. Every day of delay could mean lost opportunities to collect and document this important moment. But would urgency on the part of the museum be seen as callous and self-serving? Would we, in effect, be seen as declaring an end to grief, telling people to move on? Although we might feel an ethical obligation to act expeditiously, we also had an ethical obligation to not intrude on those trying to navigate the shock of loss and the depths of grief. We recognized that collecting memorial materials—materials left in makeshift memorials around New York and at the crash sites—would be particularly problematic.[5] Years later, David Shayt, a curator at the Museum of American History reflecting back on his experience, voiced this reluctance: "I felt it would be an act of desecration to collect something off a living memorial."[6] Indeed, collecting those materials and storing them in a museum—removing them from public view—would negate the very purpose of the memorials, the reasons they were created and left. Could museums ethically remove memorial materials from public view, even if the intention was to save them? There was no easy answer—the public complained if the materials were allowed to deteriorate but also complained if they were removed. In the final analysis, NMAH and the other museums involved moved forward with collecting but within a far more emotional context than we were accustomed to.

But beyond the ethical and emotional issues, there were practical challenges that had to be addressed. To begin with, clearly no one museum "owned"

September 11—the terrorist attacks impacted all of us in one way or another, and many museums, particularly in New York, wrestled with how to proceed. What we knew we did not want to do was engage in unseemly competition—we would all be tainted by any suggestion of territorial rivalry. To avoid that, in a rare moment of collaboration, over 30 museums and cultural organizations pledged to communicate and share, to move forward not unilaterally but as a collecting community. In the long run, however, the few unique objects we all wanted proved less problematic than the sheer volume and range of other materials we faced. Although we knew pieces of construction steel from the World Trade Center would be important, evocative pieces, there were tons of it. How much material could any museum realistically collect? Collecting would have to be highly selective, even more so for NMAH than for the other museums. The Museum of American History faced a very different collecting imperative from that of the other museums, each of which was focused on one crash site—NMAH's charge was to develop a collection that would represent all three crash sites. We were responsible not for any one story but for the larger national memory, and that made our collecting agenda fundamentally more challenging.

The National Museum of American History and the other collecting museums not only had to be realistic about how much we could process and house but also had to be prepared to face rather daunting conservation issues associated with the objects. Materials from the crash sites were almost certainly contaminated and even bore traces of human remains. How do you preserve such objects? What treatment is necessary, and how far should it be taken? Should deposits and debris be removed, or are they essential parts of the objects? Would cleaning destroy historical evidence and interpretive value? But what if leaving contaminants on the objects would jeopardize the health of curators and even the public, not to mention posing the risk of contaminating other collections? Objects like the Bellevue "Wall of Prayers," collected by the Museum of the City of New York, posed different challenges. The Bellevue wall and other memorials were essentially assemblages—complex, composite objects, consisting of painted plywood, paper, tape, and other materials, many of which are inherently unstable. Should the priority be preserving the components of a memorial or the memorial itself, including its plywood base? Can you preserve the look and feel of a memorial while addressing its structural and material instabilities? Is it enough to simply photograph a memorial to create a documentary record and then preserve the flyers and other materials separately? What about the potential for mold growth and other problems that might arise in materials that have been

exposed to the elements? Museums always have to balance the commitment to preserving collections with the costs of taking responsibility for them, and in this case the potential costs could be considerable.[7]

But even if we had the resources to collect everything, should we? What should we collect? How would we make choices? The National Museum of American History collected essentially three different kinds of objects—different not in terms of materials but rather in terms of what they say about that day and how they help us understand it. First of all, although NMAH's priorities are always objects that tell stories, that evoke moments and lives, rather than fragments or relics of more emotional than historical value, we quickly learned that the public did not see that distinction and believed that collecting fragments from the crash sites should be a priority. For many of the public, such fragments held special meaning that we could not simply ignore or dismiss, and a number even thought we should take portions of the World Trade Center or a crushed fire truck and establish a memorial, a place where Americans could honor those who had lost their lives. We went to great pains to avoid a memorial role—what we do as a museum is make meaning of the past, whereas memorials convey very selective messages and lack the nuance and depth we see at the heart of good history. Nevertheless, we did decide to collect a few fragments—an appropriate decision given our larger interest in collecting what people value and think is important. From the World Trade Center, we collected a large piece of twisted steel

FIGURE 1.

Building fragment from the Pentagon. Photo courtesy of Armed Forces History Division, National Museum of American History, Smithsonian Institution.

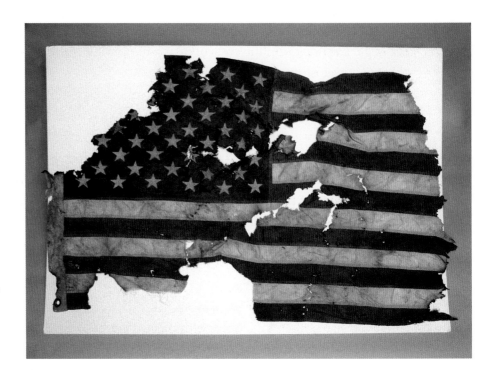

FIGURE 2.
This badly damaged American flag was found by a recovery worker in the World Trade Center debris at the Staten Island recovery site. Transfer from the Federal Bureau of Investigation. Photo courtesy of Armed Forces History Division, National Museum of American History, Smithsonian Institution.

FIGURE 3.
Firefighter's pry bar carried by the New York Fire Department's Lt. Kevin Pfeifer, who was killed in the World Trade Center collapse. Gift of Battalion Chief Joseph W. Pfeifer, FDNY. Photo courtesy of Armed Forces History Division, National Museum of American History, Smithsonian Institution.

that constitutes a powerful symbol for the larger story, and from the Pentagon we collected similarly symbolic objects, including a damaged and charred fragment of the Pentagon's limestone facade (Figure 1).

We also collected airplane parts, which certainly evoke emotions and stand for the moment even if they do not reflect the stories of specific individuals. One of the most emotionally powerful objects collected by the museum is a damaged American flag, one of a very few to survive, retrieved by a recovery worker from the World Trade Center rubble at the Staten Island landfill. Torn and severely damaged, it became the focus of public discussion about the meaning of the flag and, in tatters, became a powerful symbol of patriotism, survival, and resilience (Figure 2).[8]

Second, although objects such as the flag and the fragments from the crash sites were important symbols of the attacks, the museum also collected stories, moments that turned commonplace objects into compelling ones. The museum collected stories of loss—for example, the pry bar carried by the New York Fire Department's Lt. Kevin Pfeifer, who was killed in the World Trade Center collapse. The bar was given to NMAH by his brother, Chief Joseph Pfeifer, the first fire chief to arrive on the scene (Figure 3).[9] When this ordinary tool became part of the nation's collection, it also became part of the official memory of that day. Lieutenant Pfeifer's story took on a level of meaning it might not otherwise have had—it ceased to be just a private story of loss and became part of the public narrative, indeed part of our collective memory. Donating such objects to museums became part of what historian Ed Linenthal terms "active grief"—moving beyond private, intimate, passive grief to take action to preserve the memory of a moment and its consequences.[10] The need on the part of many people to express their grief in this way created collecting opportunities for curators: instead of holding on to objects for their individual needs, people offered them to museums, to public memory. But that active grief also made the work of curators more difficult—they more often had to say "no, thank you" to individuals struggling to address their grief and to preserve their memories through gifts to museums.

The National Museum of American History also collected a number of personal objects that told dramatic stories of escape that day—such as the shoes that Cecilia Benavente was wearing as she fled the 103rd floor of 2 World Trade Center, and the squeegee that Jan Demczur used to escape from an elevator in the north building.[11] The most compelling object for me is a small name tag, one of several objects that tell stories of rescue at the Pentagon. What makes this insignificant object so compelling is the story told at the donation ceremony by

Navy Captain David Thomas. Thomas explained that he tore off the name tag of Navy physician Lt. Cdr. David Tarantino so he would remember his name, convinced, after witnessing his heroic rescue acts, that he might never see Tarantino again and wanted to be able to tell the story of his heroism. Thus a small and ostensibly insignificant name tag became a powerful object that connects us to a compelling story of personal risk and heroism (Figure 4).[12]

FIGURE 4.
Name tag of Navy physician Lt. Cdr. David Tarantino, the Pentagon. Gift of Captain David M. Thomas Jr. and Lieutenant Commander David Tarantino. Photo courtesy of Armed Forces History Division, National Museum of American History, Smithsonian Institution.

A third category of September 11 objects is what I would term the ephemera of loss—materials that reflect the outpouring of grief not only on that day but in the weeks and months that followed. Grassroots memorials became icons of our shared loss, and preserving them became inextricably tied up in preserving the memory of that day. Initially, the photos and messages people posted were not intended as memorials but as part of the search for the missing—over 90,000 such fliers were posted across New York. But in too short a time, the missing became the lost, and missing fliers became the core of more complex makeshift memorials consisting of jumbles of candles, flowers, flags, stuffed animals, and other objects that reflected the outpouring of public grief. Although the Museum of American History did not collect entire memorial installations, others did. For NMAH the issue was not whether it was appropriate to collect memorials but where to best focus its collecting efforts, and its sister museums were clearly better positioned to take on this agenda. The memorials at the Bellevue Hospital, Liberty Plaza, St. Paul's Chapel, and elsewhere were site specific, rooted in place; hence, the best fit was with local and state institutions such as the Museum of the City of New York and the New York State Museum.[13] However, all such memorials were not in public—the Museum of American History collected materials from a makeshift memorial set up in a trailer by the New York Port Authority Police Department to honor fallen comrades. Recognizing it as an expression of grief, the museum's curator did not take the materials or even ask for them—he collected them only when they were offered.[14] In the context of September 11, many otherwise entrepreneurial curators demonstrated heightened ethical sensitivity.

Gardner

286

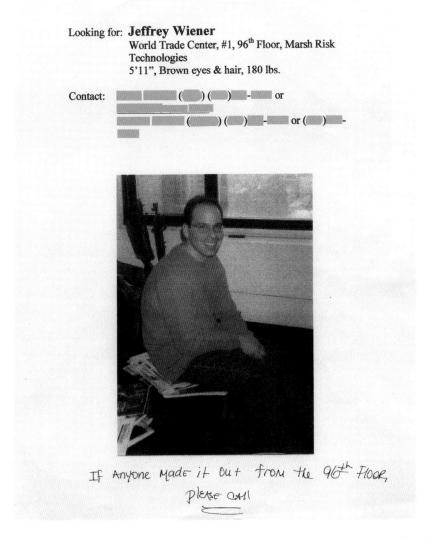

Looking for: **Jeffrey Wiener**
World Trade Center, #1, 96th Floor, Marsh Risk
Technologies
5'11", Brown eyes & hair, 180 lbs.

Contact:

If Anyone Made it Out from the 96th Floor, Please call

FIGURE 5.
Jeffrey Wiener's family members distributed this poster in their search. Sadly, they never found Jeff alive. Gift of Robin Wiener. Photo courtesy of Armed Forces History Division, National Museum of American History, Smithsonian Institution.

For me, the most powerful and compelling objects are not the larger memorial assemblages but rather materials that connect us more directly to a family's search for a missing relative. The National Museum of American History collected a poster distributed by the Wiener family as they looked for Jeffrey Wiener, their husband, son, and brother, and a list of hospitals on which they made notations as they tried unsuccessfully to find him alive.[15] This simple document engages us in the deep loss that families and friends experienced, not just the shock of the moment but the days of futile hope and then grief that followed. Such objects shift the story from death statistics to real individuals, engaging us all in a moment we cannot begin to imagine and hope to never experience (Figure 5).

FIGURE 6.
Search helmet used during the search and recovery work at the World Trade Center by New York State Police K-9 officer Richard M. Scranton. Photo courtesy of Armed Forces History Division, National Museum of American History, Smithsonian Institution.

Working collaboratively, NMAH curators built an important collection for the museum and for the nation. It remains a work in progress; indeed, we expect the collection to grow as we gain historical perspective and a greater understanding of the events of September 11. The collection includes nearly 4,000 objects:

- about 150 objects from the World Trade Center attacks, including pieces of emergency rescue equipment pulled from the wreckage and personal effects from victims, survivors, and rescuers (Figure 6)
- about 100 objects from the Pentagon attacks, including materials from victims, survivors, and rescuers at the Pentagon as well as from the victims on the plane
- about 25 objects from Flight 93, including pieces of the plane, objects associated with the victims, and Flight 93 memorial materials
- about 25 other objects, including commemorative and memorial materials
- over 1,600 photographic images documenting that day and the aftermath

The museum's collecting also extended to the web—NMAH partnered with the Center for History and New Media at George Mason University and the American Social History Project at the City University of New York Graduate Center in the development of the September 11 Digital Archive, which preserves over 150,000 messages, images, and other electronic files that constitute a critical resource for understanding that day and its impact.[16]

Although NMAH's September 11 collection is not a large one within the context of its over three million objects, it is an important one, constituting powerful evidence of that day and its impact. Developing the collection was challenging—we had to respond to the needs and concerns of the public without compromising our commitment to making meaning of the past. But then, that is always our goal. What was different was the level of emotion that constituted the context for and shaped that work. In developing the collection, we responded thoughtfully and positively to the challenges we encountered, embracing the opportunity to help our visitors understand these tragic events and contributing to the nation's healing.

Shortly before the 10th anniversary of the September 11 attacks, I left the Museum of American History for a new position at the National Archives. So I was an outsider looking in during the 2011 commemoration. What was striking was how little had actually changed over that decade. In 2002, the curatorial staff considered how things might be different in a decade, with the passage of time and the fading of emotion, but NMAH and other institutions preserving and interpreting September 11 have found that emotions are still raw a decade later, that the nation has not yet healed. Indeed, the sadness and fear that shaped that first year of collecting remained strong in 2011, and the objects remained powerful symbols of public loss, markers of public memory.

ACKNOWLEDGMENTS

Cedric Yeh, deputy chair, Division of Armed Forces History, NMAH, and Jennifer L. Jones, chair, Division of Armed Forces History, NMAH, went beyond the call of duty in working with me on this essay, and I thank them for their collegiality, support, and hard work over the years on NMAH's September 11 project.

NOTES

1. For additional information on Commander Dunn's ID card, see "September 11: Bearing Witness to History," National Museum of American History, accessed May 14, 2013, http://amhistory.si.edu/september11/collection/search_record.asp?search=1&keywords=dunn&mode=&record=0.

2. Dillon Ripley, *The Sacred Grove: Essays on Museums* (New York: Simon and Schuster, 1969), 67.

3. Steven Lubar and Kathleen Kendrick, *Legacies: Collecting America's History at the Smithsonian* (Washington, D.C.: Smithsonian Institution Press, 2001), 11.

4. This essay draws on previously published essays: James B. Gardner, "Collecting a National Tragedy," *Museum News* 81 (March/April 2002): 42–45, 66–67; James B. Gardner and Sarah M.

Henry, "September 11 and the Mourning After: Reflections on Collecting and Interpreting the History of Tragedy," *The Public Historian* 24 (Summer 2002): 37–52; James B. Gardner, "September 11: Museums, Spontaneous Memorials, and History," in *Grassroots Memorials: The Politics of Memorializing Traumatic Death*, ed. Peter Jan Margry and Cristina Sanchez-Carretero (New York: Berghahn Books, 2010), 285–303.

5. For a discussion of the larger context of public memorialization, see Peter Jan Margry and Cristina Sanchez-Carretero, eds., *Grassroots Memorials: The Politics of Memorializing Traumatic Death* (New York: Berghahn Books, 2010).

6. David Shayt, e-mail message to author, May 3, 2007.

7. For more discussion of the September 11 grassroots memorials, see Gardner, "September 11: Museums, Spontaneous Memorials, and History."

8. For additional information on NMAH's September 11 collections, see "September 11: Bearing Witness to History," National Museum of American History, accessed May 14, 2013, http://americanhistory.si.edu/september11/collection/index.asp.

9. For additional information on the pry bar, see "September 11: Bearing Witness to History," accessed May 14, 2013, http://americanhistory.si.edu/september11/collection/search_record.asp?search=1&keywords=pry%20bar&mode=&record=0.

10. Edward T. Linenthal, *The Unfinished Bombing: Oklahoma City in American Memory* (New York: Oxford University Press, 2001), 98–108.

11. For additional information on Benavente's shoes (including an interview with the curator), see "September 11: Bearing Witness to History,"

accessed May 14, 2013, http://americanhistory.si.edu/september11/collection/search_record.asp?search=1&keywords=shoes&mode=&record=1; for additional information on Demczur's squeegee (including an interview with the curator), see "September 11: Bearing Witness to History," accessed May 14, 2013, http://americanhistory.si.edu/september11/collection/search_record.asp?search=1&keywords=squeegee&mode=&record=0.

12. For additional information on the nametag (including a statement from Tarantino and an interview with the curator), see "September 11: Bearing Witness to History," accessed May 14, 2013, http://americanhistory.si.edu/september11/collection/search_record.asp?search=1&keywords=tarantino&mode=&record=0.

13. For more details on the New York State Museum's September 11 collection, see "The World Trade Center: Rescue, Recovery, Response," New York State Museum, accessed May 14, 2013, http://www.nysm.nysed.gov/wtc/index.html.

14. For additional information on the Port Authority police memorial, see "September 11: Bearing Witness to History," accessed June 10, 2015, http://americanhistory.si.edu/september11/collection/record.asp?ID=51.

15. For additional information on the Wiener material, see "September 11: Bearing Witness to History," accessed May 14, 2013, http://americanhistory.si.edu/september11/collection/search_record.asp?search=1&keywords=wiener&mode=&record=0.

16. "The September 11 Digital Archive," Roy Rosenzweig Center for History and New Media and American Social History Project/Center for Media and Learning, accessed May 14, 2013, http://911digitalarchive.org/.

BIBLIOGRAPHY

Gardner, James B. "Collecting a National Tragedy." *Museum News* 81 (March/April 2002): 42–45, 66–67.

———. "September 11: Museums, Spontaneous Memorials, and History." In *Grassroots Memorials: The Politics of Memorializing Traumatic Death*,

The Amazing Ruby Slippers and Their Magical Travels

Ellen Roney Hughes

From a pair of off-the-shelf shoes to iconic national treasure, the Ruby Slippers in the Smithsonian's National Museum of American History collections have traveled a winding yellow brick road of their own, changing status, location, and meaning along the way. The original magical silver shoes went from L. Frank Baum's imagination to the pages of his novel, where they were given shape by the illustrator in the 1900 *The Wonderful Wizard of Oz* book.[1] Baum's silver slippers were recreated on paper almost four decades later as ruby-red pumps by Hollywood film makers; they materialized from mass-produced footwear purchased and glamorized to sparkle in Technicolor by MGM's costume department, and finally, they were worn by a movie star as a central prop in the 1939 film *The Wizard of Oz*. Their film work done, these red pumps were banished for many years to studio storage and much later were auctioned off for a considerable profit. In the hands of their new owner they existed as personal property and possibly a status symbol before being presented as a (tax-deductible) donation to the museum in 1979.[2] A permanent home at last!

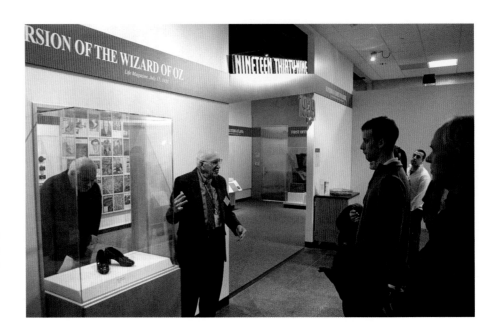

At the museum the Ruby Slippers' status rose again when they were exhibited as a symbol of movies as a unifying American experience in a diversifying nation. They became highly touted tourist attractions, were enmeshed in academic controversy, starred in their own exhibition cases on the MGM film, and recently traveled around the nation and world as one of America's national treasures (Figure 1). Over the course of this amazing journey, these lovely shoes were handled by manufacturers, costumers, actors, auctioneers, fans, collectors, technicians, and curators. From the beginning, they were seared into the imagination of millions of Oz book and film fans. Inevitably, they also came under the scrutiny of scholars, writers, and museum curators.

The following words from the paper and celluloid lips of the Good Witch instigated a cottage industry of scholars analyzing the 1900 book and 1939 film, including the magical shoes of silver or ruby red:

> The Silver Shoes have wonderful powers. And one of the most curious things about them is that they can carry you to any place in the world in three steps, and each step will be made in the wink of an eye. All you have to do is to knock the heels together three times and command the shoes to carry you wherever you wish to go.[3]

> Then close your eyes and tap your heels together three times.[4]

This analysis did not, however, happen right away. For decades the book and film were largely left alone to be enjoyed by children and adults. Neither format was taken terribly seriously as art or allegory until the 1960s when American scholars

strayed from traditional focus on Milton and Shakespeare and Jefferson and Roosevelt and began looking critically at popular culture. This new social and cultural history promoted the study of events, artifacts, and cultural expressions closer to ordinary Americans' experiences in both the distant and more recent past, including Baum's turn of the century book, *The Wonderful Wizard of Oz,* and the 1939 film it inspired, MGM's *The Wizard of Oz.* The storied shoes came to the Smithsonian just as this new trend in scholarship was unfolding. It was a shift in perspective that significantly changed, even revolutionized, what was studied and collected in museums including at the Smithsonian. In 1980, the National Museum of History and Technology officially changed its name to the National Museum of American History. This name change reflected the new trend in museums, academia, and the history profession at large away from focusing exclusively on customary subjects such as political, military, and technological history toward opening up to the examination of issues of immigration, community life, work, education, sports, and entertainment.

The acceptance of the movie prop shoes during this same period as part of the national collections was part of the museum's refocusing.[5] These shifts were made clear in the choice of museum objects for the expansive 1976 bicentennial exhibition *A Nation of Nations.* On permanent display until 1991 this exhibition of some 5,000 artifacts portrayed America's immigrant heritage. Among the artifacts were such iconic objects as George Washington's Revolutionary War uniform, two rooms of an early colonial house, a windmill, a schoolroom from Cleveland, Ohio, Abraham Lincoln's handball, Muhammad Ali's gloves, a Model T Ford, Thomas Edison's light bulbs, and the Ruby Slippers.[6] This exhibition was the first time that they were displayed at the Smithsonian.

Positioned in the prominent glass case in the "Shared Experiences" section of this exhibit, the artifacts were tersely identified as being worn by Judy Garland as Dorothy Gale in the MGM film. It was here that the magical appeal of these artifacts to visitors was first felt.[7] Their placement in the context of an exhibition that argued for the importance of American entertainment as a unifying experience for most Americans regardless of age, race, or national origin suggested a significance larger than that of a mere film prop. They were featured along with a pantheon of entertainment history artifacts: circus posters, Irving Berlin's transposing piano, a George M. Cohan costume, Minnie Madden Fiske's glittering stage costume, and Howdy Doody and Kermit the Frog puppets, among others. This exhibition was also the beginning of a series of interpretations by various curators that often drew upon the work of film and literary scholars.

By definition, museums' responsibilities include interpreting artifacts, along with collecting, preserving, studying, and displaying them. Without study and interpretation, museums are a muddle of things. Objects usually have meaning for us only through a framework of concepts and assumptions with which we, both curators and audience, approach them. This framework is precisely why interpretation is often the most contested of the scholarly pursuits. We all have our own cherished assumptions about the things and stories we love, and when museums challenge these assumptions, it can be perilous.[8] Over their life history in the museum, our curatorial staff has placed the Ruby Slippers in several different interpretive contexts, and our visitors have reacted both positively and negatively to these new intepretations.[9]

The first exhibition where the shoes were the featured object, *The Ruby Slippers and the Wizard of Oz*, opened in 1991, just after the exhibition *Nation of Nations* closed. This small show, which I curated, featured additional objects that had been added to the collections since 1979: one of the original Baum books, a movie poster and stills, the Scarecrow costume pieces, a page from the movie script (showing a change from Baum's silver slippers to red shoes), and various fan materials such as an Oz lunch box . The exhibition text retold the fundamental fairytale of the book and film, that of a youthful Dorothy Gale and her dog Toto swept away by a storm to a magical land where she meets three other lost souls. The four characters band together, and Dorothy leads them on a quest to find what is most dear to each of them, encountering both enchanted helpers and frightening foes. In the end they find that they each already possessed what they sought. The Tin Woodsman learns that he has emotions, the Lion realizes he is brave, the Scarecrow understands he has brains, and Dorothy finds that she can get back to her home by clicking the heels of the shoes she has been wearing since the beginning of the film's dream sequence. The Ruby Slippers are the bit of magic needed to pull off the impossible. The tale is also in many ways a version of the American story of the rugged individualist, the self-sufficient and exceptional hero or heroine, one who takes on and defeats evil and suspect technology.[10] This straightforward interpretation also highlighted the obvious gender implications, especially because all of the strong main characters—Dorothy, the Wicked Witch of the West, and Glinda, the Good Witch—are female. The flawed characters are male, including the Wizard, who is exposed in the end as a fraud. The exhibition case, with these simple interpretations, remained on public view, and the slippers continued to gain in popularity with the museum's audience.

A few years later, this same exhibition case was reinterpreted by a curatorial colleague at the museum employing basically the same group of artifacts but drawing

upon the work of several prominent historians who argued that Baum's story and its characters were a parable of monetary populism (the failed agrarian revolt in the 1890s) and that the magical silver slippers represented the silver currency favored by William Jennings Bryan's Populist Party.[11] The populist allegory theory was not universally accepted, and it had many critics. A prominent Baum biographer presents evidence that the idea was baseless. Others found no compelling evidence for such an interpretation but suggested that perhaps Baum's tale could have been an unconscious allegory. In any case, the theory makes a memorable (if flawed) explanation of the complicated monetary issues of the Progressive Era that most people today little remember.[12] Regardless, the scholarly debate surrounding these various theories was important for taking Baum seriously as a writer and for viewing his work as social criticism.

In the museum, this economic reinterpretation did not sit well with our audiences, and this exhibit case provoked much comment and consternation. Most visitors were keen on the Ruby Slippers, and few could relate to the little-remembered slice of history that involved only the original silver shoes in the book. Many scholars, and even a Baum descendant, strongly criticized the museum for focusing attention on such a controversial theory.[13] The outcry prompted the museum to return the exhibit text to the more universally accepted theme of the quest, and so the red shoes remained in this case until they began their international travels as an American icon.

Smithsonian's America: An Exhibition of American History and Culture, an exhibit created specifically for Japan, was envisioned by its sponsors as a means to promote understanding and friendship between the two countries. It opened in Chiba, Japan, in 1994.[14] The curatorial staff and I, as senior, selected over 250 important artifacts from the National Museum of American History and the National Air and Space Museum. The artifacts included, among others, a Wright brothers' airplane, an Apollo space capsule, George Washington's mess kit, Edison's earliest light bulbs, a Conestoga wagon, the earliest Levis, the Jim Henson puppet Kermit the Frog, and the Ruby Slippers. All the artifacts were flown to Japan in a jumbo cargo plane and were carefully assembled in a 40,000 square foot exhibition space. Placed in the section on American popular culture, the Ruby Slippers represented the power of American movies to reach across cultures. Although the shoes were exhibited for only six weeks, they were visited by over a million and a half people, many of whom were quite familiar with the *Wizard of Oz* film. The slippers supported the exhibit's goal of mutual understanding among the people of the two countries, and through their international exposure the Ruby Slippers' fame and iconic status increased.

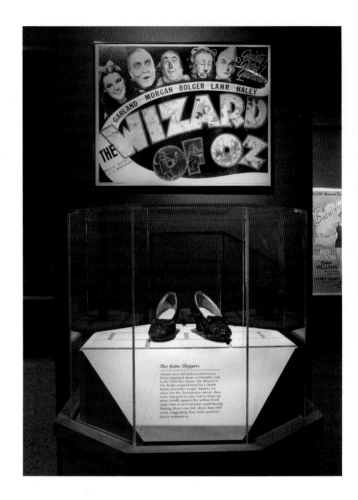

FIGURE 2.
The Ruby Slippers installed in the ex-
hibit *Thanks for the Memories, American
Popular Culture.* Photo by Hugh Talman,
National Museum of American History,
2008. Ruby Slippers from *The Wizard of
Oz* used courtesy of Warner Bros.
Entertainment Inc. ™ & © Turner Enter-
tainment Co. (s15)

Once the shoes returned to the United States, the Ruby Slippers began to star
in a series of exhibitions that featured objects considered to be American treasures.
Because of their popularity, they were included in the exhibition *America's Smithson-
ian*, a two-year (1995–1997) traveling show created to celebrate the institution's 150th
anniversary. In 2008 the museum reopened after a two-year renovation, and the
Ruby Slippers went back on view in the exhibition *Thanks for the Memories, American
Popular Culture,* curated by Dwight Blocker Bowers (Figure 2). In 2012, the shoes were
reinstalled in a new exhibition, *American Stories,* which examined the people, inven-
tions, issues, and events that shape America. Here the Oz story was characterized as a
tale of American ingenuity, another notable reinterpretation of these slippers.

What makes the Ruby Slippers and the Oz story so compelling? According to
Baum biographer Rebecca Loncraine, the Oz book (and the film it inspired) is a
masterpiece of interpretative openness and psychological depth allowing readers

and film fans to construe the fantastical story, its characters, and props in so many different and personal ways.[15] Salman Rushdie did not read the book as a child but was introduced to the story through the film. In his essay "A Short Text About Magic" in his book *The Wizard of Oz*, he interprets *The Wizard of Oz* as an anarchic "film whose driving force is the inadequacy of adults, even of good adults, and how the weakness of grown-ups forces children to take control of their own destinies, and so, ironically, grow up themselves."[16] With regard to Dorothy, "by her adventure's end [she] has certainly grown to fill those shoes, or, rather those Ruby Slippers."[17] The Ruby Slippers, for Rushdie, are a symbol of Dorothy's youthful power, and the movie had a powerful effect on him. He said, "It made a writer of me."[18] In the second half of this book of critical analysis, personal reminiscences, and technical details about the film, he gives us a short story, "At the Auction of the Ruby Slippers," in which he fictionalizes the auction of a pair of Ruby Slippers that were found on the MGM lot and sold for $15,000 to an anonymous bidder. He describes the frenzied atmosphere in the auction salesroom, the circus of attendees, some of whom are dressed as characters from the movie, and the desire that fuels the escalating bidding for the slippers.[19] Indeed, who would not want to possess this symbol of youthful power that can magically transport us at a click of the heels?

If history is a joke that the living play on the dead, as Voltaire suggested, then many of us have had a good laugh at Baum's expense. Baum himself called his work not an allegory, not a history, not reality, but a fairy tale for children, pure and simple. He would most likely be most amused by all the interpretative hullabaloo around the slippers. Although perhaps his tale should stand on its own as an artistic work, it is time and again judged by scholars as either a statement of the author or a representation of some other reality. In fact, most everyone who cares about the magical slippers and the book and film in which they appear has their own personal reasons for loving them and their own interpretations that incorporate the magical shoes into their own dreams and realities. This personalization may be why the Ruby Slippers continue on their journey around the nation, around the world, and in the thoughts of their fans everywhere, shoes no more but icons of our American culture.

ACKNOWLEDGMENTS

I thank Richard Strauss, Alicia Cutler, and Vanessa Pares of the National Museum of American History and Marguerite Roby of the Smithsonian Institution Archives

for their help in locating photographs of historical exhibitions of the Ruby Slippers at the National Museum of American History.

NOTES

1. L. Frank Baum, *The Wonderful Wizard of Oz* (Chicago: George M. Hill Company, 1900). William Wallace "W. W." Denslow (May 25, 1856–May 27, 1915) illustrated the first Oz book.

2. The accession file holds files of correspondence, photographs, and museum forms tracing the history of the acquisition and museum use of the objects. Ruby Slippers accession file, accession 1979.1230, National Museum of American History, Smithsonian Institution, Washington, D.C.

3. Baum, *The Wonderful Wizard of Oz,* 176.

4. *The Wizard of Oz* (MGM, 1939).

5. On these trends within the Smithsonian, see Ellen Roney Hughes, "The Unstifled Muse: The 'All in the Family' Exhibit and Popular Culture at the National Museum of American History," in *Exhibiting Dilemmas: Issues of Representation at the Smithsonian*, ed. Amy Henderson and Adrienne Keappler (Washington, D.C.: Smithsonian Institution Press, 1997), 156–175.

6. See Peter C. Marzio, ed., *A Nation of Nations: The People Who Came to America as Seen through Objects and Documents Exhibited at the Smithsonian Institution* (New York: Harper and Row, 1976).

7. So popular were the shoes that the visitors wore holes in the carpet in front of them, and it had to be replaced several times. For the museum, it was a graphic demonstration of the shoes' power as an attraction.

8. Stephen E. Weil, "The Proper Business of Museums: Ideas or Things," in *Rethinking the Museum and Other Meditations* (Washington, D.C.: Smithsonian Institution Press, 1990), 45–56.

9. According to Susan Sontag in her provocative essay, to interpret is to translate for an audience. Interpretation "presupposes a discrepancy between the clear meaning of the text and the demands of the (later) readers. It seeks to solve this discrepancy." Modern criticism looks for the subtext to expose. She calls these contemporary interpretive tactics the "revenge of the intellect upon art." Susan Sontag, "Against Interpretation," in *Against Interpretation and Other Essays* (New York: Farrar, Straus and Giroux, 1961), 3.

10. William R. Leach wrote in an edition of the Baum book, "It helped make people feel at home in America's new industrial economy, and it helped them appreciate and enjoy, without guilt, the new consumer abundance and way of living produced by that economy." His interpretation is based not on the author's unknowable intent but on the circumstances and emotions of the audience. It works just as well for the 1939 film, coming at the end of the Great Depression as it did. William R. Leach, "The Clown from Syracuse: The Life and Times of L. Frank Baum," in L. Frank Baum, *The Wonderful Wizard of Oz* (repr., Belmont, CA: Wadsworth, 1991), 2.

11. Martin Gardner alluded to Baum's politics in his essay "The Royal Historian of Oz": "Aside from marching in a few torchlight parades for William Jennings Bryan, Baum was as inactive in politics as in church affairs [which is to say, pretty inactive]. He consistently voted as a democrat, however, and his sympathies always seem to have been on the side of the laboring classes." See Martin Gardner, "The Royal Historian of Oz," in *The Wizard of Oz and Who He Was*, ed. Martin Gardner and Russell B. Nye (East Lansing: Michigan State University Press, 1957), 29. Henry M. Littlefield built on Gardner's statement in fashioning his compelling argument for a Populist interpretation of the book that remains widely accepted today despite the many scholars who have debunked it; see Henry M. Littlefield, "The Wizard of Oz: Parable on Populism," *American Quarterly* 16, no. 1 (Spring 1964): 47–58.

12. Embellishers include Hugh Rockoff, "The Wizard of Oz as Monetary Allegory," *Journal of Political Economy* 98, no. 4 (1990): 739–760; and Gretchen Ritter, "Silver Slippers and a Golden Cap: L. Frank Baum's 'The Wonderful Wizard of Oz' and Historical Memory in American Politics," *Journal of American Studies* 31, no. 2 (August 1977): 171–202.

13. Ruby Slippers accession file, accession 1979.1230, National Museum of American History, Smithsonian Institution.

14. The exhibition was sponsored by *Yomiuri Shimbun*, a newspaper, and NHK, the Japanese Broadcasting Corporation, and was created by the National Museum of American History with the National Air and Space Museum.

15. Rebecca Loncraine, *The Real Wizard of Oz: The Life and Times of L. Frank Baum* (New York: Gotham Books, 2009), 173. Other interpretations include the shoes as magical healers as in the 2003 Broadway musical *Wicked*, itself interpreted as a "queer and feminist" play; see Stacy Ellen Wolf, "'Defying Gravity': Queer Conventions in the Musical *Wicked*," *Theatre Journal* 60, no. 1 (March 2007): 1–21.

16. Salman Rushdie, "A Short Text About Magic," in *The Wizard of Oz*, Film Classics Series (London: British Film Institute, 1992), 10.

17. Rushdie, "A Short Text About Magic," 10.

18. Rushdie, "A Short Text About Magic," 18.

19. Salman Rushdie, "At the Auction of the Ruby Slippers," in *The Wizard of Oz*, Film Classics Series (London: British Film Institute, 1992), 58–65.

BIBLIOGRAPHY

Baum, L. Frank. *The Wonderful Wizard of Oz*. Chicago: George M. Hill Company, 1900.

Gardner, Martin. "The Royal Historian of Oz." In *The Wizard of Oz and Who He Was,* ed. Martin Gardner and Russell B. Nye, pp. 19–46. East Lansing: Michigan State University Press, 1957.

Hughes, Ellen Roney. "The Unstifled Muse: The 'All in the Family' Exhibit and Popular Culture at the National Museum of American History." In *Exhibiting Dilemmas: Issues of Representation at the Smithsonian*, ed. Amy Henderson and Adrienne Keappler, pp. 156–175. Washington, D.C.: Smithsonian Institution Press, 1997.

Leach, William R. "The Clown from Syracuse: The Life and Times of L. Frank Baum." In L. Frank Baum, *The Wonderful Wizard of Oz*, pp. 1–34. Reprint, Belmont, CA: Wadsworth, 1991.

Littlefield, Henry M. "The Wizard of Oz: Parable on Populism." *American Quarterly* 16, no. 1 (Spring 1964): 47–58.

Loncraine, Rebecca. *The Real Wizard of Oz: The Life and Times of L. Frank Baum*. New York: Gotham Books, 2009.

Marzio, Peter C., ed. *A Nation of Nations: The People Who Came to America as Seen through Objects and Documents Exhibited at the Smithsonian Institution*. New York: Harper and Row, 1976.

Ritter, Gretchen. "Silver Slippers and a Golden Cap: L. Frank Baum's 'The Wonderful Wizard of Oz' and Historical Memory in American Politics." *Journal of American Studies* 31, no. 2 (August 1977): 171–202.

Rockoff, Hugh. "The Wizard of Oz as Monetary Allegory." *Journal of Political Economy* 98, no. 4 (1990): 739–760.

Ruby Slippers accession file. Accession 1979.1230. National Museum of American History, Smithsonian Institution.

Rushdie, Salman. *The Wizard of Oz*. Film Classics Series. London: British Film Institute, 1992.

Sontag, Susan. "Against Interpretation." In *Against Interpretation and Other Essays*, pp. 1–10. New York: Farrar, Straus and Giroux, 1961.

Weil, Stephen E. "The Proper Business of Museums: Ideas or Things." In *Rethinking the Museum and other Meditations*, pp. 45–56. Washington, D.C.: Smithsonian Institution Press, 1990.

Wolf, Stacy Ellen. "'Defying Gravity': Queer Conventions in the Musical *Wicked*." *Theatre Journal* 60, no. 1 (March 2007): 1–21.

September 11, 2001

Plate 10
ID badge, Commander Patrick Dunn

Date: ca. 2001
Materials: Plastic
Measurements: 5.08 cm (2 in) height × 3.81 cm (1.5 in) width
Catalog number: 2004.0141.04
Armed Forces History Division, National Museum of American History
Donated in 2004 by Stephanie Dunn, widow of Commander Dunn.

Robert J. Terry Anatomical Skeletal Collection (not pictured)
Date: ca. 1920–1960s
Accession number: 279084
National Museum of Natural History
1,728 specimens (of known age, sex, ethnic origin, cause of death, and pathological condition)
Transferred in 1967 from the Washington University Medical School, St. Louis, Missouri.

Dunn,
Patrick

Pay Grade
O5

Issu
20
Expiration
2004M

Geneva Conventions Identificatio

Collecting a National Tragedy: The National Museum of American History and September 11

James B. Gardner

The military ID in Plate 10 belonged to Commander Patrick Dunn, a victim of the terrorist attack on the Pentagon on September 11, 2001. Commander Dunn was the watch commander of the Navy Command Center on the first floor in the D ring of the Pentagon, and was one of 29 people who died in the center when the hijacked American Airlines Flight 77 slid directly into it. His heavily burned ID card was given to the National Museum of American History by Stephanie Dunn, his widow, and was one of many donations to the museum's collections in the weeks and months that followed the attacks of September 11 (Plate 10).[1] It was not, however, a given that the museum would accept this or any donation—contrary to popular belief, the Museum of American History does not collect

anything and everything and really never has, and the decision to collect objects was not made easily.

The Smithsonian has long been known as the "nation's attic," and no museum is more closely identified with that epithet than the National Museum of American History (NMAH). There is an unfortunate popular assumption that, just like one's own attic, the museum is filled to the brim with this and that, with everything imaginable—that it is one of those museums that function, in the words of former Smithsonian Secretary Dillon Ripley, "as storehouses, as catch-alls."[2] More bluntly, in their 2001 book *Legacies: Collecting America's History at the Smithsonian*, Steven Lubar and Kathleen M. Kendrick contend that "despite its familiar and affectionate overtones, the nickname implies mustiness and cobwebs, oddities and castoffs, forgotten and obsolete gadgets, useless junk."[3] They argue that although such a characterization may apply to some of the museum's collections, it does not apply to the majority. While previous generations of curators may have methodically built collections in some areas, the reality is that history collecting today is not so much a systematic science as a subjective art: using their scholarly knowledge and expertise, curators make careful and difficult decisions every day about what to collect and what not to collect. Although one might be able to find instances of "vacuum cleaner" collecting at moments in the past, NMAH's curators today are very selective, focusing on collecting objects with compelling stories that help us make meaning of the past.

Thus, NMAH did not simply go out and start collecting indiscriminately in the wake of the tragic events of September 11, 2001.[4] Despite some initial opportunistic collecting, the curatorial staff recognized the necessity of carefully thinking through what to collect, of making sure that we had a strategy for collecting the larger story, not simply fragments of it. And we realized that moving forward in the usual way within traditional collecting specializations would not work—September 11 was a moment more complicated than could be accommodated under the usual collecting rubrics. We needed to address it not as individual curators or curatorial units but as a museum, working collaboratively toward a larger collecting agenda. The museum's Collections Committee had already scheduled a "conversation on collecting" for that week, so we used that venue to begin discussing how to tackle our collecting roles and responsibilities. In that and later conversations, we tried to sort out what public expectations and professional challenges we would face. What sort of collection would we be expected to build? Would we face pressure to do more than our usual measured collecting? What should a September 11 collection include? How would we, as a history museum, establish and maintain

the historical perspective or distance critical to our work when we were in the middle of unfolding events? How would we deal with the emotions that would certainly frame collecting in this area? Could we do good history at a moment when anger and grief were obscuring perspectives, even our own? But no matter what doubts and questions we had, in the final analysis we did not really have a choice. Although the museum cannot and does not collect everything, we are stewards of the nation's memory and were obligated to collect September 11 materials to ensure that the events of that day were represented in the nation's collections. If any doubt remained, in December 2001 the U.S. Congress formally charged NMAH with collecting and preserving artifacts relating to the terrorist attacks.

But when should we collect? As history curators, we recognize that often the best collecting strategy is to simply wait and see what is valued and held on to through the passage of time, rather than focus on what curators think at the moment is important. But could we really wait in this context? Or was it our responsibility to move in quickly? We soon recognized that between the rescue efforts, the cleanup, and the elements, some things might simply not be available later—not to mention what might disappear in the course of official investigations. Every day of delay could mean lost opportunities to collect and document this important moment. But would urgency on the part of the museum be seen as callous and self-serving? Would we, in effect, be seen as declaring an end to grief, telling people to move on? Although we might feel an ethical obligation to act expeditiously, we also had an ethical obligation to not intrude on those trying to navigate the shock of loss and the depths of grief. We recognized that collecting memorial materials—materials left in makeshift memorials around New York and at the crash sites—would be particularly problematic.[5] Years later, David Shayt, a curator at the Museum of American History reflecting back on his experience, voiced this reluctance: "I felt it would be an act of desecration to collect something off a living memorial."[6] Indeed, collecting those materials and storing them in a museum—removing them from public view—would negate the very purpose of the memorials, the reasons they were created and left. Could museums ethically remove memorial materials from public view, even if the intention was to save them? There was no easy answer—the public complained if the materials were allowed to deteriorate but also complained if they were removed. In the final analysis, NMAH and the other museums involved moved forward with collecting but within a far more emotional context than we were accustomed to.

But beyond the ethical and emotional issues, there were practical challenges that had to be addressed. To begin with, clearly no one museum "owned"

September 11—the terrorist attacks impacted all of us in one way or another, and many museums, particularly in New York, wrestled with how to proceed. What we knew we did not want to do was engage in unseemly competition—we would all be tainted by any suggestion of territorial rivalry. To avoid that, in a rare moment of collaboration, over 30 museums and cultural organizations pledged to communicate and share, to move forward not unilaterally but as a collecting community. In the long run, however, the few unique objects we all wanted proved less problematic than the sheer volume and range of other materials we faced. Although we knew pieces of construction steel from the World Trade Center would be important, evocative pieces, there were tons of it. How much material could any museum realistically collect? Collecting would have to be highly selective, even more so for NMAH than for the other museums. The Museum of American History faced a very different collecting imperative from that of the other museums, each of which was focused on one crash site—NMAH's charge was to develop a collection that would represent all three crash sites. We were responsible not for any one story but for the larger national memory, and that made our collecting agenda fundamentally more challenging.

The National Museum of American History and the other collecting museums not only had to be realistic about how much we could process and house but also had to be prepared to face rather daunting conservation issues associated with the objects. Materials from the crash sites were almost certainly contaminated and even bore traces of human remains. How do you preserve such objects? What treatment is necessary, and how far should it be taken? Should deposits and debris be removed, or are they essential parts of the objects? Would cleaning destroy historical evidence and interpretive value? But what if leaving contaminants on the objects would jeopardize the health of curators and even the public, not to mention posing the risk of contaminating other collections? Objects like the Bellevue "Wall of Prayers," collected by the Museum of the City of New York, posed different challenges. The Bellevue wall and other memorials were essentially assemblages—complex, composite objects, consisting of painted plywood, paper, tape, and other materials, many of which are inherently unstable. Should the priority be preserving the components of a memorial or the memorial itself, including its plywood base? Can you preserve the look and feel of a memorial while addressing its structural and material instabilities? Is it enough to simply photograph a memorial to create a documentary record and then preserve the flyers and other materials separately? What about the potential for mold growth and other problems that might arise in materials that have been

exposed to the elements? Museums always have to balance the commitment to preserving collections with the costs of taking responsibility for them, and in this case the potential costs could be considerable.[7]

But even if we had the resources to collect everything, should we? What should we collect? How would we make choices? The National Museum of American History collected essentially three different kinds of objects—different not in terms of materials but rather in terms of what they say about that day and how they help us understand it. First of all, although NMAH's priorities are always objects that tell stories, that evoke moments and lives, rather than fragments or relics of more emotional than historical value, we quickly learned that the public did not see that distinction and believed that collecting fragments from the crash sites should be a priority. For many of the public, such fragments held special meaning that we could not simply ignore or dismiss, and a number even thought we should take portions of the World Trade Center or a crushed fire truck and establish a memorial, a place where Americans could honor those who had lost their lives. We went to great pains to avoid a memorial role—what we do as a museum is make meaning of the past, whereas memorials convey very selective messages and lack the nuance and depth we see at the heart of good history. Nevertheless, we did decide to collect a few fragments—an appropriate decision given our larger interest in collecting what people value and think is important. From the World Trade Center, we collected a large piece of twisted steel

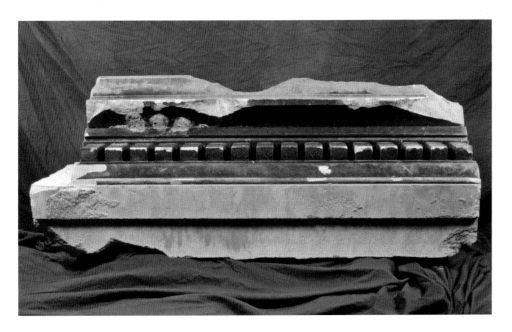

FIGURE 1.

Building fragment from the Pentagon. Photo courtesy of Armed Forces History Division, National Museum of American History, Smithsonian Institution.

FIGURE 2.
This badly damaged American flag was found by a recovery worker in the World Trade Center debris at the Staten Island recovery site. Transfer from the Federal Bureau of Investigation. Photo courtesy of Armed Forces History Division, National Museum of American History, Smithsonian Institution.

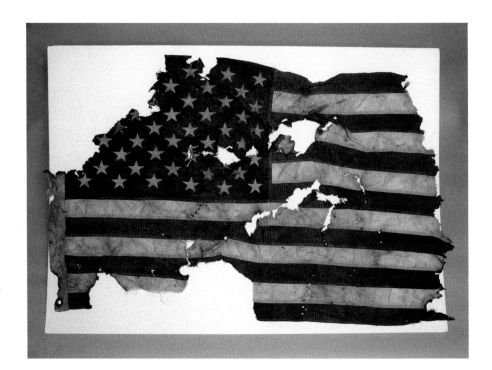

FIGURE 3.
Firefighter's pry bar carried by the New York Fire Department's Lt. Kevin Pfeifer, who was killed in the World Trade Center collapse. Gift of Battalion Chief Joseph W. Pfeifer, FDNY. Photo courtesy of Armed Forces History Division, National Museum of American History, Smithsonian Institution.

that constitutes a powerful symbol for the larger story, and from the Pentagon we collected similarly symbolic objects, including a damaged and charred fragment of the Pentagon's limestone facade (Figure 1).

We also collected airplane parts, which certainly evoke emotions and stand for the moment even if they do not reflect the stories of specific individuals. One of the most emotionally powerful objects collected by the museum is a damaged American flag, one of a very few to survive, retrieved by a recovery worker from the World Trade Center rubble at the Staten Island landfill. Torn and severely damaged, it became the focus of public discussion about the meaning of the flag and, in tatters, became a powerful symbol of patriotism, survival, and resilience (Figure 2).[8]

Second, although objects such as the flag and the fragments from the crash sites were important symbols of the attacks, the museum also collected stories, moments that turned commonplace objects into compelling ones. The museum collected stories of loss—for example, the pry bar carried by the New York Fire Department's Lt. Kevin Pfeifer, who was killed in the World Trade Center collapse. The bar was given to NMAH by his brother, Chief Joseph Pfeifer, the first fire chief to arrive on the scene (Figure 3).[9] When this ordinary tool became part of the nation's collection, it also became part of the official memory of that day. Lieutenant Pfeifer's story took on a level of meaning it might not otherwise have had—it ceased to be just a private story of loss and became part of the public narrative, indeed part of our collective memory. Donating such objects to museums became part of what historian Ed Linenthal terms "active grief"—moving beyond private, intimate, passive grief to take action to preserve the memory of a moment and its consequences.[10] The need on the part of many people to express their grief in this way created collecting opportunities for curators: instead of holding on to objects for their individual needs, people offered them to museums, to public memory. But that active grief also made the work of curators more difficult—they more often had to say "no, thank you" to individuals struggling to address their grief and to preserve their memories through gifts to museums.

The National Museum of American History also collected a number of personal objects that told dramatic stories of escape that day—such as the shoes that Cecilia Benavente was wearing as she fled the 103rd floor of 2 World Trade Center, and the squeegee that Jan Demczur used to escape from an elevator in the north building.[11] The most compelling object for me is a small name tag, one of several objects that tell stories of rescue at the Pentagon. What makes this insignificant object so compelling is the story told at the donation ceremony by

Navy Captain David Thomas. Thomas explained that he tore off the name tag of Navy physician Lt. Cdr. David Tarantino so he would remember his name, convinced, after witnessing his heroic rescue acts, that he might never see Tarantino again and wanted to be able to tell the story of his heroism. Thus a small and ostensibly insignificant name tag became a powerful object that connects us to a compelling story of personal risk and heroism (Figure 4).[12]

FIGURE 4.

Name tag of Navy physician Lt. Cdr. David Tarantino, the Pentagon. Gift of Captain David M. Thomas Jr. and Lieutenant Commander David Tarantino. Photo courtesy of Armed Forces History Division, National Museum of American History, Smithsonian Institution.

A third category of September 11 objects is what I would term the ephemera of loss—materials that reflect the outpouring of grief not only on that day but in the weeks and months that followed. Grassroots memorials became icons of our shared loss, and preserving them became inextricably tied up in preserving the memory of that day. Initially, the photos and messages people posted were not intended as memorials but as part of the search for the missing—over 90,000 such fliers were posted across New York. But in too short a time, the missing became the lost, and missing fliers became the core of more complex makeshift memorials consisting of jumbles of candles, flowers, flags, stuffed animals, and other objects that reflected the outpouring of public grief. Although the Museum of American History did not collect entire memorial installations, others did. For NMAH the issue was not whether it was appropriate to collect memorials but where to best focus its collecting efforts, and its sister museums were clearly better positioned to take on this agenda. The memorials at the Bellevue Hospital, Liberty Plaza, St. Paul's Chapel, and elsewhere were site specific, rooted in place; hence, the best fit was with local and state institutions such as the Museum of the City of New York and the New York State Museum.[13] However, all such memorials were not in public—the Museum of American History collected materials from a makeshift memorial set up in a trailer by the New York Port Authority Police Department to honor fallen comrades. Recognizing it as an expression of grief, the museum's curator did not take the materials or even ask for them—he collected them only when they were offered.[14] In the context of September 11, many otherwise entrepreneurial curators demonstrated heightened ethical sensitivity.

Gardner

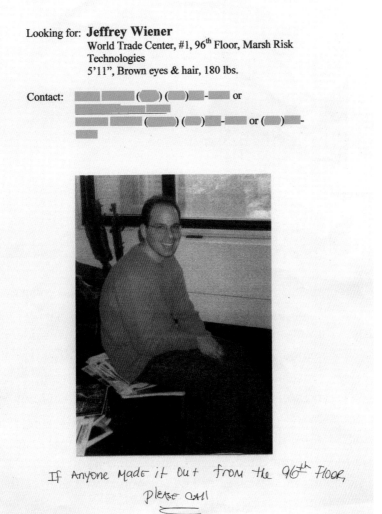

Looking for: **Jeffrey Wiener**
World Trade Center, #1, 96th Floor, Marsh Risk Technologies
5'11", Brown eyes & hair, 180 lbs.

Contact: ▊▊ ▊▊ (●) (▊)▊-▊ or
▊▊ ▊
▊▊ ▊ (●) (▊)▊-▊ or (▊)▊-
▊

If Anyone Made it Out from the 96th Floor, Please call

FIGURE 5.
Jeffrey Wiener's family members distributed this poster in their search. Sadly, they never found Jeff alive. Gift of Robin Wiener. Photo courtesy of Armed Forces History Division, National Museum of American History, Smithsonian Institution.

For me, the most powerful and compelling objects are not the larger memorial assemblages but rather materials that connect us more directly to a family's search for a missing relative. The National Museum of American History collected a poster distributed by the Wiener family as they looked for Jeffrey Wiener, their husband, son, and brother, and a list of hospitals on which they made notations as they tried unsuccessfully to find him alive.[15] This simple document engages us in the deep loss that families and friends experienced, not just the shock of the moment but the days of futile hope and then grief that followed. Such objects shift the story from death statistics to real individuals, engaging us all in a moment we cannot begin to imagine and hope to never experience (Figure 5).

FIGURE 6.
Search helmet used during the search and recovery work at the World Trade Center by New York State Police K-9 officer Richard M. Scranton. Photo courtesy of Armed Forces History Division, National Museum of American History, Smithsonian Institution.

Working collaboratively, NMAH curators built an important collection for the museum and for the nation. It remains a work in progress; indeed, we expect the collection to grow as we gain historical perspective and a greater understanding of the events of September 11. The collection includes nearly 4,000 objects:

- about 150 objects from the World Trade Center attacks, including pieces of emergency rescue equipment pulled from the wreckage and personal effects from victims, survivors, and rescuers (Figure 6)
- about 100 objects from the Pentagon attacks, including materials from victims, survivors, and rescuers at the Pentagon as well as from the victims on the plane
- about 25 objects from Flight 93, including pieces of the plane, objects associated with the victims, and Flight 93 memorial materials
- about 25 other objects, including commemorative and memorial materials
- over 1,600 photographic images documenting that day and the aftermath

The museum's collecting also extended to the web—NMAH partnered with the Center for History and New Media at George Mason University and the American Social History Project at the City University of New York Graduate Center in the development of the September 11 Digital Archive, which preserves over 150,000 messages, images, and other electronic files that constitute a critical resource for understanding that day and its impact.[16]

Although NMAH's September 11 collection is not a large one within the context of its over three million objects, it is an important one, constituting powerful evidence of that day and its impact. Developing the collection was challenging—we had to respond to the needs and concerns of the public without compromising our commitment to making meaning of the past. But then, that is always our goal. What was different was the level of emotion that constituted the context for and shaped that work. In developing the collection, we responded thoughtfully and positively to the challenges we encountered, embracing the opportunity to help our visitors understand these tragic events and contributing to the nation's healing.

Shortly before the 10th anniversary of the September 11 attacks, I left the Museum of American History for a new position at the National Archives. So I was an outsider looking in during the 2011 commemoration. What was striking was how little had actually changed over that decade. In 2002, the curatorial staff considered how things might be different in a decade, with the passage of time and the fading of emotion, but NMAH and other institutions preserving and interpreting September 11 have found that emotions are still raw a decade later, that the nation has not yet healed. Indeed, the sadness and fear that shaped that first year of collecting remained strong in 2011, and the objects remained powerful symbols of public loss, markers of public memory.

ACKNOWLEDGMENTS

Cedric Yeh, deputy chair, Division of Armed Forces History, NMAH, and Jennifer L. Jones, chair, Division of Armed Forces History, NMAH, went beyond the call of duty in working with me on this essay, and I thank them for their collegiality, support, and hard work over the years on NMAH's September 11 project.

NOTES

1. For additional information on Commander Dunn's ID card, see "September 11: Bearing Witness to History," National Museum of American History, accessed May 14, 2013, http://amhistory.si.edu/september11/collection/search_record.asp?search=1&keywords=dunn&mode=&record=0.

2. Dillon Ripley, *The Sacred Grove: Essays on Museums* (New York: Simon and Schuster, 1969), 67.

3. Steven Lubar and Kathleen Kendrick, *Legacies: Collecting America's History at the Smithsonian* (Washington, D.C.: Smithsonian Institution Press, 2001), 11.

4. This essay draws on previously published essays: James B. Gardner, "Collecting a National Tragedy," *Museum News* 81 (March/April 2002): 42–45, 66–67; James B. Gardner and Sarah M.

Henry, "September 11 and the Mourning After: Reflections on Collecting and Interpreting the History of Tragedy," *The Public Historian* 24 (Summer 2002): 37–52; James B. Gardner, "September 11: Museums, Spontaneous Memorials, and History," in *Grassroots Memorials: The Politics of Memorializing Traumatic Death*, ed. Peter Jan Margry and Cristina Sanchez-Carretero (New York: Berghahn Books, 2010), 285–303.

5. For a discussion of the larger context of public memorialization, see Peter Jan Margry and Cristina Sanchez-Carretero, eds., *Grassroots Memorials: The Politics of Memorializing Traumatic Death* (New York: Berghahn Books, 2010).

6. David Shayt, e-mail message to author, May 3, 2007.

7. For more discussion of the September 11 grassroots memorials, see Gardner, "September 11: Museums, Spontaneous Memorials, and History."

8. For additional information on NMAH's September 11 collections, see "September 11: Bearing Witness to History," National Museum of American History, accessed May 14, 2013, http://americanhistory.si.edu/september11/collection/index.asp.

9. For additional information on the pry bar, see "September 11: Bearing Witness to History," accessed May 14, 2013, http://americanhistory.si.edu/september11/collection/search_record.asp?search=1&keywords=pry%20bar&mode=&record=0.

10. Edward T. Linenthal, *The Unfinished Bombing: Oklahoma City in American Memory* (New York: Oxford University Press, 2001), 98–108.

11. For additional information on Benavente's shoes (including an interview with the curator), see "September 11: Bearing Witness to History,"

accessed May 14, 2013, http://americanhistory.si.edu/september11/collection/search_record.asp?search=1&keywords=shoes&mode=&record=1; for additional information on Demczur's squeegee (including an interview with the curator), see "September 11: Bearing Witness to History," accessed May 14, 2013, http://americanhistory.si.edu/september11/collection/search_record.asp?search=1&keywords=squeegee&mode=&record=0.

12. For additional information on the nametag (including a statement from Tarantino and an interview with the curator), see "September 11: Bearing Witness to History," accessed May 14, 2013, http://americanhistory.si.edu/september11/collection/search_record.asp?search=1&keywords=tarantino&mode=&record=0.

13. For more details on the New York State Museum's September 11 collection, see "The World Trade Center: Rescue, Recovery, Response," New York State Museum, accessed May 14, 2013, http://www.nysm.nysed.gov/wtc/index.html.

14. For additional information on the Port Authority police memorial, see "September 11: Bearing Witness to History," accessed June 10, 2015, http://americanhistory.si.edu/september11/collection/record.asp?ID=51.

15. For additional information on the Wiener material, see "September 11: Bearing Witness to History," accessed May 14, 2013, http://americanhistory.si.edu/september11/collection/search_record.asp?search=1&keywords=wiener&mode=&record=0.

16. "The September 11 Digital Archive," Roy Rosenzweig Center for History and New Media and American Social History Project/Center for Media and Learning, accessed May 14, 2013, http://911digitalarchive.org/.

BIBLIOGRAPHY

Gardner, James B. "Collecting a National Tragedy." *Museum News* 81 (March/April 2002): 42–45, 66–67.

———. "September 11: Museums, Spontaneous Memorials, and History." In *Grassroots Memorials: The Politics of Memorializing Traumatic Death*,

ed. Peter Jan Margry and Cristina Sanchez-Carretero, pp. 285–303. New York: Berghahn Books, 2010.

Gardner, James B., and Sarah M. Henry. "September 11 and the Mourning After: Reflections on Collecting and Interpreting the History of Tragedy." *The Public Historian* 24 (Summer 2002): 37–52.

Linenthal, Edward T. *The Unfinished Bombing: Oklahoma City in American Memory.* New York: Oxford University Press, 2001.

Lubar, Steven, and Kathleen Kendrick. *Legacies: Collecting America's History at the Smithsonian.* Washington, D.C.: Smithsonian Institution Press, 2001.

Margry, Peter Jan, and Cristina Sanchez-Carretero, eds. *Grassroots Memorials: The Politics of Memorializing Traumatic Death.* New York: Berghahn Books, 2010.

National Museum of American History. "September 11: Bearing Witness to History." Accessed May 14, 2013. http://amhistory.si.edu/september11/collection/search_record.asp?search=1&keywords=dunn&mode=&record=0.

New York State Museum. "The World Trade Center: Rescue, Recovery, Response." Accessed May 14, 2013. http://www.nysm.nysed.gov/wtc/index.html.

Ripley, Dillon. *The Sacred Grove: Essays on Museums.* New York: Simon and Schuster, 1969.

Roy Rosenzweig Center for History and New Media and American Social History Project/Center for Media and Learning. "The September 11 Digital Archive." Accessed May 14, 2013. http://911digitalarchive.org/.

Collecting a National Tragedy

September 11, 2001, a Moment in Time: Relevance of the Smithsonian Human Skeleton Collections

Marilyn R. London

My introduction to the human skeletal collections at the Smithsonian occurred on the first day of my final class at The George Washington University, Anthropology of the Skeleton. The course was taught at the museum by J. Lawrence Angel, curator of physical anthropology, and he had placed a human skull at every position around a seminar table. As we sat down, nervous and excited, I exclaimed, "This one is a Neolithic male from Turkey!" The student across from me paled. "You have been here for fifteen seconds and you already figured that out?" he asked. "I'm dropping the class." He might have, except that I pointed out that the information came from the label on the skull itself. Decades later, I have learned to analyze human remains and develop descriptive identities for them

even when they are not labeled. In addition, I have developed a deep interest in how diseases affect bones and how bone diseases affect the patient's quality of life. To get to this point, I have studied thousands of skeletonized individuals, most of them in the collections of the National Museum of Natural History.

SMITHSONIAN COLLECTIONS AND SKELETAL ANALYSIS

Generations of physical anthropologists, including myself, have relied on Smithsonian collections of human skeletons for information on human variation. The Division of Physical Anthropology of the Department of Anthropology in the National Museum of Natural History houses and conserves large numbers of human skeletons. The first human skeletons were donated to the National Museum of Man (now the National Museum of Natural History) in 1857 by Charles Wilkes. Now, more than 30,000 individuals are cataloged in the collections. Some of these skeletons were individually donated by members of the public. Others were collected from archaeological and historic burial sites around the world over the past 150 years. Skeletal collections have been transferred from other museums, notably the Army Medical Museum (now the National Museum of Health and Medicine). We also have many skeletons that are "documented"; that is, we know each individual's name, sex, age at death, and often such details as standing height, diseases that affected the person during life, and cause of death. The largest group of documented human skeletons at the Smithsonian is the Robert J. Terry Collection. Over 1,700 skeletons of known age, sex, and ancestry were collected by Dr. Terry, an anatomist at Washington University in St. Louis, Missouri. These individuals range in age at death from 16 to 102 years. When Mildred Trotter, Terry's successor, retired in 1967, the collection was transferred to the Smithsonian to allow researchers access to the skeletons.[1] Scores of physical anthropologists and anatomists, professionals and students from the United States and from the international community, study these individuals every year.[2] The results of their research are presented at professional meetings and published in journals such as the *American Journal of Physical Anthropology*, which was founded by the Smithsonian's first physical anthropology curator, Aleš Hrdlička, in 1918.

All individuals from a single site or collection are kept together as a "population," so that researchers can compare measurements and observations of these populations to other groups. Conversely, individual skeletons brought in

London

for comparison can often be associated with one of these populations on the basis of their similarities to the group. The collections at the Smithsonian do not include only the best examples or the one "right" version of the object or organism, whether the object of study is a manmade article such as a chair, an organism such as a plant or animal, or a work of art such as a painting. Biological entities have an incredible amount of variation, for instance, which allows populations to withstand and adapt to changes in environment. So for each collection, the museum wants samples of as many individuals and populations as possible. Think of it as a library. One book cannot explain everything about a topic. So having thousands of examples of the human skeleton is necessary for accurate analysis, and a scholar who has studied only a few skeletons cannot appreciate the variation between and within human populations. Just as no two living people look exactly alike, no two skeletons are identical. They have differences in shape and size that are due to age, sex, ancestry, and pathological conditions. Even twins exhibit differences because life events—bone fractures, cavities in the teeth, nutritional stress—are recorded in our bones. The living tissue in the skeleton is susceptible to many kinds of stress and responds in recognizable ways. The donated and documented human skeletons serve as a reference library to represent the rest of humanity. It is not a perfect collection, and there are many gaps. However, these individuals provide a valuable data set against which to measure the rest of us, and the collection has enough skeletons to make statistical comparisons valid.

It is the Terry collection, other documented collections at the Smithsonian, and similar collections around the world that have established the standards for the analysis of human skeletons.[3] Study of these known individuals has shown physical anthropologists what is normal in the human skeleton, how the skeleton changes during a person's lifetime, differences between male and female skeletal structure, and how much variation can be expected, both within a particular population and between populations. For instance, researchers have used the Smithsonian's documented collections to develop techniques for the determination of age at death, sex, stature, and ancestry.[4] These methods may involve measurements, observations (e.g., presence or absence), or the development of mathematical models or statistical techniques. Populations have been compared on the basis of the shape and size of individual bones or bone structures, such as the cranium. Medical records from the documented individuals reveal the clinical manifestations of the diseases we see in their bones.[5] Frequently, research is

"case generated"; that is, a question arises during the analysis of a population or an individual, a hypothesis is formed, and data are collected on known individuals to determine if the hypothesis can be supported. The Terry and other Smithsonian collections are also used to test techniques developed elsewhere. It is important to add that much of the research has been done on individual skeletal elements or even on sections of these elements. The results are thus applicable to situations where human remains are skeletonized, incomplete, damaged, or fragmented. In mass disaster situations with multiple fatalities, the anthropology team applies this body of knowledge and their own experience to the identification of the human remains. Sometimes only a single measurement can be made or one angle analyzed or an isolated feature scored for presence or absence. These small pieces of information are organized, collated, and analyzed and then used to help identify the individuals. This identification process is easier in a closed population like that from an airplane crash, in which the number and identity of the individuals is known. It is more difficult when dealing with an open population, such as the victims of Hurricane Katrina, for which even the number of victims is in question. The anthropologists work closely with the DNA collection and analysis teams and with the pathologists, each group using the others for quality assurance and verification.

Virtually every living skeletal biologist has studied at the Smithsonian, has a mentor who did research on the Smithsonian collections, or relies on the publications of those who have done research there. Information on variation in the human skeleton has accumulated in medical, biological, and anthropological literature for more than 100 years, and our knowledge increases every year.

SEPTEMBER 11, 2001

A few people in every U.S. community—people responsible for disaster management, first responders, law enforcement supervisors—had given some thought to it, but planning for a terrorist attack within the continental United States was not really what Americans were thinking about in 2001. When the attacks did occur on September 11 in New York City, at the Pentagon, and on an airplane over Pennsylvania (Figure 1), few knew how to respond. But Americans were not without resources. Local emergency responders stepped forward to help, many of them losing their own lives trying to save others. State, local, and federal government agencies went into action to provide security, medical supplies,

FIGURE 1.
Flight 93 National Memorial,
Somerset County, Pennsylvania.
Photo by David A. Jackson.

manpower, and communications. Citizens made donations of food and money to the Red Cross, the Salvation Army, and local charitable groups. Some people simply made coffee or meals to hand out to responders at the attack sites. In a dark hour, Americans did what they could to save victims of the attack and to help the responders.

But what about the aftermath? What happened after the fires had been controlled, the injured had been cared for, and the smoke had cleared? There was still work to do, and that included the recovery of human remains, separating structural materials (from the buildings and the aircraft) from biological materials, and the identification of the dead. It is an unfortunate fact that when people are victims of mass disasters, their remains are not often recovered as whole bodies. There is significant trauma to each individual, and remains become commingled. Often, the recognizable flesh—of the face and hands, for instance—is damaged or destroyed. The responders must be able to recognize what is human and to recover those human remains for identification.

A very small part of the population is prepared to do this kind of work. It is, under the best of circumstances, emotionally draining, physically tiring, and psychologically disturbing. Historically, funeral directors, emergency medical personnel, and law enforcement agencies have stepped forward to assist in this necessary task. In the 1990s, the U.S. Department of Health and Human Services' National Disaster Medical System organized a specialized team to respond when local resources were overwhelmed by multiple fatality incidents. This team, the Disaster Mortuary Operational Response Team (DMORT), comprises pathologists, dentists, mortuary personnel, logistics staff, photographers and radiology technologists, and physical anthropologists. These people have "regular" jobs but are trained to work together to identify the dead. When deployed, the team members leave their everyday positions and become temporary federal employees. The team is divided into 10 geographic regions, but members can be asked to respond to disasters anywhere in the United States. The Disaster Mortuary Operational Response Team has been deployed to floods, hurricanes, airplane and train crashes, and terrorist attacks. Members also act as part of advance teams to prepare for possible problems in situations such as presidential inaugurations and joint sessions of the U.S. Congress.

Many of the physical anthropologists associated with the Smithsonian's National Museum of Natural History were trained and experienced in mass disaster response long before September 11, 2001. The Department of Anthropology has had a

long history in the identification of human remains in forensic and multiple-fatality situations.[6] The physical anthropology curatorial staff work closely with the Federal Bureau of Investigation and other law enforcement agencies, as well as medical examiners and coroners from around the country. Several employees and long-term contractors were part of the DMORT system. Their skills had been developed over years, through coursework, research, and documentation of hundreds of individual skeletons, many in the collections of the National Museum of Natural History.

The ongoing research on Smithsonian collections has given generations of physical anthropologists new techniques and new knowledge, tools that can be used to help identify unknown human remains in historic, forensic, and mass disaster situations. Those of us who have concentrated on skeletal biology and who have worked extensively with museum collections like those at the Smithsonian have acquired the skills to provide descriptions of the living based on their skeletal remains. Thus, when thousands of people died in the terrorist attacks of September 11, 2001, physical anthropologists, including me and other Smithsonian anthropologists, were able to help with the recovery and identification of people who died in the airplanes and buildings. From the Smithsonian, curators Douglas H. Ubelaker and Douglas W. Owsley were sent to the Armed Forces Mortuary Affairs Operations at Dover Air Force Base in Delaware. The victims who died at the Pentagon were sent to Dover for identification. At the time, I was a contractor in the Repatriation Osteology Laboratory at the Smithsonian and teaching part time at the University of Maryland and The George Washington University. Dawn M. Mulhern (another contractor, now on the faculty of Fort Lewis College in Durango, Colorado) and I were deployed by DMORT to Somerset, Pennsylvania. Terrorists had taken control of United Airlines Flight 93, a Boeing 757 flying from Newark to San Francisco. The passengers and crew on the flight learned through telephone calls that other airplanes had been used to attack the World Trade Center and the Pentagon earlier that morning. They were able to thwart the terrorists' plans to attack other targets, but the plane crashed into an open field in Somerset County, Pennsylvania. All aboard, 40 passengers and crew and 4 terrorists, were killed.

At Somerset, we joined anthropologists from the National Museum of Health and Medicine, Mercyhurst College (Erie, PA), Michigan State University, and the Maricopa County (Arizona) Medical Examiner's Office. Several of the anthropologists had responded to other air crashes and terrorist attacks (e.g., EgyptAir Flight 990, Executive Air, Korean Air Flight 801, and Oklahoma City Murrah Building)

and were thus experienced in working on mass fatality incidents with the National Transportation Safety Board (NTSB) and other disaster response agencies. One anthropologist had special training in obtaining DNA samples.

The Flight 93 crash site was considered to be a crime scene and was under the control of the Federal Bureau of Investigation (FBI), instead of the NTSB. Because the attack sites are all crime scenes, those of us who responded are not permitted to discuss the actual work we did in the morgues. However, we can discuss how the agencies cooperated and the roles we played. The DMORT team leader took on the responsibility for communication between the FBI, the DMORT personnel, the local coroner, and other agencies that were present. Because I had experience with several air crash responses, I assumed the role of morgue manager, a position normally taken by the team leader. Part of my responsibility was to supervise the development of a protocol for each area of activity within the morgue to ensure that all remains were analyzed using standard procedure. The morgue stations included triage, admitting, radiography, photography, anthropology, pathology, odontology (dentistry), and DNA sampling. (The FBI had its own protocol for fingerprinting.) The protocols were initially written by experienced personnel on the basis of previous experiences and were modified during the September 11 incident to reflect the medicolegal aspects of the situation. With written instructions, team members were able to work confidently in their areas, and turnovers in staffing were smooth.

Our morgue was set up in a National Guard armory in Somerset. At the time, DMORT had its own mobile morgue unit, equipped with computers, X-ray machines, autopsy room supplies, measuring tools, literature, comparative anatomical casts, protective clothing, etc. That morgue unit was deployed to New York City because of the large number of victims there. In Somerset, we had next to nothing, but the local citizens came forward to meet our needs. Furniture and medical equipment were donated or loaned. Somerset Hospital provided not only radiographic equipment but trained employees to operate it. The supervisor made telephone calls to get donations of X-ray film. A copy machine appeared when needed. The Department of Anthropology at Pennsylvania State University loaned us anthropometric tools and reference materials, and DMORT contracted with Kenyon International Emergency Services for other necessary supplies and materials.

The schedule was a 12-hour day (standard for DMORT), 7 days a week. We worked from 7:00 AM to 7:00 PM. Security was supplied by the Pennsylvania

State Police, the National Guard, and the FBI. We were required to sign in and out of the morgue every time we went through the door. Special identification badges were made for the crash site and the morgue, and without a badge you could not enter either area. The work was tough, but the team had trained for this kind of response, and most things went smoothly. Some evenings we de-stressed by having group activities (bowling, meeting at the local all-you-can-eat Chinese restaurant, going to a local laundromat). Other evenings we broke into smaller groups. Few of us watched any television.

I would like to take some space here to acknowledge the support we got from the community. The Red Cross set up a cafeteria just outside the armory and provided meals and refreshments for all personnel. They also had counselors available if anyone wanted to talk. (This did not happen much, as the DMORT responders are self-selected for and experienced in the kind of work we do, and the team members tend to debrief each other rather than going to outside sourc-es.) The Salvation Army also provided support near the crash site. Both of these organizations, and the people who worked for them, were exemplary. For ex-ample, after the first few days, the Red Cross people asked me if there were other services they could provide. As most of the morgue personnel were standing on a concrete floor for about 12 hours a day, I jokingly suggested that we needed some massage therapists. The next day, and for every day we were there after that, at least two massage therapists showed up to give foot and back massages.

One day a local church invited us all to come for lunch. A group of women in the neighborhood baked dozens of cupcakes and sent them to us. The fences along the roads between our motels and the morgue were plastered with posters thanking us for coming to help. A group of schoolchildren in Ohio sent letters of support. The local firefighters were supposed to host a national meeting the week after September 11, but the event was canceled. It was too late, however, to cancel their orders for food, drink, and entertainment. They invited everyone associated with the response to come and relax and eat and sing along with the karaoke machine for an evening. When we went to dinner in the community in the evenings, people were friendly and gracious. In other words, they were all responding to the situation just as we were. The following year I heard two soci-ologists from Ohio talk about the community as a group of "mountain people" who were frightened by the situation and did not know how to respond. That insulting description of the Somerset residents infuriated me because I had been the recipient of their good will, kindness, and very appropriate responses.

State Police, the National Guard, and the FBI...

The DMORT team finished most of the work in Pennsylvania within two weeks, and everyone went home. However, several of us returned a few weeks later to join about 300 firefighters who volunteered to search the crash site for any evidence that had been missed. In February of 2002, after all of the DNA samples had been processed, a group of four anthropologists, including Erica B. Jones from the Repatriation Osteology Laboratory and me, returned to Somerset to assist the Somerset County coroner, Wally Miller, with the process of reassociating the commingled remains into individuals so that they could be returned to their families.

Physical anthropologists responding to the attacks of September 11, 2001, were involved in all stages of the response, from recovery to identification. They had many duties within the morgue environment, from assisting the radiographic team to collecting DNA samples. They worked directly with pathologists, dentists, medical examiners and coroners, law enforcement agents, and DNA specialists. My training and experience in physical anthropology and with the Smithsonian collections gave me the vocabulary, flexibility, and skills necessary to perform these critical functions.

ACKNOWLEDGMENTS

I gratefully acknowledge the support and encouragement given to me by Alison S. Brooks (professor, George Washington University) and David R. Hunt (collections manager, National Museum of Natural History) and by the late J. Lawrence Angel and Donald J. Ortner (curators, Physical Anthropology, National Museum of Natural History) throughout my career.

NOTES

1. David R. Hunt and John Albanese, "Historic and Demographic Composition of the Robert J. Terry Anatomical Collection," *American Journal of Physical Anthropology* 127, no. 4 (2005): 406–417.
2. In addition to my work with the Terry anatomical collections, I have also worked documenting skeletal remains of Native Americans at the National Museum of Natural History that are being repatriated to Native American tribes in response to the National Museum of the American Indian Act of 1989. The process involves describing and identifying each individual as well as possible on the basis of skeletal traits and measurements, information on the burial, and associated objects. Repatriation staff members work to establish connections between the remains and the tribes who are requesting their return, so that everyone concerned is confident that all remains and objects are identified and repatriated correctly.
3. Jane E. Buikstra and Douglas H. Ubelaker, eds., *Standards for Data Collection from Human*

Skeletal Remains: Proceedings of a Seminar at the Field Museum of Natural History (Fayetteville: Arkansas Archaeological Survey Press, 1994).

4. For determination of age at death, see Laurent Matrille, Douglas H. Ubelaker, Cristina Cattaneo, Fabienne Seguret, Marie Tremblay, and Eric Baccino, "Comparison of Four Skeletal Methods for the Estimation of Age at Death on White and Black Adults," *Journal of Forensic Sciences* 52, no. 2 (2007): 302–307. For determination of sex, see Emily L. Berrizbeitia, "Sex Determination from the Head of the Radius," *Journal of Forensic Sciences* 34, no. 5 (1989): 1206–1213. For stature, see Mildred Trotter and Goldine C. Gleser, "Estimation of Stature from Long Bones of American Whites and Negroes,"

American Journal of Physical Anthropology 10, no. 4 (1952): 463–514. For ancestry, see J. Lawrence Angel and Jennifer Olsen Kelley, "Inversion of the Posterior Edge of the Jaw Ramus: New Race Trait," in *Skeletal Attribution of Race: Methods for Forensic Anthropology*, ed. George W. Gill and Stanley Rhine, Anthropological Papers of the Maxwell Museum of Anthropology 4 (Albuquerque, NM: Maxwell Museum of Anthropology, 1990), 33–39.

5. Donald J. Ortner, *Identification of Pathological Conditions in Human Skeletal Remains*, 2nd ed., (San Diego: Academic Press, 2003).

6. David Hunt, "Forensic Anthropology at the Smithsonian Institution," *AnthroNotes* 27, no. 1 (Spring 2006): 6–12.

BIBLIOGRAPHY

Angel, J. Lawrence, and Jennifer Olsen Kelley. "Inversion of the Posterior Edge of the Jaw Ramus: New Race Trait." In *Skeletal Attribution of Race: Methods for Forensic Anthropology*, ed. George W. Gill and Stanley Rhine, pp. 33–39. Anthropological Papers of the Maxwell Museum of Anthropology 4. Albuquerque, NM: Maxwell Museum of Anthropology, 1990.

Berrizbeitia, Emily L. "Sex Determination from the Head of the Radius." *Journal of Forensic Sciences* 34, no. 5 (1989): 1206–1213.

Buikstra, Jane E., and Douglas H. Ubelaker, eds. *Standards for Data Collection from Human Skeletal Remains: Proceedings of a Seminar at the Field Museum of Natural History*. Fayetteville: Arkansas Archaeological Survey Press, 1994.

Hunt, David. "Forensic Anthropology at the Smithsonian Institution." *AnthroNotes* 27, no. 1 (Spring 2006): 6–12.

Hunt, David R., and John Albanese. "Historic and Demographic Composition of the Robert J. Terry Anatomical Collection." *American Journal of Physical Anthropology* 127, no. 4 (2005): 406–417.

Mann, Robert W., and Douglas H. Ubelaker. "The Forensic Anthropologist." *FBI Law Enforcement Bulletin* 59, no .7 (1990): 20–23.

Matrille, Laurent, Douglas H. Ubelaker, Cristina Cattaneo, Fabienne Seguret, Marie Tremblay, and Eric Baccino. "Comparison of Four Skeletal Methods for the Estimation of Age at Death on White and Black Adults." *Journal of Forensic Sciences* 52, no. 2 (2007): 302–307.

Ortner, Donald J. *Identification of Pathological Conditions in Human Skeletal Remains*. 2nd ed. San Diego: Academic Press, 2003.

Trotter, Mildred, and Goldine C. Gleser. "Estimation of Stature from Long Bones of American Whites and Negroes." *American Journal of Physical Anthropology* 10, no. 4 (1952): 463–514.

Ubelaker, Douglas H. "Skeletons Testify: Anthropology in Forensic Science—AAPA Luncheon Address: April 12, 1996." *Yearbook of Physical Anthropology* 39 (1996): 229–244.

Contributors

Mary Jo Arnoldi is Curator of African Ethnology and Arts at the National Museum of Natural History. She has conducted research in West Africa since 1978, and her publications include *Playing with Time: Art and Performance in Central Mali* (1995), *African Material Culture* (1996), "Bamako, Mali: Monuments and Modernity in the Urban Imagination" (2007), and "Preservation and Heritage Management in Mali: The Old towns of Djenné and the *Sanké Mon* Fishing Rite" (2014) as well as numerous articles on the museum's historic African collections and its African exhibitions. She cocurated *African Voices*, the museum's permanent African exhibition (2000), cocurated *From Timbuktu to Washington* (Mali Program) at the Smithsonian Folklife Festival (2003), and cocurated *Mud Masons of Mali* and produced the film *Mud Masons of Djenné* (2013).

Dwight Blocker Bowers is Curator of American Entertainment History at the Smithsonian's National Museum of American History. He has created numerous exhibitions, including *Red, Hot and Blue: A Salute to American Musicals*, for which he served as cocurator and coauthor of the book with the same title. He has produced and annotated over 30 recordings and received three Grammy Award nominations.

S. Terry Childs is an archaeologist who spent over 20 years in East and south Central Africa studying ancient and precolonial metal working. She has excavated Early and Later Iron Age sites in Tanzania, Democratic Republic of the Congo, and Uganda; conducted ethnoarchaeological interviews of blacksmiths in Uganda; studied collections stored in museums in Tanzania, Uganda, Zimbabwe, Belgium, and the United States; and conducted laboratory analyses of ancient iron and copper objects and metallurgical waste products in various U.S. laboratories. She has numerous publications about this work. She is currently the manager of the Department of the Interior Museum Program.

Roger Connor curates extensive aeronautical technical collections for the National Air and Space Museum, including helicopters and other vertical flight aircraft. An experienced commercial pilot, he holds master's degrees in American history from George Mason University and museum studies from The George Washington University and is a Ph.D. candidate in American history at George Mason University. His current areas of research focus on the government stewardship of technology in mid-twentieth-century America and the proliferation of aeronautical smuggling before World War II.

Bernard Finn is Curator Emeritus at the Smithsonian's Museum of American History, with academic degrees in engineering physics and history of science. His exhibits and publications have dealt mainly with electrical topics, including occasional reflections on relationships to art. In recent years he has paid special attention to the development of technical museums, cofounding an international organization called Artefacts that encourages various ways of using objects in historical studies of science and technology in museums and elsewhere.

Richard Fiske is Geologist Emeritus in the Division of Petrology and Volcanology in the Department of Mineral Sciences, National Museum of Natural History. As a research geologist he specializes in the study of volcanoes, both active and ancient. His current research is focused on volcanoes in Japan and in Hawaii. Interrupted only by a 5-year stint as the director of the Smithsonian's National Museum of Natural History, he has worked continuously on Kīlauea volcano on the Big Island of Hawaii for the past 50 years.

Bruno Frohlich is a biological anthropologist and an emeritus scientist with the National Museum of Natural History of the Smithsonian Institution. He has worked on fieldwork research projects in Europe, the Arctic/sub-Arctic regions, Iran, northern Africa, the Middle East, and, most recently, Mongolia, Peru, and Bolivia. For nine years, in collaboration with the Mongolian Academy of Sciences, he has directed several Mongolian projects, including surveying and excavations of Bronze Age burial mounds, forensic investigations of executed Buddhist monks, and research of human mummified remains from the Gobi Desert. His books include *To the Aleutians and Beyond* (2002) and *The Early Bronze Age I Tombs and Burials of Bâb edh-Dhrâ', Jordan* (with Donald Ortner, 2008). He has also published more than 50 scientific and popular articles.

James B. Gardner is Executive for Legislative Archives, Presidential Libraries, and Museum Services at the National Archives. He previously served as Senior Scholar and as Associate Director for Curatorial Affairs at the National Museum of American History. He served as president of the National Council on Public History, chair of the Nominating Board of the Organization of American Historians, on the American Association of State and Local History Council, and on the editorial boards of *The Public Historian* and the AAM Press. His most recent publications include essays in *The Routledge Companion to Museum Ethics: Redefining Ethics for the Twenty-First Century Museum* (2011), *Grassroots Memorials: The Politics of Memorializing Traumatic Death* (2011), *Museum Practice: Critical Debates in the Museum Sector* (2015), and *Museum Theory: An Expanded Field* (2015). He is coeditor of the *Oxford Handbook of Public History.*

Frank H. Goodyear III is the codirector of the Bowdoin College Museum of Art in Brunswick, Maine. He was previously a curator of photographs at the Smithsonian's National Portrait Gallery. A graduate of Princeton University (A.B.) and the University of Texas at Austin (M.A., Ph.D.), Goodyear has done research in the history of photography, American art history, and the history of the American West. While at the National Portrait Gallery, he curated or cocurated more than a dozen exhibitions. He is the author of numerous scholarly essays and six books, including *Red Cloud: Photographs of a Lakota Chief* (2003), *Faces of the Frontier: Photographic Portraits from the American West, 1845–1924* (2009), *A President in Yellowstone: The F. Jay Haynes Photographic Album of Chester Arthur's 1883 Expedition* (2013), and, with Joel Dinerstein, *American Cool* (2014).

Ellen Roney Hughes is a cultural historian and Curator Emeritus at the Smithsonian's Museum of American History, where she spent over four decades curating more than 20 exhibitions, including *The Wizard Oz and the Ruby Slippers* and *Sports: Breaking Records, Breaking Barriers.* She built museum collections on American sports, American puppetry, women's sports, and television comedy and authored a book, book chapters, and articles. Most recently, she worked on the inaugural sports exhibition for the National Museum of African American History and Culture. She received her Ph.D. from the University of Maryland and serves as an adjunct faculty in the American Studies Department, where she has taught graduate courses on museum scholarship.

David R. Hunt is a collection manager in the Division of Physical Anthropology, Department of Anthropology at the National Museum of Natural History. He received two B.A. degrees from the University of Illinois, in physical anthropology and classical archaeology, and M.A. and Ph.D. degrees from the University of Tennessee in skeletal biology and forensic anthropology. He is an adjunct faculty at George Washington University, and a consultant for the Office of Chief Medical Examiner, Northern Virginia Region, for Project Alert and for the Forensic Imaging Unit at the National Center for Missing and Exploited Children. He consults on human skeletal collections management and conducts U.S. archeological excavations, as well as international archeological excavations and skeletal biological research in Mongolia, Egypt, and Rwanda. He is a diplomate of the American Board of Forensic Anthropologists.

Peter L. Jakab is Chief Curator of the Smithsonian's National Air and Space Museum. He has curated numerous exhibitions and frequently lectured on aviation history and the history of technology in general. His books include *Visions of a Flying Machine: The Wright Brothers and the Process of Invention* (1990), *The Published Writings of Wilbur and Orville Wright* (2000), and *The Wright Brothers and the Invention of the Aerial Age* (2003).

Adrienne L. Kaeppler is a social/cultural anthropologist and Curator of Oceanic Ethnology at the National Museum of Natural History, Smithsonian Institution. Her research focuses on the visual and performing arts and material culture in their cultural contexts, especially dance, music, and poetry in their traditional social and political structures and modern cultural identity. She has carried out field research in many parts of the Pacific with long-term research in Tonga, Hawaii, and Rapa Nui. Her books include *Hula Pahu: Hawaiian Drum Dances* (1993), *The Pacific Arts of Polynesia and Micronesia* (2008) and *Lakalaka: A Tongan Masterpiece of Performing Arts* (2012), which documents a Tongan performing art that was declared a Masterpiece of the Oral and Intangible Heritage of Humanity by UNESCO.

Marilyn R. London is a skeletal biologist who has worked extensively with the collections at the National Museum of Natural History. She earned her B.A. at The George Washington University and her M.A. at the University of New Mexico. She is a forensic anthropologist with the Disaster Mortuary Operational Response Team and currently teaches for several departments at the University of Maryland.

Katherine Ott is curator at the National Museum of American History and holds a Ph.D. in history. Her research interests include the history of the body, disability, ethnic and folk medicine, integrative and alternative medicine, ophthalmology, plastic surgery and dermatology, medical technology, prosthetics and rehabilitation, gender and sexuality, visual and material culture, and ephemera. She has curated exhibitions on AIDS, the Disability Rights Movement, and polio, among others. She is the author or coeditor of three books and teaches a graduate course in American studies at The George Washington University. She tweets @amhistcurator.

Ann M. Shumard is Senior Curator of Photographs at the Smithsonian's National Portrait Gallery, where she is responsible for building, diversifying, and interpreting the museum's photography collection. Her research has resulted in exhibitions such as *A Durable Memento: Portraits by Augustus Washington, African American Daguerreotypist* (1999), *Edward Steichen: Portraits* (2008), *In Vibrant Color: Vintage Celebrity Portraits from the Harry Warnecke Studio* (2012), *Bound for Freedom's Light: African Americans and the Civil War* (2013), and *Yousuf Karsh: American Portraits* (2013). She has contributed to a number of publications, including the books *Portrait of the Art World: A Century of ARTnews Photographs* (2002), *At First Sight: Photography and the Smithsonian* (2003), *Let Your Motto Be Resistance: African American Portraits* (2007), and *Smithsonian Civil War: Inside the National Collection* (2013).

Richard Stamm is the curator of the Smithsonian's Castle Collection, which is used to furnish the offices and public spaces of the Smithsonian Institution's first building. He was coauthor of the 1993 book *The Castle: An Illustrated History of the Smithsonian Building* and sole author of the updated 2012 second edition. He has written and published several articles on Smithsonian history, historic lighting fixtures, and nineteenth century furniture and curated related exhibits in the Castle. He has been with the Smithsonian since 1975.

Gary Sturm has worked since 1975 to increase the scope of the Smithsonian's collections of musical instruments, with a special interest in the violin family. As the chair of the Division of Musical History, he was responsible for the preservation and study of its 5,000 musical instruments that range from Tennessee fiddles to elegant French harpsichords and served as Executive Director of the Smithsonian Chamber Music Society. He has participated in more than a dozen Smithsonian exhibitions, ranging from automatic musical instruments and electric guitars to international performance tours of Stradivari instruments

Matthew A. White is a Ph.D. candidate in the history of science at the University of Florida. He has 20 years of experience in museums of science and technology, including as the director of the Hands On Science Center at the Smithsonian Institution's National Museum of American History, where he also served as the educator on the exhibition *Whatever Happened to Polio?*

Judith Zilczer, Curator Emeritus of the Hirshhorn Museum and Sculpture Garden, Smithsonian Institution, organized more than two dozen exhibitions in her 29 years at the museum, where she served as historian, Curator of Paintings, and Acting Chief Curator. Her publications include *"The Noble Buyer": John Quinn, Patron of the Avant-Garde* (1978), *Willem de Kooning from the Hirshhorn Museum Collection* (1993), *Richard Lindner: Paintings and Watercolors, 1948–1977* (1996), *Visual Music: Synaesthesia in Art and Music Since 1900* (2005), and *A Way of Living: The Art of Willem de Kooning* (2014). The recipient of the 2006 George Wittenborn Memorial Book Award of the Art Libraries Society of North America, she has written and lectured widely on modern and contemporary art and currently serves on the editorial board of *The Woman's Art Journal*.